P9-ARK-396

GOSPELS AND ACTS

The Saint John's Bible

Handwritten and Illuminated by Donald Jackson

©2005
The Order of Saint Benedict
Collegeville, Minnesota 56321
All rights reserved.
The Saint John's Bible
Published by Liturgical Press

Scripture quotations are from the New
Revised Standard Version of the Bible,
Catholic Edition, ©1989, 1993 National
Council of the Churches of Christ in the
United States of America. Used by
permission. All rights reserved.

No part of this book may be reproduced in
any form, by print, microfilm, microfiche,
mechanical recording, photocopying,
translation, or by any other means, known or
yet unknown, for any purpose, except brief
quotations in reviews, without the previous
written permission of the Liturgical Press,
Saint John's Abbey, P.O. Box 7500,
Collegeville, Minnesota 56321-7500.
Printed in China.

www.saintjohnsbible.org
www.litpress.org

1 3 5 7 9 10 8 6 4 2

ISBN 0-8146-9051-3

Library of Congress Cataloging-in-Publication Data

Bible. English. New Revised Standard. 2005.
 The Saint John's Bible / handwritten and illuminated
by Donald Jackson.
 p. cm.
 Summary: "A full-color reproduction of the handwrit-
ten and illuminated work, The Saint John's Bible, in
seven volumes"—Provided by publisher.
 ISBN 0-8146-9058-0 ((set) : alk. paper) — ISBN 0-
8146-9052-1 (alk. paper) — ISBN 0-8146-9053-X (alk.
paper) — ISBN 0-8146-9054-8 (alk. paper) — ISBN 0-
8146-9055-6 (alk. paper) — ISBN 0-8146-9056-4 (alk.
paper) — ISBN 0-8146-9051-3 (alk. paper) — ISBN 0-
8146-9057-2 (alk. paper)
 1. Bible. 2. Saint John's Bible. 3. Manuscripts,
English—Minnesota—Collegeville—Facsimiles.
4. St. John's University (Collegeville, Minn.) 5. Bible—
Illustrations. 6. Saint John's Bible—Illustrations.
7. Illumination of books and manuscripts—Wales.
8. Jackson, Donald, 1938- I. Title: St. John's Bible.
II. Jackson, Donald, 1938- III. St. John's University
(Collegeville, Minn.) IV. Title.

BS191.5.A12005 .C65
220.5'20434—dc22
 2004025099

There are 1,150 pages of *The Saint John's Bible* in seven distinct volumes: *Pentateuch, Historical Books, Wisdom Literature, Psalms, Prophets, Gospels and Acts* and *Letters and Revelation.*

In addition, a separate book entitled *Illuminating the Word: The Making of The Saint John's Bible*, by Christopher Calderhead, is available.

Donald Jackson, as Artistic Director, gathered a group of artist-calligraphers and illuminators from around the world. He worked together with them to produce the very best in calligraphy and illumination. They each brought their own skills and perspectives. Their expertise and affection for the art and for *The Saint John's Bible* project contributed to this volume in countless ways.

Artistic Director
Donald Jackson

Artists, Scribes and Designers
Hazel Dolby
Vin Godier
Aidan Hart
Sue Hufton
Thomas Ingmire
Andrew Jamieson
Sally Mae Joseph
Suzanne Moore
Brian Simpson
Chris Tomlin

Hebrew Script
Christopher Calderhead, *Notes*
Izzy Pludwinski, *Consultant*

Other members of the Scriptorium team
Mabel Jackson, *Partner*
Rebecca Cherry, *PA/Coordinator*
Olivia Edwards, *Project Manager 1999-2001*
Mark L'Argent, *Studio Assistant 2000-2002*
Sally Sargeant, *Proofreader*

GOSPELS AND ACTS

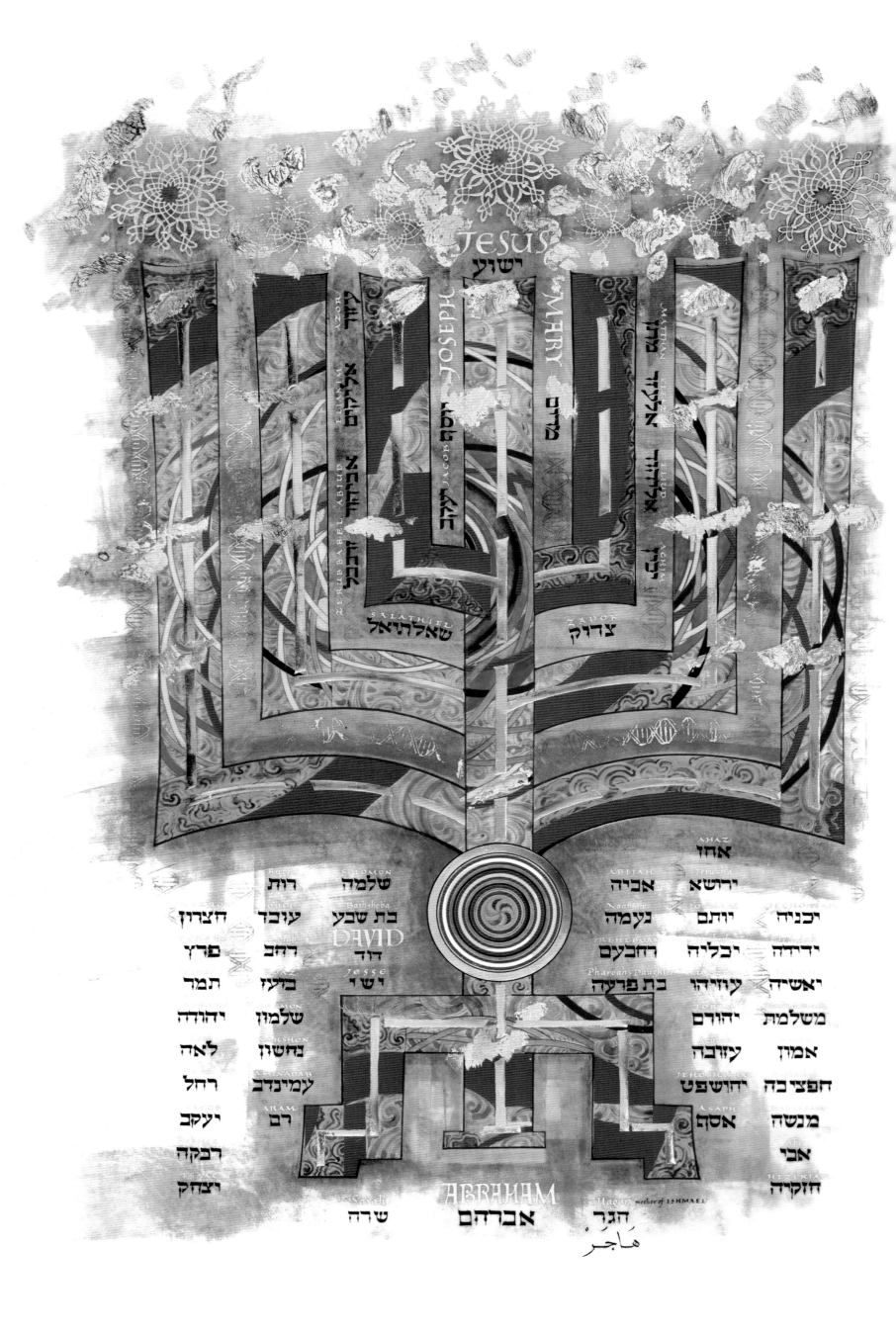

THE GOSPEL ACCORDING TO MATTHEW

1 AN ACCOUNT OF THE GENEALOGY OF JESUS THE MESSIAH, THE SON OF DAVID, THE SON OF ABRAHAM·

2 ▌ABRAHAM WAS THE FATHER OF ISAAC, AND ISAAC THE FATHER OF JACOB, AND JACOB THE FATHER OF JUDAH AND HIS BROTHERS, 3 AND JUDAH THE FATHER OF PEREZ AND ZERAH BY TAMAR, AND PEREZ THE FATHER OF HEZRON, AND HEZRON THE FATHER OF ARAM, 4 AND ARAM THE FATHER OF AMINADAB, AND AMINADAB THE FATHER OF NAHSHON, AND NAHSHON THE FATHER OF SALMON, 5 AND SALMON THE FATHER OF BOAZ BY RAHAB, AND BOAZ THE FATHER OF OBED BY RUTH, AND OBED THE FATHER OF JESSE, 6 & JESSE THE FATHER OF KING DAVID.

▌AND DAVID WAS THE FATHER OF SOLOMON BY THE WIFE OF URIAH, 7 AND SOLOMON THE FATHER OF REHOBOAM, & REHOBOAM THE FATHER OF ABIJAH, AND ABIJAH THE FATHER OF ASAPH, 8 AND ASAPH THE FATHER OF JEHOSHAPHAT, AND JEHOSHAPHAT THE FATHER OF JORAM, AND JORAM THE FATHER OF UZZIAH, 9 AND UZZIAH THE FATHER OF JOTHAM, AND JOTHAM THE FATHER OF AHAZ, AND AHAZ THE FATHER OF HEZEKIAH, 10 AND HEZEKIAH THE FATHER OF MANASSEH, AND MANASSEH THE FATHER OF AMOS, AND AMOS THE FATHER OF JOSIAH, 11 AND JOSIAH THE FATHER OF JECHONIAH & HIS BROTHERS, AT THE TIME OF THE DEPORTATION TO BABYLON.

12 ▌AND AFTER THE DEPORTATION TO BABYLON: JECHONIAH WAS THE FATHER OF SALATHIEL, AND SALATHIEL THE FATHER OF ZERUBBABEL, 13 AND ZERUBBABEL THE FATHER OF ABIUD, AND ABIUD THE FATHER OF ELIAKIM, AND ELIAKIM THE FATHER OF AZOR, 14 AND AZOR THE FATHER OF ZADOK, AND ZADOK THE FATHER OF ACHIM, AND ACHIM THE FATHER OF ELIUD, 15 AND ELIUD THE FATHER OF ELEAZAR, AND ELEAZAR THE FATHER OF MATTHAN, AND MATTHAN THE FATHER OF JACOB, 16 AND JACOB THE FATHER OF JOSEPH THE HUSBAND OF MARY, OF WHOM JESUS WAS BORN, WHO IS CALLED THE MESSIAH.

17 ▌SO ALL THE GENERATIONS FROM ABRAHAM TO DAVID ARE FOURTEEN GENERATIONS; AND FROM DAVID TO THE DEPORTATION TO BABYLON, FOURTEEN GENERATIONS; AND FROM THE DEPORTATION TO BABYLON TO THE MESSIAH, FOURTEEN GENERATIONS·

a Or *birth*
b Or *Jesus Christ*
c Other ancient authorities read *Asa*
d Other ancient authorities read *Asa*
e Other ancient authorities read *Amon*
f Other ancient authorities read *Amon*
g Or *the Christ*
h Or *the Christ*

❚ NOW THE BIRTH OF JESUS THE MESSIAH CAME ABOUT IN THIS WAY.

When his mother Mary had been engaged to Joseph, but before they lived together, she was found to be with child from the Holy Spirit. ¹⁹Her husband Joseph, being a righteous man and unwilling to expose her to public disgrace, planned to dismiss her quietly. ²⁰But just when he had resolved to do this, an angel of the Lord appeared to him in a dream and said, "Joseph, son of David, do not be afraid to take Mary as your wife, for the child conceived in her is from the Holy Spirit. ²¹She will bear a son, and you are to name him Jesus, for he will save his people from their sins." ²²All this took place to fulfill what had been spoken by the Lord through the prophet:

²³"Look, the virgin shall conceive and bear a son,
 and they shall name him Emmanuel,"

which means, "God is with us." ²⁴When Joseph awoke from sleep, he did as the angel of the Lord commanded him; he took her as his wife, ²⁵but had no marital relations with her until she had borne a son; and he named him Jesus.

2

In the time of King Herod, after Jesus was born in Bethlehem of Judea, wise men from the East came to Jerusalem, ²asking, "Where is the child who has been born king of the Jews? For we observed his star at its rising, and have come to pay him homage." ³When King Herod heard this, he was frightened, and all Jerusalem with him; ⁴and calling together all the chief priests and scribes of the people, he inquired of them where the Messiah was to be born. ⁵They told him, "In Bethlehem of Judea; for so it has been written by the prophet:

⁶'And you, Bethlehem, in the land of Judah,
 are by no means least among the rulers of Judah;
 for from you shall come a ruler
 who is to shepherd my people Israel.'"

⁷❚Then Herod secretly called for the wise men and learned from them the exact time when the star had appeared. ⁸Then he sent them to Bethlehem, saying, "Go and search diligently for the child; and when you have found him, bring me word so that I may also go & pay him homage." ⁹When they had heard the king, they set out; and there, ahead of them, went the star that they had seen at its rising, until it stopped over the place where the child was. ¹⁰When they saw that the star had stopped, they were overwhelmed with joy. ¹¹ On entering the house, they saw the child with Mary his mother; and they knelt down and paid him homage. Then, opening their treasure chests, they offered him gifts of gold, frankincense and myrrh. ¹²And having been warned in a dream not to return to Herod, they left for their own country by another road.

¹³ ❚ Now after they had left, an angel of the Lord appeared to Joseph in a dream and said, "Get up, take the child and his mother, & flee to Egypt, & remain there until I tell you; for Herod is about to search for the child, to destroy him." ¹⁴Then Joseph got up, took the child and his mother by night, and went to Egypt, ¹⁵and remained there until the death of Herod. This was to fulfill what had been spoken by the Lord through the prophet, "Out of Egypt I have called my son." ¹⁶❚When Herod saw that he had been tricked by the wise men, he was infuriated & he sent and killed all the children in and around Bethlehem who were two years old or under, according to the time that he had learned from the wise men. ¹⁷Then was fulfilled what had been spoken through the prophet Jeremiah:

¹⁸"A voice was heard in Ramah,
 wailing and loud lamentation,
 Rachel weeping for her children;
 she refused to be consoled, because they are no more."

¹⁹ ❚When Herod died, an angel of the Lord suddenly appeared in a dream to Joseph in Egypt and said, ²⁰"Get up, take the child and his mother, and go to the land of Israel, for those who were seeking the child's life are dead." ²¹Then Joseph got up, took the child and his mother, and went to the land of Israel. ²²But when he heard that Archelaus was ruling over Judea in place of his father Herod, he was afraid to go there. And after being warned in a dream, he went away to the district of Galilee. ²³There he made his home in a town called Nazareth, so that what had been spoken through the prophets might be fulfilled, "He will be called a Nazorean."

3

In those days John the Baptist appeared in the wilderness of Judea, proclaiming, ²"Repent, for the kingdom of heaven has come near." ³This is the one of whom the prophet Isaiah spoke when he said,

"The voice of one crying out in the wilderness:
 'Prepare the way of the Lord,
 make his paths straight.'"

⁴ Now John wore clothing of camel's hair with a leather belt around his waist, & his food was locusts & wild honey. ⁵Then the people of Jerusalem and all Judea were going out to him, and all the region

ᵏ or Jesus Christ
ˡ Other ancient authorities
 read her firstborn son
ᵃ or astrologers; Gk magi
ᵇ or in the East
ᵐ or the Christ
ⁿ or rule
ᵒ or astrologers; Gk magi
ᵖ or in the East
ᵠ Gk saw the star
ʳ Gk he
ˢ or astrologers; Gk magi
ᵗ or astrologers; Gk magi
ᵘ Gk he
ᵛ or is at hand

along the Jordan, ⁶ and they were baptized by him in the river Jordan, confessing their sins. ■ But when he saw many Pharisees & Sadducees coming for baptism, he said to them, "You brood of vipers! Who warned you to flee from the wrath to come? ⁸ Bear fruit worthy of repentance.⁹ Do not presume to say to yourselves, 'We have Abraham as our ancestor'; for I tell you, God is able from these stones to raise up children to Abraham. ¹⁰ Even now the ax is lying at the root of the trees; every tree therefore that does not bear good fruit is cut down and thrown into the fire. ■ "I baptize you with water for repentance, but one who is more powerful than I is coming after me; I am not worthy to carry his sandals. He will baptize you with the Holy Spirit and fire. ¹² His winnowing fork is in his hand and he will clear his threshing floor and will gather his wheat into the granary; but the chaff he will burn with unquenchable fire. "■ Then Jesus came from Galilee to John at the Jordan, to be baptized by him. ¹⁴ John would have prevented him, saying, "I need to be baptized by you, and do you come to me?" ¹⁵ But Jesus answered him, "Let it be so now; for it is proper for us in this way to fulfill all righteousness." Then he consented. ¹⁶ And when Jesus had been baptized, just as he came up from the water, suddenly the heavens were opened to him and he saw the Spirit of God descending like a dove and alighting on him. ¹⁷ And a voice from heaven said, 'This is my Son, the Beloved, with whom I am well pleased."

4

Then Jesus was led up by the Spirit into the wilderness to be tempted by the devil. ²He fasted forty days & forty nights, and afterwards he was famished. ³ The tempter came & said to him, "If you are the Son of God, command these stones to become loaves of bread." ⁴ But he answered, "It is written,

'One does not live by bread alone,
but by every word that comes from the mouth of God.'"

⁵ ■ Then the devil took him to the holy city and placed him on the pinnacle of the temple, ⁶ saying to him, "If you are the Son of God, throw yourself down; for it is written,

'He will command his angels concerning you,'
and 'On their hands they will bear you up,
so that you will not dash your foot against a stone.'"

⁷ Jesus said to him, "Again it is written, 'Do not put the Lord your God to the test.'" ⁸ Again, the devil took him to a very high mountain & showed him all the kingdoms of the world and their splendor; ⁹ And he said to him, "All these I will give you,

if you will fall down and worship me." ¹⁰ Jesus said to him, "Away with you, Satan! for it is written,

'Worship the Lord your God,
and serve only him.'"

¹¹ Then the devil left him, and suddenly angels came and waited on him.

¹² ■ Now when Jesus heard that John had been arrested, he withdrew to Galilee. ¹³ He left Nazareth & made his home in Capernaum by the sea, in the territory of Zebulun and Naphtali. ¹⁴ so that what had been spoken through the prophet Isaiah might be fulfilled:

¹⁵ "Land of Zebulun, land of Naphtali,
on the road by the sea, across the Jordan,
Galilee of the Gentiles —
¹⁶ the people who sat in darkness
have seen a great light,
and for those who sat in the region & shadow of death
light has dawned."

¹⁷ From that time Jesus began to proclaim, "Repent, for the kingdom of heaven has come near." ■ ¹⁸ As he walked by the Sea of Galilee, he saw two brothers, Simon, who is called Peter, and Andrew his brother; casting a net into the sea — for they were fishermen. ¹⁹ And he said to them, "Follow me, and I will make you fish for people." ²⁰ Immediately they left their nets and followed him. ²¹ As he went from there, he saw two other brothers, James son of Zebedee and his brother John, in the boat with their father Zebedee, mending their nets, and he called them. ²² Immediately they left the boat and their father, and followed him.

²³ ■ Jesus went throughout Galilee, teaching in their synagogues and proclaiming the good news of the kingdom & curing every disease and every sickness among the people. ²⁴ So his fame spread throughout all Syria, and they brought to him all the sick, those who were afflicted with various diseases & pains, demoniacs, epileptics, and paralytics, and he cured them. ²⁵ And great crowds followed him from Galilee, the Decapolis, Jerusalem, Judea, & from beyond the Jordan.

ʷ Or in
ˣ Or in
ʸ Or my beloved Son
ᶻ Gk he
ᵃ Or is at hand
ᵇ Gk He
ᶜ Gk gospel

5

When Jesus saw the crowds, he went up the mountain; and after he sat down, his disciples came to him. ²Then he began to speak, and taught them, saying:

³ ■ "Blessed are the poor in spirit, for theirs is the kingdom of heaven. ■ ⁴"Blessed are those who mourn, for they will be comforted. ■ ⁵"Blessed are the meek, for they will inherit the earth. ■ ⁶"Blessed are those who hunger and thirst for righteousness, for they will be filled. ■ ⁷"Blessed are the merciful, for they will receive mercy. ■ ⁸"Blessed are the pure in heart, for they will see God. ■ ⁹"Blessed are the peacemakers, for they will be called children of God. ■ ¹⁰"Blessed are those who are persecuted for righteousness' sake, for theirs is the kingdom of heaven. ■ ¹¹"Blessed are you when people revile you and persecute you and utter all kinds of evil against you falsely on my account. ¹²Rejoice and be glad, for your reward is great in heaven, for in the same way they persecuted the prophets who were before you. ■ ¹³"You are the salt of the earth; but if salt has lost its taste, how can its saltiness be restored? It is no longer good for anything, but is thrown out and trampled under foot.

■ ¹⁴"You are the light of the world. A city built on a hill cannot be hid. ¹⁵No one after lighting a lamp puts it under the bushel basket, but on the lampstand, and it gives light to all in the house. ¹⁶In the same way, let your light shine before others, so that they may see your good works & give glory to your Father in heaven. ■ ¹⁷"Do not think that I have come to abolish the law or the prophets; I have come not to abolish but to fulfill. ¹⁸For truly I tell you, until heaven & earth pass away, not one letter, not one stroke of a letter, will pass from the law until all is accomplished. ¹⁹Therefore, whoever breaks one of the least of these commandments, and teaches others to do the same, will be called least in the kingdom of heaven; but whoever does them & teaches them will be called great in the kingdom of heaven. ²⁰For I tell you, unless your righteousness exceeds that of the scribes and Pharisees, you will never enter the kingdom of heaven. ■ ²¹"You have heard that it was said to those of ancient times, 'You shall not murder'; and 'whoever murders shall be liable to judgement.' ²²But I say to you that if you are angry with a brother or sister, you will be liable to judgement; and if you insult a brother or sister, you will be liable to the council; and if you say, 'You fool,' you will be liable to the hell of fire. ²³So when you are offering your gift at the altar, if you remember that your brother or sister has something against you, ²⁴leave your gift there before the altar and go; first be reconciled to your brother or sister, and then come and offer your gift. ²⁵Come to terms quickly with your accuser while you are on the way to court with him, or your accuser may hand you over to the judge, and the judge to the guard, and you will be thrown into prison. ²⁶Truly I tell you, you will never get out until you have paid the last penny. ■ ²⁷"You have heard that it was said, 'You shall not commit adultery.' ²⁸But I say to you that everyone who looks at a woman with lust has already committed adultery with her in his heart. ²⁹If your right eye causes you to sin, tear it out & throw it away; it is better for you to lose one of your members than for your whole body to be thrown into hell. ³⁰And if your right hand causes you to sin, cut it off & throw it away; it is better for you to lose one of your members than for your whole body to go into hell. ■ ³¹"It was also said, 'Whoever divorces his wife, let him give her a certificate of divorce.' ³²But I say to you that anyone who divorces his wife, except on the ground of unchastity, causes her to commit adultery; and whoever marries a divorced woman commits adultery. ■ ³³"Again, you have heard that it was said to those of ancient times, 'You shall not swear falsely, but carry out the vows you have made to the Lord.' ³⁴But I say to you, Do not swear at all, either by heaven, for it is the throne of God, ³⁵or by the earth, for it is his footstool, or by Jerusalem, for it is the city of the great King. ³⁶And do not swear by your head, for you cannot make one hair white or black. ³⁷Let your word be 'Yes, Yes' or 'No, No'; anything more than this comes from the evil one. ■ ³⁸"You have heard that it was said, 'An eye for an eye & a tooth for a tooth.' ³⁹But I say to you, Do not resist an evildoer. But if anyone strikes you on the right cheek, turn the other also; ⁴⁰and if anyone wants to sue you & take your coat, give your cloak as well; ⁴¹and if anyone forces you to go one mile, go also the second mile. ⁴²Give to everyone who begs from you, and do not refuse anyone who wants to borrow from you. ■ ⁴³"You have heard that it was said, 'You shall love your neighbor and hate your enemy.' ⁴⁴But I say to you, Love your enemies & pray for those who persecute you, ⁴⁵so that you may be children of your Father in heaven; for he makes his sun rise on the evil & on the good, and sends rain on the righteous & on the unrighteous. ⁴⁶For if you love those who love you, what reward do you have? Do not even the tax collectors do the same? ⁴⁷And if you greet only your brothers and sisters, what more are you doing than others? Do not even the Gentiles do the same? ⁴⁸Be perfect therefore, as your heavenly Father is perfect.

RSB
Matt 5:10
Matt 5:39-41
Matt 5:44

a Gk *he*
b Other ancient authorities lack *falsely*
c Gk *one iota*
d Or *annuls*
e Gk *a brother*; other ancient authorities add *without cause*
f Gk say *Raca* to [an obscure term of abuse]
g Gk *a brother*
h Gk *Gehenna*
i Gk *your brother*
j Gk *lacks to court*
k Gk *Gehenna*
l Gk *Gehenna*
m Or *evil*
n Gk *your brothers*

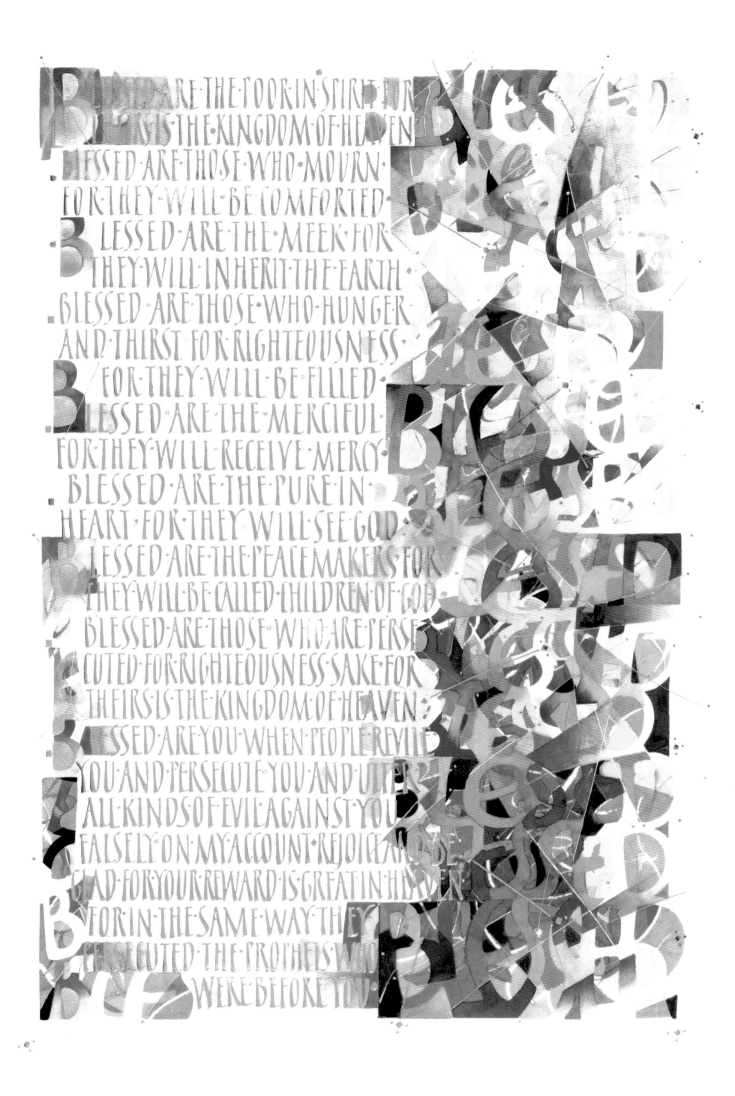

BLESSED ARE THE POOR IN SPIRIT FOR THEIRS IS THE KINGDOM OF HEAVEN BLESSED ARE THOSE WHO MOURN FOR THEY WILL BE COMFORTED BLESSED ARE THE MEEK FOR THEY WILL INHERIT THE EARTH BLESSED ARE THOSE WHO HUNGER AND THIRST FOR RIGHTEOUSNESS FOR THEY WILL BE FILLED BLESSED ARE THE MERCIFUL FOR THEY WILL RECEIVE MERCY BLESSED ARE THE PURE IN HEART FOR THEY WILL SEE GOD BLESSED ARE THE PEACEMAKERS FOR THEY WILL BE CALLED CHILDREN OF GOD BLESSED ARE THOSE WHO ARE PERSECUTED FOR RIGHTEOUSNESS SAKE FOR THEIRS IS THE KINGDOM OF HEAVEN BLESSED ARE YOU WHEN PEOPLE REVILE YOU AND PERSECUTE YOU AND UTTER ALL KINDS OF EVIL AGAINST YOU FALSELY ON MY ACCOUNT REJOICE AND BE GLAD FOR YOUR REWARD IS GREAT IN HEAVEN FOR IN THE SAME WAY THEY PERSECUTED THE PROPHETS WHO WERE BEFORE YOU

6

Beware of practicing your piety before others in order to be seen by them; for then you have no reward from your Father in heaven. 2 "So whenever you give alms, do not sound a trumpet before you, as the hypocrites do in the synagogues and in the streets, so that they may be praised by others. Truly I tell you, they have received their reward. 3 But when you give alms, do not let your left hand know what your right hand is doing, 4 so that your alms may be done in secret; and your 5 Father who sees in secret will reward you. "And whenever you pray, do not be like the hypocrites; for they love to stand and pray in the synagogues and at the street corners, so that they may be seen by others. Truly I tell you, they have received their reward. 6 But whenever you pray, go into your room and shut the door and pray to your Father who is in secret; and your Father who sees in secret will 7 reward you. "When you are praying, do not heap up empty phrases as the Gentiles do; for they think that they will be heard because of their many words. 8 Do not be like them, for your Father knows what you need before you ask him. 9 "Pray then in this way:

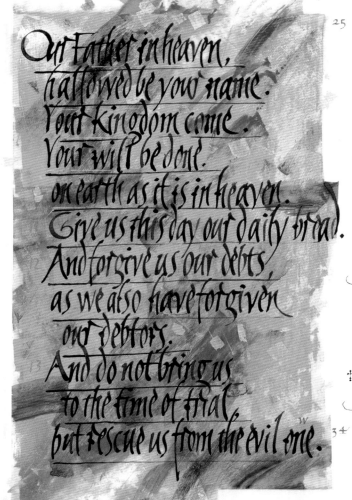

Our Father in heaven,
hallowed be your name.
Your kingdom come.
Your will be done.
on earth as it is in heaven.
Give us this day our daily bread.
And forgive us our debts,
as we also have forgiven
our debtors.
And do not bring us
to the time of trial,
but rescue us from the evil one.

14 For if you forgive others their trespasses, your heavenly Father will also forgive you; 15 but if you do not forgive others, neither will your Father forgive your trespasses. 16 "And whenever you fast, do not look dismal, like the hypocrites, for they disfigure their faces so as to show others that they are fasting. Truly I tell you, they have received their reward. 17 But when you fast, put oil on your head and wash your face, 18 so that your fasting may be seen not by others but by your Father who is in secret; and your Father who sees in secret will reward you. 19 "Do not store up for yourselves treasures on earth, where moth and rust consume & where thieves break in and steal; 20 but store up for yourselves treasures in heaven, where neither moth nor rust consumes and where thieves do not break in and steal. 21 For where your treasure 22 is, there your heart will be also. "The eye is the lamp of the body. So, if your eye is healthy, your whole body will be full of light; 23 but if your eye is unhealthy, your whole body will be full of darkness. If then the light in you is darkness, how great is the 24 darkness! "No one can serve two masters; for a slave will either hate the one and love the other, or be devoted to the one and despise the other. You 25 cannot serve God and wealth. "Therefore I tell you, do not worry about your life, what you will eat or what you will drink, or about your body, what you will wear. Is not life more than food, and the body more than clothing? 26 Look at the birds of the air; they neither sow nor reap nor gather into barns, and yet your heavenly Father feeds them. Are you not of more value than they? 27 And can any of you by worrying add a single hour to your span of life? 28 And why do you worry about clothing? Consider the lilies of the field, how they grow; they neither toil nor spin, 29 yet I tell you, even Solomon in all his glory was not clothed like one of these. 30 But if God so clothes the grass of the field, which is alive today and tomorrow is thrown into the oven, will he not much more clothe you—you of little faith? 31 Therefore do not worry, saying, 'What will we eat?' or 'What will we drink?' or 'What will we wear?' 32 For it is the Gentiles who strive for all these things; and indeed your heavenly Father knows that you need all these things. 33 But strive first for the kingdom of God and his righteousness, and all these things will be given to you as well. 34 "So do not worry about tomorrow, for tomorrow will bring worries of its own. Today's trouble is enough for today.

7

Do not judge, so that you may not be judged. 2 For with the judgement you make you will be judged, and the measure you give will be the measure you get. 3 Why do you see the speck in your neighbor's eye, but do not notice the log in your own eye? 4 Or how can you say to your neighbor, 'Let me take the speck out of your eye,' while the log is in your own eye? 5 You hypocrite, first take the log out of your own eye, and then you will see clearly to take the speck out of your neighbor's eye. 6 "Do not give what is holy to dogs; and do not throw your pearls before swine, or they will trample them under foot and turn and maul you.

7 "Ask, and it will be given you; search, and you will find; knock, and the door will be opened for you. 8 For everyone who asks receives, and everyone who searches finds, & for everyone who knocks, the door will be opened. 9 Is there anyone among you who, if your child asks for bread, will give a stone? 10 Or if the child asks for a fish, will give a snake? 11 If you then, who are evil, know how to give good gifts to your children, how much more will your Father in heaven give good things to those who ask him! 12 "In everything do to others as you would have them do to you; for this is the law and the prophets. 13 "Enter through the narrow gate; for the gate is wide and the road is easy that leads to destruction, and there are many who take it. 14 For the gate is narrow and the road is hard that leads to life, and there are few who find it. 15 "Beware of false prophets, who come to you in sheep's clothing but inwardly are ravenous wolves. 16 You will know them by their fruits. Are grapes gathered from thorns, or figs from thistles? 17 In the same way, every good tree bears good fruit, but the bad tree bears bad fruit. 18 A good tree cannot bear bad fruit, nor can a bad tree bear good fruit. 19 Every tree that does not bear good fruit is cut down and thrown into the fire. 20 Thus you will know them by their fruits. 21 "Not everyone who says to me, 'Lord, Lord,' will enter the kingdom of heaven, but only the one who does the will of my Father in heaven. 22 On that day many will say to me, 'Lord, Lord, did we not prophesy in your name, and cast out demons in your name, and do many deeds of power in your name?' 23 Then I will declare to them, 'I never knew you; go away from me, you evildoers.' 24 "Everyone then who hears these words of mine and acts on them will be like a wise man who built his house on rock. 25 The rain fell, the floods came, and the winds blew and beat on that house, but it did not fall, because it had been founded on rock. 26 And everyone who hears these words of mine and does not act on them will be like a foolish man

who built his house on sand. 27 The rain fell, and the floods came, and the winds blew & beat against that house, and it fell—and great was its fall!" 28 Now when Jesus had finished saying these things, the crowds were astounded at his teaching, 29 for he taught them as one having authority, and not as their scribes.

8

When Jesus had come down from the mountain, great crowds followed him; 2 and there was a leper who came to him & knelt before him, saying, "Lord, if you choose, you can make me clean." 3 He stretched out his hand & touched him, saying, "I do choose. Be made clean!" Immediately his leprosy was cleansed. 4 Then Jesus said to him, "See that you say nothing to anyone; but go, show yourself to the priest, and offer the gift that Moses commanded, as a testimony to them."

5 When he entered Capernaum, a centurion came to him, appealing to him 6 and saying, "Lord, my servant is lying at home paralyzed, in terrible distress." 7 And he said to him, "I will come and cure him." 8 The centurion answered, "Lord, I am not worthy to have you come under my roof; but only speak the word, and my servant will be healed. 9 For I also am a man under authority, with soldiers under me; and I say to one, 'Go,' and he goes, and to another, 'Come,' and he comes, and to my slave, 'Do this,' and the slave does it." 10 When Jesus heard him, he was amazed & said to those who followed him, "Truly I tell you, in no one in Israel have I found such faith. 11 I tell you, many will come from east and west and will eat with Abraham & Isaac & Jacob in the kingdom of heaven, 12 while the heirs of the kingdom will be thrown into the outer darkness, where there will be weeping and gnashing of teeth." 13 And to the centurion Jesus said, "Go; let it be done for you according to your faith." And the servant was healed in that hour. 14 When Jesus entered Peter's house, he saw his mother-in-law lying in bed with a fever; 15 he touched her hand, and the fever left her, and she got up and began to serve him. 16 That evening they brought to him many who were possessed with demons; and he cast out the spirits with a word, and cured all who were sick. 17 This was to fulfill what had been spoken through the prophet Isaiah, "He took our infirmities and bore our disease." 18 Now when Jesus saw great crowds around him, he gave orders to go over to the other side. 19 A scribe then approached & said, "Teacher, I will follow you wherever you go." 20 And Jesus said to him, "Foxes have holes, and birds of the air have nests; but the Son of Man has no

מחבר·

ψ.
†
ψΨ
Matt 6:10
Matt 6:12–13
Matt 6:33
Matt 7:3
Matt 7:12
Matt 7:14
Matt 7:24–25

c Other ancient authorities add openly
f Other ancient authorities add openly
w Or our bread for tomorrow
x Or us into temptation
y Or from evil, other ancient authorities add, in some form, For the kingdom and the power and the glory are yours forever. Amen.
z Other ancient authorities add openly
y Gk eating
z Gk eating
a Gk mammon
b Other ancient authorities lack or what you will drink
c or add one cubit to your height
d Other ancient authorities lack of God
e Or its
f Gk brothers
g Gk brothers
h Gk brothers
i Other ancient authorities read for the road is wide and easy
j Gk he
k The terms leper and leprosy can refer to several diseases
l The terms leper and leprosy can refer to several diseases
m Other ancient authorities read Truly I tell you, not even

where to lay his head." [21] Another of his disciples said to him, "Lord, first let me go & bury my father." [22] But Jesus said to him, "Follow me, and let the dead bury their own dead." And when he got into the boat, his disciples followed him. [24] A windstorm arose on the sea, so great that the boat was being swamped by the waves; but he was asleep. [25] And they went and woke him up, saying, "Lord, save us! we are perishing!" [26] And he said to them, "Why are you afraid, you of little faith?" Then he got up and rebuked the winds & the sea; and there was a dead calm. [27] They were amazed, saying, "What sort of man is this, that even the winds and the sea obey him?" When he came to the other side, to the country of the Gadarenes, two demoniacs coming out of the tombs met him. They were so fierce that no one could pass that way. [29] Suddenly they shouted, "What have you to do with us, Son of God? Have you come here to torment us before the time?" [30] Now a large herd of swine was feeding at some distance from them. [31] The demons begged him, "If you cast us out, send us into the herd of swine." [32] And he said to them, "Go!" So they came out and entered the swine; and suddenly, the whole herd rushed down the steep bank into the sea and perished in the water. [33] The swineherds ran off, and on going into the town, they told the whole story about what had happened to the demoniacs. [34] Then the whole town came out to meet Jesus; and when they saw him, they begged him to leave their neighborhood.

9 And after getting into a boat he crossed the sea & came to his own town. And just then some people were carrying a paralyzed man lying on a bed. When Jesus saw their faith, he said to the paralytic, "Take heart, son; your sins are forgiven." [3] Then some of the scribes said to themselves, "This man is blaspheming." [4] But Jesus, perceiving their thoughts, said, "Why do you think evil in your hearts? [5] For which is easier, to say, 'your sins are forgiven', or to say, 'Stand up & walk'? [6] But so that you may know that the Son of Man has authority on earth to forgive sins"— he then said to the paralytic—"Stand up, take your bed and go to your home." [7] And he stood up and went to his home. [8] When the crowds saw it, they were filled with awe, and they glorified God, who had given such authority to human beings.

As Jesus was walking along, he saw a man called Matthew sitting at the tax booth; and he said to him, "Follow me." And he got up and followed him.

And as he sat at dinner in the house, many tax collectors & sinners came and were sitting with him and his disciples. [11] When the Pharisees saw this, they said to his disciples, "Why does your teacher eat with tax collectors and sinners?" [12] But when he

heard this, he said, "Those who are well have no need of a physician, but those who are sick. [13] Go & learn what this means, 'I desire mercy, not sacrifice.' For I have come to call not the righteous but sinners." Then the disciples of John came to him, saying, "Why do we and the Pharisees fast often, but your disciples do not fast?" [15] And Jesus said to them, "The wedding guests cannot mourn as long as the bridegroom is with them, can they? The days will come when the bridegroom is taken away from them, and then they will fast. [16] No one sews a piece of unshrunk cloth on an old cloak, for the patch pulls away from the cloak, and a worse tear is made. [17] Neither is new wine put into old wineskins; otherwise, the skins burst, and the wine is spilled, and the skins are destroyed; but new wine is put into fresh wineskins, and so both are preserved." While he was saying these things to them, suddenly a leader of the synagogue came in and knelt before him, saying, "My daughter has just died; but come and lay your hand on her, and she will live." [19] And Jesus got up and followed him, with his disciples. [20] Then suddenly a woman who had been suffering from hemorrhages for twelve years came up behind him and touched the fringe of his cloak, [21] for she said to herself, "If I only touch his cloak, I will be made well." [22] Jesus turned, and seeing her he said, "Take heart, daughter; your faith has made you well."

RSB
Matt 9:12

[n] Other ancient authorities read Gergesenes; others, Gerasenes
[o] Gk reclined
[p] Gk were reclining
[q] Other ancient authorities lack often
[r] Gk lacks of the synagogue

good news of the kingdom, & curing every disease and every sickness.³⁶ When he saw the crowds, he had compassion for them, because they were ha -rassed and helpless, like sheep without a shepherd. ³⁷ Then he said to his disciples, "The harvest is plentiful, but the laborers are few; ³⁸ therefore ask the Lord of the harvest to send out laborers into his harvest."

10

Then Jesus summoned his twelve disciples & gave them authority over unclean spirits, to cast them out, & to cure every disease and every sickness.² These are the names of the twelve apostles: first, Simon, also known as Peter, and his brother Andrew; James son of Zebedee, and his brother John;³ Philip and Bartholomew; Thomas and Matthew the tax collector; James son of Alphaeus, & Thaddaeus;⁴ Simon the Cananaean, and Judas Iscariot, the one who betrayed him. ⁵ ▮ These twelve Jesus sent out with the following instructions: "Go nowhere among the Gentiles, and enter no town of the Samaritans, but go rather to the lost sheep of the house of Israel.⁷ As you go, proclaim the good news, 'The kingdom of heaven has come near.'⁸ Cure the sick, raise the dead, cleanse the lepers, cast out demons. You received without payment; give without payment.⁹ Take no gold, or silver, or copper in your belts,¹⁰ no bag for your journey, or two tunics, or sandals, or a staff; for laborers deserve their food.¹¹ Whatever town or village you enter, find out who in it is worthy, and stay there until you leave.¹² As you enter the house, greet it.¹³ If the house is worthy, let your peace come upon it; but if it is not worthy, let your peace return to you.¹⁴ If anyone will not welcome you or listen to your words, shake off the dust from your feet as you leave that house or town.¹⁵ Truly I tell you, it will be more tolerable for the land of Sodom and Gomorrah on the day of judgement than for that town. ▮ ¹⁶ "See, I am sending you out like sheep into the midst of wolves; so be wise as serpents and innocent as doves.¹⁷ Beware of them, for they will hand you over to councils & flog you in their synagogues;¹⁸ and you will be dragged before governors and kings because of me, as a testimony to them and the Gentiles.¹⁹ When they hand you over, do not worry about how you are to speak or what you are to say; for what you are to say will be given to you at that time;²⁰ for it is not you who speak, but the Spirit of your Father speaking through you. ²¹ Brother will betray brother to death, & a father his child, and children will rise against parents & have them put to death;²² and you will be hated by

And instantly the woman was made well.²³ When Jesus came to the leader's house and saw the flute players & the crowd making a commotion,²⁴ he said, "Go away; for the girl is not dead but sleeping." And they laughed at him.²⁵ But when the crowd had been put outside, he went in and took her by the hand, and the girl got up.²⁶ And the report of this spread throughout that district. ▮ ²⁷ As Jesus went on from there, two blind men followed him, crying loudly, "Have mercy on us, Son of David!" ²⁸ When he entered the house, the blind men came to him; & Jesus said to them, "Do you believe that I am able to do this?" They said to him, "Yes, Lord." ²⁹ Then he touched their eyes & said, "According to your faith let it be done to you." ³⁰ And their eyes were opened. Then Jesus sternly ordered them, "See that no one knows of this." ³¹ But they went away and spread the news about him throughout that ³² district. ▮ After they had gone away, a demoniac who was mute was brought to him.³³ And when the demon had been cast out, the one who had been mute spoke; and the crowds were amazed & said, "Never has anything like this been seen in Israel." ³⁴ But the Pharisees said, "By the ruler of the demons he casts out the demons."

³⁵ ▮ Then Jesus went about all the cities and villages, teaching in their synagogues, and proclaiming the

✝
RSV
Matt. 10:22

ˢ Other ancient authorities lack this verse
ᵗ Gk he
ᵘ Other ancient authorities read Lebbaeus, or Lebbaeus called Thaddaeus
ᵛ Or is at hand
ʷ The terms leper and leprosy can refer to several diseases

All because of my name. But the one who endures to the end will be saved. [23] When they persecute you in one town, flee to the next; for truly I tell you, you will not have gone through all the towns of Israel before the Son of Man comes. [24] "A disciple is not above the teacher, nor a slave above the master; [25] it is enough for the disciple to be like the teacher, and the slave like the master. If they have called the master of the house Beelzebul, how much more will they malign those of his household!

[26] "So have no fear of them; for nothing is covered up that will not be uncovered, and nothing secret that will not become known. [27] What I say to you in the dark, tell in the light; and what you hear whispered, proclaim from the housetops. [28] Do not fear those who kill the body but cannot kill the soul; rather fear him who can destroy both soul and body in hell. [29] Are not two sparrows sold for a penny? Yet not one of them will fall to the ground apart from your Father. [30] And even the hairs of your head are all counted. [31] So do not be afraid; you are of more value than many sparrows. [32] "Every one therefore who acknowledges me before others, I also will acknowledge before my father in heaven; [33] but whoever denies me before others, I also will deny before my Father in heaven. [34] "Do not think that I have come to bring peace to the earth; I have not come to bring peace, but a sword.

[35] For I have come to set a man against his father,
and a daughter against her mother,
and a daughter-in-law against her mother-in-law;
[36] and one's foes will be members of one's own household.

[37] Whoever loves father or mother more than me is not worthy of me; and whoever loves son or daughter more than me is not worthy of me; [38] and whoever does not take up the cross & follow me is not worthy of me. [39] Those who find their life will lose it, and those who lose their life for my sake will find it. [40] "Whoever welcomes you welcomes me, and whoever welcomes me welcomes the one who sent me. [41] Whoever welcomes a prophet in the name of a prophet will receive a prophet's reward; and whoever welcomes a righteous person in the name of a righteous person will receive the reward of the righteous; [42] and whoever gives even a cup of cold water to one of these little ones in the name of a disciple — truly I tell you, none of these will lose their reward."

x Gk Gehenna
y Or the Christ
z Other ancient authorities
 read two of his
a The terms leper and
 leprosy can refer to several
 diseases
b Or Why then did you go
 out? To see someone
c Other ancient authorities
 read Why then did you go
 out? To see a prophet?
d Or has been coming
 violently
e Other ancient authorities
 add to hear
f Other ancient authorities
 read children

11

[1] Now when Jesus had finished instructing his twelve disciples, he went on from there to teach & proclaim his message in their cities. [2] When John heard in prison what the Messiah was doing, he sent word by his disciples [3] and said to him, "Are you the one who is to come, or are we to wait for another?" [4] Jesus answered them, "Go and tell John what you hear & see: [5] the blind receive their sight, the lame walk, the lepers are cleansed, the deaf hear, the dead are raised, and the poor have good news brought to them. [6] And blessed is anyone who takes no offense at me."

[7] As they went away, Jesus began to speak to the crowds about John: "What did you go out into the wilderness to look at? A reed shaken by the wind? [8] What then did you go out to see? Someone dressed in soft robes? Look, those who wear soft robes are in royal palaces. [9] What then did you go out to see? A prophet? Yes, I tell you, and more than a prophet. [10] This is the one about whom it is written,

'See, I am sending my messenger ahead of you,
who will prepare your way before you.'

[11] Truly I tell you, among those born of women no one has arisen greater than John the Baptist; yet the least in the kingdom of heaven is greater than he. [12] From the days of John the Baptist until now the kingdom of heaven has suffered violence, and the violent take it by force. [13] For all the prophets and the law prophesied until John came; [14] and if you are willing to accept it, he is Elijah who is to come. [15] Let anyone with ears listen! [16] "But to what will I compare this generation? It is like children sitting in the marketplaces and calling to one another,

[17] 'We played the flute for you, and you did not dance;
we wailed, and you did not mourn.'

[18] For John came neither eating nor drinking, and they say, 'He has a demon'; [19] the Son of Man came eating and drinking, and they say, 'Look, a glutton and a drunkard, a friend of tax collectors and sinners!' Yet wisdom is vindicated by her deeds."

[20] Then he began to reproach the cities in which most of his deeds of power had been done, because they did not repent. [21] "Woe to you, Chorazin! Woe to you, Bethsaida! For if the deeds of power done in you had been done in Tyre and Sidon, they would have repented long ago in sackcloth & ashes. [22] But I tell you, on the day of judgment it will be more tolerable for Tyre and Sidon than for you. [23] And you, Capernaum,

will you be exalted to heaven?
No, you will be brought down to Hades.

For if the deeds of power done in you had been done in Sodom, it would have remained until this

day.²⁴ But I tell you that on the day of judgment it will be more tolerable for the land of Sodom than for you." ¶ ²⁵ At that time Jesus said, "I thank you, Father, Lord of heaven & earth, because you have hidden these things from the wise & the intelligent, and have revealed them to infants; ²⁶ yes, Father, for such was your gracious will. ²⁷ All things have been handed over to me by my Father; and no one knows the Son except the Father, & no one knows the Father except the Son and anyone to whom the Son chooses to reveal him. ¶ ²⁸ "Come to me, all you that are weary and are carrying heavy burdens, and I will give you rest. ²⁹ Take my yoke upon you, and learn from me; for I am gentle and humble in heart, and you will find rest for your souls. ³⁰ For my yoke is easy, and my burden is light."

12

At that time Jesus went through the grain fields on the sabbath; his disciples were hungry, and they began to pluck heads of grain and to eat. ² When the Pharisees saw it, they said to him, "Look, your disciples are doing what is not lawful to do on the sabbath." ³ He said to them, "Have you not read what David did when he and his companions were hungry? ⁴ He entered the house of God and ate the bread of the Presence, which it was not lawful for him or his companions to eat, but only for the priests. ⁵ Or have you not read in the law that on the sabbath the priests in the temple break the sabbath and yet are guiltless? ⁶ I tell you, something greater than the temple is here. ⁷ But if you had known what this means, 'I desire mercy & not sacrifice,' you would not have condemned the guiltless. ⁸ For the Son of Man is lord of the sabbath." ¶ ⁹ He left that place & entered their synagogue; ¹⁰ a man was there with a withered hand, and they asked him, "Is it lawful to cure on the sabbath?" so that they might accuse him. ¹¹ He said to them, "Suppose one of you has only one sheep and it falls into a pit on the sabbath; will you not lay hold of it and lift it out? ¹² How much more valuable is a human being than a sheep! So it is lawful to do good on the sabbath." ¹³ Then he said to the man, "Stretch out your hand." He stretched it out, and it was restored, as sound as the other. ¹⁴ But the Pharisees went out & conspired against him, how to destroy him. ¶ ¹⁵ When Jesus became aware of this, he departed. Many crowds followed him, and he cured all of them, ¹⁶ and he ordered them not to make him known. ¹⁷ This was to fulfill what had been spoken through the prophet Isaiah:

¹⁸ "Here is my servant, whom I have chosen,
 my beloved, with whom my soul is well pleased.
 I will put my Spirit upon him,
 and he will proclaim justice to the Gentiles.
¹⁹ He will not wrangle or cry aloud,
 nor will anyone hear his voice in the streets.
²⁰ He will not break a bruised reed
 or quench a smouldering wick
 until he brings justice to victory.
²¹ And in his name the Gentiles will hope."

²² ¶ Then they brought to him a demoniac who was blind and mute; and he cured him, so that the one who had been mute could speak and see. ²³ All the crowds were amazed and said, "Can this be the Son of David?" ²⁴ But when the Pharisees heard it, they said, "It is only by Beelzebul, the ruler of the demons, that this fellow casts out the demons." ²⁵ He knew what they were thinking and said to them, "Every kingdom divided against itself is laid waste, and no city or house divided against itself will stand. ²⁶ If Satan casts out Satan, he is divided against himself; how then will his kingdom stand? ²⁷ If I cast out demons by Beelzebul, by whom do your own exorcists cast them out? Therefore they will be your judges. ²⁸ But if it is by the Spirit of God that I cast out demons, then the kingdom of God has come to you. ²⁹ Or how can one enter a strong man's house and plunder his property, without first tying up the strong man? Then indeed the house can be plundered. ³⁰ Whoever is not with me is against me, and whoever does not gather with me scatters. ³¹ Therefore I tell you, people will be forgiven for every sin and blasphemy, but blasphemy against the Spirit will not be forgiven. ³² Whoever speaks a word against the Son of Man will be forgiven, but whoever speaks against the Holy Spirit will not be forgiven, either in this age or in the age to come. ¶ ³³ "Either makes the tree good, and its fruit good; or make the tree bad, and its fruit bad; for the tree is known by its fruit. ³⁴ You brood of vipers! How can you speak good things, when you are evil? For out of the abundance of the heart the mouth speaks. ³⁵ The good person brings good things out of a good treasure, and the evil person brings evil things out of an evil treasure. ³⁶ I tell you, on the day of judgment you will have to give an account for every careless word you utter; ³⁷ for by your words you will be justified, & by your words you will be condemned." ¶ ³⁸ Then some of the scribes and Pharisees said to him, "Teacher, we wish to see a sign from you." ³⁹ But he answered them, "An evil & adulterous generation asks for a sign, but no sign will be given to it except the sign of the prophet Jonah. ⁴⁰ For just as Jonah was three days and three nights in the belly of the

g or praise
h or for so it was well-
 pleasing in your sight
i Other ancient authorities
 lack crowds
j Gk sons

sea monster, so for three days and three nights the Son of Man will be in the heart of the earth. 41 The people of Nineveh will rise up at the judgment with this generation and condemn it, because they repented at the proclamation of Jonah, & see, something greater than Jonah is here! 42 The queen of the South will rise up at the judgment with this generation & condemn it, because she came from the ends of the earth to listen to the wisdom of Solomon, & see, something greater than Solomon

43 is here! ∎ "When the unclean spirit has gone out of a person, it wanders through waterless regions looking for a resting place, but it finds none. 44 Then it says, 'I will return to my house from which I came.' When it comes, it finds it empty, swept, and put in order. 45 Then it goes and brings along seven other spirits more evil than itself, and they enter & live there; and the last state of that person is worse than the first. So will it be also with this evil generation."

46 ∎ While he was still speaking to the crowds, his mother and his brothers were standing outside, wanting to speak to him. 47 Someone told him, "Look, your mother and your brothers are standing outside wanting to speak to you." 48 But to the one who had told him this, Jesus replied, "Who is my mother, and who are my brothers?" 49 And pointing to his disciples, he said, "Here are my mother & my brothers! 50 For whoever does the will of my Father in heaven is my brother & sister & mother."

13

That same day Jesus went out of the house and sat beside the sea. 2 Such great crowds gathered around him that he got into a boat and sat there, while the whole crowd stood on the beach. 3 And he told them many things in parables, saying: "Listen! A sower went out to sow. 4 And as he sowed, some seeds fell on the path, and the birds came and ate them up. 5 Other seeds fell on rocky ground, where they did not have much soil, and they sprang up quickly, since they had no depth of soil. 6 But when the sun rose, they were scorched; and since they had no root, they withered away. 7 Other seeds fell among thorns, and the thorns grew up & choked them. 8 Other seeds fell on good soil and brought forth grain, some a hundredfold, some sixty, some thirty. 9 Let anyone with ears

10 listen!" ∎ Then the disciples came and asked him, "Why do you speak to them in parables?" 11 He answered, "To you it has been given to know the secrets of the kingdom of heaven, but to them it has not been given. 12 For to those who have, more will be given, and they will have an abundance;

k Other ancient authorities lack verse 47
l Gk he
m Other ancient authorities add to hear
n Or mysteries
o Gk stumbles

but from those who have nothing, even what they have will be taken away. 13 The reason I speak to them in parables is that 'seeing they do not perceive, and hearing they do not listen, nor do they understand.' 14 With them indeed is fulfilled the prophecy of Isaiah that says:

'You will indeed listen, but never understand,
 and you will indeed look, but never perceive.
15 For this people's heart has grown dull,
 and their ears are hard of hearing,
 and they have shut their eyes;
 so that they might not look with their eyes,
 and listen with their ears,
 and understand with their heart and turn—
 and I would heal them.'

16 But blessed are your eyes, for they see, and your ears, for they hear. 17 Truly I tell you, many prophets and righteous people longed to see what you see, but did not see it, and to hear what you hear, but

18 did not hear it. ∎ "Hear then the parable of the sower. 19 When anyone hears the word of the kingdom & does not understand it, the evil one comes and snatches away what is sown in the heart; this is what is sown on the path. 20 As for what was sown on rocky ground, this is the one who hears the word and immediately receives it with joy; 21 yet such a person has no root, but endures only for a while, & when trouble or persecution arises on account of the word, that person immediately falls away. 22 As for what was sown among thorns, this is the one who hears the word, but the cares of the world and the lure of wealth choke the word, and it yields nothing. 23 But as for what was sown on good soil, this is the one who hears the word and understands it, who indeed bears fruit and yields in one case a hundredfold, in another sixty,

24 and in another thirty." ∎ He put before them another parable: "The kingdom of heaven may be compared to someone who sowed good seed in his field; 25 but while everybody was asleep, an enemy came & sowed weeds among the wheat, and then went away. 26 So when the plants came up & bore grain, then the weeds appeared as well. 27 And the slaves of the householder came and said to him, 'Master, did you not sow good seed in your field? Where, then, did these weeds come from?' 28 He answered, 'An enemy has done this.' The slaves said to him, 'Then do you want us to go & gather them?' 29 But he replied, 'No; for in gathering the weeds you would uproot the wheat along with them. Let both of them grow together until the harvest; and at harvest time I will tell the reapers, Collect the weeds first & bind them in bundles to be burned,

31 but gather the wheat into my barn.'" ∎ He put be

fore them another parable: "The kingdom of heaven is like a mustard seed that someone took & sowed in his field; it is the smallest of all the seeds, but when it has grown it is the greatest of shrubs and becomes a tree, so that the birds of the air come & make nests in its branches." He told them

35 another parable: "The kingdom of heaven is like yeast that a woman took and mixed in with three measures of flour until all of it was leavened."

34 Jesus told the crowds all these things in parables; without a parable he told them nothing. This was to fulfill what had been spoken through the prophet:

"I will open my mouth to speak in parables;
I will proclaim what has been hidden from the
foundation of the world."

36 Then he left the crowds and went into the house. And his disciples approached him, saying, "Explain to us the parable of the weeds of the field." He answered, "The one who sows the good seed is the Son of Man; the field is the world and the good seed are the children of the kingdom; the weeds are the children of the evil one. And the enemy who sowed them is the devil; the harvest is the end of the age, and the reapers are angels. Just as the weeds are collected & burned up with fire, so will it be at the end of the age. The Son of Man will send his angels, and they will collect out of his kingdom all causes of sin and all evildoers, and they will throw them into the furnace of fire, where there will be weeping & gnashing of teeth. Then the righteous will shine like the sun in the kingdom

44 of their Father. Let anyone with ears listen! "The kingdom of heaven is like treasure hidden in a field which someone found and hid; then in his joy he goes and sells all that he has and buys that field.

45 "Again, the kingdom of heaven is like a merchant in search of fine pearls; on finding one pearl of great value, he went and sold all that he had and

47 bought it. "Again, the kingdom of heaven is like a net that was thrown into the sea and caught fish of every kind; when it was full they drew it ashore, sat down, and put the good into baskets but threw out the bad. So it will be at the end of the age. The angels will come out & separate the evil from the righteous and throw them into the furnace of fire, where there will be weeping and gnashing

51 of teeth. "Have you understood all this?" They
† answered, "Yes." And he said to them, "Therefore every scribe who has been trained for the kingdom of heaven is like the master of a household who brings out of his treasure what is new and what is old." When Jesus had finished these parables, he

54 left that place. He came to his hometown and began to teach the people in their synagogue, so

that they were astounded and said, "Where did this man get this wisdom and these deeds of power? Is not this the carpenter's son? Is not his mother called Mary? And are not his brothers James and Joseph and Simon and Judas? And are not all his sisters with us? Where then did this man get all this?" And they took offense at him. But Jesus said to them, "Prophets are not without honor except in their own country and in their own house." And he did not do many deeds of power there, because of their unbelief.

14

At that time Herod the ruler heard reports about Jesus; and he said to his servants, "This is John the Baptist; he has been raised from the dead, and for this reason these powers are at work in him." For Herod had arrested John, bound him, & put him in prison on account of Herodias, his brother Philip's wife, because John had been telling him, "It is not lawful for you to have her." Though Herod wanted to put him to death, he feared the crowd, because they regarded him as a prophet. But when Herod's birthday came, the daughter of Herodias danced before the company, and she pleased Herod so much that he promised on oath to grant her whatever she might ask. Prompted by her mother, she said, "Give me the head of John the Baptist here on a platter." The king was grieved, yet out of regard for his oaths and for the guests, he commanded it to be given; he sent and had John beheaded in the prison. The head was brought on a platter & given to the girl, who brought it to her mother. His disciples came and took the body and buried it; then they went &

13 told Jesus. Now when Jesus heard this, he withdrew from there in a boat to a deserted place by himself. But when the crowds heard it, they followed him on foot from the towns. When he went ashore, he saw a great crowd; and he had compassion for them & cured their sick. When it was evening, the disciples came to him & said, "This is a deserted place, and the hour is now late; send the crowds away so that they may go into the villages and buy food for themselves." Jesus said to them, "They need not go away; you give them something to eat." They replied, "We have nothing here but five loaves and two fish." And he said, "Bring them here to me." Then he ordered the crowds to sit down on the grass. Taking the five loaves and the two fish, he looked up to heaven, and blessed and broke the loaves, and gave them to the disciples, and the disciples gave them to the crowds. And all ate and

†
RSB
Matt 13:52

p Gk: hid in
q Other ancient authorities
read the prophet Isaiah
r Other ancient authorities
lack of the world
s Other ancient authorities
add to hear
t Gk: them
u Gk: tetrarch
v Other ancient authorities
read his brother's wife
w Gk: he

were filled; and they took up what was left over of the broken pieces, twelve baskets full. ²¹And those who ate were about five thousand men, besides women and children. ◼ Immediately he made the

22 disciples get into the boat and go on ahead to the other side, while he dismissed the crowds. ²³And after he had dismissed the crowds, he went up the mountain by himself to pray. When evening came, he was there alone, ²⁴ but by this time the boat, battered by the waves, was far from the land, for the wind was against them. ²⁵And early in the morning he came walking toward them on the sea. ²⁶ But when the disciples saw him walking on the sea, they were terrified, saying, "It is a ghost!" And they cried out in fear. ²⁷But immediately Jesus spoke to them & said, "Take heart, it is I; do not be afraid."

28 ◼ Peter answered him, "Lord, if it is you, command me to come to you on the water." ²⁹ He said, "Come." So Peter got out of the boat, started walking on the water, & came toward Jesus. ³⁰ But when he noticed the strong wind, he became frightened, and beginning to sink, he cried out, "Lord, save me!" ³¹ Jesus immediately reached out his hand & caught him, saying to him, "You of little faith, why did you doubt?" ³² When they got into the boat, the wind ceased. ³³And those in the boat worshipped him, saying,

34 "Truly you are the Son of God." ◼ When they had crossed over, they came to land at Gennesaret. ³⁵After the people of that place recognized him, they sent word throughout the region and brought all who were sick to him, ³⁶ and begged him that they might touch even the fringe of his cloak; and all who touched it were healed.

15

T hen Pharisees & scribes came to Jesus from Jerusalem and said,² "Why do your disciples break the tradition of the elders? For they do not wash their hands before they eat." ³ He answered them, "And why do you break the commandment of God for the sake of your tradition? ⁴ For God said, 'Honor your father & your mother,' and, 'Whoever speaks evil of father or mother must surely die.' ⁵ But you say that whoever tells father or mother, 'Whatever support you might have had from me is given to God,' then that person need not honor the father. ⁶ So, for the sake of your tradition, you make void the word of God. ⁷ You hypocrites! Isaiah prophesied rightly about you when he said:

⁸ 'This people honors me with their lips,
 but their hearts are far from me;

⁹ in vain do they worship me,

 teaching human precepts as doctrines.'"

* Other ancient authorities
 read was out on the sea
ʸ Other ancient authorities
 read the wind
ᶻ Other ancient authorities
 read commanded, saying
ᵃ Or is an offering
ᵇ Other ancient authorities
 add or the mother
ᶜ Other ancient authorities
 read law; others
 commandment
ᵈ Other ancient authorities
 lack of the blind

10 ◼ Then he called the crowd to him & said to them, "Listen and understand:¹¹ it is not what goes into the mouth that defiles a person, but it is what comes out of the mouth that defiles." ¹² Then the disciples approached and said to him, "Do you know that the Pharisees took offense when they heard what you said?" ¹³ He answered, "Every plant that my heavenly Father has not planted will be uprooted. ¹⁴ Let them alone; they are blind guides of the blind. And if one blind person guides another, both will fall into a pit." ¹⁵ But Peter said to him, "Explain this parable to us." ¹⁶ Then he said, "Are you also still without understanding? ¹⁷ Do you not see that whatever goes into the mouth enters the stomach, and goes out into the sewer? ¹⁸ But what comes out of the mouth proceeds from the heart, and this is what defiles. ¹⁹ For out of the heart come evil intentions, murder, adultery, fornication, theft, false witness, slander. ²⁰ These are what defile a person, but to eat with unwashed hands does not defile."

21 ◼ Jesus left that place & went away to the district of Tyre and Sidon. ²² Just then a Canaanite woman from that region came out & started shouting, "Have mercy on me, Lord, Son of David; my daughter is tormented by a demon." ²³ But he did not answer her at all. And his disciples came and urged him, saying, "Send her away, for she keeps shouting after us." ²⁴ He answered, "I was sent only to the lost sheep of the house of Israel." ²⁵ But she came and knelt before him, saying, "Lord, help me." ²⁶ He answered, "It is not fair to take the children's food and throw it to the dogs." ²⁷ She said, "Yes, Lord, yet even the dogs eat the crumbs that fall from their master's table." ²⁸ Then Jesus answered her, "Woman, great is your faith! Let it be done for you as you wish."

29 And her daughter was healed instantly. ◼ After Jesus had left that place, he passed along the Sea of Galilee, and he went up the mountain, where he sat down. ³⁰ Great crowds came to him, bringing with them the lame, the maimed, the blind, the mute, and many others. They put them at his feet, and he cured them, ³¹ so that the crowd was amazed when they saw the mute speaking, the maimed whole, the lame walking, and the blind seeing. And they

32 praised the God of Israel. ◼ Then Jesus called his disciples to him & said, "I have compassion for the crowd, because they have been with me now for three days & have nothing to eat; and I do not want to send them away hungry, for they might faint on the way." ³³ The disciples said to him, "Where are we to get enough bread in the desert to feed so great a crowd?" ³⁴ Jesus asked them, "How many loaves have you?" They said, "Seven, and a few small fish." ³⁵ Then ordering the crowd to sit down on the ground,

AND ON THIS ROCK
I WILL BUILD MY CHURCH
AND THE GATES OF
HADES WILL NOT
PREVAIL AGAINST IT

YOU ARE
THE
MESSIAH
THE SON
OF THE
LIVING
GOD

ישׂראל

³⁶he took the seven loaves and the fish; and after giving thanks he broke them and gave them to the disciples, and the disciples gave them to the crowds. ³⁷And all of them ate & were filled; and they took up the broken pieces left over, seven baskets full. ³⁸Those who had eaten were four thousand men, besides women & children. ³⁹After sending away the crowds, he got into the boat and went to the region of Magadan.

16

The Pharisees and Sadducees came, and to test Jesus they asked him to show them a sign from heaven.² He answered them, "When it is evening, you say, 'It will be fair weather; for the sky is red.'³ And in the morning, 'It will be stormy today, for the sky is red and threatening.' You know how to interpret the appearance of the sky, but you cannot interpret the signs of the times. ⁴An evil and adulterous generation asks for a sign, but no sign will be given to it except the sign of Jonah." Then he left them and went away. When the disciples reached the other side, they had forgotten to bring any bread.⁶ Jesus said to them, "Watch out, and beware of the yeast of the Pharisees and Sadducees."⁷ They said to one another, "It is because we have brought no bread."⁸And becoming aware of it, Jesus said, "You of little faith, why are you talking about having no bread?⁹ Do you still not perceive? Do you not remember the five loaves for the five thousand, and how many baskets you gathered?¹⁰ Or the seven loaves for the four thousand, and how many baskets you gathered?¹¹ How could you fail to perceive that I was not speaking about bread? Beware of the yeast of the Pharisees & Sadducees!"¹²Then they understood that he had not told them to beware of the yeast of bread, but of the teaching of the Pharisees and Sadducees.

5

¹³ Now when Jesus came into the district of Caesarea Philippi, he asked his disciples, "Who do people say that the Son of Man is?"¹⁴And they said, "Some say John the Baptist, but others Elijah, & still others Jeremiah or one of the prophets."¹⁵ He said to them, "But who do you say that I am?"¹⁶Simon Peter answered, "You are the Messiah, the Son of the living God."¹⁷And Jesus answered him, "Blessed are you, Simon son of Jonah! For flesh and blood has not revealed this to you, but my Father in heaven.¹⁸And I tell you, you are Peter, & on this rock I will build my church, and the gates of Hades will not prevail against it.¹⁹I will give you the keys of the kingdom of heaven, and whatever you bind on earth will be bound in heaven, and whatever you loose on earth will be loosed in heaven."²⁰Then he sternly ordered the disciples not to tell anyone that he was the Messiah. From that time on, Jesus began to show his disciples that he must go to Jerusalem & undergo great suffering at the hands of the elders and chief priests and scribes, and be killed, and on the third day be raised.²²And Peter took him aside & began to rebuke him, saying, "God forbid it, Lord! This must never happen to you."²³But he turned and said to Peter, "Get behind me, Satan! You are a stumbling block to me; for you are setting your mind not on divine things but on human things."

21

✝

²⁴ Then Jesus told his disciples, "If any want to become my followers, let them deny themselves and take up their cross and follow me. ²⁵For those who want to save their life will lose it, & those who lose their life for my sake will find it.²⁶For what will it profit them if they gain the whole world but forfeit

24

✝
RSB
Matt 16:24

ᵉ Other ancient authorities
read Magdala or Magdalan
ᶠ Gk him
ᵍ Other ancient authorities
lack "When it is...of the
times
ʰ Or the Christ
ⁱ Gk Petros
ʲ Gk petra
ᵏ Other ancient authorities
add Jesus
ˡ Or the Christ

their life? Or what will they give in return for their life? ▪ 27 "For the Son of Man is to come with his angels in the glory of his Father, and then he will repay everyone for what has been done." 28 Truly I tell you, there are some standing here who will not taste death before they see the Son of Man coming in his kingdom."

17

Six days later, Jesus took with him Peter and James & his brother John and led them up a high mountain, by themselves. 2 And he was transfigured before them, and his face shone like the sun, and his clothes became dazzling white. 3 Suddenly there appeared to them Moses & Elijah, talking with him. 4 Then Peter said to Jesus, "Lord, it is good for us to be here; if you wish, I will make three dwellings here, one for you, one for Moses, and one for Elijah." 5 While he was still speaking, suddenly a bright cloud overshadowed them, and from the cloud a voice said, "This is my Son, the Beloved; with him I am well pleased; listen to him!" 6 When the disciples heard this, they fell to the ground & were overcome by fear. 7 But Jesus came and touched them, saying, "Get up and do not be afraid." 8 And when they looked up, they saw no one except Jesus himself alone. ▪ 9 As they were coming down the mountain, Jesus ordered them, "Tell no one about the vision until after the Son of Man has been raised from the dead." 10 And the disciples asked him, "Why, then, do the scribes say that Elijah must come first?" 11 He replied, "Elijah is indeed coming and will restore all things; 12 but I tell you that Elijah has already come, and they did not recognize him, but they did to him whatever they pleased. So also the Son of Man is about to suffer at their hands." 13 Then the disciples understood that he was speaking to them about John the Baptist. ▪ 14 When they came to the crowd, a man came to him, knelt before him, 15 and said, "Lord, have mercy on my son, for he is an epileptic and he suffers terribly; he often falls into the fire & often into the water. 16 And I brought him to your disciples, but they could not cure him." 17 Jesus answered, "You faithless and perverse generation, how much longer must I be with you? How much longer must I put up with you? Bring him here to me." 18 And Jesus rebuked the demon, and it came out of him, & the boy was cured instantly. 19 Then the disciples came to Jesus privately & said, "Why could we not cast it out?" 20 He said to them, "Because of your little faith. For truly I tell you, if you have faith the size of a mustard seed, you will say to this mountain, 'Move from here to there,' and it will move; and

nothing will be impossible for you." 22 ▪ As they were gathering in Galilee, Jesus said to them, "The Son of Man is going to be betrayed into human hands, 23 and they will kill him, and on the third day he will be raised." And they were greatly distressed. 24 ▪ When they reached Capernaum, the collectors of the temple tax came to Peter and said, "Does your teacher not pay the temple tax?" 25 He said, "Yes, he does." And when he came home, Jesus spoke of it first, asking, "What do you think, Simon? From whom do kings of the earth take toll or tribute? From their children or from others?" 26 When Peter said, "From others," Jesus said to him, "Then the children are free. 27 However, so that we do not give offense to them, go to the sea and cast a hook; take the first fish that comes up; and when you open its mouth, you will find a coin; take that & give it to them for you and me."

18

At that time the disciples came to Jesus & asked, "Who is the greatest in the kingdom of heaven?" 2 He called a child, whom he put among them, 3 and said, "Truly I tell you, unless you change and become like children, you will never enter the kingdom of heaven. 4 Whoever becomes humble like this child is the greatest in the kingdom of heaven. 5 Whoever welcomes one such child in my name welcomes me. ▪ 6 If any of you put a stumbling block before one of these little ones who believe in me, it would be better for you if a great millstone were fastened around your neck & you were drowned in the depth of the sea. 7 Woe to the world because of stumbling blocks! Occasions for stumbling are bound to come, but woe to the one by whom the stumbling block comes! ▪ 8 "If your hand or your foot causes you to stumble, cut it off & throw it away; it is better for you to enter life maimed or lame than to have two hands or two feet & to be thrown into the eternal fire. 9 And if your eye causes you to stumble, tear it out and throw it away; it is better for you to enter life with one eye than to have two eyes & to be thrown into the hell of fire. ▪ 10 "Take care that you do not despise one of these little ones; for, I tell you, in heaven their angels continually see the face of my Father in heaven. 12 What do you think? If a shepherd has a hundred sheep, and one of them has gone astray, does he not leave the ninety-nine on the mountains & go in search of the one that went astray? 13 And if he finds it, truly I tell you, he rejoices over it more than over the ninety-nine that never went astray. 14 So it is not the will of your Father in heaven that

☩
RSB
Matt 18 : 6

m Other ancient authorities read we
n Or tents
o Or my beloved Son
p Gk it or him
q Gk the demon
r Gk faith as a grain of
s other ancient authorities add verse 21, But this kind does not come out except by prayer & fasting
t other ancient authorities read living
u Gk didrachma
v Gk didrachma
w Gk he
x Gk stater; the stater was worth two didrachmas
y Gk Gehenna
z other ancient authorities add verse 11, For the Son of Man came to save the lost
a other ancient authorities read my

15 one of these little ones should be lost. If another member of the church sins against you, go and point out the fault when the two of you are alone. If the member listens to you, you have regained that one. 16 But if you are not listened to, take one or two others along with you, so that every word may be confirmed by the evidence of two or three witnesses. 17 If the member refuses to listen to them, tell it to the church; and if the offender refuses to listen even to the church, let such a one be to you as a Gentile and a tax collector. 18 Truly I tell you, whatever you bind on earth will be bound in heaven and whatever you loose on earth will be loosed in heaven. 19 Again, truly I tell you, if two of you agree on earth about anything you ask, it will be done for you by my Father in heaven. 20 For where two or three are gathered in my name, I am there among them."

21 Then Peter came & said to him, "Lord, if another member of the church sins against me, how often should I forgive? As many as seven times?" 22 Jesus said to him, "Not seven times, but, I tell you, seventy-seven times. 23 "For this reason the kingdom of heaven may be compared to a king who wished to settle accounts with his slaves. 24 When he began the reckoning, one who owed him ten thousand talents was brought to him; 25 and, as he could not pay, his lord ordered him to be sold, together with his wife and children and all his possessions, and payment to be made. 26 So the slave fell on his knees before him, saying, 'Have patience with me, and I will pay you everything.' 27 And out of pity for him, the lord of that slave released him and forgave him the debt. 28 But that same slave, as he went out, came upon one of his fellow slaves who owed him a hundred denarii; and seizing him by the throat, he said, 'Pay what you owe.' 29 Then his fellow slave fell down & pleaded with him, 'Have patience with me, and I will pay you.' 30 But he refused; then he went & threw him into prison until he would pay the debt. 31 When his fellow slaves saw what had happened, they were greatly distressed, and they went and reported to their lord all that had taken place. 32 Then his lord summoned him and said to him, 'You wicked slave! I forgave you all that debt because you pleaded with me. 33 Should you not have had mercy on your fellow slave, as I had mercy on you?' 34 And in anger his lord handed him over to be tortured until he would pay his entire debt. 35 So my heavenly Father will also do to every one of you, if you do not forgive your brother or sister from your heart."

When Jesus had finished saying these things, he left Galilee & went to the region of Judea beyond the Jordan. 2 Large crowds followed him, and he cured them there. 3 Some Pharisees came to him, & to test him they asked, "Is it lawful for a man to divorce his wife for any cause?" 4 He answered, "Have you not read that the one who made them at the beginning made them male and female, 5 and said, 'For this reason a man shall leave his father & mother & be joined to his wife, and the two shall become one flesh'? 6 So they are no longer two, but one flesh. Therefore what God has joined together, let no one separate." 7 They said to him, "Why then did Moses command us to give a certificate of dismissal & to divorce her?" 8 He said to them, "It was because you were so hard-hearted that Moses allowed you to divorce your wives, but from the beginning it was not so. 9 And I say to you, whoever divorces his wife, except for unchastity, & marries another commits adultery." 10 His disciples said to him, "If such is the case of a man with his wife, it is better not to marry." 11 But he said to them, "Not everyone can accept this teaching, but only those to whom it is given. 12 For there are eunuchs who have been so from birth, and there are eunuchs who have been made eunuchs by others, and there are eunuchs who have made themselves eunuchs for the sake of the kingdom of heaven. Let anyone accept this who can." 13 Then little children were being brought to him in order that he might lay his hands on them and pray. The disciples spoke sternly to those who brought them; 14 but Jesus said, "Let the little children come to me, and do not stop them; for it is to such as these that the kingdom of heaven belongs." 15 And he laid his hands on them and went on his way. 16 Then someone came to him & said, "Teacher, what good deed must I do to have eternal life?" 17 And he said to him, "Why do you ask me about what is good? There is only one who is good. If you wish to enter into life, keep the commandments." 18 He said to him, "Which ones?" And Jesus said, "You shall not murder; You shall not commit adultery; You shall not steal; You shall not bear false witness; 19 Honor your father and mother; also, You shall love your neighbor as yourself." 20 The young man said to him, "I have kept all these; what do I still lack?" 21 Jesus said to him, "If you wish to be perfect, go, sell your possessions, & give the money to the poor; and you will have treasure in heaven; then come, follow me." 22 When the young man heard this word, he went away grieving, for he had many possessions. 23 Then Jesus said to his disciples, "Truly I tell you, it will be hard for a rich person to enter~

RSV
Matt 19:18

b Gk If your brother
c Other ancient authorities lack against you
d Gk the brother
e Gk if my brother
f Or seventy times seven
g A talent was worth more than fifteen years' wages of a laborer
* The denarius was the usual day's wage for a laborer
i Gk brother
j Other ancient authorities read except on the ground of unchastity, causes her to commit adultery; others add at the end of the verse and he who marries a divorced woman commits adultery
h Other ancient authorities add from my youth
i Gk lacks the money

the kingdom of heaven. ²⁴Again I tell you, it is easier for a camel to go through the eye of a needle than for someone who is rich to enter the kingdom of God." ²⁵When the disciples heard this, they were greatly astounded & said, "Then who can be saved?" ²⁶But Jesus looked at them and said, "For mortals it is impossible, but for God all things are possible."

²⁷ Then Peter said in reply, "Look, we have left everything and followed you. What then will we have?" ²⁸Jesus said to them, "Truly I tell you, at the renewal of all things, when the Son of Man is seated on the throne of his glory, you who have followed me will also sit on twelve thrones, judging the twelve tribes of Israel. ²⁹And everyone who has left houses or brothers or sisters or father or mother or children or fields, for my name's sake, will receive a hundredfold, and will inherit eternal life. ³⁰But many who are first will be last, and the last will be first.

20

For the kingdom of heaven is like a landowner who went out early in the morning to hire laborers for his vineyard. ²After agreeing with the laborers for the usual daily wage, he sent them into his vineyard. ³When he went out about nine o'clock, he saw others standing idle in the marketplace; ⁴and he said to them, 'You also go into the vineyard, and I will pay you whatever is right.' So they went. ⁵When he went out again about noon & about three o'clock, he did the same. ⁶And about five o'clock he went out and found others standing around; and he said to them, 'Why are you standing here idle all day?' ⁷They said to him, 'Because no one has hired us.' He said to them, 'You also go into the vineyard.' ⁸When evening came, the owner of the vineyard said to his manager, 'Call the laborers and give them their pay, beginning with the last & then going to the first.' ⁹When those hired about five o'clock came, each of them received the usual daily wage. ¹⁰Now when the first came, they thought they would receive more; but each of them also received the usual daily wage. ¹¹And when they received it, they grumbled against the landowner, ¹²saying, 'These last worked only one hour, & you have made them equal to us who have borne the burden of the day and the scorching heat.' ¹³But he replied to one of them, 'Friend, I am doing you no wrong; did you not agree with me for the usual daily wage? ¹⁴Take what belongs to you and go; I choose to give to this last the same as I give to you. ¹⁵Am I not allowed to do what I choose with what belongs to me? Or are you envious because I am generous?' ¹⁶So the last will be first, and the first will be last."

¹⁷ While Jesus was going up to Jerusalem, he took the twelve disciples aside by themselves, and said to them on the way, ¹⁸"See, we are going up to Jerusalem, and the Son of Man will be handed over to the chief priests and scribes, and they will condemn him to death; ¹⁹then they will hand him over to the Gentiles to be mocked & flogged & crucified; and on the third day he will be raised." ²⁰ Then the mother of the sons of Zebedee came to him with her sons, & kneeling before him, she asked a favor of him. ²¹And he said to her, "What do you want?" She said to him, "Declare that these two sons of mine will sit, one at your right hand & one at your left, in your kingdom." ²²But Jesus answered, "You do not know what you are asking. Are you able to drink the cup that I am about to drink?" They said to him, "We are able." ²³He said to them, "You will indeed drink my cup, but to sit at my right hand & at my left, this is not mine to grant, but it is for those for whom it has been prepared by my Father."

²⁴ When the ten heard it, they were angry with the two brothers. ²⁵But Jesus called them to him and said, "You know that the rulers of the Gentiles lord it over them, and their great ones are tyrants over them. ²⁶It will not be so among you; but whoever wishes to be great among you must be your servant, ²⁷and whoever wishes to be first among you must be your slave; ²⁸just as the Son of Man came not to be served but to serve, and to give his life a ransom for many." ²⁹ As they were leaving Jericho, a large crowd followed him. ³⁰There were two blind men sitting by the roadside. When they heard that Jesus was passing by, they shouted, "Lord, have mercy on us, Son of David!" ³¹The crowd sternly ordered them to be quiet; but they shouted even more loudly, "Have mercy on us, Lord, Son of David!" ³²Jesus stood still and called them, saying, "What do you want me to do for you?" ³³They said to him, "Lord, let our eyes be opened." ³⁴Moved with compassion, Jesus touched their eyes. Immediately they regained their sight and followed him.

ᵐ Other ancient authorities read manifold
ⁿ Gk a denarius
ᵒ Gk a denarius
ᵖ Gk a denarius
ᵠ Gk a denarius
ʳ Gk is your eye evil because I am good?
ˢ Other ancient authorities add for many are called but few are chosen
ᵗ Other ancient authorities add or to be baptized with the baptism that I am baptized with?
ᵘ Other ancient authorities lack Lord

When they had come near Jerusalem & had reached Bethphage, at the Mount of Olives, Jesus sent two disciples, 2 saying to them, "Go into the village ahead of you, and immediately you will find a donkey tied, and a colt with her; untie them and bring them to me. 3 If anyone says anything to you, just say this, 'The Lord needs them.' And he will send them immediately." 4 This took place to fulfill what had been spoken through the prophet, saying,

5 "Tell the daughter of Zion,
Look, your king is coming to you,
humble, and mounted on a donkey,
and on a colt, the foal of a donkey."

6 The disciples went and did as Jesus had directed them; 7 they brought the donkey and the colt, and put their cloaks on them, and he sat on them. 8 A very large crowd spread their cloaks on the road, and others cut branches from the trees and spread them on the road. 9 The crowds that went ahead of him and followed were shouting,

"Hosanna to the Son of David!
Blessed is the one who comes in the name of the Lord!
Hosanna in the highest heaven!"

10 When he entered Jerusalem, the whole city was in turmoil, asking, "Who is this?" 11 The crowds were saying, "This is the prophet Jesus from Nazareth in Galilee." 12 Then Jesus entered the temple & drove out all who were selling and buying in the temple, & he overturned the tables of the money changers and the seats of those who sold doves. 13 He said to them, "It is written,

'My house shall be called a house of prayer';
but you are making it a den of robbers."

14 The blind & the lame came to him in the temple, and he cured them. 15 But when the chief priests & the scribes saw the amazing things that he did, and heard the children crying out in the temple, "Hosanna to the Son of David," they became angry 16 and said to him, "Do you hear what these are saying?" Jesus said to them, "Yes; have you never read,

'Out of the mouths of infants and nursing babies
you have prepared praise for yourself'?"

17 He left them, went out of the city to Bethany, 18 and spent the night there. In the morning, when he returned to the city, he was hungry. 19 And seeing a fig tree by the side of the road, he went to it and found nothing at all on it but leaves. Then he said to it, "May no fruit ever come from you again!" And the fig tree withered at once. 20 When the disciples saw it, they were amazed, saying, "How did the fig tree wither at once?" 21 Jesus answered them, "Truly I tell you, if you have faith & do not doubt, not only will you do what has been done to the fig tree, but even if you say to this mountain, 'Be lifted up and thrown into the sea,' it will be done. 22 Whatever you ask for in prayer with faith, you will receive."

23 When he entered the temple, the chief priests and the elders of the people came to him as he was teaching, and said, "By what authority are you doing these things, and who gave you this authority?" 24 Jesus said to them, "I will also ask you one question; if you tell me the answer, then I will also tell you by what authority I do these things. 25 Did the baptism of John come from heaven, or was it of human origin?" And they argued with one another, "If we say, 'From heaven,' he will say to us, 'Why then did you not believe him?' 26 But if we say, 'Of human origin,' we are afraid of the crowd; for all regard John as a prophet." 27 So they answered Jesus, "We do not know." And he said to them, "Neither will I tell you by what authority I am doing these things.

28 "What do you think? A man had two sons; he went to the first and said, 'Son, go and work in the vineyard today.' 29 He answered, 'I will not'; but later he changed his mind and went. 30 The father went to the second & said the same; & he answered, 'I go, sir'; but he did not go. 31 Which of the two did the will of his father?" They said, "The first." Jesus said to them, "Truly I tell you, the tax collectors & the prostitutes are going into the kingdom of God ahead of you. 32 For John came to you in the way of righteousness and you did not believe him, but the tax collectors and the prostitutes believed him; and even after you saw it, you did not change your minds and believe him.

33 "Listen to another parable. There was a landowner who planted a vineyard, put a fence around it, dug a wine press in it, and built a watchtower. Then he leased it to tenants and went to another country. 34 When the harvest time had come, he sent his slaves to the tenants to collect his produce. 35 But the tenants seized his slaves & beat one, killed another, and stoned another. 36 Again he sent other slaves, more than the first; and they treated them in the same way. 37 Finally he sent his son to them, saying, 'They will respect my son.' 38 But when the tenants saw the son, they said to themselves, 'This is the heir; come, let us kill him & get his inheritance.' 39 So they seized him, threw him out of the vineyard, and killed him. 40 Now when the owner of the vineyard comes, what will he do to those tenants?" 41 They said to him, "He will put those wretches to a miserable death, and lease the vineyard to other tenants who will give him the produce at the harvest time." 42 Jesus said to them, "Have you never read in the scriptures:

The stone that the builders rejected
has become the cornerstone;

v Or 'The Lord needs them and will send them back immediately.
w Or Most of the crowd
x Other ancient authorities add of God
y Gk lacks heard
z Gk He
a Or keystone

this was the Lord's doing,

and it is amazing in our eyes'?

⁴³Therefore I tell you, the kingdom of God will be taken away from you and given to a people that produces the fruits of the kingdom.⁴⁴ The one who falls on this stone will be broken to pieces; 45 and it will crush anyone on whom it falls." When the chief priests & the Pharisees heard his parables, they realized that he was speaking about them. ⁴⁶ They wanted to arrest him, but they feared the crowds, because they regarded him as a prophet.

22

Once more Jesus spoke to them in parables, saying: ² "The kingdom of heaven may be compared to a king who gave a wedding banquet for his son.³ He sent his slaves to call those who had been invited to the wedding banquet, but they would not come. ⁴ Again he sent other slaves, saying,' Tell those who have been invited: Look, I have prepared my dinner; my oxen & my fat calves have been slaughtered, and everything is ready; come to the wedding banquet'. ⁵ But they made light of it and went away, one to his farm, another to his business, ⁶ while the rest seized his slaves, mistreated them and killed them.⁷ The king was enraged. He sent his troops, destroyed those murderers, and burned their city.⁸ Then he said to his slaves,' The wedding is ready, but those invited were not worthy. ⁹ Go therefore into the main streets, & invite every-one you find to the wedding banquet'. ¹⁰ Those slaves went out into the streets & gathered all whom they found, both good and bad; so the wedding hall was 11 filled with guests. "But when the king came in to see the guests, he noticed a man there who was not wearing a wedding robe, ¹² and he said to him,' Friend, how did you get in here without a wedding robe?' And he was speechless.' ³ Then the king said to the attendants,' Bind him hand & foot, and throw him into the outer darkness, where there will be weeping and gnashing of teeth.' ¹⁴ For many are called, but 15 few are chosen." Then the Pharisees went and plotted to entrap him in what he said. ¹⁶ So they sent their disciples to him, along with the Herodians, saying, "Teacher, we know that you are sincere, and teach the way of God in accordance with truth, and show deference to no one; for you do not regard people with partiality. ¹⁷ Tell us, then, what you think. Is it lawful to pay taxes to the emperor, or not?" ¹⁸ But Jesus, aware of their malice, said, "Why are you putting me to the test, you hypocrites? ¹⁹ Show me the coin used for the tax." And they brought him a denarius.²⁰ Then he said to them, "Whose

head is this, and whose title?"²¹ They answered, "The emperor's." Then he said to them, "Give therefore to the emperor the things that are the emperor's, and to God the things that are God's."²² When they heard this, they were amazed; and they left him 23 and went away. The same day some Sadducees came to him, saying there is no resurrection; and they asked him a question, saying,²⁴"Teacher, Moses said,' If a man dies childless, his brother shall marry the widow, and raise up children for his brother.' ²⁵ Now there were seven brothers among us; the first married, and died childless, leaving the widow to his brother.²⁶ The second did the same, so also the third, down to the seventh.²⁷ Last of all, the woman herself died.²⁸ In the resurrection, then, whose wife of the seven will she be? For all of them 29 had married her." Jesus answered them, "You are wrong, because you know neither the scriptures nor the power of God.³⁰ For in the resurrection they neither marry nor are given in marriage, but are like angels in heaven.³¹And as for the resurrection of the dead, have you not read what was said to you by God,³²'I am the God of Abraham, the God of Isaac, and the God of Jacob'? He is God not of the dead, but of the living."³³And when the crowd heard it, they were astounded at his teaching. 34 When the Pharisees heard that he had silenced the Sadducees, they gathered together,³⁵ and one of them, a lawyer, asked him a question to test him. ³⁶"Teacher, which commandment in the law is the † greatest?"³⁷ He said to him,

'YOU SHALL LOVE THE LORD YOUR GOD WITH ALL YOUR HEART, AND WITH ALL YOUR SOUL, AND WITH ALL YOUR MIND.' 38 THIS IS THE GREATEST AND FIRST COMMANDMENT. 39 AND A SECOND IS LIKE IT: 'YOU SHALL LOVE YOUR NEIGHBOR AS YOURSELF.' 40 ON THESE TWO COMMAND-MENTS HANG ALL THE LAW AND THE PROPHETS."

†
RSB
Matt 37:39

ᵇ Gk the fruits of it
ᶜ Other ancient authorities lack verse 44
ᵈ Other ancient authorities read who say that there is no resurrection
ᵉ Other ancient authorities add of God

⁴¹ ❡ Now while the Pharisees were gathered together, Jesus asked them this question: ⁴² "What do you think of the Messiah? Whose son is he?" They said to him, "The son of David." ⁴³ He said to them, "How is it then that David by the Spirit calls him Lord, saying,

⁴⁴ 'The Lord said to my Lord,
 "Sit at my right hand,
 until I put your enemies under your feet"'?

⁴⁵ If David thus calls him Lord, how can he be his son?" ⁴⁶ No one was able to give him an answer, nor from that day did anyone dare to ask him any more questions.

23

Then Jesus said to the crowds and to his disciples, ² "The scribes and the Pharisees sit on Moses' seat; ³ therefore, do whatever they teach you and follow it; but do not do as they do, for they do not practice what they teach. ⁴ They tie up heavy burdens, hard to bear, and lay them on the shoulders of others; but they themselves are unwilling to lift a finger to move them. ⁵ They do all their deeds to be seen by others; for they make their phylacteries broad & their fringes long. ⁶ They love to have the place of honor at banquets & the best seats in the synagogues, ⁷ and to be greeted with respect in the marketplaces, & to have people call them rabbi. ⁸ But you are not to be called rabbi, for you have one teacher, and you are all students. ⁹ And call no one your father on earth, for you have one Father—the one in heaven. ¹⁰ Nor are you to be called instructors, for you have one instructor, the Messiah. ¹¹ The greatest among you will be your servant. ¹² All who exalt themselves will be humbled, and all who humble themselves will be exalted.

¹³ ❡ "But woe to you, scribes & Pharisees, hypocrites! For you lock people out of the kingdom of heaven. For you do not go in yourselves, and when others are going in, you stop them. ¹⁵ Woe to you, scribes and Pharisees, hypocrites! For you cross sea & land to make a single convert, and you make the new convert twice as much a child of hell as yourselves. ¹⁶ ❡ "Woe to you, blind guides, who say, 'Whoever swears by the sanctuary is bound by nothing, but whoever swears by the gold of the sanctuary is bound by the oath.' ¹⁷ You blind fools! For which is greater, the gold or the sanctuary that has made the gold sacred? ¹⁸ And you say, 'Whoever swears by the altar is bound by nothing, but whoever swears by the gift that is on the altar is bound by the oath.' ¹⁹ How blind you are! For which is greater, the gift or the altar that makes the gift sacred? ²⁰ So whoever swears by the altar, swears by it and by everything on it; ²¹ & whoever swears by the sanctuary, swears by it and by the one who dwells in it; ²² and whoever swears by heaven, swears by the throne of God & by the one who is seated upon it. ²³ ❡ "Woe to you, scribes & Pharisees, hypocrites! For you tithe mint, dill, & cummin, and have neglected the weightier matters of the law: justice and mercy & faith. It is these you ought to have practiced without neglecting the others. ²⁴ You blind guides! You strain out a gnat but swallow a camel! ²⁵ ❡ "Woe to you, scribes and Pharisees, hypocrites! For you clean the outside of the cup and of the plate, but inside they are full of greed and self-indulgence. ²⁶ You blind Pharisee! First clean the inside of the cup, so that the outside also may become clean. ²⁷ ❡ "Woe to you, scribes and Pharisees, hypocrites! For you are like whitewashed tombs, which on the outside look beautiful, but inside they are full of the bones of the dead and of all kinds of filth. ²⁸ So you also on the outside look righteous to others, but inside you are full of hypocrisy and lawlessness. ²⁹ ❡ "Woe to you, scribes and Pharisees, hypocrites! For you build the tombs of the prophets & decorate the graves of the righteous, ³⁰ and you say, 'If we had lived in the days of our ancestors, we would not have taken part with them in shedding the blood of the prophets.' ³¹ Thus you testify against yourselves that you are descendants of those who murdered the prophets. ³² Fill up, then, the measure of your ancestors. ³³ You snakes, you brood of vipers! How can you escape being sentenced to hell? ³⁴ Therefore I send you prophets, sages, and scribes, some of whom you will kill & crucify, and some you will flog in your synagogues and pursue from town to town, ³⁵ so that upon you may come all the righteous blood shed on earth, from the blood of righteous Abel to the blood of Zechariah son of Barachiah, whom you murdered between the sanctuary and the altar. ³⁶ Truly I tell you, all this will come upon this generation. ³⁷ ❡ "Jerusalem, Jerusalem, the city that kills the prophets & stones those who are sent to it! How often have I desired to gather your children together as a hen gathers her brood under her wings, and you were not willing! ³⁸ See, your house is left to you, desolate. ³⁹ For I tell you, you will not see me again until you say, 'Blessed is the one who comes in the name of the Lord.'"

24

As Jesus came out of the temple and was going away, his disciples came to point out to him the buildings of the temple. ² Then he asked them, "You see all these, do you not? Truly I tell you, not one stone will be left here upon

✝
RSB
Matt 23:3

f Or Christ
g Gk in spirit
h Other ancient authorities lack hard to bear
i Gk brothers
j Or the Christ
k Other authorities add here [or after verse 12] verse 14, Woe to you, scribes and Pharisees, hypocrites! for you devour widows' houses and for the sake of appearance you make long prayers; therefore you will receive the greater condemnation
l Gk Gehenna
m Other ancient authorities add and of the plate
n Gk Gehenna
o Other ancient authorities lack desolate

3 another; all will be thrown down." ▰ When he was sitting on the Mount of Olives, the disciples came to him privately, saying, "Tell us, when will this be, & what will be the sign of your coming and of the end of the age?" 4 Jesus answered them, "Beware that no one leads you astray. 5 For many will come in my name, saying, 'I am the Messiah!' and they will lead many astray. 6 And you will hear of wars and rumors of wars; see that you are not alarmed; for this must take place, but the end is not yet. 7 For nation will rise against nation, and kingdom against kingdom, and there will be famines and earthquakes in various places. 8 all this is but the

9 beginning of the birth pangs. ▰ "Then they will hand you over to be tortured and will put you to death, and you will be hated by all nations because of my name. 10 Then many will fall away, and they will betray one another & hate one another. 11 And many false prophets will arise & lead many astray. 12 And because of the increase of lawlessness, the love of many will grow cold. 13 But the one who endures to the end will be saved. 14 And this good news of the kingdom will be proclaimed throughout the world, as a testimony to all the nations; and

15 then the end will come. ▰ "So when you see the desolating sacrilege standing in the holy place, as was spoken of by the prophet Daniel [let the reader understand], 16 then those in Judea must flee to the mountains; 17 the one on the housetop must not go down to take what is in the house; 18 the one in the field must not turn back to get a coat. 19 Woe to

those who are pregnant & to those who are nursing infants in those days! 20 Pray that your flight may not be in winter or on a sabbath. 21 For at that time there will be great suffering, such as has not been from the beginning of the world until now, no, and never will be. 22 And if those days had not been cut short, no one would be saved; but for the sake of the elect those days will be cut short. 23 Then if any one says to you, 'Look! Here is the Messiah!' or 'There he is!'—do not believe it. 24 For false messiahs and false prophets will appear and produce great signs and omens, to lead astray, if possible, even the elect. 25 Take note, I have told you beforehand. 26 So, if they say to you, 'Look! He is in the wilderness,' do not go out. If they say, 'Look! He is in the inner rooms,' do not believe it. 27 For as the lightning comes from the east & flashes as far as the west, so will be the coming of the Son of Man. 28 Wherever the corpse

29 is, there the vultures will gather. ▰ "Immediately after the suffering of those days

the sun will be darkened,
and the moon will not give its light;
the stars will fall from heaven,
and the powers of heaven will be shaken.

30 Then the sign of the Son of Man will appear in heaven, & then all the tribes of the earth will mourn, & they will see 'the Son of Man coming on the clouds of heaven' with power and great glory. 31 And he will send out his angels with a loud trumpet call, and they will gather his elect from the four winds, from one end of heaven to the other. ▰ "From the

p Or the Christ
q Other ancient authorities
add and pestilences
r Or stumble
s Or gospel
t Or the Christ
u Or christs

fig tree learn its lesson: as soon as its branch becomes tender and puts forth its leaves, you know that summer is near. ³³ So also, when you see all these things, you know that he is near, at the very gates. ³⁴ Truly I tell you, this generation will not pass away until all these things have taken place. ³⁵ Heaven and earth will pass away, but my words will not

36 pass away. ▪ "But about that day and hour no one knows, neither the angels of heaven, nor the Son, but only the Father. ³⁷ For as the days of Noah were, so will be the coming of the Son of Man. ³⁸ For as in those days before the flood they were eating and drinking, marrying and giving in marriage, until the day Noah entered the ark, ³⁹ and they knew nothing until the flood came & swept them all away, so too will be the coming of the Son of Man. ⁴⁰ Then two will be in the field; one will be taken and one will be left. ⁴¹ Two women will be grinding meal together; one will be taken & one will be left. ⁴² Keep awake therefore, for you do not know on what day your Lord is coming. ⁴³ But understand this: if the owner of the house had known in what part of the night the thief was coming, he would have stayed awake and would not have let his house be broken into. ⁴⁴ Therefore you also must be ready, for the Son of Man is coming at an unexpected hour.

45 ▪ "Who then is the faithful and wise slave, whom his master has put in charge of his household, to give the other slaves their allowance of food at the proper time? ⁴⁶ Blessed is that slave whom his master
† will find at work when he arrives. ⁴⁷ Truly I tell you, he will put that one in charge of all his possessions. ⁴⁸ But if that wicked slave says to himself, 'My master is delayed,' ⁴⁹ & he begins to beat his fellow slaves, and eats and drinks with drunkards, ⁵⁰ the master of that slave will come on a day when he does not expect him and at an hour that he does not know. ⁵¹ He will cut him in pieces and put him with the hypocrites, where there will be weeping and gnashing of teeth.

25

Then the kingdom of heaven will be like this. Ten bridesmaids took their lamps & went to meet the bridegroom. ² Five of them were foolish, and five were wise. ³ When the foolish took their lamps, they took no oil with them; ⁴ but the wise took flasks of oil with their lamps. ⁵ As the bridegroom was delayed, all of them became drowsy and slept. ⁶ But at midnight there was a shout, 'Look! Here is the bridegroom! Come out to meet him.' ⁷ Then all those bridesmaids got up and trimmed their lamps. ⁸ The foolish said to the wise, 'Give us some of your oil, for our lamps

are going out.' ⁹ But the wise replied, 'No! there will not be enough for you and for us; you had better go to the dealers and buy some for yourselves.' ¹⁰ And while they went to buy it, the bridegroom came, and those who were ready went with him into the wedding banquet; and the door was shut. ¹¹ Later the other bridesmaids came also, saying, 'Lord, lord, open to us.' ¹² But he replied, 'Truly I tell you, I do not know you.' ¹³ Keep awake therefore, for
14 you know neither the day nor the hour. ▪ For it is as if a man, going on a journey, summoned his slaves and entrusted his property to them; ¹⁵ to one he gave five talents, to another two, to another one, to each according to his ability. Then he went away. ¹⁶ The one who had received the five talents went off at once and traded with them, and made five more talents. ¹⁷ In the same way, the one who had the two talents made two more talents. ¹⁸ But the one who had received the one talent went off and dug a hole in the ground & hid his master's money. ¹⁹ After a long time the master of those slaves came & settled accounts with them. ²⁰ Then the one who had received the five talents came forward, bringing five more talents, saying, 'Master, you handed over to me five talents; see, I have made five more talents.' ²¹ His master said to him, 'Well done, good & trustworthy slave; you have been trustworthy in a few things, I will put you in charge of many things; enter into the joy of your master.' ²² And the one with the two talents also came forward, saying, 'Master, you handed over to me two talents; see, I have made two more talents.' ²³ His master said to him, 'Well done, good and trustworthy slave; you have been trustworthy in a few things, I will put you in charge of many things; enter into the joy of your master.' ²⁴ Then the one who had received the one talent also came forward, saying, 'Master, I knew that you were a harsh man, reaping where you did not sow, and gathering where you did not scatter seed; ²⁵ so I was afraid, and I went and hid your talent in the ground. Here you have what is yours.' ²⁶ But his master replied, 'You wicked & lazy slave! You knew, did you, that I reap where I did not sow, and gather where I did not scatter? ²⁷ Then you ought to have invested my money with the bankers, and on my return I would have received what was my own with interest. ²⁸ So take the talent from him, and give it to the one with the ten talents. ²⁹ For to all those who have, more will be given, and they will have an abundance; but from those who have nothing, even what they have will be taken away. ³⁰ As for this worthless slave, throw him into the outer darkness, where there will be weeping and gnashing
31 of teeth.' ▪ "When the Son of Man comes in his

RSV
Matt 24 : 47

ᵛ Or it
ʷ Other ancient authorities lack nor the Son
ˣ Other ancient authorities read at what hour
ʸ Gk to give them
ᶻ Or cut him off
ᵃ Gk virgins
ᵇ Other ancient authorities add and the bride
ᶜ Gk virgins
ᵈ Gk virgins
ᵉ Other ancient authorities add in which the Son of Man is coming
ᶠ A talent was worth more than fifteen years' wages of a laborer

glory, and all the angels with him, then he will sit on the throne of his glory. ³²All the nations will be gathered before him, and he will separate people one from another as a shepherd separates the sheep from the goats, ³³ and he will put the sheep at his right hand and the goats at the left. ³⁴ Then the king will say to those at his right hand, 'Come you that are blessed by my Father; inherit the kingdom prepared for you from the foundation of the world; ³⁵ for I was hungry and you gave me food, I was thirsty and you gave me something to drink, I was a stranger & you welcomed me, ³⁶ I was naked and you gave me clothing, I was sick and you took care of me, I was in prison and you visited me.' ³⁷ Then the righteous will answer him, 'Lord, when was it that we saw you hungry & gave you food, or thirsty and gave you something to drink? ³⁸And when was it that we saw you a stranger and welcomed you, or naked and gave you clothing? ³⁹And when was it that we saw you sick or in prison & visited you?' ⁴⁰ And the king will answer them, 'Truly I tell you, just as you did it to one of the least of these who are members of my family,ᵍ you did it to me.' ⁴¹ Then he will say to those at his left hand, 'You that are accursed, depart from me into the eternal fire prepared for the devil & his angels; ⁴² for I was hungry and you gave me no food, I was thirsty & you gave me nothing to drink, ⁴³ I was a stranger and you did not welcome me, naked and you did not give me clothing, sick and in prison & you did not visit me.' ⁴⁴ Then they also will answer, 'Lord, when was it that we saw you hungry or thirsty or a stranger or naked or sick or in prison, and did not take care of you?' ⁴⁵ Then he will answer them, 'Truly I tell you, just as you did not do it to one of the least of these, you did not do it to me.' ⁴⁶And these will go away into eternal punishment, but the righteous into eternal life."

26

When Jesus had finished saying all these things, he said to his disciples, ² "You know that after two days the Passover is coming, and the Son of Man will be handed over to be crucified." ☐ ³ Then the chief priests and the elders of the people gathered in the palace of the high priest, who was called Caiaphas, ⁴ and they conspired to arrest Jesus by stealth and kill him. ⁵ But they said, "Not during the festival, or there may be a riot among the people." ☐ ⁶ Now while Jesus was at Bethany in the house of Simon the leper,ʰ ⁷ a woman came to him with an alabaster jar of very costly ointment, and she poured it on his head as he sat at the table. ⁸ But when the disciples saw it,

✝
RSB
Matt 25:35–36
Matt 25:40

ᵍ Gk these my brothers
ʰ The terms leper and leprosy can refer to several diseases
ⁱ Or gospel
ʲ Other ancient authorities add disciples
ᵏ Other ancient authorities add new

they were angry and said, "Why this waste? ⁹ For this ointment could have been sold for a large sum, & the money given to the poor." ¹⁰ But Jesus, aware of this, said to them, "Why do you trouble the woman? She has performed a good service for me. ¹¹ For you always have the poor with you, but you will not always have me. ¹² By pouring this ointment on my body she has prepared me for burial. ¹³ Truly I tell you, wherever this good newsⁱ is proclaimed in the whole world, what she has done will be told in remembrance of her." ☐ ¹⁴ Then one of the twelve, who was called Judas Iscariot, went to the chief priests ¹⁵ and said, "What will you give me if I betray him to you?" They paid him thirty pieces of silver. ¹⁶And from that moment he began to look for an opportunity to betray him. ☐ ¹⁷ On the first day of Unleavened Bread the disciples came to Jesus, saying, "Where do you want us to make the preparations for you to eat the Passover?" ¹⁸ He said, "Go into the city to a certain man, and say to him, 'The Teacher says, My time is near; I will keep the Passover at your house with my disciples.'" ¹⁹ So the disciples did as Jesus had directed them, and they prepared the Passover meal. ☐ ²⁰ When it was evening, he took his place with the twelve; ²¹ and while they were eating, he said, "Truly I tell you, one of you will betray me." ²²And they became greatly distressed and began to say to him one after another, "Surely not I, Lord?" ²³He answered, "The one who has dipped his hand into the bowl with me will betray me. ²⁴ The Son of Man goes as it is written of him, but woe to that one by whom the Son of Man is betrayed! It would have been better for that one not to have been born." ²⁵ Judas, who betrayed him, said, "Surely not I, Rabbi?" He replied, "You have said so." ²⁶ ☐ While they were eating, Jesus took a loaf of bread, and after blessing it he broke it, gave it to the disciples, & said, "Take, eat; this is my body." ²⁷ Then he took a cup, and after giving thanks he gave it to them, saying, "Drink from it, all of you; ²⁸ for this is my blood of theᵏ covenant, which is poured out for many for the forgiveness of sins. ²⁹ I tell you, I will never again drink of this fruit of the vine until that day when I drink it new with you in my Father's kingdom." ☐ ³⁰ When they had sung the hymn, they went out to the Mount of Olives. ☐ ³¹ Then Jesus said to them, "You will all become deserters because of me this night; for it is written,

'I will strike the shepherd,
 and the sheep of the flock will be scattered.'

³² But after I am raised up, I will go ahead of you to Galilee." ³³ Peter said to him, "Though all become deserters because of you, I will never desert you." ³⁴ Jesus said to him, "Truly I tell you, this very night, before the cock crows, you will deny me three times."

35 Peter said to him, "Even though I must die with you, I will not deny you." And so said all the disciples.

36 ❧ Then Jesus went with them to a place called Gethsemane; and he said to his disciples, "Sit here while I go over there and pray." 37 He took with him Peter & the two sons of Zebedee, and began to be grieved and agitated. 38 Then he said to them, "I am deeply grieved, even to death; remain here, & stay awake with me." 39 And going a little farther, he threw himself on the ground and prayed, "My Father, if it is possible, let this cup pass from me; yet not what I want but what you want." 40 Then he came to the disciples and found them sleeping; and he said to Peter, "So, could you not stay awake with me one hour? 41 Stay awake & pray that you may not come into the time of trial; the spirit indeed is willing, but the flesh is weak." 42 Again he went away for the second time and prayed, "My Father, if this cannot pass unless I drink it, your will be done." 43 Again he came and found them sleeping, for their eyes were heavy. 44 So leaving them again, he went away & prayed for the third time, saying the same words. 45 Then he came to the disciples and said to them, "Are you still sleeping and taking your rest? See, the hour is at hand, and the Son of Man is betrayed into the hands of sinners. 46 Get up, let us be going. 47 See, my betrayer is at hand." ❧ While he was still speaking, Judas, one of the twelve, arrived; with him was a large crowd with swords and clubs, from the chief priests & the elders of the people. 48 Now the betrayer had given them a sign, saying, "The one I will kiss is the man; arrest him." 49 At once he came up to Jesus and said, "Greetings, Rabbi!" and kissed him. 50 Jesus said to him, "Friend, do what you are here to do." Then they came and laid hands on Jesus and arrested him. 51 Suddenly, one of those with Jesus put his hand on his sword, drew it, and struck the slave of the high priest, cutting off his ear. 52 Then Jesus said to him, "Put your sword back into its place; for all who take the sword will perish by the sword. 53 Do you think that I cannot appeal to my Father, & he will at once send me more than twelve legions of angels? 54 But how then would the scriptures be fulfilled, which say it must happen in this way?" 55 At that hour Jesus said to the crowds, "Have you come out with swords & clubs to arrest me as though I were a bandit? Day after day I sat in the temple teaching, and you did not arrest me. 56 But all this has taken place, so that the scriptures of the prophets may be fulfilled." Then all the disciples deserted him and fled. 57 ❧ Those who had arrested Jesus took him to Caiaphas the high priest, in whose house the scribes & the elders had gathered. 58 But Peter was following him at a distance, as far as the courtyard of the high priest; & going inside, he sat with the guards in order to see how this would end. 59 Now the chief priests and the whole council were looking for false testimony against Jesus so that they might put him to death, 60 but they found none, though many false witnesses came forward. At last two came forward 61 and said, "This fellow said, 'I am able to destroy the temple of God and to build it in three days.'" 62 The high priest stood up & said, "Have you no answer? What is it that they testify against you?" 63 But Jesus was silent. Then the high priest said to him, "I put you under oath before the living God, tell us if you are the Messiah,ᵐ the Son of God." 64 Jesus said to him, "You have said so. But I tell you,

From now on you will see the Son of Man
 seated at the right hand of Power
 and coming on the clouds of heaven."

65 Then the high priest tore his clothes & said, "He has blasphemed! Why do we still need witnesses? You have now heard his blasphemy! 66 What is your verdict?" They answered, "He deserves death." 67 Then they spat in his face & struck him; & some slapped him, 68 saying, "Prophesy to us, you Messiah!ⁿ Who is it that struck you?" ❧ 69 Now Peter was sitting outside in the courtyard. A servant-girl came to him and said, "You also were with Jesus the Galilean." 70 But he denied it before all of them, saying, "I do not know what you are talking about." 71 When he went out to the porch, another servant-girl saw him, and she said to the bystanders, "This man was with Jesus of Nazareth."ᵒ 72 Again he denied it with an oath, "I do not know the man." 73 After a little while the bystanders came up & said to Peter, "Certainly you are also one of them, for your accent betrays you." 74 Then he began to curse, & he swore an oath, "I do not know the man!" At that moment the cock crowed. 75 Then Peter remembered what Jesus had said: "Before the cock crows, you will deny me three times." And he went out and wept bitterly.

27

When morning came, all the chief priests and the elders of the people conferred together against Jesus in order to bring about his death. 2 They bound him, led him away, & handed him over to Pilate the governor. 3 ❧ When Judas, his betrayer, saw that Jesusᵖ was condemned, he repented and brought back the thirty pieces of silver to the chief priests and the elders. 4 He said, "I have sinned by betraying innocent blood."ᵍ But they said, "What is that to us? See to it yourself." 5 Throwing down the pieces of silver in the temple,

✝
RSV
Matt 26:50

l Or into temptation
m Or Christ
n Or Christ
o Gk the Nazorean
p Gk he
q Other ancient authorities read righteous

he departed; and he went & hanged himself. [6] But the chief priests, taking the pieces of silver, said, "It is not lawful to put them into the treasury, since they are blood money." [7] After conferring together, they used them to buy the potter's field as a place to bury foreigners. [8] For this reason that field has been called the Field of Blood to this day. [9] Then was fulfilled what had been spoken through the prophet Jeremiah, "And they took the thirty pieces of silver, the price of the one on whom a price had been set, on whom some of the people of Israel had set a price, [10] and they gave them for the potter's field, as the Lord commanded me." ¶ [11] Now Jesus stood before the governor; and the governor asked him, "Are you the King of the Jews?" Jesus said, "You say so." [12] But when he was accused by the chief priests & elders, he did not answer. [13] Then Pilate said to him, "Do you not hear how many accusations they make against you?" [14] But he gave him no answer, not even to a single charge, so that the governor was greatly amazed. ¶ [15] Now at the festival the governor was accustomed to release a prisoner for the crowd, anyone whom they wanted. [16] At that time they had a notorious prisoner, called Jesus Barabbas. [17] So after they had gathered, Pilate said to them, "Whom do you want me to release for you, Jesus Barabbas or Jesus who is called the Messiah?" [18] For he realized that it was out of jealousy that they had handed him over. [19] While he was sitting on the judgment seat, his wife sent word to him, "Have nothing to do with that innocent man, for today I have suffered a great deal because of a dream about him." [20] Now the chief priests and the elders persuaded the crowds to ask for Barabbas and to have Jesus killed. [21] The governor again said to them, "Which of the two do you want me to release for you?" And they said, "Barabbas." [22] Pilate said to them, "Then what should I do with Jesus who is called the Messiah?" All of them said, "Let him be crucified!" [23] Then he asked, "Why, what evil has he done?" But they shouted all the more, "Let him be crucified!" ¶ [24] So when Pilate saw that he could do nothing, but rather that a riot was beginning, he took some water and washed his hands before the crowd, saying, "I am innocent of this man's blood; see to it yourselves." [25] Then the people as a whole answered, "His blood be on us and on our children!" [26] So he released Barabbas for them; and after flogging Jesus, he handed him over to be crucified. ¶ [27] Then the soldiers of the governor took Jesus into the governor's headquarters, and they gathered the whole cohort around him. [28] They stripped him and put a scarlet robe on him, [29] and after twisting some thorns into a crown, they put it on his head. They put a reed in his right hand

אֵלִי אֵלִי
לְמָה שְׁבַקְתַּנִי

[r] Other ancient authorities read Zechariah or Isaiah
[s] Or I took.
[t] Or the price of the precious one
[u] Other ancient authorities read I gave
[v] Other ancient authorities lack Jesus
[w] Other ancient authorities lack Jesus
[x] Or the Christ
[y] Or the Christ
[z] Other ancient authorities read this righteous blood, or this righteous man's blood
[a] Gk. the praetorium
[b] Other ancient authorities add in order that what had been spoken through the prophet might be fulfilled: "They divided my clothes among themselves, and for my clothing they cast lots."
[c] Or blasphemed
[d] Or is he unable to save himself?
[e] Or earth
[f] Other ancient authorities add And another took a spear and pierced his side, and out came water and blood.
[g] Or gave up his spirit
[h] Or a son of God

& knelt before him and mocked him, saying, "Hail, King of the Jews!" [30] They spat on him, and took the reed & struck him on the head. [31] After mocking him, they stripped him of the robe and put his own clothes on him. Then they led him away to crucify him. ¶ [32] As they went out, they came upon a man from Cyrene named Simon; they compelled this man to carry his cross. [33] And when they came to a place called Golgotha (which means Place of a skull), [34] they offered him wine to drink, mixed with gall; but when he tasted it, he would not drink it. [35] And when they had crucified him, they divided his clothes among themselves by casting lots; [36] then they sat down there & kept watch over him. [37] Over his head they put the charge against him, which read, "This is Jesus, the King of the Jews." ¶ [38] Then two bandits were crucified with him, one on his right & one on his left. [39] Those who passed by derided him, shaking their heads [40] and saying, "You who would destroy the temple and build it in three days, save yourself! If you are the Son of God, come down from the cross." [41] In the same way the chief priests also, along with the scribes and elders, were mocking him, saying, [42] "He saved others; he cannot save himself. He is the King of Israel; let him come down from the cross now, and we will believe in him. [43] He trusts in God; let God deliver him now, if he wants to; for he said, 'I am God's Son.'" [44] The bandits who were crucified with him also taunted him in the same way. ¶ [45] From noon on, darkness came over the whole land until three in the afternoon. [46] And about three o'clock Jesus cried with a loud voice, "Eli, Eli, lema sabachthani?" that is, "My God, my God, why have you forsaken me?" [47] When some of the bystanders heard it, they said, "This man is calling for Elijah." [48] At once one of them ran & got a sponge, filled it with sour wine, put it on a stick, and gave it to him to drink. [49] But the others said, "Wait, let us see whether Elijah will come to save him." [50] Then Jesus cried again with a loud voice & breathed his last. [51] At that moment the curtain of the temple was torn in two, from top to bottom. The earth shook, & the rocks were split. [52] The tombs also were opened, and many bodies of the saints who had fallen asleep were raised. [53] After his resurrection they came out of the tombs and entered the holy city and appeared to many. [54] Now when the centurion & those with him, who were keeping watch over Jesus, saw the earthquake and what took place, they were terrified and said, [55] "Truly this man was God's Son!" ¶ Many women were also there, looking on from a distance; they had followed Jesus from Galilee and had provided for him. [56] Among them were Mary Magdalene, &

Mary the mother of James and Joseph, and the
57 mother of the sons of Zebedee. ■ When it was evening, there came a rich man from Arimathea, named
Joseph, who was also a disciple of Jesus. 58 He went
to Pilate & asked for the body of Jesus; then Pilate
ordered it to be given to him. 59 So Joseph took the
body and wrapped it in a clean linen cloth 60 and
laid it in his own new tomb, which he had hewn in
the rock. He then rolled a great stone to the door
of the tomb and went away. 61 Mary Magdalene &
the other Mary were there, sitting opposite the tomb.
62 ■ The next day, that is, after the day of Preparation,
the chief priests and the Pharisees gathered before
Pilate 63 and said, "Sir, we remember what that imposter said while he was still alive, 'After three days
I will rise again'. 64 Therefore command the tomb
to be made secure until the third day; otherwise his
disciples may go and steal him away, and tell the
people, 'He has been raised from the dead', and the
last deception would be worse than the first." 65 Pilate
said to them, "You have a guard of soldiers; go, make
it as secure as you can." 66 So they went with the
guard & made the tomb secure by sealing the stone

28

After the sabbath, as the first day of the
week was dawning, Mary Magdalene &
the other Mary went to see the tomb.
2 And suddenly there was a great earthquake; for
an angel of the Lord, descending from heaven, came
and rolled back the stone and sat on it. 3 His appearance was like lightning, and his clothing white as
snow. 4 For fear of him the guards shook & became
like dead men. 5 But the angel said to the women,
"Do not be afraid; I know that you are looking for
Jesus who was crucified. 6 He is not here; for he has
been raised, as he said. Come, see the place where
he lay. 7 Then go quickly and tell his disciples, 'He
has been raised from the dead, and indeed he is
going ahead of you to Galilee; there you will see
him.' This is my message for you." 8 So they left the
tomb quickly with fear and great joy, and ran to
tell his disciples. 9 Suddenly Jesus met them and
said, "Greetings!" And they came to him, took hold
of his feet, and worshiped him. 10 Then Jesus said
to them, "Do not be afraid; go and tell my brothers
11 to go to Galilee; there they will see me." ■ While
they were going, some of the guard went into the
city and told the chief priests everything that had
happened. 12 After the priests had assembled with
the elders, they devised a plan to give a large sum
of money to the soldiers, 13 telling them, "You must
say, 'His disciples came by night & stole him away

while we were asleep.' 14 If this comes to the governor's
ears, we will satisfy him & keep you out of trouble."
15 So they took the money & did as they were directed. And this story is still told among the Jews to
16 this day. ■ Now the eleven disciples went to Galilee,
to the mountain to which Jesus had directed them.
17 When they saw him, they worshiped him; but
some doubted. 18 And Jesus came & said to them,
"All authority in heaven & on earth has been given
to me. 19 Go therefore & make disciples of all nations,
baptizing them in the name of the Father & of the
Son & of the Holy Spirit, 20 & teaching them to obey
everything that I have commanded you. And remember, I am with you always, to the end of the age."

i Or Take a guard
j Gk you know how
k Other ancient authorities
read the Lord
l Other ancient authorities
lack from the dead
m Gk they
n Other ancient authorities
add Amen

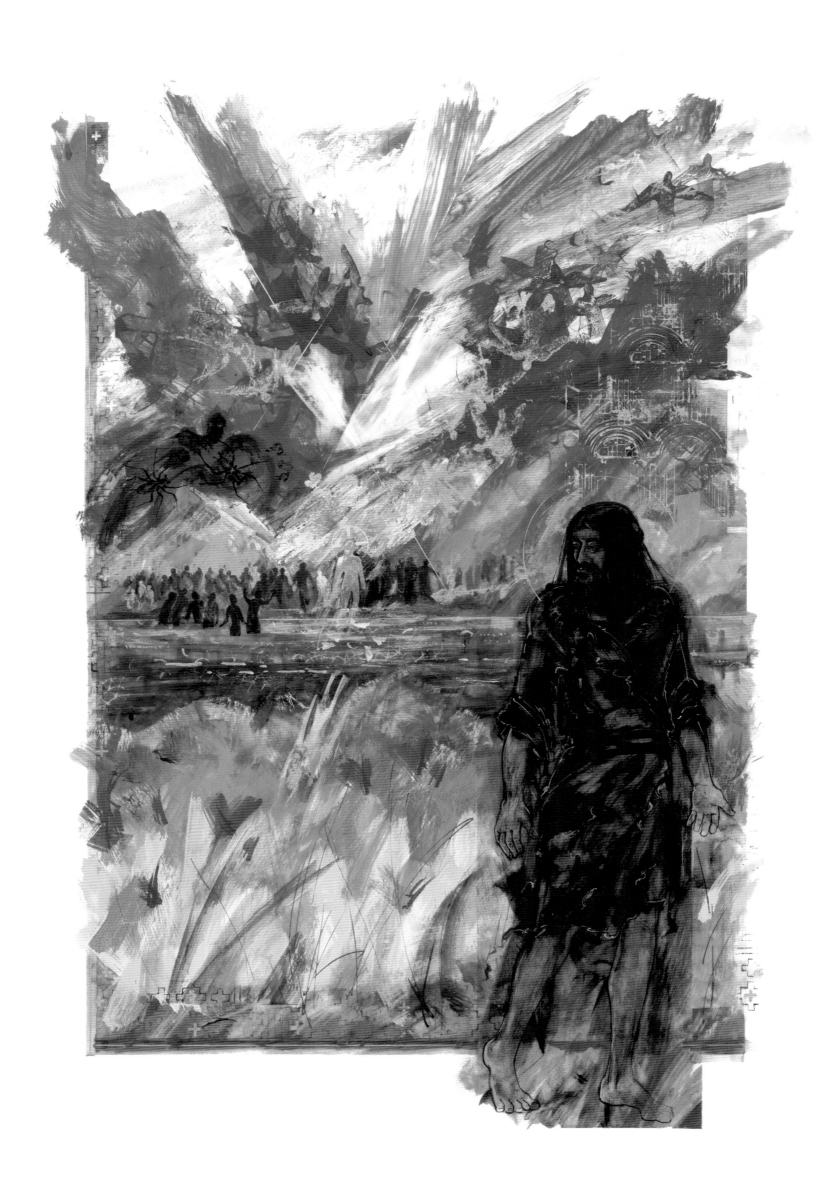

THE GOSPEL ACCORDING TO MARK

1 THE BEGINNING OF THE GOOD NEWS[a] OF JESUS CHRIST, THE SON OF GOD.[b]

2 ■ AS IT IS WRITTEN IN THE PROPHET ISAIAH,[c] "SEE, I AM SENDING MY MESSENGER AHEAD OF YOU,[d] WHO WILL PREPARE YOUR WAY; 3 THE VOICE OF ONE CRYING OUT IN THE WILDERNESS: 'PREPARE THE WAY OF THE LORD, MAKE HIS PATHS STRAIGHT.'"

4 ■ JOHN THE BAPTIZER APPEARED[e] IN THE WILDERNESS, PROCLAIMING A BAPTISM OF REPENTANCE FOR THE FORGIVENESS OF SINS. 5 AND PEOPLE FROM THE WHOLE JUDEAN COUNTRYSIDE AND ALL THE PEOPLE OF JERUSALEM WERE GOING OUT TO HIM, AND WERE BAPTIZED BY HIM IN THE RIVER JORDAN, CONFESSING THEIR SINS. 6 NOW JOHN WAS CLOTHED WITH CAMEL'S HAIR, WITH A LEATHER BELT AROUND HIS WAIST, AND HE ATE LOCUSTS AND WILD HONEY. 7 HE PROCLAIMED, "THE ONE WHO IS MORE POWERFUL THAN I IS COMING AFTER ME; I AM NOT WORTHY TO STOOP DOWN AND UNTIE THE THONG OF HIS SANDALS. 8 I HAVE BAPTIZED YOU WITH[f] WATER; BUT HE WILL BAPTIZE YOU WITH[f] THE HOLY SPIRIT."

9 ■ IN THOSE DAYS JESUS CAME FROM NAZARETH OF GALILEE, AND WAS BAPTIZED BY JOHN IN THE JORDAN. 10 AND JUST AS HE WAS COMING UP OUT OF THE WATER, HE SAW THE HEAVENS TORN APART & THE SPIRIT DESCENDING LIKE A DOVE ON HIM. 11 AND A VOICE CAME FROM HEAVEN, "YOU ARE MY SON, THE BELOVED;[h] WITH YOU I AM WELL PLEASED." ■ AND THE 12 SPIRIT IMMEDIATELY DROVE HIM OUT INTO THE WILDERNESS.

13 He was in the wilderness forty days, tempted by Satan; and he was with the wild beasts; and the angels waited on him. ■ Now after John was arrested, 14 Jesus came to Galilee, proclaiming the good news[i] of God,[j] 15 and saying, "The time is fulfilled, and the kingdom of God has come near;[k] repent, and believe in the good news."[l]

16 ■ As Jesus passed along the sea of Galilee, he saw Simon and his brother Andrew casting a net into the sea—for they were fishermen. 17 And Jesus said to them, "Follow me and I will make you fish for people." 18 And immediately they left their nets & followed him. 19 As he went a little farther, he saw James son of Zebedee & his brother John, who were in the boat mending the nets. 20 Immediately he called them; and they left their father Zebedee in the boat with the hired men, and followed him.

21 ■ They went to Capernaum; & when the sabbath came he entered the synagogue & taught. 22 They were astounded at his teaching, for he taught them as one having authority, and not as the scribes. 23 Just then there was in their synagogue a man with an unclean spirit, 24 and he cried out, "What have you to do with us, Jesus of Nazareth? Have you come to destroy us? I know who you are, the Holy One of God." 25 But Jesus rebuked him, saying, "Be silent, and come out of him!" 26 And the unclean spirit, convulsing him and crying with a loud voice, came out of him. 27 They were all amazed, and they kept on asking one another, "What is this? A new teaching—with authority! He[m] commands even the unclean spirits, and they obey him." 28 At once his fame began to spread throughout the surrounding region of Galilee. ■ As soon as they left the synagogue, 29 they entered the house of Simon & Andrew, with James and John. 30 Now Simon's mother-in-law was in bed with a fever, and they told him about her at

a or gospel
b other ancient authorities lack the Son of God
c other ancient authorities read in the prophets
d Gk before your face
e other ancient authorities read John was baptizing
f or in
g or in
h or my beloved Son
i or gospel
j other ancient authorities read of the kingdom
k or is at hand
l or gospel
m or A new teaching! With authority he
n other ancient authorities read he

once. ³¹He came and took her by the hand & lifted her up. Then the fever left her, and she began to serve them. ■ ³²That evening, at sunset, they brought to him all who were sick or possessed with demons. ³³And the whole city was gathered around the door. ³⁴And he cured many who were sick with various diseases, and cast out many demons; and he would not permit the demons to speak, because they knew him. ■ ³⁵In the morning, while it was still very dark, he got up and went out to a deserted place, and there he prayed. ³⁶And Simon and his companions hunted for him. ³⁷When they found him, they said to him, "Everyone is searching for you." ³⁸He answered, "Let us go on to the neighboring towns, so that I may proclaim the message there also; for that is what I came out to do." ³⁹And he went throughout Galilee, proclaiming the message in their synagogues and casting out demons. ■ ⁴⁰A leper came to him begging him, and kneeling he said to him, "If you choose, you can make me clean." ⁴¹Moved with pity, Jesus stretched out his hand and touched him, & said to him, "I do choose. Be made clean!" ⁴²Immediately the leprosy left him, and he was made clean. ⁴³After sternly warning him he sent him away at once, ⁴⁴saying to him, "See that you say nothing to anyone; but go, show yourself to the priest, and offer for your cleansing what Moses commanded, as a testimony to them." ⁴⁵But he went out & began to proclaim it freely, and to spread the word, so that Jesus could no longer go into a town openly, but stayed out in the country; and people came to him from every quarter.

2

When he returned to Capernaum after some days, it was reported that he was at home. ²So many gathered around that there was no longer room for them, not even in front of the door; and he was speaking the word to them. ³Then some people came, bringing to him a paralyzed man, carried by four of them. ⁴And when they could not bring him to Jesus because of the crowd, they removed the roof above him; and after having dug through it, they let down the mat on which the paralytic lay. ⁵When Jesus saw their faith, he said to the paralytic, "Son, your sins are forgiven." ⁶Now some of the scribes were sitting there, questioning in their hearts, ⁷"Why does this fellow speak in this way? It is blasphemy! Who can forgive sins but God alone?" ⁸At once Jesus perceived in his spirit that they were discussing these questions among themselves; and he said to them, "Why do you raise such questions in your hearts? ⁹Which is easier, to

say to the paralytic, 'Your sins are forgiven,' or to say, 'Stand up & take your mat & walk'? ¹⁰But so that you may know that the Son of Man has authority on earth to forgive sins"—he said to the paralytic— ¹¹"I say to you, stand up, take your mat and go to your home." ¹²And he stood up, and immediately took the mat & went out before all of them; so that they were all amazed & glorified God, saying, "We have never seen anything like this!"

■ ¹³Jesus went out again beside the sea; the whole crowd gathered around him, and he taught them. ¹⁴As he was walking along, he saw Levi son of Alphaeus sitting at the tax booth, and he said to him, "Follow me." And he got up & followed him. ■ ¹⁵And as he sat at dinner in Levi's house, many tax collectors and sinners were also sitting with Jesus & his disciples—for there were many who followed him. ¹⁶When the scribes of the Pharisees saw that he was eating with sinners and tax collectors, they said to his disciples, "Why does he eat with tax collectors and sinners?" ¹⁷When Jesus heard this, he said to them, "Those who are well have no need of a physician, but those who are sick; I have come to call not the righteous but sinners." ■ ¹⁸Now John's disciples & the Pharisees were fasting; and people came and said to him, "Why do John's disciples and the disciples of the Pharisees fast, but your disciples do not fast?" ¹⁹Jesus said to them, "The wedding guests cannot fast while the bridegroom is with them, can they? As long as they have the bridegroom with them, they cannot fast. ²⁰The days will come when the bridegroom is taken away from them, & then they will fast on that day. ■ ²¹"No one sews a piece of unshrunk cloth on an old cloak; otherwise, the patch pulls away from it, the new from the old, and a worse tear is made. ²²And no one puts new wine into old wineskins; otherwise, the wine will burst the skins, and the wine is lost, and so are the skins; but one puts new wine into fresh wineskins."

■ ²³One sabbath he was going through the grainfields; and as they made their way his disciples began to pluck heads of grain. ²⁴The Pharisees said to him, "Look, why are they doing what is not lawful on the sabbath?" ²⁵And he said to them, "Have you never read what David did when he and his companions were hungry & in need of food? ²⁶He entered the house of God, when Abiathar was high priest, and ate the bread of the Presence, which it is not lawful for any but the priests to eat, and he gave some to his companions." ²⁷Then he said to them, "The sabbath was made for humankind, and not humankind for the sabbath; ²⁸so the Son of Man is lord even of the sabbath."

*The terms *leper* and *leprosy* can refer to several diseases

b other ancient authorities lack *kneeling*

c other ancient authorities read *anger*

r Gk *he*

s The terms *leper* and *leprosy* can refer to several diseases

t Gk *he*

u Gk *they*

v Gk *He*

w Gk *reclined*

x Gk *his*

y Gk *reclining*

z other ancient authorities read *and*

a other ancient authorities add *and drink*

b Gk *they*

c other ancient authorities lack *but one puts new wine into fresh wineskins*

3

Again he entered the synagogue, and a man was there who had a withered hand. They watched him to see whether he would cure him on the sabbath, so that they might accuse him. And he said to the man who had the withered hand, "Come forward." Then he said to them, "Is it lawful to do good or to do harm on the sabbath, to save life or to kill?" But they were silent. He looked around at them with anger; he was grieved at their hardness of heart & said to the man,"Stretch out your hand." He stretched it out, and his hand was restored. The Pharisees went out & immediately conspired with the Herodians against him, how to destroy him.

Jesus departed with his disciples to the sea, and a great multitude from Galilee followed him; hearing all that he was doing, they came to him in great numbers from Judea, Jerusalem, Idumea, beyond the Jordan, and the region around Tyre and Sidon. He told his disciples to have a boat ready for him because of the crowd, so that they would not crush him; for he had cured many, so that all who had diseases pressed upon him to touch him. Whenever the unclean spirits saw him, they fell down before him and shouted, "You are the Son of God!" But he sternly ordered them not to make him known.

He went up the mountain & called to him those whom he wanted, and they came to him. And he appointed twelve, whom he also named apostles, to be with him, and to be sent out to proclaim the message, and to have authority to cast out demons. So he appointed the twelve: Simon [to whom he gave the name Peter]; James son of Zebedee and John the brother of James [to whom he gave the name Boanerges, that is, Sons of Thunder]; and Andrew, and Philip, and Bartholomew, and Matthew, and Thomas, and James son of Alphaeus, & Thaddaeus, and Simon the Cananaean, and Judas Iscariot, who betrayed him. Then he went home; and the crowd came together again, so that they went out to restrain him, for people were saying, "He has gone out of his mind." And the scribes who came down from Jerusalem said, "He has Beelzebul, and by the ruler of the demons he casts out demons." And he called them to him, and spoke to them in parables, "How can Satan cast out Satan? If a kingdom is divided against itself, that kingdom cannot stand. And if a house is divided against itself, that house will not be able to stand. And if Satan has risen up against himself and is divided, he cannot stand, but his end has come. But no one can enter a strong man's house & plunder his prop-

could not even eat. When his family heard it, they

erty without first tying up the strong man; then indeed the house can be plundered. "Truly I tell you, people will be forgiven for their sins & whatever blasphemies they utter; but whoever blasphemes against the Holy Spirit can never have forgiveness, but is guilty of an eternal sin"—for they had said, "He has an unclean spirit." Then his mother & his brothers came; and standing outside, they sent to him and called him. A crowd was sitting around him; and they said to him, "Your mother and your brothers and sisters are outside, asking for you." And he replied, "Who are my mother and my brothers?" And looking at those who sat around him, he said, "Here are my mother and my brothers! Whoever does the will of God is my brother and sister and mother."

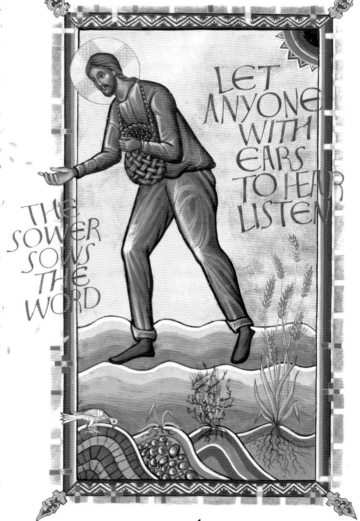

LET ANYONE WITH EARS TO HEAR LISTEN

THE SOWER SOWS THE WORD

4

Again he began to teach beside the sea. Such a very large crowd gathered around him that he got into a boat on the sea and sat there, while the whole crowd was beside the sea on the land. He began to teach them many things in parables, and in his teaching he said to them: "Listen! A sower went out to sow. And as he sowed, some

d Other ancient authorities lack whom he also named apostles

e Other ancient authorities lack So he appointed the twelve

f Other ancient authorities lack and sisters

seed fell on the path, and the birds came & ate it up. 5 Other seed fell on rocky ground, where it did not have much soil, and it sprang up quickly, since it had no depth of soil. 6 And when the sun rose, it was scorched; and since it had no root, it withered away. 7 Other seed fell among thorns, and the thorns grew up and choked it, and it yielded no grain. 8 Other seed fell into good soil and brought forth grain, growing up and increasing & yielding thirty and sixty and a hundredfold." 9 And he said, "Let anyone with ears to hear listen!" ◾ When he was alone, those who were around him along with the twelve asked him about the parables. 11 And he said to them, "To you has been given the secret[a] of the kingdom of God, but for those outside, everything comes in parables; 12 in order that

'they may indeed look, but not perceive,
and may indeed listen, but not understand;
so that they may not turn again and be forgiven.'"

◾ And he said to them, "Do you not understand this parable? Then how will you understand all the parables? 14 The sower sows the word. 15 These are the ones on the path where the word is sown: when they hear, Satan immediately comes & takes away the word that is sown in them. 16 And these are the ones sown on rocky ground: when they hear the word, they immediately receive it with joy. 17 But they have no root, and endure only for a while; then, when trouble or persecution arises on account of the word, immediately they fall away.[b] 18 And others are those sown among the thorns: these are the ones who hear the word, 19 but the cares of the world, & the lure of wealth, and the desire for other things come in and choke the word, and it yields nothing. 20 And these are the ones sown on the good soil: they hear the word & accept it & bear fruit, thirty and sixty and a hundredfold." ◾ He said to them, "Is a lamp brought in to be put under the bushel basket, or under the bed, and not on the lampstand? 22 For there is nothing hidden, except to be disclosed; nor is anything secret, except to come to light. 23 Let anyone with ears to hear listen!" 24 And he said to them, "Pay attention to what you hear; the measure you give will be the measure you get, and still more will be given you. 25 For to those who have, more will be given; and from those who have nothing, even what they have will be taken away." ◾ He also said, "The kingdom of God is as if someone would scatter seed on the ground, 27 and would sleep and rise night and day, and the seed would sprout and grow, he does not know how. 28 The earth produces of itself, first the stalk, then the head, then the full grain in the head. 29 But when the grain is ripe, at once he goes in with his sickle, because the harvest

has come." ◾ He also said, "With what can we compare the kingdom of God, or what parable will we use for it? 31 It is like a mustard seed, which, when sown upon the ground, is the smallest of all the seeds on earth; 32 yet when it is sown it grows up & becomes the greatest of all shrubs, and puts forth large branches, so that the birds of the air can make nests in its shade." ◾ With many such parables he spoke the word to them, as they were able to hear it; 34 he did not speak to them except in parables, but he explained everything in private to his disciples.

◾ On that day, when evening had come, he said to them, "Let us go across to the other side." 36 And leaving the crowd behind, they took him with them in the boat, just as he was. Other boats were with him. 37 A great windstorm arose, and the waves beat into the boat, so that the boat was already being swamped. 38 But he was in the stern, asleep on the cushion; and they woke him up and said to him, "Teacher, do you not care that we are perishing?" 39 He woke up and rebuked the wind, and said to the sea, "Peace! Be still!" Then the wind ceased, and there was a dead calm. 40 He said to them, "Why are you afraid? Have you still no faith?" 41 And they were filled with great awe and said to one another, "Who then is this, that even the wind & the sea obey him?"

5

They came to the other side of the sea, to the country of the Gerasenes.[c] 2 And when he had stepped out of the boat, immediately a man out of the tombs with an unclean spirit met him. 3 He lived among the tombs; and no one could restrain him any more, even with a chain; 4 for he had often been restrained with shackles & chains but the chains he wrenched apart, and the shackles he broke in pieces; and no one had the strength to subdue him. 5 Night and day among the tombs & on the mountains he was always howling & bruising himself with stones. 6 When he saw Jesus from a distance, he ran and bowed down before him; 7 and he shouted at the top of his voice, "What have you to do with me, Jesus, Son of the Most High God? I adjure you by God, do not torment me." 8 For he had said to him, "Come out of the man, you unclean spirit!" 9 Then Jesus asked him, "What is your name?" He replied, "My name is Legion; for we are many." 10 He begged him earnestly not to send them out of the country. 11 Now there on the hillside a great herd of swine was feeding; 12 and the unclean spirits begged him, "Send us into the swine; let us enter them." 13 So he gave them permission. And the un-

a Or mystery
b Or stumble
c Other ancient authorities read Gergesenes; others Gadarenes
d Gk he
e Gk they
f Gk him
g Gk he
h Other ancient authorities lack in the boat
i Or ignoring; other ancient authorities read hearing

clean spirits came out and entered the swine; and the herd, numbering about two thousand, rushed down the steep bank into the sea, and were drowned 14 in the sea. ▪ The swineherds ran off and told it in the city and in the country. Then people came to see what it was that had happened. ¹⁵They came to Jesus & saw the demoniac sitting there, clothed and in his right mind, the very man who had had the legion; and they were afraid. ¹⁶Those who had seen what had happened to the demoniac & to the swine reported it. ¹⁷Then they began to beg Jesus to leave their neighborhood. ¹⁸As he was getting into the boat, the man who had been possessed by demons begged him that he might be with him. ¹⁹But Jesus refused, and said to him, "Go home to your friends, and tell them how much the Lord has done for you, and what mercy he has shown you." ²⁰And he went away and began to proclaim in the Decapolis how much Jesus had done for him; and 21 everyone was amazed. ▪ When Jesus had crossed again in the boat to the other side, a great crowd gathered around him; and he was by the sea. ²²Then one of the leaders of the synagogue named Jairus came and, when he saw him, fell at his feet ²³and begged him repeatedly, "My little daughter is at the point of death. Come and lay your hands on her, so that she may be made well, and live." ²⁴So he went with him. ▪ And a large crowd followed him and pressed in on him. ²⁵Now there was a woman who had been suffering from hemorrhages for twelve years. ²⁶She had endured much under many physicians, and had spent all that she had; and she was no better, but rather grew worse. ²⁷She had heard about Jesus, and came up behind him in the crowd & touched his cloak, ²⁸for she said, "If I but touch his clothes, I will be made well." ²⁹Immediately her hemorrhage stopped; and she felt in her body that she was healed of her disease. ³⁰Immediately aware that power had gone forth from him, Jesus turned about in the crowd & said, "Who touched my clothes?" ³¹And his disciples said to him, "You see the crowd pressing in on you; how can you say, 'Who touched me?'" ³²He looked all around to see who had done it. ³³But the woman, knowing what had happened to her, came in fear & trembling, fell down before him, and told him the whole truth. ³⁴He said to her, "Daughter, your faith has made you well; go in peace, and be healed of your disease." ▪ While he was still 35 speaking, some people came from the leader's house to say, "Your daughter is dead. Why trouble the teacher any further?" ³⁶But overhearing what they said, Jesus said to the leader of the synagogue, "Do not fear, only believe." ³⁷He allowed no one to follow him except Peter, James, and John, the brother of James.

³⁸When they came to the house of the leader of the synagogue, he saw a commotion, people weeping & wailing loudly. ³⁹When he had entered, he said to them, "Why do you make a commotion & weep? The child is not dead but sleeping." ⁴⁰And they laughed at him. Then he put them all outside, and took the child's father and mother and those who were with him, and went in where the child was. ⁴¹He took her by the hand and said to her, "Talitha cum," which means, "Little girl, get up!" ⁴²And immediately the girl got up and began to walk about [she was twelve years of age]. At this they were overcome with amazement. ⁴³He strictly ordered them that no one should know this, and told them to give her something to eat.

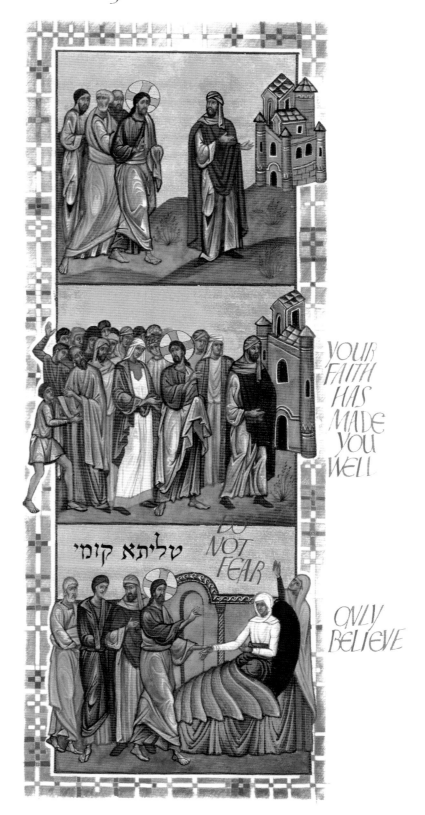

YOUR FAITH HAS MADE YOU WELL

טליתא קומי

DO NOT FEAR

ONLY BELIEVE

6

He left that place and came to his home town, and his disciples followed him. On the sabbath he began to teach in the synagogue, & many who heard him were astounded. They said, "Where did this man get all this? What is this wisdom that has been given to him? What deeds of power are being done by his hands! Is not this the carpenter, the son of Mary & brother of James and Joses & Judas & Simon, and are not his sisters here with us?" And they took offense at him. Then Jesus said to them, "Prophets are not without honor, except in their hometown, and among their own kin, and in their own house." And he could do no deed of power there, except that he laid his hands on a few sick people and cured them. And he was amazed at their unbelief.

Then he went about among the villages teaching. He called the twelve and began to send them out two by two, and gave them authority over the unclean spirits. He ordered them to take nothing for their journey except a staff; no bread, no bag, no money in their belts; but to wear sandals and not to put on two tunics. He said to them, "Wherever you enter a house, stay there until you leave the place. If any place will not welcome you and they refuse to hear you, as you leave, shake off the dust that is on your feet as a testimony against them." So they went out and proclaimed that all should repent. They cast out many demons, & anointed with oil many who were sick and cured them. King Herod heard of it, for Jesus' name had become known. Some were saying, "John the baptizer has been raised from the dead; and for this reason these powers are at work in him." But others said, "It is Elijah." And others said, "It is a prophet, like one of the prophets of old." But when Herod heard of it, he said, "John, whom I beheaded, has been raised." For Herod himself had sent men who arrested John, bound him, and put him in prison on account of Herodias, his brother Philip's wife, because Herod had married her. For John had been telling Herod, "It is not lawful for you to have your brother's wife." And Herodias had a grudge against him, and wanted to kill him. But she could not, for Herod feared John, knowing that he was a righteous and holy man, and he protected him. When he heard him, he was greatly perplexed; and yet he liked to listen to him. But an opportunity came when Herod on his birthday gave a banquet for his courtiers and officers & for the leaders of Galilee. When his daughter Herodias came in & danced, she pleased Herod & his guests; and the king said to the girl, "Ask me for whatever you wish, and I will give it." And he solemnly swore to her, "Whatever you ask me, I will give you, even half of my kingdom." She went out and said to her mother, "What should I ask for?" She replied, "The head of John the baptizer." Immediately she rushed back to the king and requested, "I want you to give me at once the head of John the Baptist on a platter." The king was deeply grieved; yet out of regard for his oaths and for the guests, he did not want to refuse her. Immediately the king sent a soldier of the guard with orders to bring John's head. He went and beheaded him in the prison, brought his head on a platter, and gave it to the girl. Then the girl gave it to her mother. When his disciples heard about it, they came and took his body, and laid it in a tomb.

The apostles gathered around Jesus, and told him all that they had done and taught. He said to them, "Come away to a deserted place all by yourselves and rest a while." For many were coming and going, and they had no leisure even to eat. And they went away in the boat to a deserted place by themselves. Now many saw them going and recognized them, and they hurried there on foot from all the towns and arrived ahead of them. As he went ashore, he saw a great crowd; and he had compassion for them, because they were like sheep without a shepherd; and he began to teach them many

Other ancient authorities read *son of the carpenter and of Mary*

Or *stumbled*

Gk *his*

Other ancient authorities read *he was*

Gk *he*

Other ancient authorities read *he did many things*

Other ancient authorities read *the daughter of Herodias herself*

Gk *his*

things. ³⁵ When it grew late, his disciples came to him & said, "This is a deserted place, and the hour is now very late; ³⁶ send them away so that they may go into the surrounding country and villages and buy something for themselves to eat." ³⁷ But he answered them, "You give them something to eat." They said to him, "Are we to go and buy two hundred denarii worth of bread, and give it to them to eat?" ³⁸ And he said to them, "How many loaves have you? Go and see." When they had found out, they said, "Five, and two fish." ³⁹ Then he ordered them to get all the people to sit down in groups on the green grass. ⁴⁰ So they sat down in groups of hundreds and of fifties. ⁴¹ Taking the five loaves and the two fish, he looked up to heaven, and blessed & broke the loaves, and gave them to his disciples to set before the people; and he divided the two fish among them all. ⁴² And all ate and were filled; ⁴³ and they took up twelve baskets full of broken pieces and of the fish. ⁴⁴ Those who had eaten the loaves numbered

45 five thousand men. ▪ Immediately he made his disciples get into the boat & go on ahead to the other side, to Bethsaida, while he dismissed the crowd. ⁴⁶ After saying farewell to them, he went up on the

47 mountain to pray. ▪ When evening came, the boat was out on the sea, and he was alone on the land. ⁴⁸ When he saw that they were straining at the oars against an adverse wind, he came towards them early in the morning, walking on the sea. He intended to pass them by. ⁴⁹ But when they saw him walking on the sea, they thought it was a ghost and cried out; ⁵⁰ for they all saw him and were terrified. But immediately he spoke to them & said, "Take heart, it is I; do not be afraid." ⁵¹ Then he got into the boat with them & the wind ceased. And they were utterly astounded, ⁵² for they did not understand about

53 the loaves, but their hearts were hardened. ▪ When they had crossed over, they came to land at Gennesaret and moored the boat. ⁵⁴ When they got out of the boat, people at once recognized him, ⁵⁵ and rushed about that whole region and began to bring the sick on mats to wherever they heard he was. ⁵⁶ And wherever he went, into villages or cities or farms, they laid the sick in the marketplaces, and begged him that they might touch even the fringe of his cloak; and all who touched it were healed.

7

ᴺow when the Pharisees and some of the scribes who had come from Jerusalem gathered around him, ² they noticed that some of his disciples were eating with defiled hands, that is, without washing them. ³ [For the Pharisees, and all the Jews, do not eat unless they thoroughly wash their hands, thus observing the tradition of the elders; ⁴ and they do not eat anything from the market unless they wash it; and there are also many other traditions that they observe, the washing of cups, pots, and bronze kettles.] ⁵ So the Pharisees and the scribes asked him, "Why do your disciples not live according to the tradition of the elders, but eat with defiled hands?" ⁶ He said to them, "Isaiah prophesied rightly about you hypocrites, as it is written,

'This people honors me with their lips,
 but their hearts are far from me;
7 in vain do they worship me,
 teaching human precepts as doctrines.'

8 You abandon the commandment of God & hold

9 to human tradition." ▪ Then he said to them, "You have a fine way of rejecting the commandment of God in order to keep your tradition! ¹⁰ For Moses said, 'Honor your father & your mother'; and, 'Whoever speaks evil of father or mother must surely die.' ¹¹ But you say that if anyone tells father or mother, 'Whatever support you might have had from me is Corban' [that is, an offering to God] — ¹² then you no longer permit doing anything for a father or mother, ¹³ thus making void the word of God through your tradition that you have handed on. And you do

14 many things like this." ▪ Then he called the crowd again and said to them, "Listen to me, all of you, and understand; ¹⁵ there is nothing outside a person

קרבן

ᵗ The denarius was the usual day's wage for a laborer
ᵘ Meaning of Gk uncertain
² Other ancient authorities read and when they come from the marketplace, they do not eat unless they purify themselves
ᵃ Other ancient authorities add and beds
ᵇ Gk walk
ᶜ Gk lacks to God

that by going in can defile, but the things that come
17 out are what defile." ❡ When he had left the crowd & entered the house, his disciples asked him about the parable. ¹⁸ He said to them, "Then do you also fail to understand? Do you not see that whatever goes into a person from outside cannot defile, ¹⁹ since it enters, not the heart but the stomach, and goes out into the sewer?" (Thus he declared all foods clean.) ²⁰ And he said, "It is what comes out of a person that defiles. ²¹ For it is from within, from the human heart, that evil intentions come: fornication, theft, murder, ²² adultery, avarice, wickedness, deceit, licentiousness, envy, slander, pride, folly. ²³ All these evil things come from within, & they defile a person."

24 ❡ From there he set out & went away to the region of Tyre. He entered a house and did not want anyone to know he was there. Yet he could not escape notice, ²⁵ but a woman whose little daughter had an unclean spirit immediately heard about him, and she came and bowed down at his feet. ²⁶ Now the woman was a Gentile, of Syrophœnician origin. She begged him to cast the demon out of her daughter. ²⁷ He said to her, "Let the children be fed first, for it is not fair to take the children's food and throw it to the dogs." ²⁸ But she answered him, "Sir, even the dogs under the table eat the children's crumbs." ²⁹ Then he said to her, "For saying that, you may go—the demon has left your daughter." ³⁰ So she went home, found the child lying on the bed, and the demon gone. ❡ Then he returned from the region
31 of Tyre, and went by way of Sidon towards the Sea of Galilee, in the region of the Decapolis. ³² They brought to him a deaf man who had an impediment in his speech; and they begged him to lay his hand on him. ³³ He took him aside in private, away from the crowd, and put his fingers into his ears, and he spat and touched his tongue. ³⁴ Then looking up to heaven, he sighed & said to him, "Ephphatha," that is, "Be opened." ³⁵ And immediately his ears were opened, his tongue was released, and he spoke plainly. ³⁶ Then Jesus ordered them to tell no one; but the more he ordered them, the more zealously they proclaimed it. ³⁷ They were astounded beyond measure, saying, "He has done everything well; he even makes the deaf to hear and the mute to speak."

אתפתח ·

d Other ancient authorities add verse 16, "Let anyone with ears to hear listen"
e Other ancient authorities add and Sidon
f Or Lord; other ancient authorities prefix Yes
g Gk he
h Other ancient authorities read Mageda or Magdala
i Gk they
j Other ancient authorities read the Herodians
k Gk They
l Gk he
m Gk he

8

In those days when there was again a great crowd without anything to eat, he called his disciples and said to them, ² "I have compassion for the crowd, because they have been with me now for three days and have nothing to eat. ³ If I send them away hungry to their homes, they will faint on the way—and some of them have come from a great distance." ⁴ His disciples replied, "How can one feed these people with bread here in the desert?" ⁵ He asked them, "How many loaves do you have?" They said, "Seven." ⁶ Then he ordered the crowd to sit down on the ground; and he took the seven loaves, and after giving thanks he broke them & gave them to his disciples to distribute; and they distributed them to the crowd. ⁷ They had also a few small fish; and after blessing them, he ordered that these too should be distributed. ⁸ They ate and were filled; and they took up the broken pieces left over, seven baskets full. ⁹ Now there were about four thousand people. And he sent them away. ¹⁰ And immediately he got into the boat with his disciples and went to
11 the district of Dalmanutha. ❡ The Pharisees came and began to argue with him, asking him for a sign from heaven, to test him. ¹² And he sighed deeply in his spirit & said, "Why does this generation ask for a sign? Truly I tell you, no sign will be given to this generation." ¹³ And he left them, and getting into the boat again, he went across to the other side.
14 ❡ Now the disciples had forgotten to bring any bread; and they had only one loaf with them in the boat. ¹⁵ And he cautioned them, saying, "Watch out—beware of the yeast of the Pharisees and the yeast of Herod." ¹⁶ They said to one another, "It is because we have no bread." ¹⁷ And becoming aware of it, Jesus said to them, "Why are you talking about having no bread? Do you still not perceive or understand? Are your hearts hardened? ¹⁸ Do you have eyes, and fail to see? Do you have ears, and fail to hear? And do you not remember? ¹⁹ When I broke the five loaves for the five thousand, how many baskets full of broken pieces did you collect?" They said to him, "Twelve." ²⁰ And the seven for the four thousand, how many baskets full of broken pieces did you collect?" And they said to him, "Seven." ²¹ Then he said to them, "Do you not yet understand?"

22 ❡ They came to Bethsaida. Some people brought a blind man to him and begged him to touch him. ²³ He took the blind man by the hand and led him out of the village; and when he had put saliva on his eyes and laid his hands on him, he asked him, "Can you see anything?" ²⁴ And the man looked up and said, "I can see people, but they look like trees, walking." ²⁵ Then Jesus laid his hands on his eyes

again; and he looked intently and his sight was restored, and he saw everything clearly. 26 Then he sent him away to his home, saying, "Do not even go into the village."

27 ¶ Jesus went on with his disciples to the villages of Caesarea Philippi; and on the way he asked his disciples, "Who do people say that I am?" 28 And they answered him, "John the Baptist; and others, Elijah; and still others, one of the prophets." 29 He asked them, "But who do you say that I am?" Peter answered him, "You are the Messiah." 30 And he sternly ordered them not to tell anyone about him. ¶ Then 31 he began to teach them that the Son of Man must undergo great suffering, and be rejected by the elders, the chief priests, and the scribes, and be killed, and after three days rise again. 32 He said all this quite openly. And Peter took him aside and began to rebuke him. 33 But turning & looking at his disciples, he rebuked Peter and said, "Get behind me, Satan! For you are setting your mind not on divine things but on human things." ¶ He called the crowd 34 with his disciples, and said to them, "If any want to become my followers, let them deny themselves and take up their cross and follow me. 35 For those who want to save their life will lose it, and those who lose their life for my sake, and for the sake of the gospel, will save it. 36 For what will it profit them to gain the whole world and forfeit their life? 37 Indeed, what can they give in return for their life? 38 Those who are ashamed of me and of my words in this adulterous & sinful generation, of them the Son of Man will also be ashamed when he comes in the glory of his Father with the holy angels."

9 ¶ And he said to them, "Truly I tell you, there are some standing here who will not taste death until they see that the kingdom of God has come with power." 2 ¶ Six days later, Jesus took with him Peter & James & John, and led them up a high mountain apart, by themselves. And he was transfigured before them, 3 and his clothes became dazzling white, such as no one on earth could bleach them. 4 And there appeared to them Elijah with Moses, who were talking with Jesus. 5 Then Peter said to Jesus, "Rabbi, it is good for us to be here; let us make three dwellings, one for you, one for Moses, and one for Elijah." 6 He did not know what to say, for they were terrified. 7 Then a cloud overshadowed them, and from the cloud there came a voice, "This is my Son, the Beloved; listen to him!" 8 Suddenly when they looked around, they saw no one with them any more, but 9 only Jesus. ¶ As they were coming down the mountain, he ordered them to tell no one about what they had seen, until after the Son of Man had risen

from the dead. 10 So they kept the matter to themselves, questioning what this rising from the dead could mean. 11 Then they asked him, "Why do the scribes say that Elijah must come first?" 12 He said to them, "Elijah is indeed coming first to restore all things. How then is it written about the Son of Man, that he is to go through many sufferings and be treated with contempt? 13 But I tell you that Elijah has come, and they did to him whatever they pleased, as it is written about him." ¶ When they came to 14 the disciples, they saw a great crowd around them, and some scribes arguing with them. 15 When the whole crowd saw him, they were immediately overcome with awe, and they ran forward to greet him. 16 He asked them, "What are you arguing about with them?" 17 Someone from the crowd answered him, "Teacher, I brought you my son; he has a spirit that makes him unable to speak; 18 and whenever it seizes him, it dashes him down; and he foams and grinds his teeth & becomes rigid; and I asked your disciples to cast it out, but they could not do so." 19 He answered them, "You faithless generation, how much longer must I be among you? How much longer must I put up with you? Bring him to me." 20 And they brought the boy to him. When the spirit saw him, immediately it convulsed the boy, and he fell on the ground & rolled about, foaming at the mouth. 21 Jesus asked the father, "How long has this been happening to him?" And he said, "From childhood. 22 It has often cast him into the fire & into the water, to destroy him; but if you are able to do anything, have pity on us and help us." 23 Jesus said to him, "If you are able!—All things can be done for the one who believes." 24 Immediately the father of the child cried out, "I believe; help my unbelief!" 25 When Jesus saw that a crowd came running together, he rebuked the unclean spirit, saying to it, "You spirit that keeps this boy from speaking and hearing, I command you, come out of him, and never enter him again!" 26 After crying out and convulsing him terribly, it came out, and the boy was like a corpse, so that most of them said, "He is dead." 27 But Jesus took him by the hand and lifted him up, and he was able to stand. 28 When he had entered the house, his disciples asked him privately, "Why could we not cast it out?" 29 He said to them, "This kind can come out only through prayer."

30 ¶ They went on from there and passed through Galilee. He did not want anyone to know it; 31 for he was teaching his disciples, saying to them, "The Son of Man is to be betrayed into human hands, & they will kill him, and three days after being killed, he will rise again." 32 But they did not understand

n Other ancient authorities add or tell anyone in the village.
o Or the Christ
p Other ancient authorities read lose their life for the sake of the gospel
q Other ancient authorities read and of mine
r Or in
s Gk no fuller
t Or tents
u Or my beloved Son
v Gk him
w Gk him
x Gk He
y Other ancient authorities add with tears
z Other ancient authorities add and fasting

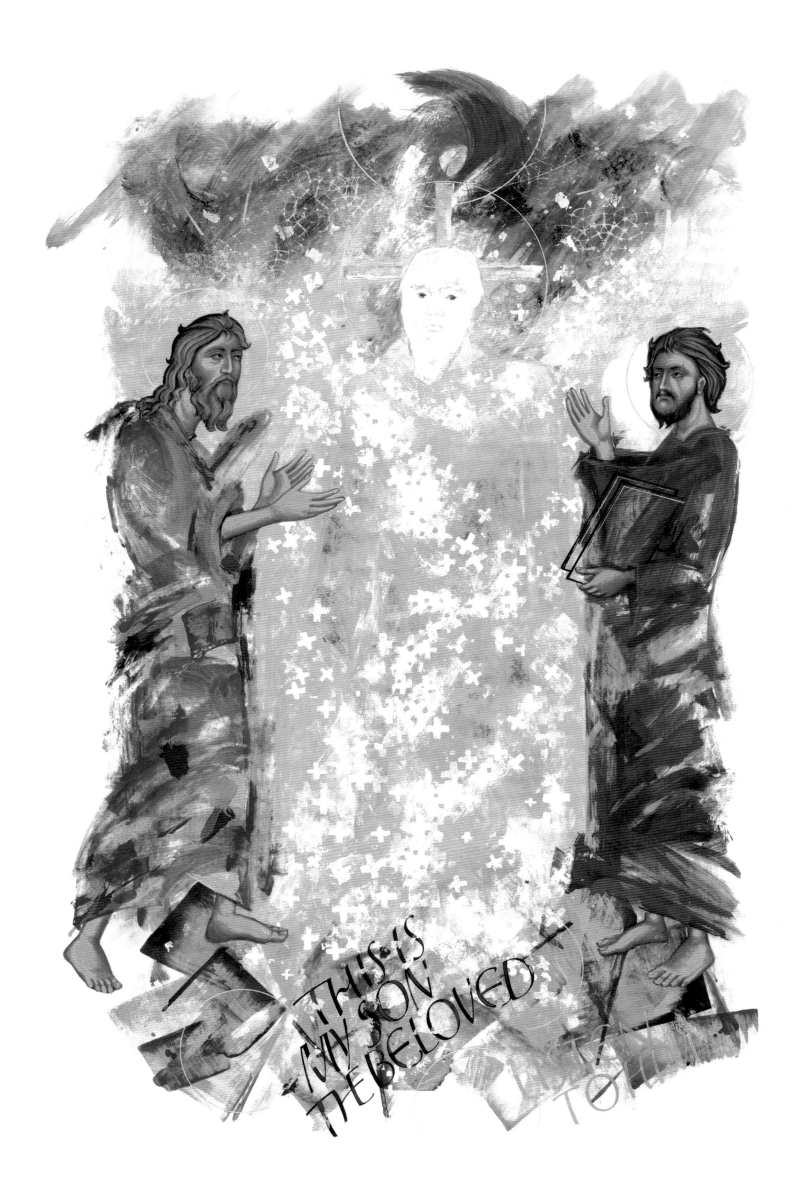

what he was saying and were afraid to ask him.
33 ¶ Then they came to Capernaum; and when he was in the house he asked them, "What were you arguing about on the way?" 34 But they were silent, for on the way they had argued with one another who was the greatest. 35 He sat down, called the twelve, and said to them, "Whoever wants to be first must be last of all and servant of all." 36 Then he took a little child and put it among them; and taking it in his arms, he said to them, 37 "Whoever welcomes one such child in my name welcomes me, and whoever welcomes me welcomes not me but the one who
38 sent me." ¶ John said to him, "Teacher, we saw someone casting out demons in your name, and we tried to stop him, because he was not following us." 39 But Jesus said, "Do not stop him; for no one who does a deed of power in my name will be able soon afterward to speak evil of me. 40 Whoever is not against us is for us. 41 For truly I tell you, whoever gives you a cup of water to drink because you bear the name of Christ will by no means lose the reward. 42 "If any of you put a stumbling block before one of these little ones who believe in me, it would be better for you if a great millstone were hung around your neck and you were thrown into the sea. 43 If your hand causes you to stumble, cut it off; it is better for you to enter life maimed than to have two hands and to go to hell, to the unquenchable fire. 45 And if your foot causes you to stumble, cut it off; it is better for you to enter life lame than to have two feet and to be thrown into hell. 47 And if your eye causes you to stumble, tear it out; it is better for you to enter the kingdom of God with one eye than to have two eyes and to be thrown into hell, 48 where their worm never dies, and the fire is never quenched.
49 ¶ "For everyone will be salted with fire. 50 Salt is good; but if salt has lost its saltiness, how can you season it? Have salt in yourselves, and be at peace with one another."

10

He left that place and went to the region of Judea and beyond the Jordan. And crowds again gathered around him; and,
2 as was his custom, he again taught them. ¶ Some Pharisees came, and to test him they asked, "Is it lawful for a man to divorce his wife?" 3 He answered them, "What did Moses command you?" 4 They said, "Moses allowed a man to write a certificate of dismissal and to divorce her." 5 But Jesus said to them, "Because of your hardness of heart he wrote this commandment for you. 6 But from the beginning of creation, 'God made them male & female.' 7 'For this reason a man shall leave his father and mother

& be joined to his wife, 8 and the two shall become one flesh.' So they are no longer two, but one flesh.
9 Therefore what God has joined together, let no
10 one separate." ¶ Then in the house the disciples asked him again about this matter. 11 He said to them, "Whoever divorces his wife and marries another commits adultery against her; 12 and if she divorces her husband and marries another, she commits adultery."
13 ¶ People were bringing little children to him in order that he might touch them; and the disciples spoke sternly to them. 14 But when Jesus saw this, he was indignant and said to them, "Let the little children come to me; do not stop them; for it is to such as these that the kingdom of God belongs. 15 Truly I tell you, whoever does not receive the kingdom of God as a little child will never enter it." 16 And he took them up in his arms, laid his hands on them,
17 and blessed them. ¶ As he was setting out on a journey, a man ran up and knelt before him, and asked him, "Good Teacher, what must I do to inherit eternal life?" 18 Jesus said to him, "Why do you call me good? No one is good but God alone. 19 You know the commandments: 'You shall not murder; You shall not commit adultery; You shall not steal; You shall not bear false witness; You shall not defraud; Honor your father and mother.'" 20 He said to him, "Teacher, I have kept all these since my youth."
21 Jesus, looking at him, loved him and said, "You lack one thing; go, sell what you own, and give the money to the poor, and you will have treasure in heaven; then come, follow me." 22 When he heard this, he was shocked and went away grieving, for
23 he had many possessions. ¶ Then Jesus looked around and said to his disciples, "How hard it will be for those who have wealth to enter the kingdom of God!" 24 And the disciples were perplexed at these words. But Jesus said to them again, "Children, how hard it is to enter the kingdom of God! 25 It is easier for a camel to go through the eye of a needle than for someone who is rich to enter the kingdom of God." 26 They were greatly astounded and said to one another, "Then who can be saved?" 27 Jesus looked at them and said, "For mortals it is impossible, but not for God; for God all things are possible."
28 ¶ Peter began to say to him, "Look, we have left everything and followed you." 29 Jesus said, "Truly I tell you, there is no one who has left house or brothers or sisters or mother or father or children or fields, for my sake & for the sake of the good news, 30 who will not receive a hundredfold now in this age — houses, brothers and sisters, mothers and children, and fields, with persecutions — and in the age to come eternal life. 31 But many who are first will be last, and the last will be first."

LISTEN
TO HIM

RSB
Mark 10:19

a Other ancient authorities add who does not follow us
b Other ancient authorities lack in me
c Gk Gehenna
d Verses 44 and 46 (which are identical with verse 48) are lacking in the best ancient authorities
e Gk Gehenna
f Verses 44 and 46 (which are identical with verse 48) are lacking in the best ancient authorities
g Gk Gehenna
h Other ancient authorities either add or substitute and every sacrifice will be salted with salt
i Or how can you restore its saltiness?
j Other ancient authorities lack and
k Other ancient authorities lack and be joined to his wife; Gk lacks the money
m Other ancient authorities add for those who trust in riches
n Other ancient authorities read to him
o Or gospel

32 ❡ They were on the road, going up to Jerusalem, & Jesus was walking ahead of them; they were amazed, and those who followed were afraid. He took the twelve aside again and began to tell them what was to happen to him, 33 saying, "See, we are going up to Jerusalem, and the Son of Man will be handed over to the chief priests and the scribes, and they will condemn him to death; then they will hand him over to the Gentiles; 34 they will mock him, & spit upon him, and flog him, and kill him; and after 35 three days he will rise again." ❡ James and John, the sons of Zebedee, came forward to him & said to him, "Teacher, we want you to do for us whatever we ask of you." 36 And he said to them, "What is it you want me to do for you?" 37 And they said to him, "Grant us to sit, one at your right hand and one at your left, in your glory." 38 But Jesus said to them, "You do not know what you are asking. Are you able to drink the cup that I drink, or be baptized with the baptism that I am baptized with?" 39 They replied, "We are able." Then Jesus said to them, "The cup that I drink you will drink; and with the baptism with which I am baptized, you will be baptized; 40 but to sit at my right hand or at my left is not mine to grant, but it is for those for whom it has been 41 prepared." ❡ When the ten heard this, they began to be angry with James and John. 42 So Jesus called them and said to them, "You know that among the Gentiles those whom they recognize as their rulers lord it over them, and their great ones are tyrants over them. 43 But it is not so among you; but whoever wishes to become great among you must be your servant, 44 and whoever wishes to be first among you must be slave of all. 45 For the Son of Man came not to be served but to serve, and to give his life a ransom for many."

46 ❡ They came to Jericho. As he and his disciples and a large crowd were leaving Jericho, Bartimaeus son of Timaeus, a blind beggar, was sitting by the roadside. 47 When he heard that it was Jesus of Nazareth, he began to shout out and say, "Jesus, Son of David, have mercy on me!" 48 Many sternly ordered him to be quiet, but he cried out even more loudly, "Son of David, have mercy on me!" 49 Jesus stood still and said, "Call him here." And they called the blind man, saying to him, "Take heart; get up, he is calling you." 50 So throwing off his cloak, he sprang up & came to Jesus. 51 Then Jesus said to him, "What do you want me to do for you?" The blind man said to him, "My teacher, let me see again." 52 Jesus said to him, "Go; your faith has made you well." Immediately he regained his sight and followed him on the way.

רב •

P Aramaic *Rabbouni* +
q Gk: *they*; other ancient authorities read *he*
r Other ancient authorities read "*If you have*

When they were approaching Jerusalem, at Bethphage and Bethany, near the Mount of Olives, he sent two of his disciples 2 and said to them, "Go into the village ahead of you, and immediately as you enter it, you will find tied there a colt that has never been ridden; untie it and bring it. 3 If anyone says to you, 'Why are you doing this?' just say this, 'The Lord needs it and will send it back here immediately.'" 4 They went away and found a colt tied near a door, outside in the street. As they were untying it, 5 some of the bystanders said to them, "What are you doing, untying the colt?" 6 They told them what Jesus had said; and they allowed them to take it. 7 Then they brought the colt to Jesus and threw their cloaks on it; and he sat on it. 8 Many people spread their cloaks on the road, and others spread leafy branches that they had cut in the fields. 9 Then those who went ahead and those who followed were shouting,

"Hosanna!

Blessed is the one who comes in the name of the Lord!

10 Blessed is the coming kingdom of our ancestor David!

Hosanna in the highest heaven!"

11 ❡ Then he entered Jerusalem and went into the temple; and when he had looked around at everything, as it was already late, he went out to Bethany 12 with the twelve. ❡ On the following day, when they came from Bethany, he was hungry. 13 Seeing in the distance a fig tree in leaf, he went to see whether perhaps he would find anything on it. When he came to it, he found nothing but leaves, for it was not the season for figs. 14 He said to it, "May no one ever eat fruit from you again." And his disciples heard it.

15 ❡ Then they came to Jerusalem. And he entered the temple and began to drive out those who were selling and those who were buying in the temple, and he overturned the tables of the money changers and the seats of those who sold doves; 16 and he would not allow anyone to carry anything through the temple. 17 He was teaching & saying, "Is it not written,

'My house shall be called a house of prayer for all the nations'?

But you have made it a den of robbers."

18 And when the chief priests & the scribes heard it, they kept looking for a way to kill him; for they were afraid of him, because the whole crowd was spellbound by his teaching. 19 And when evening came, Jesus and his disciples went out of the city.

20 ❡ In the morning as they passed by, they saw the fig tree withered away to its roots. 21 Then Peter remembered and said to him, "Rabbi, look! The fig tree that you cursed has withered." 22 Jesus answered them, "Have faith in God. 23 Truly I tell you, if you

say to this mountain, 'Be taken up and thrown into the sea,' and if you do not doubt in your heart, but believe that what you say will come to pass, it will be done for you. 24 So I tell you, whatever you ask for in prayer, believe that you have received it, and 25 it will be yours. ❡ "Whenever you stand praying, forgive, if you have anything against anyone; so that your Father in heaven may also forgive you your trespasses."

27 ❡ Again they came to Jerusalem. As he was walking in the temple, the chief priests, the scribes, and the elders came to him 28 and said, "By what authority are you doing these things? Who gave you this authority to do them?" 29 Jesus said to them, "I will ask you one question; answer me, and I will tell you by what authority I do these things. 30 Did the baptism of John come from heaven, or was it of human origin? Answer me." 31 They argued with one another, "If we say, 'From heaven,' he will say, 'Why then did you not believe him?' 32 But shall we say, 'Of human origin'?"— they were afraid of the crowd, for all regarded John as truly a prophet. 33 So they answered Jesus, "We do not know." And Jesus said to them, "Neither will I tell you by what authority I am doing these things."

12

Then he began to speak to them in parables. "A man planted a vineyard, put a fence around it, dug a pit for the wine press, and built a watchtower; then he leased it to tenants & went to another country. 2 When the season came, he sent a slave to the tenants to collect from them his share of the produce of the vineyard. 3 But they seized him, and beat him, and sent him away empty-handed. 4 And again he sent another slave to them; this one they beat over the head & insulted. 5 Then he sent another, and that one they killed.

And so it was with many others; some they beat, and others they killed. 6 He had still one other, a beloved son. Finally he sent him to them, saying, 'They will respect my son.' 7 But those tenants said to one another, 'This is the heir; come, let us kill him, and the inheritance will be ours.' 8 So they seized him, killed him, and threw him out of the vineyard. 9 What then will the owner of the vineyard do? He will come & destroy the tenants and give the vineyard to others. 10 Have you not read this scripture:

'The stone that the builders rejected
has become the cornerstone;

11 this was the Lord's doing,
and it is amazing in our eyes'?"

12 ❡ When they realized that he had told this parable against them, they wanted to arrest him, but they feared the crowd. So they left him and went away. 13 ❡ Then they sent to him some Pharisees and some Herodians to trap him in what he said. 14 And they came and said to him, "Teacher, we know that you are sincere, and show deference to no one; for you do not regard people with partiality, but teach the way of God in accordance with truth. Is it lawful to pay taxes to the emperor, or not? 15 Should we pay them, or should we not?" But knowing their hypocrisy, he said to them, "Why are you putting me to the test? Bring me a denarius and let me see it." 16 And they brought one. Then he said to them, "Whose head is this, and whose title?" They answered, "The emperor's." 17 Jesus said to them, "Give to the emperor the things that are the emperor's, and to God the things that are God's." And they were utterly amazed at him. ❡ 18 Some Sadducees, who say there is no resurrection, came to him and asked him a question, saying, 19 "Teacher, Moses wrote for us that if a man's brother dies, leaving a wife but no child, the man shall marry the widow and raise up children for his brother. 20 There were seven brothers; the first married and, when he died, left no children; 21 and the second married the widow and died, leaving no children; and the third likewise; 22 none of the seven left children. Last of all the woman herself died. 23 In the resurrection whose wife will she be? For the seven had married her." ❡ 24 Jesus said to them, "Is not this the reason you are wrong, that you know neither the scriptures nor the power of God? 25 For when they rise from the dead, they neither marry nor are given in marriage, but are like angels in heaven. 26 And as for the dead being raised, have you not read in the book of Moses, in the story about the bush, how God said to him, 'I am the God of Abraham, the God of Isaac, and the God of Jacob'? 27 He is God not of the dead, but of the living; you are quite wrong."

5 Other ancient authorities read are receiving

6 Other ancient authorities add verse 26, "But if you do not forgive, neither will your Father in heaven forgive your trespasses."

11 Or keystone

19 Gk his brother

22 Gk her

23 Other ancient authorities add when they rise

28 One of the scribes came near and heard them disputing with one another, and seeing that he answered them well, he asked him, "Which commandment is the first of all?"

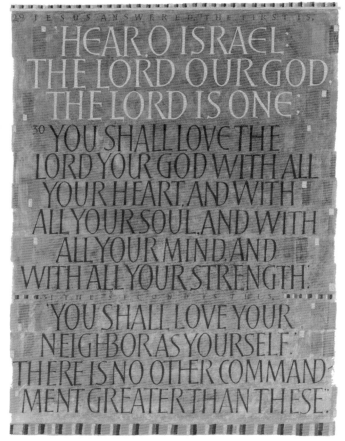

HEAR O ISRAEL:
THE LORD OUR GOD,
THE LORD IS ONE;

30 YOU SHALL LOVE THE
LORD YOUR GOD WITH ALL
YOUR HEART, AND WITH
ALL YOUR SOUL, AND WITH
ALL YOUR MIND, AND
WITH ALL YOUR STRENGTH.

YOU SHALL LOVE YOUR
NEIGHBOR AS YOURSELF.
THERE IS NO OTHER COMMAND-
MENT GREATER THAN THESE.

32 Then the scribe said to him, "You are right, Teacher; you have truly said that 'he is one, and besides him there is no other'; 33 and 'to love him with all the heart, and with all the understanding, and with all the strength,' and 'to love one's neighbor as oneself,'—this is much more important than all whole burnt offerings and sacrifices." 34 When Jesus saw that he answered wisely, he said to him, "You are not far from the kingdom of God." After that no one dared 35 to ask him any question. While Jesus was teaching in the temple, he said, "How can the scribes say that the Messiah is the son of David? 36 David himself, by the Holy Spirit, declared,

'The Lord said to my Lord,

"Sit at my right hand,

until I put your enemies under your feet."'

37 David himself calls him Lord; so how can he be his son?" And the large crowd was listening to him with 38 delight. As he taught, he said, "Beware of the scribes, who like to walk around in long robes, and to be greeted with respect in the marketplaces, 39 and to have the best seats in the synagogues and places of honor at banquets! 40 They devour widows' houses and for the sake of appearance say long prayers. 41 They will receive the greater condemnation." He

RSB
Mark 12:30-31

y Or the Christ
z Gk I am
A Gk gospel

sat down opposite the treasury, and watched the crowd putting money into the treasury. Many rich people put in large sums. 42 A poor widow came & put in two small copper coins, which are worth a penny. 43 Then he called his disciples and said to them, "Truly I tell you, this poor widow has put in more than all those who are contributing to the treasury. 44 For all of them have contributed out of their abundance; but she out of her poverty has put in everything she had, all she had to live on."

13

As he came out of the temple, one of his disciples said to him, "Look, Teacher, what large stones and what large buildings!" 2 Then Jesus asked him, "Do you see these great buildings? Not one stone will be left here upon another; all will be thrown down." 3 When he was sitting on the Mount of Olives opposite the temple, Peter, James, John, and Andrew asked him privately, 4 "Tell us, when will this be, and what will be the sign that all these things are about to be accomplished?" 5 Then Jesus began to say to them, "Beware that no one leads you astray. 6 Many will come in my name and say, 'I am he!' and they will lead many astray. 7 When you hear of wars and rumors of wars, do not be alarmed; this must take place, but the end is still to come. 8 For nation will rise against nation, and kingdom against kingdom; there will be earthquakes in various places; there will be famines. This 9 is but the beginning of the birth pangs. "As for yourselves, beware; for they will hand you over to councils; and you will be beaten in synagogues; and you will stand before governors and kings because of me, as a testimony to them. 10 And the good news must first be proclaimed to all nations. 11 When they bring you to trial and hand you over, do not worry beforehand about what you are to say; but say whatever is given you at that time, for it is not you who speak, but the Holy Spirit. 12 Brother will betray brother to death, and a father his child, and children will rise against parents & have them put to death; 13 and you will be hated by all because of my name. But the one who endures to the end will be saved. 14 "But when you see the desolating sacrilege set up where it ought not to be [let the reader understand], then those in Judea must flee to the mountains; 15 the one on the housetop must not go down or enter the house to take anything away; 16 the one in the field must not turn back to get a coat! 17 Woe to those who are pregnant & to those who are nursing infants in those days! 18 Pray that it may not be in winter. 19 For in those days there will be suffering,

such as has not been from the beginning of the creation that God created until now, no, and never will be. [20] And if the Lord had not cut short those days, no one would be saved; but for the sake of the elect, whom he chose, he has cut short those days. [21] And if anyone says to you at that time, 'Look! Here is the Messiah!' or 'Look! There he is!'—do not believe it. [22] False messiahs and false prophets will appear and produce signs and omens, to lead astray, if possible, the elect. [23] But be alert; I have already told you everything. ❡ "But in those days, after that suffering,

[24] the sun will be darkened,
　　and the moon will not give its light,
[25] and the stars will be falling from heaven,
　　and the powers in the heavens will be shaken.

[26] Then they will see 'the Son of Man coming in clouds' with great power and glory. [27] Then he will send out the angels, and gather his elect from the four winds, from the ends of the earth to the ends of heaven. ❡ "From the fig tree learn its lesson: as [28] soon as its branch becomes tender and puts forth its leaves, you know that summer is near. [29] So also, when you see these things taking place, you know that he is near, at the very gates. [30] Truly I tell you, this generation will not pass away until all these things have taken place. [31] Heaven and earth will [32] pass away, but my words will not pass away. ❡ "But about that day or hour no one knows, neither the angels in heaven, nor the Son, but only the Father. [33] Beware, keep alert; for you do not know when the time will come. [34] It is like a man going on a journey, when he leaves home & puts his slaves in charge, each with his work, and commands the doorkeeper to be on the watch. [35] Therefore, keep awake – for you do not know when the master of the house will come, in the evening, or at midnight, or at cockcrow, or at dawn, [36] or else he may find you asleep when he comes suddenly. [37] And what I say to you I say to all: Keep awake."

14

It was two days before the Passover & the festival of Unleavened Bread. The chief priests & the scribes were looking for a way to arrest Jesus by stealth and kill him; [2] for they said, "Not during the festival, or there may be a riot among the people." [3] ❡ While he was at Bethany in the house of Simon the leper, as he sat at the table, a woman came with an alabaster jar of very costly ointment of nard, and she broke open the jar and poured the ointment on his head. [4] But some were there who said to one another in anger, "Why was the ointment wasted in this way? [5] For this ointment could have been sold for more than three hundred denarii, and the money

given to the poor." And they scolded her. [6] But Jesus said, "Let her alone; why do you trouble her? She has performed a good service for me. [7] For you always have the poor with you, and you can show kindness to them whenever you wish; but you will not always have me. [8] She has done what she could; she has anointed my body beforehand for its burial. [9] Truly I tell you, wherever the good news is proclaimed in the whole world, what she has done will be told in [10] remembrance of her." ❡ Then Judas Iscariot, who was one of the twelve, went to the chief priests in order to betray him to them. [11] When they heard it, they were greatly pleased, and promised to give him money. So he began to look for an opportunity [12] to betray him. ❡ On the first day of Unleavened Bread, when the Passover lamb is sacrificed, his disciples said to him, "Where do you want us to go & make the preparations for you to eat the Passover?" [13] So he sent two of his disciples, saying to them, "Go into the city, and a man carrying a jar of water will meet you; follow him, [14] and wherever he enters, say to the owner of the house, 'The Teacher asks, Where is my guest room where I may eat the Passover with my disciples?' [15] He will show you a large room upstairs, furnished & ready. Make preparations for us there." [16] So the disciples set out and went to the city, and found everything as he had told them; [17] and they prepared the Passover meal. ❡ When it was evening, he came with the twelve. [18] And when they had taken their places and were eating, Jesus said, "Truly I tell you, one of you will betray me, one who is eating with me." [19] They began to be distressed and to say to him one after another, "Surely, not I?" [20] He said to them, "It is one of the twelve, one who is dipping bread into the bowl with me. [21] For the Son of Man goes as it is written of him, but woe to that one by whom the Son of Man is betrayed! It would have been better for that one not to have been [22] born." ❡ While they were eating, he took a loaf of bread, and after blessing it he broke it, gave it to them, and said, "Take; this is my body." [23] Then he took a cup, and after giving thanks he gave it to them, and all of them drank from it. [24] He said to them, "This is my blood of the covenant, which is poured out for many. [25] Truly I tell you, I will never again drink of the fruit of the vine until that day when I [26] drink it new in the kingdom of God." ❡ When they had sung the hymn, they went out to the Mount of Olives. [27] And Jesus said to them, "You will all become deserters; for it is written,

'I will strike the shepherd,
　and the sheep will be scattered.'

[28] But after I am raised up, I will go before you to Galilee." [29] Peter said to him, "Even though all become

b Or the Christ
c Or christs
d Or it
e Other ancient authorities add and pray
f Gk him
g The terms leper and leprosy can refer to several diseases
h The denarius was the usual day's wage for a laborer
i Or gospel
j Gk lacks bread
k Other ancient authorities read same bowl
l Other ancient authorities add new

deserters, I will not." ³⁰Jesus said to him, "Truly I tell you, this day, this very night, before the cock crows twice, you will deny me three times." ³¹But he said vehemently, "Even though I must die with you, I will not deny you." And all of them said the same.

32 ¶ They went to a place called Gethsemane; and he said to his disciples, "Sit here while I pray." ³³He took with him Peter and James and John, and began to be distressed and agitated. ³⁴And he said to them, "I am deeply grieved, even to death; remain here, and keep awake." ³⁵And going a little farther, he threw himself on the ground and prayed that, if it were possible, the hour might pass from him. ³⁶He said, "Abba, Father, for you all things are possible; remove this cup from me; yet, not what I want, but what you want." ³⁷He came and found them sleeping; and he said to Peter, "Simon, are you asleep? Could you not keep awake one hour? ³⁸Keep awake and pray that you may not come into the time of trial; the spirit indeed is willing, but the flesh is weak." ³⁹And again he went away and prayed, saying the same words. ⁴⁰And once more he came and found them sleeping, for their eyes were very heavy; and they did not know what to say to him. ⁴¹He came a third time and said to them, "Are you still sleeping and taking your rest? Enough! The hour has come; the Son of Man is betrayed into the hands of sinners. ⁴²Get up, let us be going. See, my betrayer is at hand."

43 ¶ Immediately, while he was still speaking, Judas, one of the twelve, arrived; and with him there was a crowd with swords and clubs, from the chief priests, the scribes, and the elders. ⁴⁴Now the betrayer had given them a sign, saying, "The one I will kiss is the man; arrest him and lead him away under guard." ⁴⁵So when he came, he went up to him at once and said, "Rabbi!" and kissed him. ⁴⁶Then they laid hands on him and arrested him. ⁴⁷But one of those who stood near drew his sword and struck the slave of the high priest, cutting off his ear. ⁴⁸Then Jesus said to them, "Have you come out with swords & clubs to arrest me as though I were a bandit? ⁴⁹Day after day I was with you in the temple teaching, and you did not arrest me. But let the scriptures be fulfilled."

51 ⁵⁰All of them deserted him and fled. ¶ A certain young man was following him, wearing nothing but a linen cloth. They caught hold of him, ⁵²but he left the linen cloth and ran off naked. ¶ They took Jesus 53 to the high priest; and all the chief priests, the elders, and the scribes were assembled. ⁵⁴Peter had followed him at a distance, right into the courtyard of the high priest; and he was sitting with the guards, warming himself at the fire. ⁵⁵Now the chief priests and the whole council were looking for testimony against Jesus to put him to death; but they found

אַבָּא·

ᵐAramaic for Father
ⁿ Or into temptation
ᵒ Or the Christ
ᵖ Or gateway
ᵠ Other ancient authorities
lack Then the cock
crowed

none. ⁵⁶For many gave false testimony against him, and their testimony did not agree. ⁵⁷Some stood up & gave false testimony against him, saying, ⁵⁸"We heard him say, 'I will destroy this temple that is made with hands, and in three days I will build another, not made with hands.'" ⁵⁹But even on this point their testimony did not agree. ⁶⁰Then the high priest stood up before them and asked Jesus, "Have you no answer? What is it that they testify against you?" ⁶¹But he was silent and did not answer. Again the high priest asked him, "Are you the Messiah, the Son of the Blessed One?" ⁶²Jesus said, "I am; and

> 'you will see the Son of Man
> seated at the right hand of the Power,'
> and 'coming with the clouds of heaven.'"

⁶³Then the high priest tore his clothes & said, "Why do we still need witnesses? ⁶⁴You have heard his blasphemy! What is your decision?" All of them condemned him as deserving death. ⁶⁵Some began to spit on him, to blindfold him, and to strike him, saying to him, "Prophesy!" The guards also took him 66 over and beat him. ¶ While Peter was below in the courtyard, one of the servant-girls of the high priest came by. ⁶⁷When she saw Peter warming himself, she stared at him and said, "You also were with Jesus, the man from Nazareth." ⁶⁸But he denied it, saying, "I do not know or understand what you are talking about." And he went out into the forecourt. Then the cock crowed. ⁶⁹And the servant-girl, on seeing him, began again to say to the bystanders, "This man is one of them." ⁷⁰But again he denied it. Then after a little while the bystanders again said to Peter, "Certainly you are one of them; for you are a Galilean." ⁷¹But he began to curse, and he swore an oath, "I do not know this man you are talking about." ⁷²At that moment the cock crowed for the second time. Then Peter remembered that Jesus had said to him, "Before the cock crows twice, you will deny me three times." And he broke down and wept.

15

As soon as it was morning, the chief priests held a consultation with the elders and scribes and the whole council. They bound Jesus, led him away, and handed him over to Pilate. ²Pilate asked him, "Are you the King of the Jews?" He answered him, "You say so." ³Then the chief priests accused him of many things. ⁴Pilate asked him again, "Have you no answer? See how many charges they bring against you." ⁵But Jesus made no further reply, so that Pilate was amazed. ¶ Now at the festival he 6 used to release a prisoner for them, anyone for whom they asked. ⁷Now a man called Barabbas was in

prison with the rebels who had committed murder during the insurrection. 8 So the crowd came and began to ask Pilate to do for them according to his custom. 9 Then he answered them, "Do you want me to release for you the King of the Jews?" 10 For he realized that it was out of jealousy that the chief priests had handed him over. 11 But the chief priests stirred up the crowd to have him release Barabbas for them instead. 12 Pilate spoke to them again, "Then what do you wish me to do with the man you call the King of the Jews?" 13 They shouted back, "Crucify him!" 14 Pilate asked them, "Why, what evil has he done?" But they shouted all the more, "Crucify him!" 15 So Pilate, wishing to satisfy the crowd, released Barabbas for them; and after flogging Jesus, he hand-

16 ed him over to be crucified. ¶ Then the soldiers led him into the courtyard of the palace [that is, the governor's headquarters]; and they called together the whole cohort. 17 And they clothed him in a purple cloak; and after twisting some thorns into a crown, they put it on him. 18 And they began saluting him, "Hail, King of the Jews!" 19 They struck his head with a reed, spat upon him, and knelt down in homage to him. 20 After mocking him, they stripped him of the purple cloak and put his own clothes on him.

21 Then they led him out to crucify him. ¶ They compelled a passer-by, who was coming in from the country, to carry his cross; it was Simon of Cyrene, the father of Alexander and Rufus. 22 Then they brought Jesus to the place called Golgotha [which means the place of a skull]. 23 And they offered him wine mixed with myrrh; but he did not take it. 24 And they crucified him, and divided his clothes among them, casting lots to decide what each should take.

25 ¶ It was nine o'clock in the morning when they crucified him. 26 The inscription of the charge against him read, "The King of the Jews." 27 And with him they crucified two bandits, one on his right & one on his left. 29 Those who passed by derided him, shaking their heads and saying, "Aha! You who would destroy the temple & build it in three days, 30 save yourself, and come down from the cross!" 31 In the same way the chief priests, along with the scribes, were also mocking him among themselves and saying, "He saved others; he cannot save himself. 32 Let the Messiah, the King of Israel, come down from the cross now, so that we may see & believe." Those who were crucified with him also taunted him.

33 ¶ When it was noon, darkness came over the whole land until three in the afternoon. 34 At three o'clock Jesus cried out with a loud voice, "Eloi, Eloi, lema sabachthani?" which means, "My God, my God, why have you forsaken me?" 35 When some of the bystanders heard it, they said, "Listen, he is calling for Elijah."

36 And someone ran, filled a sponge with sour wine, put it on a stick, and gave it to him to drink, saying, "Wait, let us see whether Elijah will come to take him down." 37 Then Jesus gave a loud cry & breathed his last. 38 And the curtain of the temple was torn in two, from top to bottom. 39 Now when the centurion, who stood facing him, saw that in this way he breathed his last, he said, "Truly this man was

40 God's Son!" ¶ There were also women looking on from a distance; among them were Mary Magdalene, and Mary the mother of James the younger & of Joses, and Salome. 41 These used to follow him and provided for him when he was in Galilee; and there were many other women who had come up

42 with him to Jerusalem. ¶ When evening had come, and since it was the day of Preparation, that is, the day before the sabbath, 43 Joseph of Arimathea, a respected member of the council, who was also himself waiting expectantly for the kingdom of God, went boldly to Pilate and asked for the body of Jesus. 44 Then Pilate wondered if he were already dead; and summoning the centurion, he asked him whether he had been dead for some time. 45 When he learned from the centurion that he was dead, he granted the body to Joseph. 46 Then Joseph bought a linen cloth, and taking down the body, wrapped it in the linen cloth, and laid it in a tomb that had been hewn out of the rock. He then rolled a stone against the door of the tomb. 47 Mary Magdalene and Mary the mother of Joses saw where the body was laid.

16

When the sabbath was over, Mary Magdalene, and Mary the mother of James, and Salome bought spices, so that they might go and anoint him. 2 And very early on the first day of the week, when the sun had risen, they went to the tomb. 3 They had been saying to one another, "Who will roll away the stone for us from the entrance to the tomb?" 4 When they looked up, they saw that the stone, which was very large, had already been rolled back. 5 As they entered the tomb, they saw a young man, dressed in a white robe, sitting on the right side; and they were alarmed. 6 But he said to them, "Do not be alarmed; you are looking for Jesus of Nazareth, who was crucified. He has been raised; he is not here. Look, there is the place they laid him. 7 But go, tell his disciples and Peter that he is going ahead of you to Galilee; there you will see him, just as he told you." 8 So they went out and fled from the tomb, for terror and amazement had seized them; and they said nothing to anyone, for they were afraid.

אֵלִי אֵלִי
לָמָה שְׁבַקְתַּנִי

t Other Ancient Authorities read what should I do

u Other Ancient Authorities lack the man you call

v Gk the praetorium

w Gk him

x Other Ancient Authorities add verse 28, And the scripture was fulfilled that says, "And he was counted among the lawless."

y Or blasphemed

x Or the Christ

y Or earth

z Other Ancient Authorities read made me a reproach

a Other Ancient Authorities add cried out and

b Or a son of God

c Gk he

d Gk it

e Gk it

f Some of the most ancient authorities bring the book to a close at the end of verse 8. One authority concludes the book with the shorter ending; others include the shorter ending and then continue with verses 9–20. In most authorities verses 9–20 follow immediately after verse 8, though in some of these authorities the passage is marked as being doubtful.

THE
SHORTER ENDING
OF MARK

[[And all that had been commanded them they
told briefly to those around Peter. And afterward
Jesus himself sent out through them, from east to
west, the sacred and imperishable proclamation of
eternal salvation[g].]]

THE
LONGER ENDING
OF MARK

9 [[Now after he rose early on the first day of the
week, he appeared first to Mary Magdalene, from
whom he had cast out seven demons. [10] She went out
and told those who had been with him, while they
were mourning and weeping. [11] But when they heard
that he was alive & had been seen by her, they would
not believe it. After this he appeared in another
form to two of them, as they were walking into the
country. [13] And they went back & told the rest, but
they did not believe them. Later he appeared to
the eleven themselves as they were sitting at the ta
ble; and he upbraided them for their lack of faith
and stubbornness, because they had not believed
those who saw him after he had risen. [15] And he said
to them, "Go into all the world & proclaim the good
news[i] to the whole creation. [16] The one who believes
and is baptized will be saved; but the one who does
not believe will be condemned. [17] And these signs
will accompany those who believe: by using my name
they will cast out demons; they will speak in new
tongues; [18] they will pick up snakes in their hands[j],
and if they drink any deadly thing, it will not hurt
them; they will lay their hands on the sick, and they
will recover." So then the Lord Jesus, after he had
spoken to them, was taken up into heaven and sat
down at the right hand of God. [20] And they went out
and proclaimed the good news everywhere, while
the Lord worked with them & confirmed the mes
sage by the signs that accompanied it[k].]]

[g] Other ancient authorities
add *Amen*
[h] Other ancient authorities
add, in whole or in part,
*And they excused
themselves, saying, "This
age of lawlessness and
unbelief is under Satan,
who does not allow the
truth and power of God to
prevail over the unclean
things of the spirits.
Therefore reveal your
righteousness now"—thus
they spoke to Christ. And
Christ replied to them,
"The term of years of
Satan's power has been
fulfilled, but other terrible
things draw near. And for
those who have sinned I
was handed over to death,
that they may return to the
truth and sin no more, that
they may inherit the
spiritual and imperishable
glory of righteousness
that is in heaven."*
[i] Or *gospel*
[j] Other ancient authorities
lack *in their hands*
[k] Other ancient authorities
add *Amen*

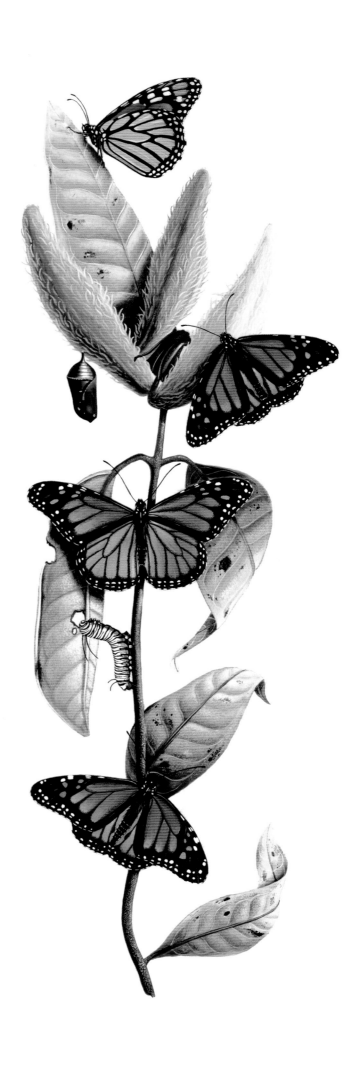

GLORY·TO·GOD
·IN·THE·
·HIGHEST·
HEAVEN

AND·ON·EARTH
·PEACE·AMONG·
·THOSE·WHOM·
·HE·FAVORS!

to give light
to those
who sit in darkness
and in
the shadow
of death

BY THE TENDER MERCY OF
OUR GOD, THE DAWN FROM ON
HIGH WILL BREAK UPON US

The Gospel According to Luke

Since many have undertaken to set down an orderly account of the events that have been fulfilled among us, [2] just as they were handed on to us by those who from the beginning were eye witnesses and servants of the word, [3] I too decided, after investigating everything carefully from the very first, to write an orderly account for you, most excellent Theophilus, [4] so that you may know the truth concerning the things about which you have been instructed.

[5] In the days of King Herod of Judea, there was a priest named Zechariah, who belonged to the priestly order of Abijah. His wife was a descendant of Aaron, and her name was Elizabeth. [6] Both of them were righteous before God, living blamelessly according to all the commandments and regulations of the Lord. [7] But they had no children, because Elizabeth was barren, and both were getting on in years.

[8] Once when he was serving as priest before God and his section was on duty, [9] he was chosen by lot, according to the custom of the priesthood, to enter the sanctuary of the Lord & offer incense. [10] Now at the time of the incense offering, the whole assembly of the people was praying outside. [11] Then there appeared to him an angel of the Lord, standing at the right side of the altar of incense. [12] When Zechariah saw him, he was terrified; and fear overwhelmed him. [13] But the angel said to him, "Do not be afraid, Zechariah, for your prayer has been heard. Your wife Elizabeth will bear you a son, and you will name him John. [14] You will have joy and gladness, and many will rejoice at his birth, [15] for he will be great in the sight of the Lord. He must never drink wine or strong drink; even before his birth he will be filled with the Holy Spirit. [16] He will turn many of the people of Israel to the Lord their God. [17] With the spirit and power of Elijah he will go before him, to turn the hearts of parents to their children, and the disobedient to the wisdom of the righteous, to make ready a people prepared for the Lord." [18] Zechariah said to the angel, "How will I know that this is so? For I am an old man, and my wife is getting on in years." [19] The angel replied, "I am Gabriel. I stand in the presence of God, and I have been sent to speak to you and to bring you this good news. [20] But now, because you did not believe my words,

which will be fulfilled in their time, you will become mute, unable to speak, until the day these things occur." [21] Meanwhile the people were waiting for Zechariah, and wondered at his delay in the sanctuary. [22] When he did come out, he could not speak to them, and they realized that he had seen a vision in the sanctuary. He kept motioning to them and remained unable to speak. [23] When his time of service was ended, he went to his home.

[24] After those days his wife Elizabeth conceived, and for five months she remained in seclusion. She said, [25] "This is what the Lord has done for me when he looked favorably on me and took away the disgrace I have endured among my people." [26] In the sixth month the angel Gabriel was sent by God to a town in Galilee called Nazareth, [27] to a virgin engaged to a man whose name was Joseph, of the house of David. The virgin's name was Mary. [28] And he came to her and said, "Greetings, favored one! The Lord is with you." [29] But she was much perplexed by his words and pondered what sort of greeting this might be. [30] The angel said to her, "Do not be afraid, Mary, for you have found favor with God. [31] And now, you will conceive in your womb and bear a son, and you will name him Jesus. [32] He will be great, and will be called the Son of the Most High, and the Lord God will give to him the throne of his ancestor David. [33] He will reign over the house of Jacob forever, and of his kingdom there will be no end." [34] Mary said to the angel, "How can this be, since I am a virgin?" [35] The angel said to her, "The Holy Spirit will come upon you, and the power of the Most High will overshadow you; therefore the child to be born will be holy; he will be called Son of God. [36] And now, your relative Elizabeth in her old age has also conceived a son; and this is the sixth month for her who was said to be barren. [37] For nothing will be impossible with God." [38] Then Mary said, "Here am I, the servant of the Lord; let it be with me according to your word." Then the angel departed from her. [39] In those days Mary set out and went with haste to a Judean town in the hill country, [40] where she entered the house of Zechariah & greeted Elizabeth. [41] When Elizabeth heard Mary's greeting, the child leaped in her womb. And Elizabeth was filled with the Holy Spirit [42] and exclaimed with a loud cry, "Blessed are you among women, and blessed is the fruit of your womb. [43] And why has this happened to me, that the mother of my Lord comes to me? [44] For as soon as I heard the sound of your greeting, the child in my womb leaped for joy. [45] And blessed is she who believed that there would be a fulfillment of what was spoken to her by the Lord."

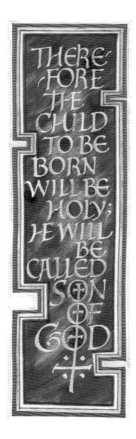

THEREFORE THE CHILD TO BE BORN WILL BE HOLY; HE WILL BE CALLED SON OF GOD

[a] Or for a long time
[b] Other ancient authorities add Blessed are you among women
[c] Gk I do not know a man
[d] Other ancient authorities add of you
[e] Or believed, for there will be.

46 ❡ AND MARY SAID,

"My soul magnifies the Lord,
and my spirit rejoices in God my Savior,
48 for he has looked with favor
on the lowliness of his servant.
Surely, from now on all generations
will call me blessed;
49 for the Mighty One has done
great things for me,
and holy is his name.
50 His mercy is for those who fear him
from generation to generation.
51 He has shown strength with his arm;
he has scattered the proud
in the thoughts of their hearts.
52 He has brought down the
powerful from their thrones,
and lifted up the lowly;
53 he has filled the hungry with good things,
and sent the rich away empty.
54 He has helped his servant Israel,
in remembrance of his mercy,
55 according to the promise he
made to our ancestors,
to Abraham & to his descendants forever."

56 ❡ And Mary remained with her about three months and then returned to her home. ❡ 57 Now the time came for Elizabeth to give birth, and she bore a son. 58 Her neighbors and relatives heard that the Lord had shown his great mercy to her, and they rejoiced with her. ❡ 59 On the eighth day they came to circumcise the child, and they were going to name him Zechariah after his father. 60 But his mother said, "No; he is to be called John." 61 They said to her, "None of your relatives has this name." 62 Then they began motioning to his father to find out what name he wanted to give him. 63 He asked for a writing tablet & wrote, "His name is John." And all of them were amazed. 64 Immediately his mouth was opened & his tongue freed, and he began to speak, praising God. 65 Fear came over all their neighbors, and all these things were talked about throughout the entire hill country of Judea. 66 All who heard them pondered them & said, "What then will this child become?" For, indeed, the hand of the Lord was with him. ❡ 67 Then his father Zechariah was filled with the Holy Spirit and spoke this prophecy:

68 "Blessed be the Lord God of Israel,
for he has looked favorably
on his people and redeemed them.
69 He has raised up a mighty savior for us
in the house of his servant David,
70 as he spoke through the mouth
of his holy prophets from of old,
71 that we would be saved from our
enemies and from the hand
of all who hate us.
72 Thus he has shown the mercy
promised to our ancestors,
& has remembered his holy covenant,
73 the oath that he swore

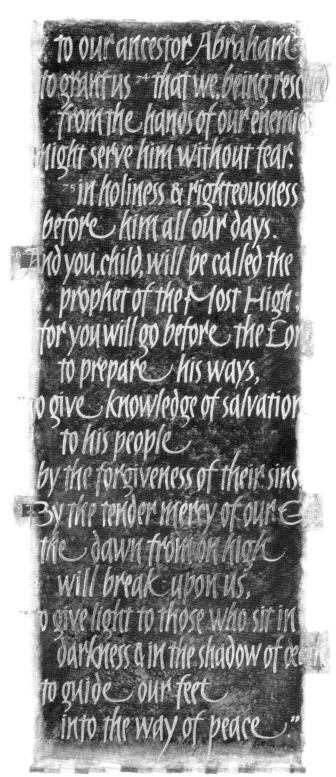

to our ancestor Abraham,
to grant us ²⁴ that we, being rescu[ed]
from the hands of our enemies
might serve him without fear, ⁷⁵ in holiness & righteousness
before him all our days.
⁷⁶ And you, child, will be called the
prophet of the Most High,
for you will go before the Lor[d]
to prepare his ways,
⁷⁷ to give knowledge of salvation
to his people
by the forgiveness of their sins.
⁷⁸ By the tender mercy of our G[od]
the dawn from on high
will break upon us,
⁷⁹ to give light to those who sit in
darkness & in the shadow of dea[th]
to guide our feet
into the way of peace."

⁸⁰ ❡ The child grew and became strong in spirit, and he was in the wilderness until the day he appeared publicly to Israel.

2

I n those days a decree went out from Emperor Augustus that all the world should be registered. ² This was the first registration and was taken while Quirinius was governor of Syria. ³ All went to their own towns to be registered. ⁴ Joseph also went from the town of Nazareth in Galilee to Judea, to the city of David called Bethlehem, because he

was descended from the house and family of David. ⁵ He went to be registered with Mary, to whom he was engaged and who was expecting a child. ⁶ While they were there, the time came for her to deliver her child. ⁷ And she gave birth to her firstborn son and wrapped him in bands of cloth, and laid him in a manger, because there was no place for them in the inn. ⁸ ❡ In that region there were shepherds living in the fields, keeping watch over their flock by night. ⁹ Then an angel of the Lord stood before them, and the glory of the Lord shone around them, and they were terrified. ¹⁰ But the angel said to them, "Do not be afraid; for see — I am bringing you good news of great joy for all the people: ¹¹ to you is born this day in the city of David a Savior, who is the Messiah, the Lord. ¹² This will be a sign for you: you will find a child wrapped in bands of cloth and lying in a manger." ¹³ And suddenly there was with the angel a multitude of the heavenly host, praising God & saying,

¹⁴ "GLORY TO GOD IN THE HIGHEST HEAVEN & ON EARTH PEACE AMONG THOSE WHOM HE FAVORS!"

¹⁵ ❡ When the angels had left them & gone into heaven, the shepherds said to one another, "Let us go now to Bethlehem and see this thing that has taken place, which the Lord has made known to us." ¹⁶ So they went with haste and found Mary and Joseph, and the child lying in the manger. ¹⁷ When they saw this, they made known what had been told them about this child; ¹⁸ and all who heard it were amazed at what the shepherds told them. ¹⁹ But Mary treasured all these words and pondered them in her heart. ²⁰ The shepherds returned, glorifying and praising God for all they had heard and seen, as it had been told them. ²¹ ❡ After eight days had passed, it was time to circumcise the child; and he was called Jesus, the name given by the angel before he was conceived in the womb. ²² ❡ When the time came for their purification according to the law of Moses, they brought him up to Jerusalem to present him to the Lord ²³ [as it is written in the law of the Lord, "Every firstborn male shall be designated as holy to the Lord"], ²⁴ and they offered a sacrifice according to what is stated in the law of the Lord, "a pair of turtledoves or two young pigeons." ❡ ²⁵ Now there was a man in Jerusalem whose name was Simeon; this man was righteous and devout, looking forward to the consolation of Israel, and the Holy Spirit

f Other ancient authorities read Elizabeth
g Gk a horn of salvation
h Other ancient authorities read has broken upon
i Or the Christ
j Gk army
k Other ancient authorities read peace, goodwill among people
l Gk Symeon

rested on him. [26] It had been revealed to him by the Holy Spirit that he would not see death before he had seen the Lord's Messiah. [27] Guided by the Spirit, Simeon came into the temple; and when the parents brought in the child Jesus, to do for him what was customary under the law, [28] Simeon took him in his arms and praised God, saying,

"MASTER, NOW YOU ARE DISMISSING YOUR SERVANT IN PEACE, ACCORDING TO YOUR WORD; FOR MY EYES HAVE SEEN YOUR SALVATION, WHICH YOU HAVE PREPARED IN THE PRESENCE OF ALL PEOPLES, A LIGHT FOR REVELATION TO THE GENTILES AND FOR GLORY TO YOUR PEOPLE ISRAEL."

[33] ■ And the child's father & mother were amazed at what was being said about him. [34] Then Simeon blessed them and said to his mother Mary, "This child is destined for the falling & the rising of many in Israel, and to be a sign that will be opposed [35] so that the inner thoughts of many will be revealed — and a sword will pierce your own soul too." ■ There [36] was also a prophet, Anna the daughter of Phanuel, of the tribe of Asher. She was of a great age, having lived with her husband seven years after her marriage, [37] then as a widow to the age of eighty four. She never left the temple but worshiped there with fasting and prayer night & day. [38] At that moment she came, and began to praise God and to speak about the child to all who were looking for the redemption of Jerusalem. ■ When they had finished [39] everything required by the law of the Lord, they returned to Galilee, to their own town of Nazareth. [40] The child grew and became strong, filled with wisdom; and the favor of God was upon him. ■ Now [41] every year his parents went to Jerusalem for the festival of the Passover. [42] And when he was twelve years old, they went up as usual for the festival. [43] When the festival was ended and they started to return, the boy Jesus stayed behind in Jerusalem, but his parents did not know it. [44] Assuming that

m Or the Lord's Christ
n Gk In the Spirit, he
o Gk he
p Gk slave
q Gk Symeon
r Gk Hanna
s Gk him
t Gk they
u Or be about my Father's interests?
v Or in stature
w Gk tetrarch
x Gk tetrarch
y Gk tetrarch

he was in the group of travelers, they went a day's journey. Then they started to look for him among their relatives and friends. [45] When they did not find him, they returned to Jerusalem to search for him. [46] After three days they found him in the temple, sitting among the teachers, listening to them and asking them questions. [47] And all who heard him were amazed at his understanding & his answers. [48] When his parents saw him they were astonished; and his mother said to him, "Child, why have you treated us like this? Look, your father & I have been searching for you in great anxiety." [49] He said to them, "Why were you searching for me? Did you not know that I must be in my Father's house?" [50] But they did not understand what he said to them. [51] Then he went down with them & came to Nazareth, and was obedient to them. His mother treasured all [52] these things in her heart. ■ And Jesus increased in wisdom & in years, and in divine & human favor.

3

In the fifteenth year of the reign of Emperor Tiberius, when Pontius Pilate was governor of Judea, and Herod was ruler of Galilee, and his brother Philip ruler of the region of Ituraea & Trachonitis, and Lysanias ruler of Abilene, [2] during the high priesthood of Annas and Caiaphas, the word of God came to John son of Zechariah in the wilderness. [3] He went into all the region around the Jordan, proclaiming a baptism of repentance for the forgiveness of sins, [4] as it is written in the book of the words of the prophet Isaiah,

"The voice of one crying out in the wilderness:
 'Prepare the way of the Lord,
 make his paths straight.'
[5] Every valley shall be filled,
 and every mountain and hill shall be made low,
 and the crooked shall be made straight,
 and the rough ways made smooth;
[6] and all flesh shall see the salvation of God.'"

[7] ■ John said to the crowds that came out to be baptized by him, "You brood of vipers! Who warned you to flee from the wrath to come? [8] Bear fruits worthy of repentance. Do not begin to say to yourselves, 'We have Abraham as our ancestor'; for I tell you, God is able from these stones to raise up children to Abraham. [9] Even now the ax is lying at the root of the trees; every tree therefore that does not bear good fruit is cut down and thrown into the fire." [10] ■ And the crowds asked him, "What then should we do?" [11] In reply he said to them, "Whoever has two coats must share with anyone who has none; and whoever has food must do likewise." [12] Even

tax collectors came to be baptized, and they asked him, "Teacher, what should we do?" [13] He said to them, "Collect no more than the amount prescribed for you." [14] Soldiers also asked him, "And we, what should we do?" He said to them, "Do not extort money from anyone by threats or false accusation, & be satisfied with your wages." [15] As the people were filled with expectation, and all were questioning in their hearts concerning John, whether he might be the Messiah, [16] John answered all of them by saying, "I baptize you with water; but one who is more powerful than I is coming; I am not worthy to untie the thong of his sandals. He will baptize you with the Holy Spirit and fire. [17] His winnowing fork is in his hand, to clear his threshing floor & to gather the wheat into his granary; but the chaff he will burn with unquenchable fire." [18] So, with many other exhortations, he proclaimed the good news to the people. [19] But Herod the ruler, who had been rebuked by him because of Herodias, his brother's wife and because of all the evil things that Herod had done, [20] added to them all by shutting up John in prison. [21] Now when all the people were baptized, and when Jesus also had been baptized & was praying, the heaven was opened, [22] and the Holy Spirit descended upon him in bodily form like a dove. And a voice came from heaven, "You are my Son, the Beloved; with you I am well pleased."

[23] Jesus was about thirty years old when he began his work. He was the son (as was thought) of Joseph son of Heli, [24] son of Matthat, son of Levi, son of Melchi, son of Jannai, son of Joseph, [25] son of Mattathias, son of Amos, son of Nahum, son of Esli, son of Naggai, [26] son of Maath, son of Mattathias, son of Semein, son of Josech, son of Joda, [27] son of Joanan, son of Rhesa, son of Zerubbabel, son of Shealtiel, son of Neri, [28] son of Melchi, son of Addi, son of Cosam, son of Elmadam, son of Er, [29] son of Joshua, son of Eliezer, son of Jorim, son of Matthat, son of Levi, [30] son of Simeon, son of Judah, son of Joseph, son of Jonam, son of Eliakim, [31] son of Melea, son of Menna, son of Mattatha, son of Nathan, son of David, [32] son of Jesse, son of Obed, son of Boaz, son of Sala, son of Nahshon, [33] son of Amminadab, son of Admin, son of Arni, son of Hezron, son of Perez, son of Judah, [34] son of Jacob, son of Isaac, son of Abraham, son of Terah, son of Nahor, [35] son of Serug, son of Reu, son of Peleg, son of Eber, son of Shelah, [36] son of Cainan, son of Arphaxad, son of Shem, son of Noah, son of Lamech, [37] son of Methuselah, son of Enoch, son of Jared, son of Mahalaleel, son of Cainan, [38] son of Enos, son of Seth, son of Adam, son of God.

4

Jesus, full of the Holy Spirit, returned from the Jordan & was led by the Spirit in the wilderness, [2] where for forty days he was tempted by the devil. He ate nothing at all during those days, & when they were over, he was famished. [3] The devil said to him, "If you are the Son of God, command this stone to become a loaf of bread." [4] Jesus answered him, "It is written, 'One does not live by bread alone.'" [5] Then the devil led him up and showed him in an instant all the kingdoms of the world. [6] And the devil said to him, "To you I will give the glory and all this authority; for it has been given over to me, and I give it to anyone I please. [7] If you, then, will worship me, it will all be yours." [8] Jesus answered him, "It is written,

'Worship the Lord your God,
and serve only him.'"

[9] Then the devil took him to Jerusalem, and placed him on the pinnacle of the temple, saying to him, "If you are the Son of God, throw yourself down from here, [10] for it is written,

'He will command his angels concerning you,
to protect you,' [11] and
'On their hands they will bear you up,
so that you will not dash your foot against a stone.'"

[12] Jesus answered him, "It is said, 'Do not put the Lord your God to the test.'" [13] When the devil had finished every test, he departed from him until an opportune time.

[14] Then Jesus, filled with the power of the Spirit, returned to Galilee, and a report about him spread through all the surrounding country. [15] He began to teach in their synagogues and was praised by everyone. [16] When he came to Nazareth, where he had been brought up, he went to the synagogue on the sabbath day, as was his custom. He stood up to read, [17] and the scroll of the prophet Isaiah was given to him. He unrolled the scroll and found the place where it was written:

[18] "The Spirit of the Lord is upon me,
because he has anointed me
to bring good news to the poor.
He has sent me to proclaim release to the captives
and recovery of sight to the blind,
to let the oppressed go free,
[19] to proclaim the year of the Lord's favor."

[20] And he rolled up the scroll, gave it back to the attendant, and sat down. The eyes of all in the synagogue were fixed on him. [21] Then he began to say to them, "Today this scripture has been fulfilled in your hearing." [22] All spoke well of him and were amazed at the gracious words that came from his

z Or the Christ
a Or in
b Gk tetrarch
c Or my beloved Son
d Other ancient authorities
 read You are my Son, today
 I have begotten you
e Gk Salathiel
f Other ancient authorities
 read Salmon
g Other ancient authorities
 read Amminadab, son of
 Aram; others vary widely
h Gk he
i Gk he
j Gk he

mouth. They said, "Is not this Joseph's son?" [23] He said to them, "Doubtless you will quote to me this proverb, 'Doctor, cure yourself!' And you will say, 'Do here also in your hometown the things that we have heard you did at Capernaum.'" [24] And he said, "Truly I tell you, no prophet is accepted in the prophet's hometown. [25] But the truth is, there were many widows in Israel in the time of Elijah, when the heaven was shut up three years & six months, and there was a severe famine over all the land; [26] yet Elijah was sent to none of them except to a widow at Zarephath in Sidon. [27] There were also many lepers in Israel in the time of the prophet Elisha, and none of them was cleansed except Naaman the Syrian." [28] When they heard this, all in the synagogue were filled with rage. [29] They got up, drove him out of the town, and led him to the brow of the hill on which their town was built, so that they might hurl him off the cliff. [30] But he passed through the midst of them & went on his way.

31 He went down to Capernaum, a city in Galilee, and was teaching them on the sabbath. [32] They were astounded at his teaching, because he spoke with authority. [33] In the synagogue there was a man who had the spirit of an unclean demon, and he cried out with a loud voice, [34] "Let us alone! What have you to do with us, Jesus of Nazareth? Have you come to destroy us? I know who you are, the Holy One of God." [35] But Jesus rebuked him, saying, "Be silent, and come out of him!" When the demon had thrown him down before them, he came out of him without having done him any harm. [36] They were all amazed & kept saying to one another, "What kind of utterance is this? For with authority & power he commands the unclean spirits, and out they come!" [37] And a report about him began to reach every place

38 in the region. After leaving the synagogue he entered Simon's house. Now Simon's mother-in-law was suffering from a high fever, and they asked him about her. [39] Then he stood over her and rebuked the fever, and it left her. Immediately she got up &

40 began to serve them. As the sun was setting, all those who had any who were sick with various kinds of diseases brought them to him; and he laid his hands on each of them & cured them. [41] Demons also came out of many, shouting, "You are the Son of God!" But he rebuked them & would not allow them to speak, because they knew that he was the

42 Messiah. At daybreak he departed & went into a deserted place. And the crowds were looking for him; and when they reached him, they wanted to prevent him from leaving them. [43] But he said to them, "I must proclaim the good news of the kingdom of God to the other cities also; for I was sent for this purpose." [44] So he continued proclaiming the message in the synagogues of Judea.

h The terms leper and leprosy can refer to several diseases
i Or the Christ
m Other ancient authorities read Galilee
n Gk he
o The terms leper and leprosy can refer to several diseases
p Gk he
q The terms leper and leprosy can refer to several diseases
r Gk him
s Other ancient authorities read was present to heal them
t Gk him
u Gk into the midst
v Gk Man

5

Once while Jesus was standing beside the lake of Gennesaret, and the crowd was pressing in on him to hear the word of God, [2] he saw two boats there at the shore of the lake; the fishermen had gone out of them and were washing their nets. [3] He got into one of the boats, the one belonging to Simon, and asked him to put out a little way from the shore. Then he sat down & taught the crowds from the boat. [4] When he had finished speaking, he said to Simon, "Put out into the deep water and let down your nets for a catch." [5] Simon answered, "Master, we have worked all night long but have caught nothing. Yet if you say so, I will let down the nets." [6] When they had done this, they caught so many fish that their nets were beginning to break. [7] So they signaled their partners in the other boat to come and help them. And they came and filled both boats, so that they began to sink. [8] But when Simon Peter saw it, he fell down at Jesus' knees, saying, "Go away from me, Lord, for I am a sinful man!" [9] For he & all who were with him were amazed at the catch of fish that they had taken; [10] and so also were James & John, sons of Zebedee, who were partners with Simon. Then Jesus said to Simon, "Do not be afraid; from now on you will be catching people." [11] When they had brought their boats to shore, they left everything and followed

12 him. Once, when he was in one of the cities, there was a man covered with leprosy. When he saw Jesus, he bowed with his face to the ground and begged him, "Lord, if you choose, you can make me clean." [13] Then Jesus stretched out his hand, touched him, and said, "I do choose. Be made clean." Immediately the leprosy left him. [14] And he ordered him to tell no one. "Go," he said, "and show yourself to the priest, and, as Moses commanded, make an offering for your cleansing, for a testimony to them." [15] But now more than ever the word about Jesus spread abroad; many crowds would gather to hear him and to be cured of their diseases. [16] But he would withdraw

17 to deserted places and pray. One day, while he was teaching, Pharisees & teachers of the law were sitting near by [they had come from every village of Galilee and Judea and from Jerusalem]; and the power of the Lord was with him to heal. [18] Just then some men came, carrying a paralyzed man on a bed. They were trying to bring him in & lay him before Jesus; [19] but finding no way to bring him in because of the crowd, they went up on the roof and let him down with his bed through the tiles into the middle of the crowd in front of Jesus. [20] When he saw their faith, he said, "Friend, your sins are forgiven you." [21] Then the scribes & the Pharisees began to question, "Who is this who is speaking blasphemies? Who

can forgive sins but God alone?" ²² When Jesus perceived their questionings, he answered them, "Why do you raise such questions in your hearts? ²³ Which is easier, to say, 'Your sins are forgiven you,' or to say, 'Stand up & walk'? ²⁴ But so that you may know that the Son of Man has authority on earth to forgive sins"—he said to the one who was paralyzed—"I say to you, stand up and take your bed and go to your home." ²⁵ Immediately he stood up before them, took what he had been lying on, and went to his home, glorifying God. ²⁶ Amazement seized all of them, and they glorified God and were filled with awe, saying, "We have seen strange things today."

²⁷ After this he went out and saw a tax collector named Levi, sitting at the tax booth; and he said to him, "Follow me." ²⁸ And he got up, left everything, ²⁹ and followed him. Then Levi gave a great banquet for him in his house; and there was a large crowd of tax collectors and others sitting at the table with them. ³⁰ The Pharisees and their scribes were complaining to his disciples, saying, "Why do you eat and drink with tax collectors and sinners?" ³¹ Jesus answered, "Those who are well have no need of a physician, but those who are sick; ³² I have come to call not the righteous but sinners to repentance."

³³ Then they said to him, "John's disciples, like the disciples of the Pharisees, frequently fast and pray, but your disciples eat and drink." ³⁴ Jesus said to them, "You cannot make wedding guests fast while the bridegroom is with them, can you? ³⁵ The days will come when the bridegroom will be taken away from them, and then they will fast in those days." ³⁶ He also told them a parable: "No one tears a piece from a new garment & sews it on an old garment; otherwise the new will be torn, and the piece from the new will not match the old. ³⁷ And no one puts new wine into old wineskins; otherwise the new wine will burst the skins & will be spilled, and the skins will be destroyed. ³⁸ But new wine must be put into fresh wineskins. ³⁹ And no one after drinking old wine desires new wine, but says, 'The old is good!'"

6

One sabbath while Jesus was going through the grainfields, his disciples plucked some heads of grain, rubbed them in their hands, and ate them. ² But some of the Pharisees said, "Why are you doing what is not lawful on the sabbath?" ³ Jesus answered, "Have you not read what David did when he & his companions were hungry? ⁴ He entered the house of God & took and ate the bread of the Presence, which it is not lawful for any but the priests to eat, and gave some to his companions?"

⁵ Then he said to them, "The Son of Man is lord of the sabbath." ⁶ On another sabbath he entered the synagogue and taught, and there was a man there whose right hand was withered. ⁷ The scribes and the Pharisees watched him to see whether he would cure on the sabbath, so that they might find an accusation against him. ⁸ Even though he knew what they were thinking, he said to the man who had the withered hand, "Come and stand here." He got up and stood there. ⁹ Then Jesus said to them, "I ask you, is it lawful to do good or to do harm on the sabbath, to save life or to destroy it?" ¹⁰ After looking around at all of them, he said to him, "Stretch out your hand." He did so, and his hand was restored. ¹¹ But they were filled with fury & discussed with one another what they might do to Jesus. ¹² Now during those days he went out to the mountain to pray; and he spent the night in prayer to God. ¹³ And when day came, he called his disciples and chose twelve of them, whom he also named apostles: ¹⁴ Simon, whom he named Peter, and his brother Andrew, and James, and John, and Philip, and Bartholomew, ¹⁵ and Matthew, and Thomas, and James son of Alphaeus, and Simon, who was called the Zealot, ¹⁶ and Judas son of James, and Judas Iscariot, who became a traitor. ¹⁷ He came down with them and stood on a level place, with a great crowd of his disciples and a great multitude of people from all Judea, Jerusalem, and the coast of Tyre and Sidon. ¹⁸ They had come to hear him and to be healed of their diseases; and those who were troubled with unclean spirits were cured. ¹⁹ And all in the crowd were trying to touch him, for power came out from him and healed all of them. ²⁰ Then he looked up at his disciples and said:

"Blessed are you who are poor,
　for yours is the kingdom of God.
²¹ "Blessed are you who are hungry now,
　for you will be filled.
"Blessed are you who weep now,
　for you will laugh.

²² "Blessed are you when people hate you, and when they exclude you, revile you, and defame you on account of the Son of Man. ²³ Rejoice in that day & leap for joy, for surely your reward is great in heaven; for that is what their ancestors did to the prophets.

²⁴ "But woe to you who are rich,
　for you have received your consolation.
²⁵ "Woe to you who are full now,
　for you will be hungry.
"Woe to you who are laughing now,
　for you will mourn and weep.
²⁶ "Woe to you when all speak well of you, for that is what their ancestors did to the false prophets.

ᵘ Gk reclining
ᵛ Other ancient authorities read better; others lack verse 39
ʸ Other ancient authorities read On the second first sabbath
ᶻ Gk he
ᵃ Other ancient authorities add to do
ᵇ Gk cast out your name as evil

27 "But I say to you that listen. Love your enemies, do good to those who hate you, ²⁸ bless those who curse you, pray for those who abuse you. ²⁹ If any one strikes you on the cheek, offer the other also; and from anyone who takes away your coat do not withhold even your shirt. ³⁰ Give to everyone who begs from you; and if anyone takes away your goods, do not ask for them again. ³¹ Do to others as you

32 would have them do to you. ¶ If you love those who love you, what credit is that to you? For even sinners love those who love them. ³³ If you do good to those who do good to you, what credit is that to you? For even sinners do the same. ³⁴ If you lend to those from whom you hope to receive, what credit is that to you? Even sinners lend to sinners, to receive as much again. ³⁵ But love your enemies, do good, and lend, expecting nothing in return. Your reward will be great, and you will be children of the Most High; for he is kind to the ungrateful & the wicked. ³⁶ Be merciful, just as your Father is merciful. ¶ "Do not

37 judge, and you will not be judged; do not condemn, and you will not be condemned. Forgive, and you will be forgiven; ³⁸ give, and it will be given to you. A good measure, pressed down, shaken together, running over, will be put into your lap; for the measure you give will be the measure you get back."

39 ¶ He also told them a parable: "Can a blind person guide a blind person? Will not both fall into a pit? ⁴⁰ A disciple is not above the teacher, but everyone who is fully qualified will be like the teacher. ⁴¹ Why do you see the speck in your neighbor's eye, but do not notice the log in your own eye? ⁴² Or how can you say to your neighbor, 'Friend, let me take out the speck in your eye,' when you yourself do not see the log in your own eye? You hypocrite, first take the log out of your own eye, and then you will see clearly to take the speck out of your neighbor's eye.

43 ¶ "No good tree bears bad fruit, nor again does a bad tree bear good fruit; ⁴⁴ for each tree is known by its own fruit. Figs are not gathered from thorns, nor are grapes picked from a bramble bush. ⁴⁵ The good person out of the good treasure of the heart produces good, and the evil person out of evil treasure produces evil; for it is out of the abundance of the heart that the mouth speaks. ¶ "Why do you

46 call me 'Lord, Lord,' and do not do what I tell you? ⁴⁷ I will show you what someone is like who comes to me, hears my words, and acts on them. ⁴⁸ That one is like a man building a house, who dug deeply & laid the foundation on rock; when a flood arose, the river burst against that house but could not shake it, because it had been well built. ⁴⁹ But the one who hears and does not act is like a man who built a house on the ground without a foundation.

RSB
Luke 6:27
Luke 6:31

c other ancient authorities read disparing of no one
d Gk brother's
e Gk brother
f Gk brother
g Gk brother's
h other ancient authorities read founded upon the rock
i Gk he
j Other ancient authorities read Next day
k Gk he
l Gk He

When the river burst against it, immediately it fell, and great was the ruin of that house."

7

After Jesus had finished all his sayings in the hearing of the people, he entered Capernaum. ² A centurion there had a slave whom he valued highly, and who was ill and close to death. ³ When he heard about Jesus, he sent some Jewish elders to him, asking him to come and heal his slave. ⁴ When they came to Jesus, they appealed to him earnestly, saying, "He is worthy of having you do this for him, ⁵ for he loves our people, and it is he who built our synagogue for us." ⁶ And Jesus went with them, but when he was not far from the house, the centurion sent friends to say to him, "Lord, do not trouble yourself, for I am not worthy to have you come under my roof; ⁷ therefore I did not presume to come to you. But only speak the word, and let my servant be healed. ⁸ For I also am a man set under authority, with soldiers under me; and I say to one, 'Go,' and he goes, and to another, 'Come,' and he comes, and to my slave, 'Do this,' and the slave does it." ⁹ When Jesus heard this he was amazed at him, and turning to the crowd that followed him, he said, "I tell you, not even in Israel have I found such faith." ¹⁰ When those who had been sent returned to the house, they found the slave in good

11 health. ¶ Soon afterwards he went to a town called Nain, and his disciples & a large crowd went with him. ¹² As he approached the gate of the town, a man who had died was being carried out. He was his mother's only son, and she was a widow; and with her was a large crowd from the town. ¹³ When the Lord saw her, he had compassion for her and said to her, "Do not weep." ¹⁴ Then he came forward and touched the bier, and the bearers stood still. And he said, "Young man, I say to you, rise!" ¹⁵ The dead man sat up & began to speak, and Jesus gave him to his mother. ¹⁶ Fear seized all of them; and they glorified God, saying, "A great prophet has risen among us!" and "God has looked favorably on his people!" ¹⁷ This word about him spread through-

18 out Judea and all the surrounding country. ¶ The disciples of John reported all these things to him. So John summoned two of his disciples ¹⁹ and sent them to the Lord to ask, "Are you the one who is to come, or are we to wait for another?" ²⁰ When the men had come to him, they said, "John the Baptist has sent us to you to ask, 'Are you the one who is to come, or are we to wait for another?'" ²¹ Jesus had just then cured many people of diseases, plagues, and evil spirits, and had given sight to many who

were blind. 22 And he answered them. "Go and tell John what you have seen & heard : the blind receive their sight, the lame walk, the lepers are cleansed, the deaf hear, the dead are raised, the poor have good news brought to them. 23 And blessed is any one who takes no offense at me." ■ 24 When John's messengers had gone, Jesus began to speak to the crowds about John : "What did you go out into the wilderness to look at ? A reed shaken by the wind ? 25 What then did you go out to see ? Someone dressed in soft robes ? Look, those who put on fine clothing and live in luxury are in royal palaces. 26 What then did you go out to see ? A prophet ? Yes, I tell you, & more than a prophet. 27 This is the one about whom it is written,

'See, I am sending my messenger ahead of you,
who will prepare your way before you.'

28 I tell you, among those born of women no one is greater than John ; yet the least in the kingdom of God is greater than he. 29 [And all the people who heard this, including the tax collectors, acknowledged the justice of God, because they had been baptized with John's baptism. 30 But by refusing to be baptized by him, the Pharisees & the lawyers rejected 31 God's purpose for themselves.] ■ "To what then will I compare the people of this generation, and what are they like ? 32 They are like children sitting in the marketplace and calling to one another:

'We played the flute for you, and you did not dance ;
we wailed, and you did not weep.'

33 For John the Baptist has come eating no bread & drinking no wine, and you say, 'He has a demon' ; 34 the Son of Man has come eating & drinking, and you say, 'Look, a glutton and a drunkard, a friend of tax collectors and sinners !' 35 Nevertheless, wis- 36 dom is vindicated by all her children." ■ One of the Pharisees asked Jesus to eat with him, and he went into the Pharisee's house and took his place at the table. 37 And a woman in the city, who was a sinner, having learned that he was eating in the Pharisee's house, brought an alabaster jar of ointment. 38 She

stood behind him at his feet, weeping, and began to bathe his feet with her tears and to dry them with her hair. Then she continued kissing his feet and anointing them with the ointment. 39 Now when the Pharisee who had invited him saw it, he said to himself, "If this man were a prophet, he would have known who and what kind of woman this is who is touching him—that she is a sinner." 40 Jesus spoke up & said to him, "Simon, I have something to say to you." "Teacher," he replied, "speak." 41 "A certain creditor had two debtors : one owed five hundred denarii, and the other fifty. 42 When they could not pay, he canceled the debts for both of them. Now which of them will love him more ?" 43 Simon answered, "I suppose the one for whom he canceled the greater debt." And Jesus said to him, "You have judged rightly." 44 Then turning toward the woman, he said to Simon, "Do you see this woman ? I entered your house ; you gave me no water for my feet, but she has bathed my feet with her tears & dried them with her hair. 45 You gave me no kiss, but from the time I came in she has not stopped kissing my feet. 46 You did not anoint my head with oil, but she has anointed my feet with ointment. 47 Therefore, I tell you, her sins, which were many, have been forgiven ; hence she has shown great love. But the one to whom little is forgiven, loves little." 48 Then he said to her, "Your sins are forgiven." 49 But those who were at the table with him began to say among themselves, "Who is this who even forgives sins ?" 50 And he said to the woman, "Your faith has saved you ; go in peace."

m The terms *leper* and *leprosy* can refer to several diseases
n Gk *he*
o Gk *him*
p Or *Why then did you go out ? To see someone*
q Or *praised God*
r Gk *him*
s The denarius was the usual day's wage for a laborer
t Gk *he*

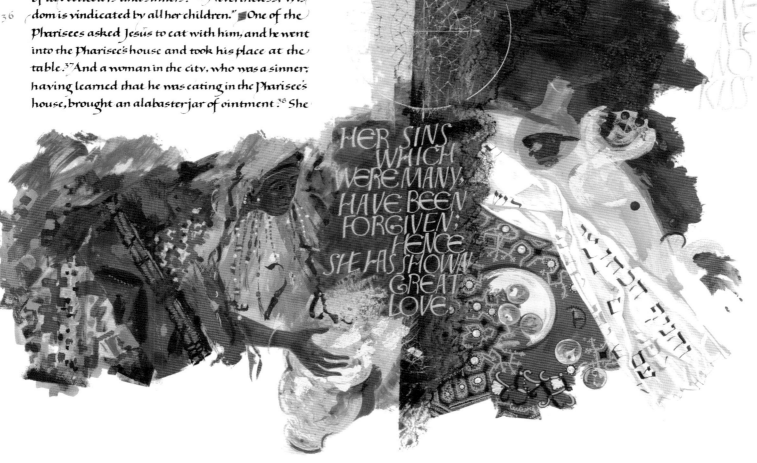

HER SINS WHICH WERE MANY, HAVE BEEN FORGIVEN; HENCE SHE HAS SHOWN GREAT LOVE.

8

Soon afterwards he went on through cities & villages, proclaiming and bringing the good news of the kingdom of God. The twelve were with him, [2] as well as some women who had been cured of evil spirits and infirmities: Mary, called Magdalene, from whom seven demons had gone out, [3] and Joanna, the wife of Herod's steward Chuza, and Susanna, and many others, who provided for them out of their resources. When a great crowd gathered and people from town after town came to him, he said in a parable: [5] "A sower went out to sow his seed; and as he sowed, some fell on the path and was trampled on, and the birds of the air ate it up. [6] Some fell on the rock; and as it grew up, it withered for lack of moisture. [7] Some fell among thorns, and the thorns grew with it and choked it. [8] Some fell into good soil, and when it grew, it produced a hundredfold." As he said this, he called out, "Let anyone with ears to hear listen!" [9] Then his disciples asked him what this parable meant. [10] He said, "To you it has been given to know the secrets of the kingdom of God; but to others I speak in parables, so that

'looking they may not perceive,
 and listening they may not understand.'

[11] "Now the parable is this: The seed is the word of God. [12] The ones on the path are those who have heard; then the devil comes & takes away the word from their hearts, so that they may not believe and be saved. [13] The ones on the rock are those who, when they hear the word, receive it with joy. But these have no root; they believe only for a while and in a time of testing fall away. [14] As for what fell among the thorns, these are the ones who hear; but as they go on their way, they are choked by the cares and riches & pleasures of life, and their fruit does not mature. [15] But as for that in the good soil, these are the ones who, when they hear the word, hold it fast in an honest and good heart, and bear fruit with patient endurance. [16] "No one after lighting a lamp hides it under a jar, or puts it under a bed, but puts it on a lampstand, so that those who enter may see the light. [17] For nothing is hidden that will not be disclosed, nor is anything secret that will not become known and come to light. [18] Then pay attention to how you listen; for to those who have, more will be given; and from those who do not have, even what they seem to have will be taken away." [19] Then his mother & his brothers came to him, but they could not reach him because of the crowd. [20] And he was told, "Your mother and your brothers are standing outside, wanting to see you." [21] But he said to them, "My mother and my brothers are those who hear the word of God and do it."

[22] One day he got into a boat with his disciples, and he said to them, "Let us go across to the other side of the lake." So they put out, [23] and while they were sailing he fell asleep. A windstorm swept down on the lake, and the boat was filling with water and they were in danger. [24] They went to him and woke him up, shouting, "Master, Master, we are perishing!" And he woke up and rebuked the wind and the raging waves; they ceased, and there was a calm. [25] He said to them, "Where is your faith?" They were afraid and amazed, and said to one another, "Who then is this, that he commands even the winds and the water, and they obey him?" [26] Then they arrived at the country of the Gerasenes, which is opposite Galilee. [27] As he stepped out on land, a man of the city who had demons met him. For a long time he had worn no clothes, and he did not live in a house but in the tombs. [28] When he saw Jesus, he fell down before him & shouted at the top of his voice, "What have you to do with me, Jesus, Son of the Most High God? I beg you, do not torment me"— [29] for Jesus had commanded the unclean spirit to come out of the man. [For many times it had seized him; he was kept under guard & bound with chains & shackles, but he would break the bonds & be driven by the demon into the wilds.] [30] Jesus then asked him, "What is your name?" He said, "Legion"; for many demons had entered him. [31] They begged him not to order them to go back into the abyss. Now there on the hillside a large herd of swine was feeding; and the demons begged Jesus to let them enter these. So he gave them permission. [33] Then the demons came out of the man and entered the swine, and the herd rushed down the steep bank into the lake and was drowned. [34] When the swineherds saw what had happened, they ran off and told it in the city & in the country. [35] Then people came out to see what had happened, and when they came to Jesus, they found the man from whom the demons had gone sitting at the feet of Jesus, clothed and in his right mind. And they were afraid. [36] Those who had seen it told them how the one who had been possessed by demons had been healed. [37] Then all the people of the surrounding country of the Gerasenes asked Jesus to leave them; for they were seized with great fear. So he got into the boat and returned. [38] The man from whom the demons had gone begged that he might be with him; but Jesus sent him away, saying, [39] "Return to your home, and declare how much God has done for you." So he went away, proclaiming throughout the city how much Jesus had done for him. [40] Now when Jesus returned, the crowd welcomed him, for they were all waiting for him. [41] Just then there came a man

a Other ancient authorities
 read him
v Or mysteries
w Gk lacks I speak
x Other ancient authorities
 read Gadarenes; others,
 Gergesenes
y Other ancient authorities
 read a man of the city who
 had had demons for a long
 time met him. He wore
z Gk he
a Gk they
b Gk him
c Other ancient authorities
 read Gadarenes; others,
 Gergesenes
d Gk him
e Gk he

named Jairus, a leader of the synagogue. He fell at Jesus' feet and begged him to come to his house, ⁴² for he had an only daughter, about twelve years old, who was dying. ❡ As he went, the crowds pressed in on him. ⁴³ Now there was a woman who had been suffering from hemorrhages for twelve years; and though she had spent all she had on physicians, no one could cure her. ⁴⁴ She came up behind him and touched the fringe of his clothes, and immediately her hemorrhage stopped. ⁴⁵ Then Jesus asked, "Who touched me?" When all denied it, Peter said, "Master, the crowds surround you & press in on you." ⁴⁶ But Jesus said, "Someone touched me; for I noticed that power had gone out from me." ⁴⁷ When the woman saw that she could not remain hidden, she came trembling; and falling down before him, she declared in the presence of all the people why she had touched him, and how she had been immediately healed. ⁴⁸ He said to her, "Daughter, your faith has made you well; go in peace." ❡ While he was still speaking, someone came from the leader's house to say, "Your daughter is dead; do not trouble the teacher any longer." ⁵⁰ When Jesus heard this, he replied, "Do not fear. Only believe, and she will be saved." ⁵¹ When he came to the house, he did not allow anyone to enter with him, except Peter, John, and James, and the child's father & mother. ⁵² They were all weeping and wailing for her; but he said, "Do not weep; for she is not dead but sleeping." ⁵³ And they laughed at him, knowing that she was dead. ⁵⁴ But he took her by the hand & called out, "Child, get up!" ⁵⁵ Her spirit returned, and she got up at once. Then he directed them to give her something to eat. ⁵⁶ Her parents were astounded; but he ordered them to tell no one what had happened.

9

Then Jesus called the twelve together and gave them power and authority over all demons and to cure diseases, ² and he sent them out to proclaim the kingdom of God and to heal. ³ He said to them, "Take nothing for your journey, no staff, nor bag, nor bread, nor money – not even an extra tunic. ⁴ Whatever house you enter, stay there, and leave from there. ⁵ Wherever they do not welcome you, as you are leaving that town shake the dust off your feet as a testimony against them." ⁶ They departed & went through the villages, bringing the good news and curing diseases everywhere. ⁷ ❡ Now Herod the ruler heard about all that had taken place, and he was perplexed, because it was said by some that John had been raised from the dead, ⁸ by some that Elijah had appeared, and

by others that one of the ancient prophets had arisen. ⁹ Herod said, "John I beheaded; but who is this about whom I hear such things?" And he tried to see him. ¹⁰ ❡ On their return the apostles told Jesus all they had done. He took them with him and withdrew privately to a city called Bethsaida. ¹¹ When the crowds found out about it, they followed him; and he welcomed them, and spoke to them about the kingdom of God, and healed those who needed to be cured. ¹² ❡ The day was drawing to a close, and the twelve came to him and said, "Send the crowd away, so that they may go into the surrounding villages & countryside, to lodge and get provisions; for we are here in a deserted place." ¹³ But he said to them, "You give them something to eat." They said, "We have no more than five loaves and two fish – unless we are to go & buy food for all these people." ¹⁴ For there were about five thousand men. And he said to his disciples, "Make them sit down in groups of about fifty each." ¹⁵ They did so and made them all sit down. ¹⁶ And taking the five loaves and the two fish, he looked up to heaven, and blessed & broke them, and gave them to the disciples to set before the crowd. ¹⁷ And all ate and were filled. What was left over was gathered up, twelve baskets of broken pieces. ❡ Once ¹⁸ when Jesus was praying alone, with only the disciples near him, he asked them, "Who do the crowds say that I am?" ¹⁹ They answered, "John the Baptist; but others, Elijah; and still others, that one of the ancient prophets has arisen." ²⁰ He said to them, "But who do you say that I am?" Peter answered, "The Messiah of God." ²¹ ❡ He sternly ordered and commanded them not to tell anyone, ²² saying, "The Son of Man must undergo great suffering, and be rejected by the elders, chief priests, and scribes, and be ✝ killed, and on the third day be raised." ❡ Then he ²³ said to them all, "If any want to become my followers, let them deny themselves and take up their cross daily and follow me. ²⁴ For those who want to save their life will lose it, and those who lose their life for my sake will save it. ²⁵ What does it profit them if they gain the whole world, but lose or forfeit themselves? ²⁶ Those who are ashamed of me and of my words, of them the Son of Man will be ashamed when he comes in his glory & the glory of the Father and of the holy angels. ²⁷ But truly I tell you, there are some standing here who will not taste death ²⁸ before they see the kingdom of God." ❡ Now about eight days after these sayings Jesus took with him Peter and John and James, and went up on the mountain to pray. ²⁹ And while he was praying, the appearance of his face changed, and his clothes became dazzling white. ³⁰ Suddenly they saw two men, Moses & Elijah, talking to him. ³¹ They appeared in glory

✝
RSB
Luke 9:23

f Other ancient authorities
 lack and though she had
 spent all she had on
 physicians
g Other ancient authorities
 add and those who were
 with him
h Gk he
i Gk tetrarch
j Gk him
k Gk he
l Or The Christ
m Gk he

"YOU SHALL
LOVE THE
LORD YOUR
GOD WITH
ALL YOUR
HEART, AND
WITH ALL
YOUR SOUL,
AND WITH
ALL YOUR
STRENGTH,
AND WITH
ALL YOUR
MIND; & YOUR
NEIGHBOR
AS YOURSELF"

a Or *but when they were fully awake*
b Or *tents*
c Other ancient authorities read *my Beloved*
d Or *it*
e Other ancient authorities add *as Elijah did*
f Other ancient authorities read *rebuked them, and said, "you do not know what spirit you are of, for the Son of Man has not come to destroy the lives of human beings but to save them." Then*
g Gk *he*
u Other ancient authorities read *seventy-two*
v Or *is at hand for you*
w Or *is at hand*

and were speaking of his departure, which he was about to accomplish at Jerusalem. 32 Now Peter & his companions were weighed down with sleep; but since they had stayed awake, they saw his glory & the two men who stood with him. 33 Just as they were leaving him, Peter said to Jesus, "Master, it is good for us to be here; let us make three dwellings, one for you, one for Moses, and one for Elijah"—not knowing what he said. 34 While he was saying this, a cloud came and overshadowed them; and they were terrified as they entered the cloud. 35 Then from the cloud came a voice that said, "This is my Son, my Chosen; listen to him!" 36 When the voice had spoken, Jesus was found alone. And they kept silent and in those days told no one any of the things they had seen. ¶ On the next day, when they had come down from the mountain, a great crowd met him. 38 Just then a man from the crowd shouted, "Teacher, I beg you to look at my son; he is my only child. 39 Suddenly a spirit seizes him, and all at once he shrieks. It convulses him until he foams at the mouth; it mauls him and will scarcely leave him. 40 I begged your disciples to cast it out, but they could not." 41 Jesus answered, "You faithless and perverse generation, how much longer must I be with you and bear with you? Bring your son here." 42 While he was coming, the demon dashed him to the ground in convulsions. But Jesus rebuked the unclean spirit, healed the boy, and gave him back to his father. 43 And all were astounded at the greatness of God. ¶ While everyone was amazed at all that he was doing, he said to his disciples, 44 "Let these words sink into your ears: The Son of Man is going to be betrayed into human hands." 45 But they did not understand this saying; its meaning was concealed from them, so that they could not perceive it. And they were afraid to ask him about this saying. ¶ An argument arose among them as to which one of them was the greatest. 47 But Jesus, aware of their inner thoughts, took a little child and put it by his side, 48 and said to them, "Whoever welcomes this child in my name welcomes me, and whoever welcomes me welcomes the one who sent me; for the least among all of you

49

is the greatest." ¶ John answered, "Master, we saw someone casting out demons in your name, and we tried to stop him, because he does not follow with us." 50 But Jesus said to him, "Do not stop him; for whoever is not against you is for you."

51

¶ When the days drew near for him to be taken up, he set his face to go to Jerusalem. 52 And he sent messengers ahead of him. On their way they entered a village of the Samaritans to make ready for him; 53 but they did not receive him, because his face was

set toward Jerusalem. 54 When his disciples James & John saw it, they said, "Lord, do you want us to command fire to come down from heaven and consume them?" 55 But he turned and rebuked them.

57

56 Then they went on to another village. ¶ As they were going along the road, someone said to him, "I will follow you wherever you go." 58 And Jesus said to him, "Foxes have holes, and birds of the air have nests; but the Son of Man has nowhere to lay his head." 59 To another he said, "Follow me." But he said, "Lord, first let me go & bury my father." 60 But Jesus said to him, "Let the dead bury their own dead; but as for you, go and proclaim the kingdom of God." 61 Another said, "I will follow you, Lord; but let me first say farewell to those at my home." 62 Jesus said to him, "No one who puts a hand to the plow and looks back is fit for the kingdom of God."

10

After this the Lord appointed seventy others and sent them on ahead of him in pairs to every town & place where he himself intended to go. 2 He said to them, "The harvest is plentiful, but the laborers are few; therefore ask the Lord of the harvest to send out laborers into his harvest. 3 Go on your way. See, I am sending you out like lambs into the midst of wolves. 4 Carry no purse, no bag, no sandals; and greet no one on the road. 5 Whatever house you enter, first say 'Peace to this house!' 6 And if anyone is there who shares in peace, your peace will rest on that person; but if not, it will return to you. 7 Remain in the same house, eating and drinking whatever they provide, for the laborer deserves to be paid. Do not move about from house to house. 8 Whenever you enter a town and its people welcome you, eat what is set before you; 9 cure the sick who are there, and say to them, 'The kingdom of God has come near to you.' 10 But whenever you enter a town & they do not welcome you, go out into its streets and say, 11 'Even the dust of your town that clings to our feet, we wipe off in protest against you. Yet know this: the kingdom of God has come near.' 12 I tell you, on that day it will be more tolerable for Sodom than for that town.

13

¶ "Woe to you, Chorazin! Woe to you, Bethsaida! For if the deeds of power done in you had been done in Tyre and Sidon, they would have repented long ago, sitting in sackcloth & ashes. 14 But at the judgment it will be more tolerable for Tyre and Sidon than for you. 15 And you, Capernaum,

will you be exalted to heaven?

†

No, you will be brought down to Hades.

16

¶ "Whoever listens to you listens to me, and who-

ever rejects you rejects me, and whoever rejects me
17 rejects the one who sent me." ❡ The seventy re-
turned with joy, saying, "Lord, in your name even
the demons submit to us!" 18 He said to them, "I
watched Satan fall from heaven like a flash of light-
ning. 19 See, I have given you authority to tread on
snakes and scorpions, and over all the power of
the enemy; and nothing will hurt you. 20 Nevertheless,
do not rejoice at this, that the spirits submit to you,
but rejoice that your names are written in heaven."

21 ❡ At that same hour Jesus rejoiced in the Holy
Spirit and said, "I thank you, Father, Lord of heaven
and earth, because you have hidden these things
from the wise and the intelligent & have revealed
them to infants; yes, Father, for such was your gra-
cious will. 22 All things have been handed over to
me by my Father; and no one knows who the Son
is except the Father, or who the Father is except the
Son and anyone to whom the Son chooses to reveal
23 him." ❡ Then turning to the disciples, Jesus said to
them privately, "Blessed are the eyes that see what
you see! 24 For I tell you that many prophets and
kings desired to see what you see, but did not see
it, and to hear what you hear, but did not hear it."

25 ❡ Just then a lawyer stood up to test Jesus. "Teacher,"
he said, "what must I do to inherit eternal life?" 26 He
said to him, "What is written in the law? What do
you read there?" 27 He answered, "You shall love the
Lord your God with all your heart, and with all your
soul, and with all your strength, and with all your
mind; and your neighbor as yourself." 28 And he
said to him, "You have given the right answer; do
29 this and you will live." ❡ But wanting to justify
himself, he asked Jesus, "And who is my neighbor?"
30 Jesus replied, "A man was going down from Jeru-
salem to Jericho, and fell into the hands of robbers,
who stripped him, beat him, and went away, leaving
him half dead. 31 Now by chance a priest was going
down that road; and when he saw him, he passed
by on the other side. 32 So likewise a Levite, when
he came to the place and saw him, passed by on the
other side. 33 But a Samaritan while traveling came
near him; and when he saw him, he was moved with
pity. 34 He went to him and bandaged his wounds,
having poured oil and wine on them. Then he put
him on his own animal, brought him to an inn, and
took care of him. 35 The next day he took out two
denarii, gave them to the innkeeper, and said, 'Take
care of him; and when I come back, I will repay you
whatever more you spend.' 36 Which of these three,
do you think, was a neighbor to the man who fell
into the hands of the robbers?" 37 He said, "The one
who showed him mercy." Jesus said to him, "Go
38 and do likewise." ❡ Now as they went on their way,

he entered a certain village, where a woman named
Martha welcomed him into her home. 39 She had a
sister named Mary, who sat at the Lord's feet and
listened to what he was saying. 40 But Martha was
distracted by her many tasks; so she came to him
& asked, "Lord, do you not care that my sister has
left me to do all the work by myself? Tell her then
to help me." 41 But the Lord answered her, "Martha,
Martha, you are worried and distracted by many
things; 42 there is need of only one thing. Mary has
chosen the better part, which will not be taken away
from her. "

11

He was praying in a certain place, and after
he had finished, one of his disciples said
to him. "Lord, teach us to pray, as John
taught his disciples." 2 He said to them, "When you
pray, say:
 Father, hallowed be your name.
 Your kingdom come.
3 Give us each day our daily bread.
4 And forgive us our sins,
 for we ourselves forgive everyone indebted to us.
 And do not bring us to the time of trial."
5 ❡ And he said to them, "Suppose one of you has a
friend, and you go to him at midnight and say to
him, 'Friend, lend me three loaves of bread; 6 for a
friend of mine has arrived, and I have nothing to
set before him.' 7 And he answers from within, 'Do
not bother me; the door has already been locked,
and my children are with me in bed; I cannot get
up and give you anything.' 8 I tell you, even though
he will not get up and give him anything because
he is his friend, at least because of his persistence
he will get up and give him whatever he needs.
9 ❡ "So I say to you, Ask, & it will be given you; search,
& you will find; knock, and the door will be opened
for you. 10 For everyone who asks receives, and every-
one who searches finds, & for everyone who knocks,
the door will be opened. 11 Is there anyone among
you who, if your child asks for a fish, will give a
snake instead of a fish? 12 Or if the child asks for an
egg, will give a scorpion? 13 If you then, who are
evil, know how to give good gifts to your children,
how much more will the heavenly Father give the
14 Holy Spirit to those who ask him!" ❡ Now he was
casting out a demon that was mute; when the de-
mon had gone out, the one who had been mute
spoke, and the crowds were amazed. 15 But some
of them said, "He casts out demons by Beelzebul,
the ruler of the demons." 16 Others, to test him, kept
demanding from him a sign from heaven. 17 But he
knew what they were thinking and said to them,

RSV
Luke 10:16
Luke 10:27

x Other ancient authorities
 read seventy-two
y Gk: he
z Other authorities read
 in the spirit
a Or praise
b Or for so it was well
 pleasing in your sight
c Gk: he
d Gk: him
e The denarius was the usual
 day's wage for a laborer
f Other ancient authorities
 read few things are
 necessary, or only one
g Other ancient authorities
 read Our Father in heaven
h A few ancient authorities
 read Your Holy Spirit come
 upon us and cleanse us,
 Other ancient authorities
 add Your will be done, on
 earth as in heaven
i Or Our bread for
 tomorrow
j Or us into temptation,
 Other ancient authorities
 add but rescue us from the
 evil one (or from evil)
k Other ancient authorities
 add bread, will give a stone;
 or if your child asks for
l Other ancient authorities
 read the Father give the
 Holy Spirit from heaven

"Every kingdom divided against itself becomes a desert, and house falls on house. [18] If Satan also is divided against himself, how will his kingdom stand? —for you say that I cast out the demons by Beelzebul. [19] Now if I cast out the demons by Beelzebul, by whom do your exorcists cast them out? Therefore they will be your judges. [20] But if it is by the finger of God that I cast out the demons, then the kingdom of God has come to you. [21] When a strong man, fully armed, guards his castle, his property is safe. [22] But when one stronger than he attacks him and overpowers him, he takes away his armor in which he trusted and divides his plunder. [23] Whoever is not with me is against me, and whoever does not gather with me scatters. [24] "When the unclean spirit has gone out of a person, it wanders through waterless regions looking for a resting place, but not finding any, it says, 'I will return to my house from which I came.' [25] When it comes, it finds it swept and put in order. [26] Then it goes and brings seven other spirits more evil than itself, and they enter and live there; and the last state of that person is worse than the first." [27] While he was saying this, a woman in the crowd raised her voice and said to him, "Blessed is the womb that bore you and the breasts that nursed you!" [28] But he said, "Blessed rather are those who hear the word of God & obey it!" [29] When the crowds were increasing, he began to say, "This generation is an evil generation; it asks for a sign, but no sign will be given to it except the sign of Jonah. [30] For just as Jonah became a sign to the people of Nineveh, so the Son of Man will be to this generation. [31] The queen of the South will rise at the judgment with the people of this generation and condemn them, because she came from the ends of the earth to listen to the wisdom of Solomon, and see, something greater than Solomon is here! [32] The people of Nineveh will rise up at the judgment with this generation and condemn it because they repented at the proclamation of Jonah, and see, something greater than Jonah is here! [33] "No one after lighting a lamp puts it in a cellar, but on the lampstand so that those who enter may see the light. [34] Your eye is the lamp of your body. If your eye is healthy, your whole body is full of light; but if it is not healthy, your body is full of darkness. [35] Therefore consider whether the light in you is not darkness. [36] If then your whole body is full of light, with no part of it in darkness, it will be as full of light as when a lamp gives you light with its rays." [37] While he was speaking, a Pharisee invited him to dine with him; so he went in and took his place at the table. [38] The Pharisee was amazed to see that he did not first wash before dinner. [39] Then the Lord said to him, "Now you Pharisees clean the

outside of the cup and of the dish, but inside you are full of greed and wickedness. [40] You fools! Did not the one who made the outside make the inside also? [41] So give for alms those things that are within; and see, everything will be clean for you. [42] "But woe to you Pharisees! For you tithe mint and rue and herbs of all kinds, and neglect justice & the love of God; it is these you ought to have practiced, without neglecting the others. [43] Woe to you Pharisees! For you love to have the seat of honor in the synagogues and to be greeted with respect in the marketplaces. [44] Woe to you! For you are like unmarked graves, and people walk over them without realizing it." [45] One of the lawyers answered him, "Teacher, when you say these things, you insult us too." [46] And he said, "Woe also to you lawyers! For you load people with burdens hard to bear, and you yourselves do not lift a finger to ease them. [47] Woe to you! For you build the tombs of the prophets whom your ancestors killed. [48] So you are witnesses & approve of the deeds of your ancestors; for they killed them, and you build their tombs. [49] Therefore also the Wisdom of God said, 'I will send them prophets and apostles, some of whom they will kill and persecute,' [50] so that this generation may be charged with the blood of all the prophets shed since the foundation of the world, [51] from the blood of Abel to the blood of Zechariah, who perished between the altar and the sanctuary. Yes, I tell you, it will be charged against this generation. [52] Woe to you lawyers! For you have taken away the key of knowledge; you did not enter yourselves, and you hindered those who were entering." [53] When he went outside, the scribes & the Pharisees began to be very hostile toward him and to cross-examine him about many things, [54] lying in wait for him, to catch him in something he might say.

12

Meanwhile, when the crowd gathered by the thousands, so that they trampled on one another, he began to speak first to his disciples, "Beware of the yeast of the Pharisees, that is, their hypocrisy. [2] Nothing is covered up that will not be uncovered, and nothing secret that will not become known. [3] Therefore whatever you have said in the dark will be heard in the light, and what you have whispered behind closed doors will be proclaimed from the housetops. [4] "I tell you, my friends, do not fear those who kill the body, and after that can do nothing more. [5] But I will warn you whom to fear: fear him who, after he has killed, has authority to cast into hell. Yes, I tell you, fear him! [6] Are not five sparrows sold for two pennies? Yet not one

m Gk sons
n Other ancient authorities add or under the bushel basket
o Or power
p Gk Gehenna

of them is forgotten in God's sight. 7 But even the hairs of your head are all counted. Do not be afraid; 8 you are of more value than many sparrows. ◼ "And I tell you, everyone who acknowledges me before others, the Son of Man also will acknowledge before the angels of God; 9 but whoever denies me before others will be denied before the angels of God. 10 And everyone who speaks a word against the Son of Man will be forgiven; but whoever blasphemes against the Holy Spirit will not be forgiven. 11 When they bring you before the synagogues, the rulers, and the authorities, do not worry about how you are to defend yourselves or what you are to say; 12 for the Holy Spirit will teach you at that very hour what 13 you ought to say." ◼ Someone in the crowd said to him, "Teacher, tell my brother to divide the family inheritance with me." 14 But he said to him, "Friend, who set me to be a judge or arbitrator over you?" 15 And he said to them, "Take care! Be on your guard against all kinds of greed; for one's life does not consist in the abundance of possessions." 16 Then he told them a parable: "The land of a rich man produced abundantly. 17 And he thought to himself, 'What should I do, for I have no place to store my crops?' 18 Then he said, 'I will do this: I will pull down my barns and build larger ones, and there I will store all my grain and my goods. 19 And I will say to my soul, Soul, you have ample goods laid up for many years; relax, eat, drink, be merry.' 20 But God said to him, 'You fool! This very night your life is being demanded of you. And the things you have prepared, whose will they be?' 21 So it is with those who store up treasures for themselves but are not rich toward 22 God." ◼ He said to his disciples, "Therefore I tell you, do not worry about your life, what you will eat, or about your body, what you will wear. 23 For life is more than food, and the body more than clothing. 24 Consider the ravens: they neither sow nor reap, they have neither storehouse nor barn, and yet God feeds them. Of how much more value are you than the birds! 25 And can any of you by worrying add a single hour to your span of life? 26 If then you are not able to do so small a thing as that, why do you worry about the rest? 27 Consider the lilies, how they grow: they neither toil nor spin; yet I tell you, even Solomon in all his glory was not clothed like one of these. 28 But if God so clothes the grass of the field, which is alive today & tomorrow is thrown into the oven, how much more will he clothe you—you of little faith! 29 And do not keep striving for what you are to eat and what you are to drink, and do not keep worrying. 30 For it is the nations of the world that strive after all these things, and your Father knows that you need them. 31 Instead, strive

for his kingdom, and these things will be given to 32 you as well. ◼ "Do not be afraid, little flock, for it is your Father's good pleasure to give you the kingdom. 33 Sell your possessions, and give alms. Make purses for yourselves that do not wear out, an unfailing treasure in heaven, where no thief comes near and no moth destroys. 34 For where your trea- 35 sure is, there your heart will be also. ◼ "Be dressed for action and have your lamps lit; 36 be like those who are waiting for their master to return from the wedding banquet, so that they may open the door for him as soon as he comes and knocks. 37 Blessed are those slaves whom the master finds alert when he comes; truly I tell you, he will fasten his belt & have them sit down to eat, and he will come and serve them. 38 If he comes during the middle of the night, or near dawn, and finds them so, blessed are 39 those slaves. ◼ "But know this: if the owner of the house had known at what hour the thief was coming, he would not have let his house be broken into. 40 You also must be ready, for the Son of Man 41 is coming at an unexpected hour." ◼ Peter said, "Lord, are you telling this parable for us or for everyone?" 42 And the Lord said, "Who then is the faithful and prudent manager whom his master will put in charge of his slaves, to give them their allowance of food at the proper time? 43 Blessed is that slave whom his master will find at work when he arrives. 44 Truly I tell you, he will put that one in charge of all his possessions. 45 But if that slave says to himself, 'My master is delayed in coming,' and if he begins to beat the other slaves, men and women, and to eat and drink and get drunk, 46 the master of that slave will come on a day when he does not expect him & at an hour that he does not know, and will cut him in pieces, and put him with the unfaithful. 47 That slave who knew what his master wanted, but did not prepare himself or do what was wanted, will receive a severe beating. 48 But the one who did not know and did what deserved a beating will receive a light beating. From everyone to whom much has been given, much will be required; and from the one to whom much has been entrusted, even more 49 will be demanded. ◼ "I came to bring fire to the earth, and how I wish it were already kindled! 50 I have a baptism with which to be baptized, and what stress I am under until it is completed! 51 Do you think that I have come to bring peace to the earth? No, I tell you, but rather division! 52 From now on five in one household will be divided, three against two and two against three; 53 they will be divided:

father against son
and son against father,
mother against daughter

q Other ancient authorities add or what

r Or add a cubit to your stature

s Other ancient authorities read Consider the lilies; they neither spin nor weave

t Other ancient authorities read God's

u Other ancient authorities add would have watched and

v Or cut him off

and daughter against mother;

mother in law against her daughter in law

and daughter in law against mother in law."

54 ❡ He also said to the crowds, "When you see a cloud rising in the west, you immediately say, 'It is going to rain'; and so it happens. 55 And when you see the south wind blowing, you say, 'There will be scorching heat'; and it happens. 56 You hypocrites! You know how to interpret the appearance of earth and sky, but why do you not know how to interpret the present time? ❡ 57 "And why do you not judge for yourselves what is right? 58 Thus, when you go with your accuser before a magistrate, on the way make an effort to settle the case, or you may be dragged before the judge, and the judge hand you over to the officer, and the officer throw you in prison. 59 I tell you, you will never get out until you have paid the very last penny."

13

At that very time there were some present who told him about the Galileans whose blood Pilate had mingled with their sacrifices. 2 He asked them, "Do you think that because these Galileans suffered in this way they were worse sinners than all other Galileans? 3 No, I tell you; but unless you repent, you will all perish as they did. 4 Or those eighteen who were killed when the tower of Siloam fell on them—do you think that they were worse offenders than all the others living in Jerusalem? 5 No, I tell you; but unless you repent, you will all perish just as they did." 6 ❡ Then he told this parable: "A man had a fig tree planted in his vineyard; and he came looking for fruit on it & found none. 7 So he said to the gardener, 'See here! For three years I have come looking for fruit on this fig tree, and still I find none. Cut it down! Why should it be wasting the soil?' 8 He replied, 'Sir, let it alone for one more year, until I dig around it and put manure on it. 9 If it bears fruit next year, well and good; but if not, you can cut it down.'" 10 ❡ Now he was teaching in one of the synagogues on the sabbath. 11 And just then there appeared a woman with a spirit that had crippled her for eighteen years. She was bent over & was quite unable to stand up straight. 12 When Jesus saw her, he called her over and said, "Woman, you are set free from your ailment." 13 When he laid his hands on her, immediately she stood up straight and began praising God. 14 But the leader of the synagogue, indignant because Jesus had cured on the sabbath, kept saying to the crowd, "There are six days on which work ought to be done; come on those days and be cured, and not on the sabbath day." 15 But the Lord answered him and said, "You

hypocrites! Does not each of you on the sabbath untie his ox or his donkey from the manger, and lead it away to give it water? 16 And ought not this woman, a daughter of Abraham whom Satan bound for eighteen long years, be set free from this bondage on the sabbath day?" 17 When he said this, all his opponents were put to shame; and the entire crowd was rejoicing at all the wonderful things that he was doing. 18 ❡ He said therefore, "What is the kingdom of God like? And to what should I compare it? 19 It is like a mustard seed that someone took & sowed in the garden; it grew and became a tree, and the birds of the air made nests in its branches." 20 ❡ And again he said, "To what should I compare the kingdom of God? 21 It is like yeast that a woman took and mixed in with three measures of flour until all of it was leavened." 22 ❡ Jesus went through one town and village after another, teaching as he made his way to Jerusalem. 23 Someone asked him, "Lord, will only a few be saved?" He said to them, 24 "Strive to enter through the narrow door; for many, I tell you, will try to enter & will not be able. 25 When once the owner of the house has got up and shut the door, and you begin to stand outside & to knock at the door, saying, 'Lord, open to us,' then in reply he will say to you, 'I do not know where you come from.' 26 Then you will begin to say, 'We ate & drank with you, and you taught in our streets.' 27 But he will say, 'I do not know where you come from; go away from me, all you evildoers!' 28 There will be weeping and gnashing of teeth when you see Abraham and Isaac and Jacob and all the prophets in the kingdom of God, and you yourselves thrown out. 29 Then people will come from east and west, from north and south, and will eat in the kingdom of God. 30 Indeed, some are last who will be first, and some are first who will be last." 31 ❡ At that very hour some Pharisees came and said to him, "Get away from here, for Herod wants to kill you." 32 He said to them, "Go and tell that fox for me, 'Listen, I am casting out demons & performing cures today & tomorrow, and on the third day I finish my work.' 33 Yet today, tomorrow, and the next day I must be on my way, because it is impossible for a prophet to be killed outside of Jerusalem.' 34 Jerusalem, Jerusalem, the city that kills the prophets and stones those who are sent to it! How often have I desired to gather your children together as a hen gathers her brood under her wings, and you were not willing! 35 See, your house is left to you. And I tell you, you will not see me until the time comes when you say, 'Blessed is the one who comes in the name of the Lord.'"

w Gk settle with him
x Gk hid in
y Gk He
z Gk lacks for me
a Other ancient authorities lack the time comes when

14

On one occasion when Jesus was going to the house of a leader of the Pharisees to eat a meal on the sabbath, they were watching him closely. 2 Just then, in front of him, there was a man who had dropsy. 3 And Jesus asked the lawyers and Pharisees, "Is it lawful to cure people on the sabbath, or not?" 4 But they were silent. So Jesus took him & healed him, and sent him away. 5 Then he said to them, "If one of you has a child or an ox that has fallen into a well, will you not immediately pull it out on a sabbath day?" 6 And they could not reply to this. ¶ 7 When he noticed how the guests chose the places of honor, he told them a parable. 8 "When you are invited by someone to a wedding banquet, do not sit down at the place of honor, in case someone more distinguished than you has been invited by your host; 9 and the host who invited both of you may come and say to you, 'Give this person your place,' and then in disgrace you would start to take the lowest place. 10 But when you are invited, go & sit down at the lowest place, so that when your host comes, he may say to you, 'Friend, move up higher'; then you will be honored in the presence of all who sit at the table with you. 11 For all who exalt themselves will be humbled, and those who humble themselves will be exalted."

12 ¶ He said also to the one who had invited him, "When you give a luncheon or a dinner, do not invite your friends or your brothers or your relatives or rich neighbors, in case they may invite you in return, and you would be repaid. 13 But when you give a banquet, invite the poor, the crippled, the lame, and the blind. 14 And you will be blessed, because they cannot repay you, for you will be repaid at the resurrection of the righteous." ¶ 15 One of the dinner guests, on hearing this, said to him, "Blessed is anyone who will eat bread in the kingdom of God!" 16 Then Jesus said to him, "Someone gave a great dinner and invited many; 17 At the time for the dinner he sent his slave to say to those who had been invited, 'Come; for everything is ready now.' 18 But they all alike began to make excuses. The first said to him, 'I have bought a piece of land, and I must go out and see it; please accept my regrets.' 19 Another said, 'I have bought five yoke of oxen, and I am going to try them out; please accept my regrets.' 20 Another said, 'I have just been married, and therefore I cannot come.' 21 So the slave returned & reported this to his master. Then the owner of the house became angry and said to his slave, 'Go out at once into the streets and lanes of the town & bring in the poor, the crippled, the blind, and the lame.' 22 And the slave said, 'Sir, what you ordered has been done, & there is still room.' 23 Then the master said to the slave, 'Go out into the roads and lanes, and compel people to come in, so that my house may be filled. 24 For I tell you, none of those who were invited will taste my dinner.'" ¶ 25 Now large crowds were traveling with him; and he turned & said to them, 26 "Whoever comes to me and does not hate father & mother, wife and children, brothers and sisters, yes, and even life itself, cannot be my disciple. 27 Whoever does not carry the cross and follow me cannot be my disciple. 28 For which of you, intending to build a tower, does not first sit down and estimate the cost, to see whether he has enough to complete it? 29 Otherwise, when he has laid a foundation and is not able to finish, all who see it will begin to ridicule him, 30 saying, 'This fellow began to build and was not able to finish.' 31 Or what king, going out to wage war against another king, will not sit down first and consider whether he is able with ten thousand to oppose the one who comes against him with twenty thousand? 32 If he cannot, then, while the other is still far away, he sends a delegation & asks for the terms of peace. 33 So therefore, none of you can become my disciple if you do not give up all your possessions. ¶ 34 "Salt is good; but if salt has lost its taste, how can its saltiness be restored? 35 It is fit neither for the soil nor for the manure pile; they throw it away. Let anyone with ears to hear listen!"

15

Now all the tax collectors & sinners were coming near to listen to him. 2 And the Pharisees & the scribes were grumbling and saying, "This fellow welcomes sinners and eats with them." 3 So he told them this parable: 4 "Which one of you, having a hundred sheep and losing one of them, does not leave the ninety-nine in the wilderness & go after the one that is lost until he finds it? 5 When he has found it, he lays it on his shoulders and rejoices. 6 And when he comes home, he calls together his friends and neighbors, saying to them, 'Rejoice with me, for I have found my sheep that was lost.' 7 Just so, I tell you, there will be more joy in heaven over one sinner who repents than over ninety-nine righteous persons who need no repentance. ¶ 8 "Or what woman having ten silver coins, if she loses one of them, does not light a lamp, sweep the house, and search carefully until she finds it? 9 When she has found it, she calls together her friends and neighbors, saying, 'Rejoice with me, for I have found the coin that I had lost.' 10 Just so, I tell you, there is joy in the presence of the angels of God over one sinner who repents." ¶ 11 Then Jesus said, "There was a man who had two sons. 12 The

✝
RSV
Luke 14 : 11
Luke 15 : 5
b Gk: he
c Gk: he
d Other ancient authorities read a donkey
e Gk: he
f The Greek word for you here is plural
g Or how can it be used for seasoning?
h Gk: drachmas, each worth about a day's wage for a laborer
i Gk: he

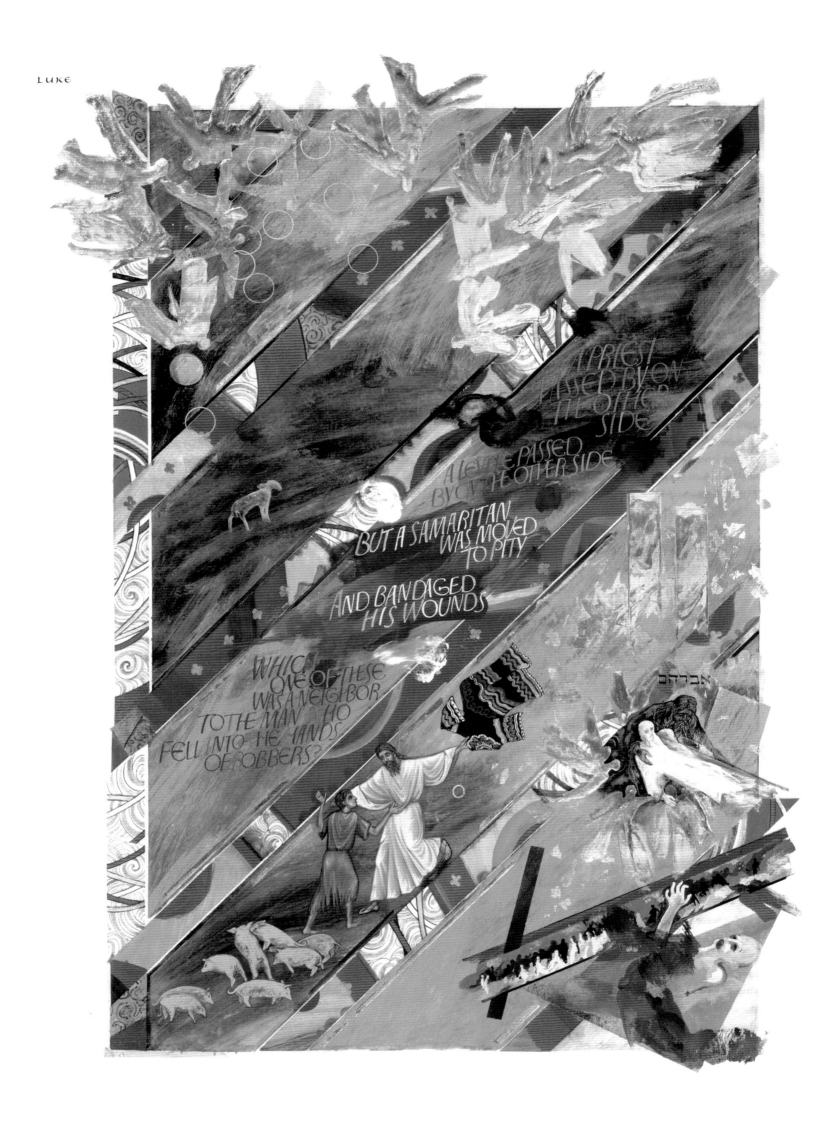

A PRIEST PASSED BY ON THE OTHER SIDE

A LEVITE PASSED BY ON THE OTHER SIDE

BUT A SAMARITAN WAS MOVED TO PITY

AND BANDAGED HIS WOUNDS

WHICH ONE OF THESE WAS A NEIGHBOR TO THE MAN WHO FELL INTO THE HANDS OF ROBBERS?

אברהם

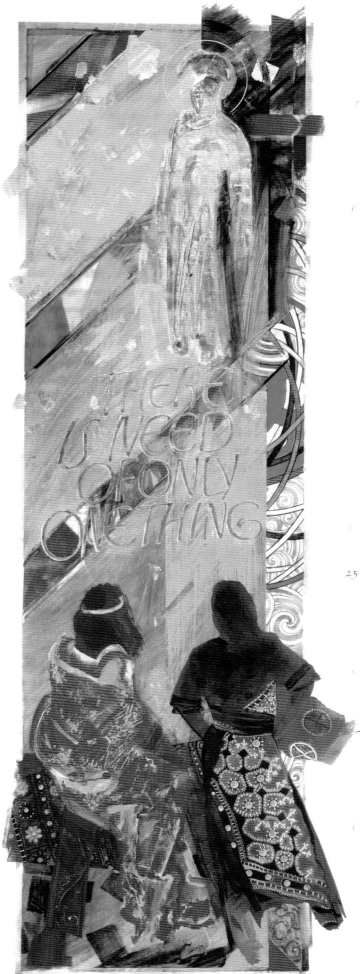

younger of them said to his father, 'Father, give me
the share of the property that will belong to me.'
So he divided his property between them. ¹³ A few
days later the younger son gathered all he had &
traveled to a distant country, and there he squan-
dered his property in dissolute living. ¹⁴ When he
had spent everything, a severe famine took place
throughout that country, and he began to be in need.
¹⁵ So he went and hired himself out to one of the
citizens of that country, who sent him to his fields
to feed the pigs. ¹⁶ He would gladly have filled him
self with the pods that the pigs were eating; and no
one gave him anything. ¹⁷ But when he came to him
self he said, 'How many of my father's hired hands
have bread enough & to spare, but here I am dying
of hunger! ¹⁸ I will get up and go to my father, and
I will say to him, "Father, I have sinned against heaven
& before you; ¹⁹ I am no longer worthy to be called
your son; treat me like one of your hired hands."'
²⁰ So he set off and went to his father. But while he
was still far off, his father saw him and was filled
with compassion; he ran and put his arms around
him and kissed him. ²¹ Then the son said to him,
'Father, I have sinned against heaven & before you;
I am no longer worthy to be called your son.' ²² But
the father said to his slaves, 'Quickly, bring out a
robe – the best one – and put it on him; put a ring
on his finger and sandals on his feet. ²³ And get the
fatted calf and kill it, and let us eat and celebrate;
²⁴ for this son of mine was dead and is alive again;
he was lost and is found!' And they began to cele-
25 brate. ❡ "Now his elder son was in the field; and
when he came & approached the house, he heard
music and dancing. ²⁶ He called one of the slaves
and asked what was going on. ²⁷ He replied, 'Your
brother has come, and your father has killed the
fatted calf, because he has got him back safe and
sound.' ²⁸ Then he became angry and refused to go
in. His father came out and began to plead with
him. ²⁹ But he answered his father, 'Listen! For all
these years I have been working like a slave for you,
and I have never disobeyed your command; yet you
have never given me even a young goat so that I might
celebrate with my friends. ³⁰ But when this son of
yours came back, who has devoured your property
with prostitutes, you killed the fatted calf for him!'
³¹ Then the father said to him, 'Son, you are always
with me, and all that is mine is yours. ³² But we had
to celebrate & rejoice, because this brother of yours
was dead and has come to life; he was lost and has
been found.' "

ʲ Other ancient authorities
read filled his stomach
with
ᵏ Other ancient authorities
add Treat me like one of
your hired servants
ˡ Gk he

16

Then Jesus said to the disciples. "There was a rich man who had a manager, and charges were brought to him that this man was squandering his property. ² So he summoned him and said to him, 'What is this that I hear about you? Give me an accounting of your management, because you cannot be my manager any longer.' ³ Then the manager said to himself, 'What will I do, now that my master is taking the position away from me? I am not strong enough to dig, and I am ashamed to beg. ⁴ I have decided what to do so that, when I am dismissed as manager, people may welcome me into their homes.' ⁵ So, summoning his master's debtors one by one, he asked the first, 'How much do you owe my master?' ⁶ He answered, 'A hundred jugs of olive oil.' He said to him, 'Take your bill, sit down quickly, and make it fifty.' ⁷ Then he asked another, 'And how much do you owe?' He replied, 'A hundred containers of wheat.' He said to him, 'Take your bill and make it eighty.' ⁸ And his master commended the dishonest manager because he had acted shrewdly; for the children of this age are more shrewd in dealing with their own generation than are the children of light. ⁹ And I tell you, make friends for yourselves by means of dishonest wealth so that when it is gone, they may welcome you into the eternal homes.

10 ¶ "Whoever is faithful in a very little is faithful also in much; and whoever is dishonest in a very little is dishonest also in much. ¹¹ If then you have not been faithful with the dishonest wealth, who will entrust to you the true riches? ¹² And if you have not been faithful with what belongs to another, who will give you what is your own? ¹³ No slave can serve two masters; for a slave will either hate the one and love the other, or be devoted to the one and despise the other. You cannot serve God and wealth."

14 ¶ The Pharisees, who were lovers of money, heard all this, and they ridiculed him. ¹⁵ So he said to them, "You are those who justify yourselves in the sight of others; but God knows your hearts; for what is prized by human beings is an abomination in the sight of God. ¶ 16 "The law and the prophets were in effect until John came; since then the good news of the kingdom of God is proclaimed, and everyone tries to enter it by force. ¹⁷ But it is easier for heaven & earth to pass away, than for one stroke of a letter in the law to be dropped. ¶ 18 "Anyone who divorces his wife and marries another commits adultery, and whoever marries a woman divorced from her husband commits adultery. ¶ 19 "There was a rich man who was dressed in purple and fine linen and who feasted sumptuously every day. ²⁰ And at his gate lay a poor man named Lazarus, covered with sores, ²¹ who longed to satisfy his hunger with what fell

from the rich man's table; even the dogs would come and lick his sores. ²² The poor man died and was carried away by the angels to be with Abraham. The rich man also died and was buried. ²³ In Hades, where he was being tormented, he looked up and saw Abraham far away with Lazarus by his side. ²⁴ He called out, 'Father Abraham, have mercy on me, and send Lazarus to dip the tip of his finger in water & cool my tongue; for I am in agony in these flames.' ²⁵ But Abraham said, 'Child, remember that during your lifetime you received your good things, and Lazarus in like manner evil things; but now he is comforted here, and you are in agony. ²⁶ Besides all this, between you and us a great chasm has been fixed, so that those who might want to pass from here to you cannot do so, and no one can cross from there to us.' ²⁷ He said, 'Then, father, I beg you to send him to my father's house— ²⁸ for I have five brothers —that he may warn them, so that they will not also come into this place of torment.' ²⁹ Abraham replied, 'They have Moses and the prophets; they should listen to them.' ³⁰ He said, 'No, father Abraham; but if someone goes to them from the dead, they will repent.' ³¹ He said to him, 'If they do not listen to Moses and the prophets, neither will they be convinced even if someone rises from the dead.'"

17

Jesus said to his disciples, "Occasions for stumbling are bound to come, but woe to anyone by whom they come! ² It would be better for you if a millstone were hung around your neck & you were thrown into the sea than for you to cause one of these little ones to stumble. ³ Be on your guard! If another disciple sins, you must rebuke the offender, and if there is repentance, you must forgive. ⁴ And if the same person sins against you seven times a day, and turns back to you seven times 5 and says, 'I repent,' you must forgive." ¶ The apostles said to the Lord, "Increase our faith!" ⁶ The Lord replied, "If you had faith the size of a mustard seed, you could say to this mulberry tree, 'Be uprooted and planted in the sea,' and it would obey you.

7 ¶ "Who among you would say to your slave who has just come in from plowing or tending sheep in the field, 'Come here at once and take your place at the table'? ⁸ Would you not rather say to him, 'Prepare supper for me, put on your apron & serve me while I eat and drink; later you may eat and drink'? ⁹ Do you thank the slave for doing what was commanded? 10 So you also, when you have done all that you were ordered to do, say, 'We are worthless slaves; we have done only what we ought to have done!'" ¶ 11 On the

RSB
Luke 16:2

מַמּוֹן ·

ᵐ Gk he
ⁿ Gk mammon
ᵒ Gk tents
ᵖ Gk mammon
�q Gk mammon
ʳ Or everyone is strongly
urged to enter it
ˢ Gk to Abraham's bosom
ᵗ Gk in his bosom
ᵘ Gk he
ᵛ Gk your brother
ʷ Gk faith as a grain of

way to Jerusalem Jesus was going through the region between Samaria and Galilee. 12 As he entered a village, ten lepers approached him. Keeping their distance, 13 they called out, saying, "Jesus, Master, have mercy on us!" 14 When he saw them, he said to them, "Go & show yourselves to the priests." And as they went, they were made clean. 15 Then one of them, when he saw that he was healed, turned back, praising God with a loud voice. 16 He prostrated himself at Jesus' feet and thanked him. And he was a Samaritan. 17 Then Jesus asked, "Were not ten made clean? But the other nine, where are they? 18 Was none of them found to return & give praise to God except this foreigner?" 19 Then he said to him, "Get up and go on your way; your faith has made you well." ❡ 20 Once Jesus was asked by the Pharisees when the kingdom of God was coming, and he answered, "The kingdom of God is not coming with things that can be observed; 21 nor will they say, 'Look, here it is!' or 'There it is!' For, in fact, the kingdom of God is among you." ❡ 22 Then he said to the disciples, "The days are coming when you will long to see one of the days of the Son of Man, and you will not see it. 23 They will say to you, 'Look there!' or 'Look here!' Do not go, do not set off in pursuit. 24 For as the lightning flashes & lights up the sky from one side to the other, so will the Son of Man be in his day. 25 But first he must endure much suffering and be rejected by this generation. 26 Just as it was in the days of Noah, so too it will be in the days of the Son of Man. 27 They were eating and drinking, and marrying & being given in marriage, until the day Noah entered the ark, and the flood came and destroyed all of them. 28 Likewise, just as it was in the days of Lot: they were eating & drinking, buying & selling, planting and building, 29 but on the day that Lot left Sodom, it rained fire and sulfur from heaven and destroyed all of them 30 -it will be like that on the day that the Son of Man is revealed. 31 On that day, anyone on the housetop who has belongings in the house must not come down to take them away; and likewise anyone in the field must not turn back. 32 Remember Lot's wife. 33 Those who try to make their life secure will lose it, but those who lose their life will keep it. 34 I tell you, on that night there will be two in one bed; one will be taken and the other left. 35 There will be two women grinding meal together; one will be taken and the other left." 37 Then they asked him, "Where, Lord?" He said to them, "Where the corpse is, there the vultures will gather."

18

Then Jesus told them a parable about their need to pray always and not to lose heart. 2 He said, "In a certain city there was a judge who neither feared God nor had respect for people. 3 In that city there was a widow who kept coming to him and saying, 'Grant me justice against my opponent.' 4 For a while he refused; but later he said to himself, 'Though I have no fear of God and no respect for anyone, 5 yet because this widow keeps bothering me, I will grant her justice, so that she may not wear me out by continually coming.'" 6 And the Lord said, "Listen to what the unjust judge says. 7 And will not God grant justice to his chosen ones who cry to him day and night? Will he delay long in helping them? 8 I tell you, he will quickly grant justice to them. And yet, when the Son of Man comes, will he find faith on earth?" ❡ 9 He also told this parable to some who trusted in themselves that they were righteous and regarded others with contempt: 10 "Two men went up to the temple to pray, one a Pharisee and the other a tax collector. 11 The Pharisee, standing by himself, was praying thus, 'God, I thank you that I am not like other people: thieves, rogues, adulterers, or even like this tax collector. 12 I fast twice a week; I give a tenth of all my income.' 13 But the tax collector, standing far off, would not even look up to heaven, but was beating his breast and saying, 'God, be merciful to me, a sinner!' 14 I tell you, this man went down to his home justified rather than the other; for all who exalt themselves will be humbled, but all who humble themselves will be exalted." ❡ 15 People were bringing even infants to him that he might touch them; and when the disciples saw it, they sternly ordered them not to do it. 16 But Jesus called for them and said, "Let the little children come to me, and do not stop them; for it is to such as these that the kingdom of God belongs. 17 Truly I tell you, whoever does not receive the kingdom of God as a little child will never enter it." 18 ❡ A certain ruler asked him, "Good Teacher, what must I do to inherit eternal life?" 19 Jesus said to him, "Why do you call me good? No one is good but God alone. 20 You know the commandments: 'You shall not commit adultery; You shall not murder; You shall not steal; You shall not bear false witness; Honor your father and mother.'" 21 He replied, "I have kept all these since my youth." 22 When Jesus heard this, he said to him, "There is still one thing lacking. Sell all that you own and distribute the money to the poor, and you will have treasure in heaven; then come, follow me." 23 But when he heard this, he became sad; for he was very rich. 24 Jesus looked at him and said, "How hard it is for those who have wealth to enter the kingdom of God! 25 Indeed, it

✝
RSB
Luke 18:13-14
Luke 18:20

a Gk he
b The terms leper and leprosy can refer to several diseases
c Gk his
a Gk he
b Or within
c Other ancient authorities lack in his day
d Other ancient authorities add verse 36, "Two will be in the field; one will be taken and the other left."
e Gk he
f Or so that she may not finally come and slap me in the face
g Gk lacks the money

is easier for a camel to go through the eye of a needle than for someone who is rich to enter the kingdom
26 of God." ❡ Those who heard it said, "Then who can be saved?" 27 He replied, "What is impossible for
28 mortals is possible for God." ❡ Then Peter said, "Look, we have left our homes and followed you." 29 And he said to them, "Truly I tell you, there is no one who has left house or wife or brothers or parents or children, for the sake of the kingdom of God, 30 who will not get back very much more in this age, and in the age to come eternal life."

31 ❡ Then he took the twelve aside and said to them, "See, we are going up to Jerusalem, and everything that is written about the Son of Man by the prophets will be accomplished. 32 For he will be handed over to the Gentiles; and he will be mocked and insulted and spat upon. 33 After they have flogged him, they will kill him, and on the third day he will rise again." 34 But they understood nothing about all these things; in fact, what he said was hidden from them, and
35 they did not grasp what was said. ❡ As he approached Jericho, a blind man was sitting by the roadside begging. 36 When he heard a crowd going by, he asked what was happening. 37 They told him, "Jesus of Nazareth[h] is passing by." 38 Then he shouted, "Jesus, Son of David, have mercy on me!" 39 Those who were in front sternly ordered him to be quiet; but he shouted even more loudly, "Son of David, have mercy on me!" 40 Jesus stood still and ordered the man to be brought to him; and when he came near, he asked him, 41 "What do you want me to do for you?" He said, "Lord, let me see again." 42 Jesus said to him, "Receive your sight; your faith has saved you." 43 Immediately he regained his sight and followed him, glorifying God; and all the people, when they saw it, praised God.

19

He entered Jericho & was passing through it. 2 A man was there named Zacchaeus; he was a chief tax collector & was rich. 3 He was trying to see who Jesus was, but on account of the crowd he could not, because he was short in stature. 4 So he ran ahead and climbed a sycamore tree to see him, because he was going to pass that way. 5 When Jesus came to the place, he looked up and said to him, "Zacchaeus, hurry & come down; for I must stay at your house today." 6 So he hurried down and was happy to welcome him. 7 All who saw it began to grumble and said, "He has gone to be the guest of one who is a sinner." 8 Zacchaeus stood there and said to the Lord, "Look, half of my possessions, Lord, I will give to the poor; and if I

h Gk. the Nazorean
i The mina, rendered here by pound, was about three months' wages for a laborer

have defrauded anyone of anything, I will pay back four times as much." 9 Then Jesus said to him, "Today salvation has come to this house, because he too is a son of Abraham. 10 For the Son of Man came to
11 seek out and to save the lost." ❡ As they were listening to this, he went on to tell a parable, because he was near Jerusalem, and because they supposed that the kingdom of God was to appear immediately. 12 So he said, "A nobleman went to a distant country to get royal power for himself & then return. 13 He summoned ten of his slaves, and gave them ten pounds,[i] and said to them, 'Do business with these until I come back.' 14 But the citizens of his country hated him and sent a delegation after him, saying, 'We do not want this man to rule over us.' 15 When he returned, having received royal power, he ordered these slaves, to whom he had given the money, to be summoned so that he might find out what they had gained by trading. 16 The first came forward & said, 'Lord, your pound has made ten more pounds.' 17 He said to him, 'Well done, good slave! Because you have been trustworthy in a very small thing, take charge of ten cities.' 18 Then the second came, saying, 'Lord, your pound has made five pounds.' 19 He said to him, 'And you, rule over five cities.' 20 Then the other came, saying, 'Lord, here is your pound. I wrapped it up in a piece of cloth, 21 for I was afraid of you, because you are a harsh man; you take what you did not deposit, and reap what you did not sow.' 22 He said to him, 'I will judge you by your own words, you wicked slave! You knew, did you, that I was a harsh man, taking what I did not deposit & reaping what I did not sow? 23 Why then did you not put my money into the bank? Then when I returned, I could have collected it with interest.' 24 He said to the bystanders, 'Take the pound from him & give it to the one who has ten pounds.' 25 (And they said to him, 'Lord, he has ten pounds!') 26 'I tell you, to all those who have, more will be given; but from those who have nothing, even what they have will be taken away. 27 But as for these enemies of mine who did not want me to be king over them—bring them here & slaughter them in my presence.'"
28 ❡ After he had said this, he went on ahead, going
29 up to Jerusalem. ❡ When he had come near Bethphage and Bethany, at the place called the Mount of Olives, he sent two of the disciples, 30 saying, "Go into the village ahead of you, and as you enter it you will find tied there a colt that has never been ridden. Untie it and bring it here. 31 If anyone asks you, 'Why are you untying it?' just say this, 'The Lord needs it.'" 32 So those who were sent departed and found it as he had told them. 33 As they were untying the colt, its owners asked them, "Why are you untying

the colt?" [34] They said, "The Lord needs it." [35] Then they brought it to Jesus; and after throwing their cloaks on the colt, they set Jesus on it. [36] As he rode along, people kept spreading their cloaks on the road. [37] As he was now approaching the path down from the Mount of Olives, the whole multitude of the disciples began to praise God joyfully with a loud voice for all the deeds of power that they had seen, [38] saying,

"Blessed is the king
 who comes in the name of the Lord !
 Peace in heaven,
 and glory in the highest heaven !"

[39] Some of the Pharisees in the crowd said to him, "Teacher, order your disciples to stop." [40] He answered, "I tell you, if these were silent, the stones would shout out." [41] As he came near and saw the city, he wept over it, [42] saying, "If you, even you, had only recognised on this day the things that make for peace! But now they are hidden from your eyes. [43] Indeed, the days will come upon you, when your enemies will set up ramparts around you and surround you, and hem you in on every side. [44] They will crush you to the ground, you and your children within you, and they will not leave within you one stone upon another; because you did not recognize the time of your visitation from God." [45] Then he entered the temple and began to drive out those who were selling things there; [46] and he said, "It is written,

'My house shall be a house of prayer';

 but you have made it a den of robbers."

[47] Every day he was teaching in the temple. The chief priests, the scribes, and the leaders of the people kept looking for a way to kill him; [48] but they did not find anything they could do, for all the people were spellbound by what they heard.

20

One day, as he was teaching the people in the temple & telling the good news, the chief priests & the scribes came with the elders [2] and said to him, "Tell us, by what authority are you doing these things? Who is it who gave you this authority?" [3] He answered them, "I will also ask you a question, and you tell me: [4] Did the baptism of John come from heaven, or was it of human origin?" [5] They discussed it with one another, saying, "If we say, 'From heaven', he will say, 'Why did you not believe him?' [6] But if we say, 'Of human origin', all the people will stone us; for they are convinced that John was a prophet." [7] So they answered that they did not know where it came from. [8] Then Jesus said to them, "Neither will I tell you by what author-

ity I am doing these things." He began to tell the people this parable: "A man planted a vineyard, and leased it to tenants, and went to another country for a long time. [10] When the season came, he sent a slave to the tenants in order that they might give him his share of the produce of the vineyard; but the tenants beat him & sent him away empty handed. [11] Next he sent another slave; that one also they beat and insulted and sent away empty handed. [12] And he sent still a third; this one also they wounded & threw out. [13] Then the owner of the vineyard said, 'What shall I do? I will send my beloved son; perhaps they will respect him.' [14] But when the tenants saw him, they discussed it among themselves and said, 'This is the heir; let us kill him so that the inheritance may be ours.' [15] So they threw him out of the vineyard and killed him. What then will the owner of the vineyard do to them? [16] He will come and destroy those tenants & give the vineyard to others." When they heard this, they said, "Heaven forbid!" [17] But he looked at them & said, "What then does this text mean:

'The stone that the builders rejected
 has become the cornerstone' [k]:

[18] Everyone who falls on that stone will be broken to pieces; and it will crush anyone on whom it falls." [19] When the scribes and chief priests realized that he had told this parable against them, they wanted to lay hands on him at that very hour, but they feared the people. So they watched him and sent spies who pretended to be honest, in order to trap him by what he said, so as to hand him over to the jurisdiction and authority of the governor. [21] So they asked him, "Teacher, we know that you are right in what you say and teach, and you show deference to no one, but teach the way of God in accordance with truth. [22] Is it lawful for us to pay taxes to the emperor, or not?" [23] But he perceived their craftiness and said to them, [24] "Show me a denarius. Whose head and whose title does it bear?" They said, "The emperor's." [25] He said to them, "Then give to the emperor the things that are the emperor's, and to God the things that are God's." [26] And they were not able in the presence of the people to trap him by what he said; and being amazed by his answer, they became silent. Some Sadducees, those who say there is no resurrection, came to him [28] and asked him a question, "Teacher, Moses wrote for us that if a man's brother dies, leaving a wife but no children, the man shall marry the widow & raise up children for his brother. [l] [29] Now there were seven brothers; the first married, and died childless; [30] then the second [31] and the third married her, and so in the same way all seven died childless. [32] Finally

[j] Gk lacks from God
[k] Or keystone
[l] Gk his brother

the woman also died. 33 In the resurrection, therefore, whose wife will the woman be? For the seven had married her." 34 Jesus said to them, "Those who belong to this age marry and are given in marriage; 35 but those who are considered worthy of a place in that age and in the resurrection from the dead neither marry nor are given in marriage. 36 Indeed they cannot die anymore, because they are like angels and are children of God, being children of the resurrection. 37 And the fact that the dead are raised Moses himself showed, in the story about the bush, where he speaks of the Lord as the God of Abraham, the God of Isaac, and the God of Jacob. 38 Now he is God not of the dead, but of the living; for to him all of them are alive." 39 Then some of the scribes answered, "Teacher, you have spoken well." 40 For they no longer dared to ask him another question.

41 ∎ Then he said to them, "How can they say that the Messiah is David's son? 42 For David himself says in the book of Psalms,

'The Lord said to my Lord,
 "Sit at my right hand,
43 until I make your enemies your footstool." '

44 David thus calls him Lord; so how can he be his 45 son?" ∎ In the hearing of all the people he said to the disciples, 46 "Beware of the scribes, who like to walk around in long robes, and love to be greeted with respect in the marketplaces, and to have the best seats in the synagogues and places of honor at banquets. 47 They devour widows' houses and for the sake of appearance say long prayers. They will receive the greater condemnation."

21

He looked up & saw rich people putting their gifts into the treasury; 2 he also saw a poor widow put in two small copper coins. 3 He said, "Truly I tell you, this poor widow has put in more than all of them; 4 for all of them have contributed out of their abundance, but she out of her poverty has put in all she had to live on."

5 ∎ When some were speaking about the temple, how it was adorned with beautiful stones and gifts dedicated to God, he said, 6 "As for these things that you see, the days will come when not one stone will be left upon another; all will be thrown down."

7 ∎ They asked him, "Teacher, when will this be, and what will be the sign that this is about to take place?" 8 And he said, "Beware that you are not led astray; for many will come in my name and say, 'I am he!' and, 'The time is near!' Do not go after them. 9 ∎ "When you hear of wars & insurrections, do not be terrified; for these things must take place first,

but the end will not follow immediately." 10 Then he said to them, "Nation will rise against nation, and kingdom against kingdom; 11 there will be great earthquakes, and in various places famines and plagues; and there will be dreadful portents and great signs 12 from heaven. ∎ "But before all this occurs, they will arrest you and persecute you; they will hand you over to synagogues and prisons, and you will be brought before kings and governors because of my name. 13 This will give you the opportunity to testify. 14 So make up your minds not to prepare your defense in advance; 15 for I will give you words and a wisdom that none of your opponents will be able to withstand or contradict. 16 You will be betrayed even by parents & brothers, by relatives & friends; and they will put some of you to death. 17 You will be hated by all because of my name. 18 But not a hair of your head will perish. 19 By your endurance 20 you will gain your souls. ∎ "When you see Jerusalem surrounded by armies, then know that its desolation has come near. 21 Then those in Judea must flee to the mountains, and those inside the city must leave it, and those out in the country must not enter it; 22 for these are days of vengeance, as a fulfillment of all that is written. 23 Woe to those who are pregnant and to those who are nursing infants in those days! For there will be great distress on the earth and wrath against this people; 24 they will fall by the edge of the sword & be taken away as captives among all nations; and Jerusalem will be trampled on by the Gentiles, until the times of the Gentiles 25 are fulfilled. ∎ "There will be signs in the sun, the moon, and the stars, and on the earth distress among nations confused by the roaring of the sea and the waves. 26 People will faint from fear & foreboding of what is coming upon the world, for the powers of the heavens will be shaken. 27 Then they will see the Son of Man coming in a cloud with power and great glory. 28 Now when these things begin to take place, stand up and raise your heads, because your 29 redemption is drawing near." ∎ Then he told them a parable: "Look at the fig tree & all the trees; 30 as soon as they sprout leaves you can see for yourselves and know that summer is already near. 31 So also, when you see these things taking place, you know that the kingdom of God is near. 32 Truly I tell you, this generation will not pass away until all things have taken place. 33 Heaven & earth will pass away, 34 but my words will not pass away. ∎ "Be on guard so that your hearts are not weighed down with dissipation and drunkenness and the worries of this life, and that day does not catch you unexpectedly, 35 like a trap. For it will come upon all who live on the face of the whole earth. 36 Be alert at all times,

RSB
Luke 21:34

m Or the Christ
n Other ancient authorities
read his
o Gk I am
p Or at hand
q Gk a mouth
r Or is at hand

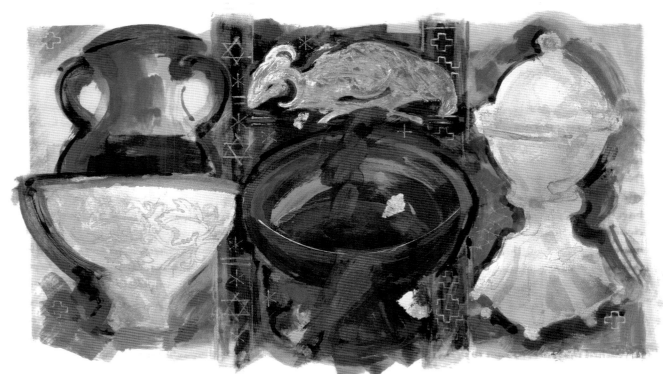

praying that you may have the strength to escape
all these things that will take place, and to stand
37 before the Son of Man." 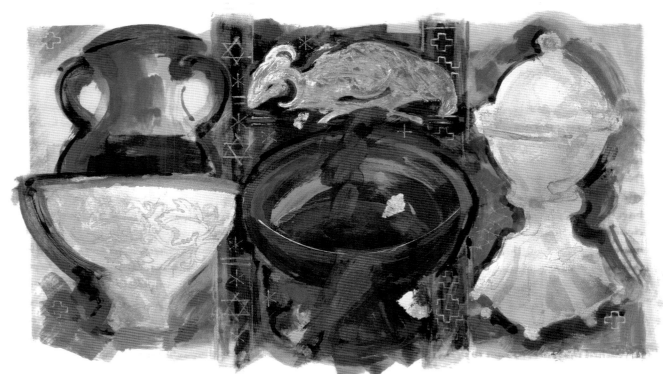 Every day he was teaching
in the temple, and at night he would go out & spend
the night on the Mount of Olives, as it was called.
38 And all the people would get up early in the morn
ing to listen to him in the temple.

22

Now the festival of Unleavened Bread, which
is called the Passover, was near. 2 The chief
priests and the scribes were looking for
a way to put Jesus to death, for they were afraid of
3 the people. Then Satan entered into Judas called
Iscariot, who was one of the twelve; 4 he went away
and conferred with the chief priests and officers of
the temple police about how he might betray him
to them. 5 They were greatly pleased and agreed to
give him money. 6 So he consented & began to look
for an opportunity to betray him to them when no
7 crowd was present. Then came the day of Unleav
ened Bread, on which the Passover lamb had to be
sacrificed. 8 So Jesus sent Peter and John, saying,
"Go and prepare the Passover meal for us that we
may eat it." 9 They asked him, "Where do you want
us to make preparations for it?" 10 "Listen," he said
to them, "when you have entered the city, a man
carrying a jar of water will meet you; follow him
into the house he enters 11 and say to the owner of
the house, 'The teacher asks you, "Where is the guest
room, where I may eat the Passover with my disci
ples?"' 12 He will show you a large room upstairs,
already furnished. Make preparations for us there."
13 So they went and found everything as he had
told them; and they prepared the Passover meal.
14 When the hour came, he took his place at the
table, and the apostles with him. 15 He said to them,

"I have eagerly desired to eat this Passover with you
before I suffer; 16 for I tell you, I will not eat it until
it is fulfilled in the kingdom of God." 17 Then he took
a cup, and after giving thanks he said, "Take this &
divide it among yourselves; 18 for I tell you that from
now on I will not drink of the fruit of the vine until
the kingdom of God comes." 19 Then he took a loaf
of bread, and when he had given thanks, he broke
it and gave it to them, saying, "This is my body, which
is given for you. Do this in remembrance of me."
20 And he did the same with the cup after supper,
saying, "This cup that is poured out for you is the
new covenant in my blood. 21 But see, the one who
betrays me is with me, and his hand is on the
table. 22 For the Son of Man is going as it has been
determined, but woe to that one by whom he is be
trayed!" 23 Then they began to ask one another which
one of them it could be who would do this. A dis
pute also arose among them as to which one of them
was to be regarded as the greatest. 25 But he said to
them, "The kings of the Gentiles lord it over them;
and those in authority over them are called benefac
tors. 26 But not so with you; rather the greatest among
you must become like the youngest, and the leader
like the one who serves. 27 For who is greater, the one
who is at the table or the one who serves? Is it not
the one at the table? But I am among you as one who
serves. "You are those who have stood by me in
my trials; 29 and I confer on you, just as my Father
has conferred on me, a kingdom, 30 so that you may
eat and drink at my table in my kingdom, and you
will sit on thrones judging the twelve tribes of Israel.
31 "Simon, Simon, listen! Satan has demanded to
sift all of you like wheat, 32 but I have prayed for
you that your own faith may not fail; and you, when
once you have turned back, strengthen your brothers."
33 And he said to him, "Lord, I am ready to go with
you to prison and to death!" 34 Jesus said, "I tell

s Gk him
t Gk he
u Other ancient authorities
read never eat it again
v Other ancient authorities
lack, in whole or in part,
verses 19b - 20 [which is
given . . . in my blood]
w or has obtained
permission
x Gk he

you, Peter, the cock will not crow this day, until you have denied three times that you know me." ▪ He

35 said to them, "When I sent you out without a purse, bag, or sandals, did you lack anything?" They said, "No, not a thing." ³⁶ He said to them, "But now, the one who has a purse must take it, and likewise a bag. And the one who has no sword must sell his cloak and buy one. ³⁷ For I tell you, this scripture must be fulfilled in me, 'And he was counted among the lawless'; and indeed what is written about me is being fulfilled." ³⁸ They said, "Lord, look, here

39 are two swords." He replied, "It is enough." ▪ He came out & went, as was his custom, to the Mount of Olives; and the disciples followed him. ⁴⁰ When he reached the place, he said to them, "Pray that you may not come into the time of trial." ⁴¹ Then he withdrew from them about a stone's throw, knelt down and prayed, ⁴² "Father, if you are willing, remove this cup from me; yet, not my will but yours be done." [[⁴³ Then an angel from heaven appeared to him and gave him strength. ⁴⁴ In his anguish he prayed more earnestly, and his sweat became like great drops of blood falling down on the ground.]]ᶻ ⁴⁵ When he got up from prayer, he came to the disciples and found them sleeping because of grief;

46 ⁴⁶ and he said to them, "Why are you sleeping? Get up and pray that you may not come into the time

47 of trial." ▪ While he was still speaking, suddenly a crowd came, and the one called Judas, one of the twelve, was leading them. He approached Jesus to kiss him; ⁴⁸ but Jesus said to him, "Judas, is it with a kiss that you are betraying the Son of Man?" ⁴⁹ When those who were around him saw what was coming, they asked, "Lord, should we strike with the sword?" ⁵⁰ Then one of them struck the slave of the high priest and cut off his right ear. ⁵¹ But Jesus said, "No more of this!" And he touched his ear and healed him. ⁵² Then Jesus said to the chief priests, the officers of the temple police, and the elders who had come for him, "Have you come out with swords & clubs as if I were a bandit? ⁵³ When I was with you day after day in the temple, you did not lay hands on me. But this is your hour, and the power of darkness!" ▪ Then they seized him and led him away, bringing him into the high priest's house. But Peter was following at a distance. ⁵⁵ When they had kindled a fire in the middle of the courtyard and sat down together, Peter sat among them. ⁵⁶ Then a servant girl, seeing him in the firelight, stared at him & said, "This man also was with him." ⁵⁷ But he denied it, saying, "Woman, I do not know him." ⁵⁸ A little later someone else, on seeing him, said, "You also are one of them." But Peter said, "Man, I am not!" ⁵⁹ Then about an hour later still another kept insist-

ing, "Surely this man also was with him; for he is a Galilean." ⁶⁰ But Peter said, "Man, I do not know what you are talking about!" At that moment, while he was still speaking, the cock crowed. ⁶¹ The Lord turned & looked at Peter. Then Peter remembered the word of the Lord, how he had said to him, "Before the cock crows today, you will deny me three times."

63 ⁶² And he went out and wept bitterly. ▪ Now the men who were holding Jesus began to mock him and beat him; ⁶⁴ they also blindfolded him and kept asking him, "Prophesy! Who is it that struck you?" ⁶⁵ They kept heaping many other insults on him.

66 ▪ When day came, the assembly of the elders of the people, both chief priests and scribes, gathered together; and they brought him to their council.ᵉ ⁶⁷ They said, "If you are the Messiah,ᵇ tell us." He replied, "If I tell you, you will not believe; ⁶⁸ and if I question you, you will not answer. ⁶⁹ But from now on the Son of Man will be seated at the right hand of the power of God." ⁷⁰ All of them asked, "Are you, then, the Son of God?" He said to them, "You say that I am." ⁷¹ Then they said, "What further testimony do we need? We have heard it ourselves from his own lips!"

23

Then the assembly rose as a body & brought Jesus before Pilate. ² They began to accuse him, saying, "We found this man perverting our nation, forbidding us to pay taxes to the emperor, and saying that he himself is the Messiah,ᵇ a king." ³ Then Pilate asked him, "Are you the king of the Jews?" He answered, "You say so." ⁴ Then Pilate said to the chief priests and the crowds, "I find no basis for an accusation against this man." ⁵ But they were insistent and said, "He stirs up the people by teaching throughout all Judea, from Galilee where

6 he began even to this place." ▪ When Pilate heard this, he asked whether the man was a Galilean. ⁷ And when he learned that he was under Herod's jurisdiction, he sent him off to Herod, who was himself in Jerusalem at that time. ⁸ When Herod saw Jesus, he was very glad, for he had been wanting to see him for a long time, because he had heard about him and was hoping to see him perform some sign. ⁹ He questioned him at some length, but Jesus gave him no answer. ¹⁰ The chief priests and the scribes stood by, vehemently accusing him. ¹¹ Even Herod with his soldiers treated him with contempt and mocked him; then he put an elegant robe on him, and sent him back to Pilate. ¹² That same day Herod and Pilate became friends with each other; before

13 this they had been enemies. ▪ Pilate then called together the chief priests, the leaders, and the people,

ʸ Or into temptation
ᶻ Other ancient authorities lack verses 43 and 44
ᵃ Or into temptation
ᵇ Or the Christ
ᶜ Gk him
ᵈ Or is an anointed king
ᵉ Gk he

14 and said to them, "You brought me this man as one who was perverting the people; and here I have examined him in your presence & have not found this man guilty of any of your charges against him. 15 Neither has Herod, for he sent him back to us. Indeed, he has done nothing to deserve death. 16 I will therefore have him flogged and release him."

17 Then they all shouted out together, "Away with this fellow! Release Barabbas for us!" 19 [This was a man who had been put in prison for an insurrection that had taken place in the city, and for murder.] 20 Pilate, wanting to release Jesus, addressed them again; 21 but they kept shouting, "Crucify, crucify him!" 22 A third time he said to them, "Why, what evil has he done? I have found in him no ground for the sentence of death; I will therefore have him flogged and then release him." 23 But they kept urgently demanding with loud shouts that he should be crucified; and their voices prevailed. 24 So Pilate gave his verdict that their demand should be granted. 25 He released the man they asked for, the one who had been put in prison for insurrection & murder, and he handed Jesus over as they wished.

26 As they led him away, they seized a man, Simon of Cyrene, who was coming from the country, and they laid the cross on him, and made him carry it behind Jesus. 27 A great number of the people followed him, and among them were women who were beating their breasts & wailing for him. 28 But Jesus turned to them and said, "Daughters of Jerusalem, do not weep for me, but weep for yourselves and for your children. 29 For the days are surely coming when they will say, 'Blessed are the barren, and the wombs that never bore, and the breasts that never nursed.' 30 Then they will begin to say to the mountains, 'Fall on us'; and to the hills, 'Cover us.' 31 For if they do this when the wood is green, what will happen when it is dry?"

32 Two others also, who were criminals, were led away to be put to death with him. 33 When they came to the place that is called The Skull, they crucified Jesus there with the criminals, one on his right and one on his left. [[34 Then Jesus said, "Father, forgive them; for they do not know what they are doing."]] And they cast lots to divide his clothing. 35 And the people stood by, watching; but the leaders scoffed at him, saying, "He saved others; let him save himself if he is the Messiah of God, his chosen one!" 36 The soldiers also mocked him, coming up & offering him sour wine, 37 and saying, "If you are the King of the Jews, save yourself!"

38 There was also an inscription over him, "This is the King of the Jews."

39 One of the criminals who were hanged there kept deriding him and saying, "Are you not the Messiah? Save yourself and us!"

40 But the other rebuked him, saying, "Do you not fear God, since you are under the same sentence of condemnation? 41 And we indeed have been condemned justly, for we are getting what we deserve for our deeds, but this man has done nothing wrong." 42 Then he said, "Jesus, remember me when you come into your kingdom." 43 He replied, "Truly I tell you, today you will be with me in Paradise."

44 It was now about noon, and darkness came over the whole land until three in the afternoon, 45 while the sun's light failed; and the curtain of the temple was torn in two. 46 Then Jesus, crying with a loud voice, said, "Father, into your hands I commend my spirit." Having said this, he breathed his last. 47 When the centurion saw what had taken place, he praised God and said, "Certainly this man was innocent." 48 And when all the crowds who had gathered there for this spectacle saw what had taken place, they returned home, beating their breasts. 49 But all his acquaintances, including the women who had followed him from Galilee, stood at a distance, watching these things.

50 Now there was a good & righteous man named Joseph, who, though a member of the council, 51 had not agreed to their plan and action. He came from the Jewish town of Arimathea, and he was waiting expectantly for the kingdom of God. 52 This man went to Pilate and asked for the body of Jesus. 53 Then he took it down, wrapped it in a linen cloth, and laid it in a rock-hewn tomb where no one had ever been laid. 54 It was the day of Preparation, and the sabbath was beginning. 55 The women who had come with him from Galilee followed, and they saw the tomb and how his body was laid. 56 Then they returned, and prepared spices and ointments.

57 On the sabbath they rested according to the commandment.

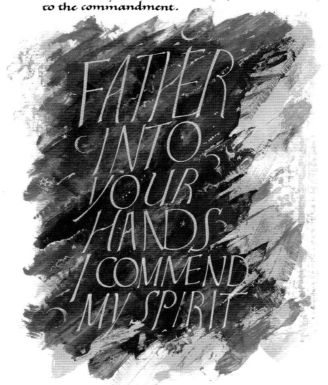

FATHER INTO YOUR HANDS I COMMEND MY SPIRIT

f Here, or after verse 19, other ancient authorities add verse 17, Now he was obliged to release someone for them at the festival
g Gk him
h Other ancient authorities lack the sentence Then Jesus . . . what they are doing
i Or the Christ
j Other ancient authorities add written in Greek and Latin and Hebrew (that is, Aramaic)
k Or blaspheming
l Or the Christ
m Other ancient authorities read in
n Or earth
o Or the sun was eclipsed Other ancient authorities read the sun was darkened
p Or righteous
q Gk was dawning

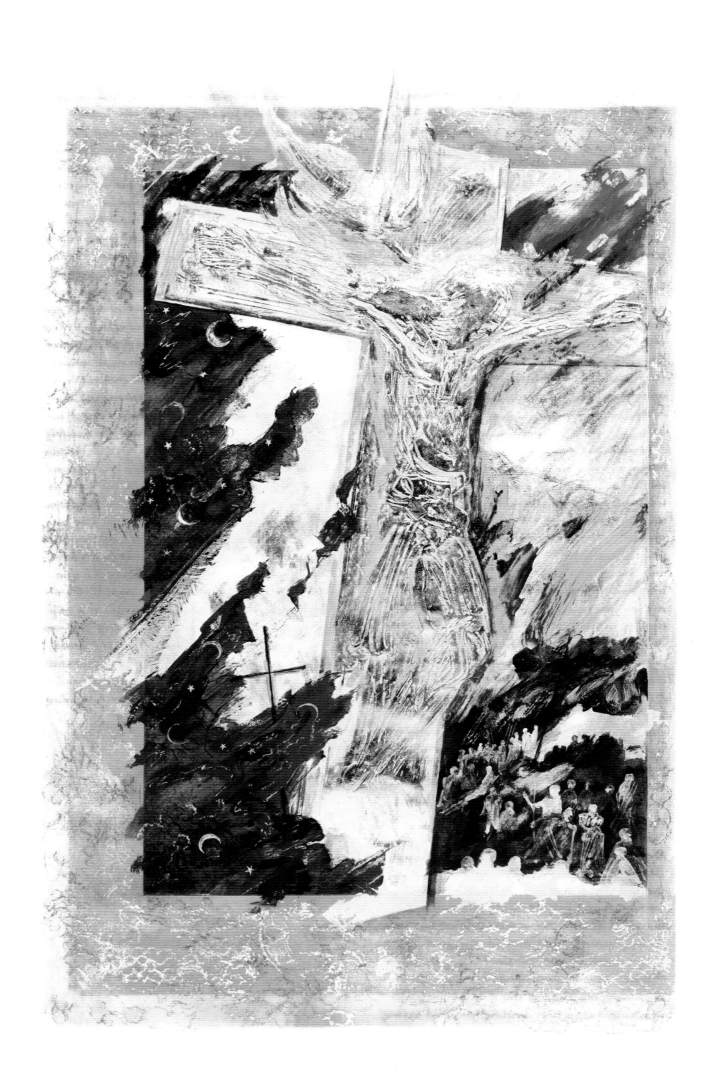

24

But on the first day of the week, at early dawn, they came to the tomb, taking the spices that they had prepared. 2 They found the stone rolled away from the tomb, 3 but when they went in, they did not find the body. 4 While they were perplexed about this, suddenly two men in dazzling clothes stood beside them. 5 The women were terrified and bowed their faces to the ground, but the men said to them, "Why do you look for the living among the dead? He is not here, but has risen.[u] 6 Remember how he told you, while he was still in Galilee, 7 that the Son of Man must be handed over to sinners, and be crucified, and on the third day rise again." 8 Then they remembered his words, 9 and returning from the tomb, they told all this to the eleven and to all the rest. 10 Now it was Mary Magdalene, Joanna, Mary the mother of James, and the other women with them who told this to the apostles. 11 But these words seemed to them an idle tale, and they did not believe them.[v] 12 But Peter got up and ran to the tomb; stooping & looking in, he saw the linen cloths by themselves; then he went home, amazed at what had happened.

13 ◼ Now on that same day two of them were going to a village called Emmaus, about seven miles from Jerusalem, 14 and talking with each other about all these things that had happened. 15 While they were talking and discussing, Jesus himself came near and went with them, 16 but their eyes were kept from recognizing him. 17 And he said to them, "What are you discussing with each other while you walk along?" They stood still, looking sad.[w] 18 Then one of them, whose name was Cleopas, answered him, "Are you the only stranger in Jerusalem who does not know the things that have taken place there in these days?" 19 He asked them, "What things?" They replied, "The things about Jesus of Nazareth,[x] who was a prophet mighty in deed and word before God and all the people, 20 and how our chief priests and leaders handed him over to be condemned to death and crucified him. 21 But we had hoped that he was the one to redeem Israel.[y] Yes, and besides all this, it is now the third day since these things took place. 22 Moreover, some women of our group astounded us. They were at the tomb early this morning, 23 and when they did not find his body there, they came back & told us that they had indeed seen a vision of angels who said that he was alive. 24 Some of those who were with us went to the tomb & found it just as the women had said; but they did not see him." 25 Then he said to them, "Oh, how foolish you are, and how slow of heart to believe all that the prophets have declared! 26 Was it not necessary that the Messiah[z] should suffer these things & then enter into his glory?" 27 Then beginning

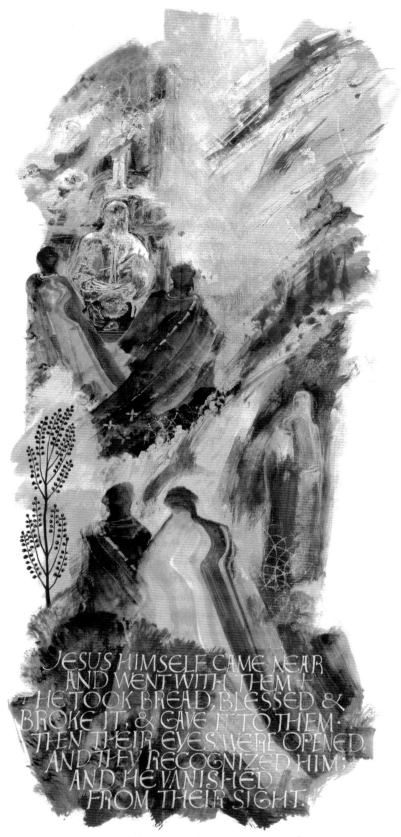

JESUS HIMSELF CAME NEAR AND WENT WITH THEM. HE TOOK BREAD, BLESSED & BROKE IT, & GAVE IT TO THEM. THEN THEIR EYES WERE OPENED AND THEY RECOGNIZED HIM; AND HE VANISHED FROM THEIR SIGHT.

with Moses and all the prophets, he interpreted to them the things about himself in all the scriptures.

28 ◼ As they came near the village to which they were going, he walked ahead as if he were going on. 29 But they urged him strongly, saying, "Stay with us, because it is almost evening & the day is now nearly over." So he went in to stay with them. 30 When he was at the table with them, he took bread, blessed & broke it, and gave it to them. 31 Then their eyes were opened, & they recognized him; and he vanished from their sight. 32 They said to each other, "Were not

r Other ancient authorities add of the Lord Jesus
s Gk They
t Gk but they
u Other ancient authorities lack He is not here, but has risen
v Other ancient authorities lack verse 12
w Gk Sixty stadia; other ancient authorities read a hundred sixty stadia
x Other ancient authorities read walk along, looking sad?
y Other ancient authorities read Jesus the Nazorean
z Or to set Israel free
a Or the Christ

our hearts burning within us while he was talking
to us on the road, while he was opening the scriptures
to us?" 33 That same hour they got up & returned to
Jerusalem; and they found the eleven & their com-
panions gathered together. 34 They were saying, "The
Lord has risen indeed, and he has appeared to Si-
mon!" 35 Then they told what had happened on the
road, and how he had been made known to them
in the breaking of the bread. ❡ While they were talk-
ing about this, Jesus himself stood among them and
said to them, "Peace be with you." 37 They were star-
tled & terrified, and thought that they were seeing
a ghost. 38 He said to them, "Why are you frightened,
and why do doubts arise in your hearts? 39 Look at
my hands and my feet; see that it is I myself. Touch
me and see; for a ghost does not have flesh & bones
as you see that I have." 40 And when he had said this,
he showed them his hands and his feet. 41 While in
their joy they were disbelieving and still wondering,
he said to them, "Have you anything here to eat?"
42 They gave him a piece of broiled fish, 43 and he took
it & ate in their presence. ❡ Then he said to them,
"These are my words that I spoke to you while I was
still with you — that everything written about me in
the law of Moses, the prophets, and the psalms must
be fulfilled." 45 Then he opened their minds to under-
stand the scriptures, 46 and he said to them, "Thus it
is written, that the Messiah is to suffer and to rise
from the dead on the third day, 47 and that repen-
tance and forgiveness of sins is to be proclaimed in his
name to all nations, beginning from Jerusalem. 48 You
are witnesses of these things. 49 And see, I am send-
ing upon you what my Father promised; so stay here
in the city until you have been clothed with power
from on high." ❡ Then he led them out as far as Beth-
any, and, lifting up his hands, he blessed them. 51 While
he was blessing them, he withdrew from them and
was carried up into heaven. 52 And they worshiped
him, and returned to Jerusalem with great joy; 53 and
they were continually in the temple blessing God.

36

44

50

b Other ancient authorities
lack within us
c Other ancient authorities
lack and said to them,
"Peace be with you."
d Other ancient authorities
lack verse 40
e Or the Christ
f Or nations. Beginning
from Jerusalem 48 you
are witness
g Other ancient
authorities lack and was
carried up into heaven
h Other ancient authorities
lack worshiped him, and
i Other ancient authorities
add Amen

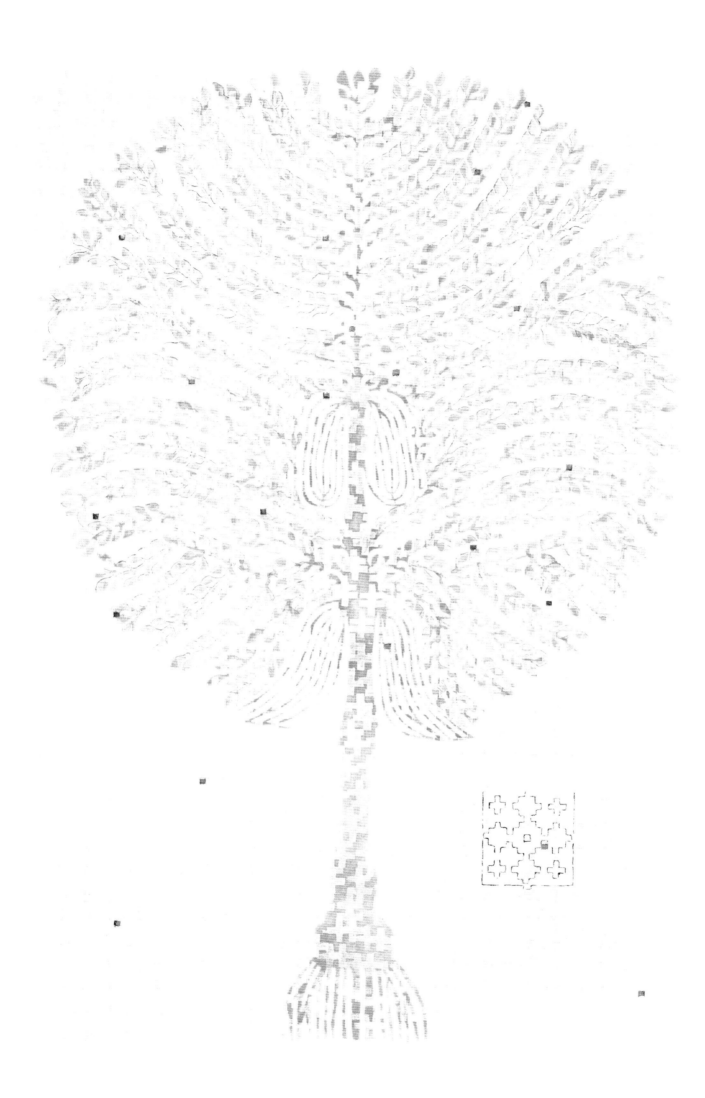

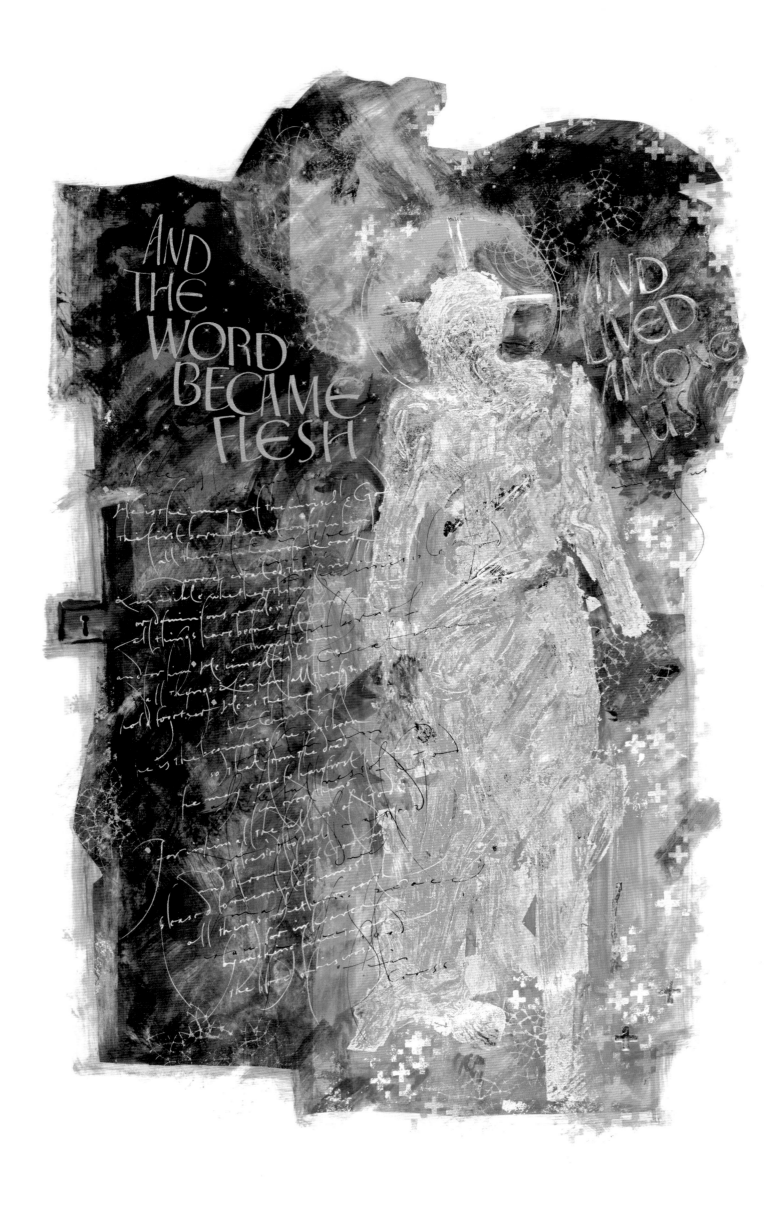

THE GOSPEL ACCORDING TO JOHN

1 IN THE BEGINNING WAS THE WORD AND THE WORD WAS WITH GOD, AND THE WORD

2 WAS GOD. HE WAS IN THE BEGINNING WITH

3 GOD. ALL THINGS CAME INTO BEING THROUGH HIM, AND WITHOUT HIM NOT ONE THING CAME INTO BEING. WHAT HAS COME INTO BEING

4 IN HIM WAS LIFE, AND THE LIFE WAS THE LIGHT

5 OF ALL PEOPLE. THE LIGHT SHINES IN THE DARKNESS, AND THE DARKNESS DID NOT OVER

6 COME IT. THERE WAS A MAN SENT FROM GOD WHOSE NAME WAS JOHN.

7 HE CAME AS A WITNESS TO TESTIFY TO THE LIGHT SO THAT ALL MIGHT BE LIEVE THROUGH HIM.

8 HE HIMSELF WAS NOT THE LIGHT, BUT HE CAME TO TESTIFY TO THE LIGHT.

9 THE TRUE LIGHT, WHICH ENLIGHTENS EVERYONE WAS COMING INTO THE

10 WORLD. HE WAS IN THE WORLD, AND THE WORLD CAME INTO BE ING THROUGH HIM; YET THE WORLD DID NOT

11 KNOW HIM. HE CAME TO WHAT WAS HIS OWN, & HIS OWN PEOPLE DID

12 NOT ACCEPT HIM. BUT TO ALL WHO RECEIVED HIM, WHO BELIEVED IN HIS NAME, HE GAVE POWER TO BECOME CHIL DREN OF GOD, WHO WERE

13 BORN, NOT OF BLOOD OR OF THE WILL OF THE FLESH OR OF THE WILL OF MAN,

14 BUT OF GOD. AND THE WORD BECAME FLESH & LIVED AMONG US, AND WE HAVE SEEN HIS GLORY, THE GLORY AS OF A FA THER'S ONLY SON, FULL OF GRACE AND TRUTH.

15 [John testified to him and cried out, "This was he of whom I said, 'He who comes after me ranks ahead of me because he was before me.'"] [16] From his fullness we have all received grace upon grace:

17 The law indeed was given through Moses; grace and truth came through Jesus Christ. [18] No one has ever seen God. It is God the only Son, who is close to the Father's heart, who has made him known.

19 This is the testimony given by John when the Jews sent priests and Levites from Jerusalem to ask him, "Who are you?" [20] He confessed & did not deny it, but confessed, "I am not the Messiah." [21] And they asked him, "What then? Are you Elijah?" He said, "I am not." "Are you the prophet?" He answered, "No."

22 Then they said to him, "Who are you? Let us have an answer for those who sent us. What do you say about yourself?" [23] He said,

"I am the voice of one crying out in the wilderness, 'Make straight the way of the Lord.'"

24 as the prophet Isaiah said. Now they had been sent from the Pharisees. [25] They asked him, "Why then are you baptizing if you are neither the Messiah, nor Elijah, nor the prophet?" [26] John answered them, "I baptize with water. Among you stands one whom you do not know, [27] the one who is coming after me; I am not worthy to untie the thong of his sandal." [28] This took place in Bethany across the Jordan where

29 John was baptizing The next day he saw Jesus coming toward him & declared, "Here is the Lamb of God who takes away the sin of the world! [30] This

a or *through him. And with out him not one thing came into being that has come into being. * In him was life

b or He was the true light that enlightens everyone coming into the world

c or to his own home

d or the Father's only Son

e other ancient authorities read It is an only Son, God, or, It is the only Son

f Gk bosom

g or the Christ

h or the Christ

is he of whom I said, 'After me comes a man who ranks ahead of me because he was before me.' ³¹ I myself did not know him; but I came baptizing with water for this reason, that he might be revealed to Israel." ³²And John testified, "I saw the Spirit descend ing from heaven like a dove, and it remained on him. ³³ I myself did not know him, but the one who sent me to baptize with water said to me, 'He on whom you see the Spirit descend and remain is the one who baptizes with the Holy Spirit.' ³⁴And I my self have seen and have testified that this is the Son of God." ▌ The next day John again was standing with two of his disciples, ³⁶ and as he watched Jesus walk by, he exclaimed, "Look, here is the Lamb of God!" ³⁷ The two disciples heard him say this, and they followed Jesus. ³⁸ When Jesus turned and saw them following, he said to them, "What are you look ing for?" They said to him, "Rabbi" [which translated means Teacher], "where are you staying?" ³⁹He said to them, "Come and see." They came and saw where he was staying, and they remained with him that day. It was about four o'clock in the afternoon. ⁴⁰ One of the two who heard John speak and followed him was Andrew, Simon Peter's brother. ⁴¹ He first found his brother Simon & said to him, "We have found the Messiah" [which is translated Anointed].

⁴² He brought Simon to Jesus, who looked at him and said, "You are Simon son of John. You are to be called Cephas" [which is translated Peter]. ▌ The next day Jesus decided to go to Galilee. He found Philip & said to him, "Follow me." ⁴⁴ Now Philip was from Bethsaida, the city of Andrew and Peter. ⁴⁵ Philip found Nathanael and said to him, "We have found him about whom Moses in the law and also the prophets wrote, Jesus son of Joseph from Nazareth." ⁴⁶ Nathanel said to him, "Can anything good come out of Nazareth?" Philip said to him, "Come and see." ⁴⁷ When Jesus saw Nathanael coming toward him, he said of him, "Here is truly an Israelite in whom there is no deceit!" ⁴⁸ Nathanael asked him, "Where did you get to know me?" Jesus answered, "I saw you under the fig tree before Philip called you." ⁴⁹ Nathanael replied, "Rabbi, you are the Son of God! You are the King of Israel!" ⁵⁰ Jesus answered, "Do you believe because I told you that I saw you under the fig tree? You will see greater things than these." ⁵¹ And he said to him, "Very truly, I tell you, you will see heaven opened and the angels of God ascending and descending upon the Son of Man."

2

On the third day there was a wedding in Cana of Galilee, and the mother of Jesus was there. ² Jesus and his disciples had also been invited to the wedding. ³ When the wine gave out, the mother of Jesus said to him, "They have no wine." ⁴ And Jesus said to her, "Woman, what concern is that to you and to me? My hour has not yet come." ⁵ His mother said to the servants, "Do whatever he tells you." ⁶ Now standing there were six stone water jars for the Jewish rites of purifica tion, each holding twenty or thirty gallons. ⁷ Jesus said to them, "Fill the jars with water." And they filled them up to the brim. ⁸ He said to them, "Now draw some out, and take it to the chief steward." So they took it. ⁹ When the steward tasted the water that had become wine, and did not know where it came from [though the servants who had drawn the water knew], the steward called the bridegroom ¹⁰ and said to him, "Everyone serves the good wine first, and then the inferior wine after the guests have become drunk. But you have kept the good wine until now." ¹¹ Jesus did this, the first of his signs, in Cana of Galilee, and revealed his glory; and his disciples believed in him. ▌ After this he went down to Capernaum with his mother, his brothers, and his disciples; and they remained there a few days. ¹³ ▌ The Passover of the Jews was near, and Jesus went up to Jerusalem. ¹⁴ In the temple he found people

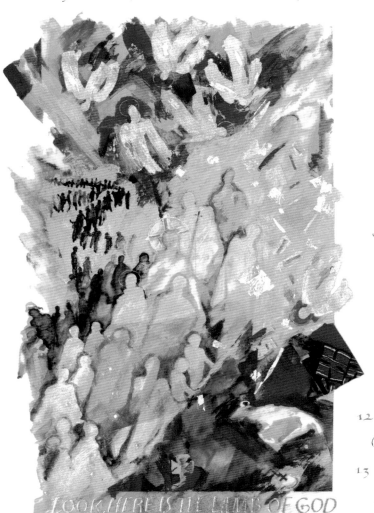

LOOK HERE IS THE LAMB OF GOD

selling cattle, sheep, and doves, and the money chang
ers seated at their tables. ¹⁵ Making a whip of cords,
he drove all of them out of the temple, both the
sheep and the cattle. He also poured out the coins
of the money changers & overturned their tables.
¹⁶ He told those who were selling the doves, "Take
these things out of here! Stop making my Father's
house a marketplace!" ¹⁷ His disciples remembered
that it was written, "Zeal for your house will con
sume me." ¹⁸ The Jews then said to him, "What sign
can you show us for doing this?" ¹⁹ Jesus answered
them, "Destroy this temple, and in three days I will
raise it up." ²⁰ The Jews then said, "This temple has
been under construction for forty-six years, and
will you raise it up in three days?" ²¹ But he was speak
ing of the temple of his body. ²² After he was raised
from the dead, his disciples remembered that he
had said this; and they believed the scripture and
the word that Jesus had spoken. ∎ When he was in
Jerusalem during the Passover festival, many believed
in his name because they saw the signs that he was
doing. ²⁴ But Jesus on his part would not entrust
himself to them, because he knew all people ²⁵ and
needed no one to testify about anyone; for he him
self knew what was in everyone.

3

Now there was a Pharisee named Nicode
mus, a leader of the Jews. ² He came to
Jesus by night and said to him, "Rabbi,
we know that you are a teacher who has come from
God; for no one can do these signs that you do apart
from the presence of God." ³ Jesus answered him,
"Very truly, I tell you, no one can see the kingdom
of God without being born from above." ⁴ Nicode
mus said to him, "How can anyone be born after
having grown old? Can one enter a second time in
to the mother's womb & be born?" ⁵ Jesus answered,
"Very truly, I tell you, no one can enter the kingdom
of God without being born of water & Spirit. ⁶ What
is born of the flesh is flesh, and what is born of the
Spirit is spirit. ⁷ Do not be astonished that I said
to you, 'You must be born from above.' ⁸ The wind
blows where it chooses, and you hear the sound of
it, but you do not know where it comes from or
where it goes. So it is with everyone who is born of
the Spirit." ⁹ Nicodemus said to him, "How can these
things be?" ¹⁰ Jesus answered him, "Are you a teacher
of Israel, and yet you do not understand these things?
∎ "Very truly, I tell you, we speak of what we know
and testify to what we have seen; yet you do not
receive our testimony. ¹² If I have told you about
earthly things and you do not believe, how can you

believe if I tell you about heavenly things? ¹³ No one
has ascended into heaven except the one who de
scended from heaven, the Son of Man. ¹⁴ And just
as Moses lifted up the serpent in the wilderness, so
must the Son of Man be lifted up, ¹⁵ that whoever
believes in him may have eternal life. ∎ "For God
so loved the world that he gave his only Son, so that
everyone who believes in him may not perish but
may have eternal life. ∎ "Indeed, God did not send
the Son into the world to condemn the world, but
in order that the world might be saved through him.
¹⁸ Those who believe in him are not condemned;
but those who do not believe are condemned already,
because they have not believed in the name of the
only Son of God. ¹⁹ And this is the judgement, that
the light has come into the world, and people loved
darkness rather than light because their deeds were
evil. ²⁰ For all who do evil hate the light and do not
come to the light, so that their deeds may not be
exposed. ²¹ But those who do what is true come to
the light, so that it may be clearly seen that their
deeds have been done in God."

∎ After this Jesus and his disciples went into the
Judean countryside, and he spent some time there
with them & baptized. ²³ John also was baptizing
at Aenon near Salim because water was abundant
there; and people kept coming & were being bap
tized ²⁴ — John, of course, had not yet been thrown
into prison. ∎ Now a discussion about purification
arose between John's disciples and a Jew. ²⁶ They
came to John and said to him, "Rabbi, the one who
was with you across the Jordan, to whom you tes
tified, here he is baptizing, and all are going to him."
²⁷ John answered, "No one can receive anything ex
cept what has been given from heaven. ²⁸ You your
selves are my witnesses that I said, 'I am not the
Messiah, but I have been sent ahead of him.' ²⁹ He
who has the bride is the bridegroom. The friend of
the bridegroom, who stands and hears him, rejoices
greatly at the bridegroom's voice. For this reason
my joy has been fulfilled. ³⁰ He must increase, but
I must decrease." ∎ The one who comes from above
is above all; the one who is of the earth belongs to
the earth and speaks about earthly things. The one
who comes from heaven is above all. ³² He testifies
to what he has seen & heard, yet no one accepts his
testimony. ³³ Whoever has accepted his testimony
has certified this, that God is true. ³⁴ He whom
God has sent speaks the words of God, for he gives
the Spirit without measure. ³⁵ The Father loves the
Son and has placed all things in his hands. ³⁶ Whoever
believes in the Son has eternal life; whoever disobeys
the Son will not see life, but must endure God's wrath.

ⁱ Other ancient authorities
read is God's chosen one
ʲ or Christ
ᵏ Gk him
ˡ From the word for rock
in Aramaic (kepha) and
Greek (petra), respectively
ᵐ Both instances of the
Greek word for you in this
verse are plural
ᵍ Gk him
ᵒ Or born anew
ᵖ The same Greek word
means both wind and spirit
ᵠ The Greek word for you
here is plural
ʳ Or anew
ˢ The same Greek word
means both wind and spirit
ᵗ The Greek word for you
here and in verse 12 is
plural
ᵘ Other ancient authorities
add who is in heaven
ᵛ Some interpreters hold
that the quotation
concludes with verse 15
ʷ Some interpreters hold
that the quotation
concludes with verse 15
ˣ Other ancient authorities
read the Jews
ʸ Or the Christ
ᶻ Some interpreters hold
that the quotation
continues through verse 36
ᵃ Gk set a seal to

4

Now when Jesus learned that the Pharisees had heard, "Jesus is making & baptizing more disciples than John"[b] —although it was not Jesus himself but his disciples who baptized— [3] he left Judea and started back to Galilee. [4] But he had to go through Samaria. [5] So he came to a Samaritan city called Sychar, near the plot of ground that Jacob had given to his son Joseph. [6] Jacob's well was there, and Jesus, tired out by his journey, was sitting by the well. It was about noon.

[7] ¶ A Samaritan woman came to draw water, and Jesus said to her, "Give me a drink." [8] [His disciples had gone to the city to buy food.] [9] The Samaritan woman said to him, "How is it that you, a Jew, ask a drink of me, a woman of Samaria?" [Jews do not share things in common with Samaritans.] [10] Jesus answered her, "If you knew the gift of God, and who it is that is saying to you, 'Give me a drink,' you would have asked him, and he would have given you living water." [11] The woman said to him, "Sir, you have no bucket, and the well is deep. Where do you get that living water? [12] Are you greater than our ancestor Jacob, who gave us the well, and with his sons and his flocks drank from it?" [13] Jesus said to her, "Everyone who drinks of this water will be thirsty again, [14] but those who drink of the water that I will give them will never be thirsty. The water that I will give will become in them a spring of water gushing up to eternal life." [15] The woman said to him, "Sir, give me this water, so that I may never be thirsty or have [16] to keep coming here to draw water." ¶ Jesus said to her, "Go, call your husband and come back." [17] The woman answered him, "I have no husband." Jesus said to her, "You are right in saying, 'I have no husband'; [18] for you have had five husbands, and the one you have now is not your husband. What you have said is true!" [19] The woman said to him, "Sir, I see that you are a prophet. [20] Our ancestors worshiped on this mountain, but you[d] say that the place where people must worship is in Jerusalem." [21] Jesus said to her, "Woman, believe me, the hour is coming when you will worship the Father neither on this mountain nor in Jerusalem. [22] You worship what you do not know; we worship what we know, for salvation is from the Jews. [23] But the hour is coming, & is now here, when the true worshipers will worship the Father in spirit and truth, for the Father seeks such as these to worship him. [24] God is spirit, and those who worship him must worship in spirit and truth." [25] The woman said to him, "I know that Messiah is coming" [who is called Christ]. "When he comes, he will proclaim all things to us." [26] Jesus said to her, "I am he,[e] the one who is speaking to [27] you." ¶ Just then his disciples came. They were as-

tonished that he was speaking with a woman, but no one said, "What do you want?" or, "Why are you speaking with her?" [28] Then the woman left her water jar and went back to the city. She said to the people, [29] "Come and see a man who told me everything I have ever done! He cannot be the Messiah, can he?" [30] They left the city and were on their way [31] to him. ¶ Meanwhile the disciples were urging him, "Rabbi, eat something." [32] But he said to them, "I have food to eat that you do not know about." [33] So the disciples said to one another, "Surely no one has brought him something to eat?" [34] Jesus said to them, "My food is to do the will of him who sent me & to complete his work. [35] Do you not say, 'Four months more, then comes the harvest'? But I tell you, look around you, and see how the fields are ripe for harvesting.[g] [36] The reaper is already receiving[g] wages & is gathering fruit for eternal life, so that sower and reaper may rejoice together. [37] For here the saying holds true, 'One sows and another reaps.' [38] I sent you to reap that for which you did not labor. Others have labored, and you have entered into their labor."

[39] ¶ Many Samaritans from that city believed in him because of the woman's testimony, "He told me everything I have ever done." [40] So when the Samaritans came to him, they asked him to stay with them; and he stayed there two days. [41] And many more believed because of his word. [42] They said to the woman, "It is no longer because of what you said that we believe, for we have heard for ourselves, and we know that [43] this is truly the Savior of the world." ¶ When the two days were over, he went from that place to Galilee [44] [for Jesus himself had testified that a prophet has no honor in the prophet's own country]. [45] When he came to Galilee, the Galileans welcomed him, since they had seen all that he had done in Jerusalem at the festival; for they too had gone to the festival.

[46] ¶ Then he came again to Cana in Galilee where he had changed the water into wine. Now there was a royal official whose son lay ill in Capernaum. [47] When he heard that Jesus had come from Judea to Galilee, he went and begged him to come down and heal his son, for he was at the point of death. [48] Then Jesus said to him, "Unless you[h] see signs and wonders you will not believe." [49] The official said to him, "Sir, come down before my little boy dies." [50] Jesus said to him, "Go, your son will live." The man believed the word that Jesus spoke to him & started on his way. [51] As he was going down, his slaves met him & told him that his child was alive. [52] So he asked them the hour when he began to recover; and they said to him, "Yesterday at one in the afternoon the fever left him." [53] The father realized that this was the hour when Jesus had said to him, "Your son will live." So

b Other ancient authorities read the Lord
c Other ancient authorities lack this sentence
d The Greek word for you here and in verses 21 and 22 is plural
e Gk I am
f Or the Christ
g Or "... the fields are already ripe for harvesting. The reaper is receiving
h Both instances of the Greek word for you in this verse are plural

he himself believed, along with his whole household. ⁵⁴ Now this was the second sign that Jesus did after coming from Judea to Galilee.

5

After this there was a festival of the Jews, and Jesus went up to Jerusalem. ❡ Now in Jerusalem by the Sheep Gate there is a pool, called in Hebrew Beth-zatha,ᵏ which has five porticoes. ³ In these lay many invalids – blind, lame, and paralyzed. ⁵ One man was there who had been ill for thirty-eight years. ⁶ When Jesus saw him lying there and knew that he had been there a long time, he said to him, "Do you want to be made well?" ⁷ The sick man answered him, "Sir, I have no one to put me into the pool when the water is stirred up; and while I am making my way, someone else steps down ahead of me." ⁸ Jesus said to him, "Stand up, take your mat and walk." ⁹ At once the man was made well, and he took up his mat and began to walk. ❡ Now that day was a sabbath. ¹⁰ So the Jews said to the man who had been cured, "It is the sabbath; it is not lawful for you to carry your mat." ¹¹ But he answered them, "The man who made me well said to me, 'Take up your mat & walk.'" ¹² They asked him, "Who is the man who said to you, 'Take it up and walk'?" ¹³ Now the man who had been healed did not know who it was, for Jesus had disappeared in the crowd that was there. ¹⁴ Later Jesus found him in the temple and said to him, "See, you have been made well! Do not sin any more, so that nothing worse happens to you." ¹⁵ The man went away and told the Jews that it was Jesus who had made him well. ¹⁶ Therefore the Jews started persecuting Jesus, because he was doing such things on the sabbath. ¹⁷ But Jesus answered them, "My Father is still working, and I also am working." ¹⁸ For this reason the Jews were seeking all the more to kill him, because he was not only breaking the sabbath, but was also calling God his own Father, thereby making himself equal to God. ❡ Jesus said to them, "Very truly, I tell you, the Son can do nothing on his own, but only what he sees the Father doing; for whatever the Father does, the Son does likewise. ²⁰ The Father loves the Son and shows him all that he himself is doing; and he will show him greater works than these, so that you will be astonished. ²¹ Indeed, just as the Father raises the dead and gives them life, so also the Son gives life to whomever he wishes. ²² The Father judges no one but has given all judgment to the Son, ²³ so that all may honor the Son just as they honor the Father. Anyone who does not honor the Son does not honor the Father who sent him. ²⁴ Very truly, I tell you, anyone who hears my word and believes him who sent me has eternal life, and does not come under judgment, but has passed from death to life. ❡ "Very truly, I tell you, the hour is coming, and is now here, when the dead will hear the voice of the Son of God, and those who hear will live. ²⁶ For just as the Father has life in himself, so he has granted the Son also to have life in himself; ²⁷ and he has given him authority to execute judgment, because he is the Son of Man. ²⁸ Do not be astonished at this; for the hour is coming when all who are in their graves will hear his voice ²⁹ and will come out — those who have done good, to the resurrection of life, and those who have done evil, to the resurrection of condemnation. ❡ "I can do nothing on my own. As I hear, I judge; and my judgment is just, because I seek to do not my own will but the will of him who sent me. ❡ "If I testify about myself, my testimony is not true. ³² There is another who testifies on my behalf, and I know that his testimony to me is true. ³³ You sent messengers to John, and he testified to the truth. ³⁴ Not that I accept such human testimony, but I say these things so that you may be saved. ³⁵ He was a burning & shining lamp, and you were willing to rejoice for a while in his light. ³⁶ But I have a testimony greater than John's. The works that the Father has given me to complete, the very works that I am doing, testify on my behalf that the Father has sent me. ³⁷ And the Father who sent me has himself testified on my behalf. You have never heard his voice or seen his form, ³⁸ and you do not have his word abiding in you, because you do not believe him whom he has sent. ❡ "You search the scriptures because you think that in them you have eternal life; and it is they that testify on my behalf. ⁴⁰ Yet you refuse to come to me to have life. ⁴¹ I do not accept glory from human beings. ⁴² But I know that you do not have the love of God in you. ⁴³ I have come in my Father's name, and you do not accept me; if another comes in his own name, you will accept him. ⁴⁴ How can you believe when you accept glory from one another and do not seek the glory that comes from the one who alone is God? ⁴⁵ Do not think that I will accuse you before the Father; your accuser is Moses, on whom you have set your hope. ⁴⁶ If you believed Moses, you would believe me, for he wrote about me. ⁴⁷ But if you do not believe what he wrote, how will you believe what I say?"

ᵏ That is, Aramaic
ˡ Other ancient authorities read Bethesda, others Bethsaida
ʰ Other ancient authorities add, wholly or in part, waiting for the stirring of the water; ⁴ for an angel of the Lord went down at certain seasons into the pool, and stirred up the water; whoever stepped in first after the stirring of the water was made well from whatever disease that person had.
ⁱ Or had left because of
ᵐ Gk that one
ⁿ Or among

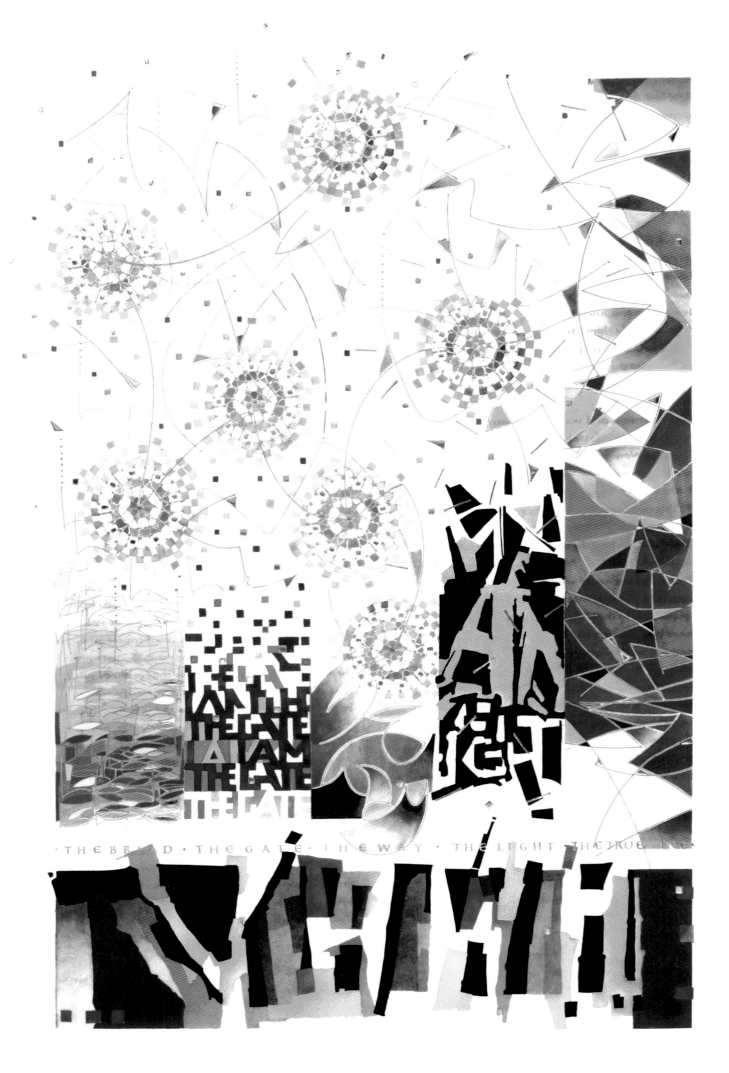

THE BREAD · THE GATE · THE WAY · THE LIGHT · THE TRUE

6

After this Jesus went to the other side of the Sea of Galilee, also called the Sea of Tiberias.[a] A large crowd kept following him, because they saw the signs that he was doing for the sick. ³ Jesus went up the mountain and sat down there with his disciples. ⁴ Now the Passover, the festival of the Jews, was near. ⁵ When he looked up & saw a large crowd coming toward him, Jesus said to Philip, "Where are we to buy bread for these people to eat?" ⁶ He said this to test him, for he himself knew what he was going to do. ⁷ Philip answered him, "Six months' wages[b] would not buy enough bread for each of them to get a little." ⁸ One of his disciples, Andrew, Simon Peter's brother, said to him, ⁹ "There is a boy here who has five barley loaves and two fish. But what are they among so many people?" ¹⁰ Jesus said, "Make the people sit down." Now there was a great deal of grass in the place; so they sat down, about five thousand in all. ¹¹ Then Jesus took the loaves, and when he had given thanks, he distributed them to those who were seated; so also the fish, as much as they wanted. ¹² When they were satisfied, he told his disciples, "Gather up the fragments left over, so that nothing may be lost." ¹³ So they gathered them up, and from the fragments of the five barley loaves, left by those who had eaten, they filled twelve baskets. ¹⁴ When the people saw the sign that he had done, they began to say, "This is indeed the prophet who is to come into the world."

¹⁵ When Jesus realized that they were about to come and take him by force to make him king, he withdrew again to the mountain by himself. ¹⁶ When evening came, his disciples went down to the sea, ¹⁷ got into a boat, and started across the sea to Capernaum. It was now dark, and Jesus had not yet come to them. ¹⁸ The sea became rough because a strong wind was blowing. ¹⁹ When they had rowed about three or four miles,[c] they saw Jesus walking on the sea and coming near the boat, and they were terrified. ²⁰ But he said to them, "It is I; do not be afraid." ²¹ Then they wanted to take him into the boat, and immediately the boat reached the land toward which they were going. ²² The next day the crowd that had stayed on the other side of the sea saw that there had been only one boat there. They also saw that Jesus had not got into the boat with his disciples, but that his disciples had gone away alone. ²³ Then some boats from Tiberias came near the place where they had eaten the bread after the Lord had given thanks.[d] ²⁴ So when the crowd saw that neither Jesus nor his disciples were there, they themselves got into the boats & went to Capernaum looking for Jesus. ²⁵ When they found him on the other side of the sea, they said to him, "Rabbi, when

did you come here?" ²⁶ Jesus answered them, "Very truly, I tell you, you are looking for me, not because you saw signs, but because you ate your fill of the loaves. ²⁷ Do not work for the food that perishes, but for the food that endures for eternal life, which the Son of Man will give you. For it is on him that God the Father has set his seal." ²⁸ Then they said to him, "What must we do to perform the works of God?" ²⁹ Jesus answered them, "This is the work of God, that you believe in him whom he has sent." ³⁰ So they said to him, "What sign are you going to give us then, so that we may see it and believe you? What work are you performing? ³¹ Our ancestors ate the manna in the wilderness; as it is written, 'He gave them bread from heaven to eat.'" ³² Then Jesus said to them, "Very truly, I tell you, it was not Moses who gave you the bread from heaven, but it is my Father who gives you the true bread from heaven. ³³ For the bread of God is that which comes down from heaven and gives life to the world." ³⁴ They said to him, "Sir, give us this bread always." ³⁵ Jesus said to them, "I am the bread of life. Whoever comes to me will never be hungry, and whoever believes in me will never be thirsty. ³⁶ But I said to you that you have seen me and yet do not believe. ³⁷ Everything that the Father gives me will come to me, and anyone who comes to me I will never drive away; ³⁸ for I have come down from heaven, not to do my own will, but the will of him who sent me. ³⁹ And this is the will of him who sent me, that I should lose nothing of all that he has given me, but raise it up on the last day. ⁴⁰ This is indeed the will of my Father, that all who see the Son and believe in him may have eternal life; and I will raise them up on the last day." ⁴¹ Then the Jews began to complain about him because he said, "I am the bread that came down from heaven." ⁴² They were saying, "Is not this Jesus, the son of Joseph, whose father and mother we know? How can he now say, 'I have come down from heaven'?" ⁴³ Jesus answered them, "Do not complain among yourselves. ⁴⁴ No one can come to me unless drawn by the Father who sent me; and I will raise that person up on the last day. ⁴⁵ It is written in the prophets, 'And they shall all be taught by God.' Everyone who has heard and learned from the Father comes to me. ⁴⁶ Not that anyone has seen the Father except the one who is from God; he has seen the Father. ⁴⁷ Very truly, I tell you, whoever believes has eternal life. ⁴⁸ I am the bread of life. ⁴⁹ Your ancestors ate the manna in the wilderness, and they died. ⁵⁰ This is the bread that comes down from heaven, so that one may eat of it and not die. ⁵¹ I am the living bread that came down from heaven. Whoever eats of this bread will live forever; and

✝

RSB

John 6:38

ᵃ Gk. of Galilee of Tiberias
ᵇ Gk. Two hundred denarii;
 the denarius was the usual
 day's wage for a laborer
ᶜ Gk. the men
ʳ Gk. about twenty-five or
 thirty stadia
ˢ Gk. I am
ᵗ Other ancient authorities
 lack after the Lord had
 given thanks
ᵘ Or he who

the bread that I will give for the life of the world is my flesh." ■ The Jews then disputed among themselves, saying, "How can this man give us his flesh to eat?" 53 So Jesus said to them, "Very truly, I tell you, unless you eat the flesh of the Son of Man & drink his blood, you have no life in you. 54 Those who eat my flesh and drink my blood have eternal life, and I will raise them up on the last day; 55 for my flesh is true food and my blood is true drink. 56 Those who eat my flesh & drink my blood abide in me, and I in them. 57 Just as the living Father sent me, and I live because of the Father, so whoever eats me will live because of me. 58 This is the bread that came down from heaven, not like that which your ancestors ate, and they died. But the one who eats this bread will live forever." 59 He said these things while he was teaching in the synagogue at Capernaum.

60 ■ When many of his disciples heard it, they said, "This teaching is difficult; who can accept it?" 61 But Jesus being aware that his disciples were complaining about it, said to them, "Does this offend you? 62 Then what if you were to see the Son of Man ascending to where he was before? 63 It is the spirit that gives life; the flesh is useless. The words that I have spoken to you are spirit and life. 64 But among you there are some who do not believe." For Jesus knew from the first who were the ones that did not believe, and who was the one that would betray him. 65 And he said, "For this reason I have told you that no one can come to me unless it is granted by the Father."

66 ■ Because of this many of his disciples turned back & no longer went about with him. 67 So Jesus asked the twelve, "Do you also wish to go away?" 68 Simon Peter answered him, "Lord, to whom can we go? You have the words of eternal life. 69 We have come to believe and know that you are the Holy One of God." 70 Jesus answered them, "Did I not choose you, the twelve? Yet one of you is a devil." 71 He was speaking of Judas son of Simon Iscariot, for he, though one of the twelve, was going to betray him.

7

After this Jesus went about in Galilee. He did not wish to go about in Judea because the Jews were looking for an opportunity to kill him. 2 Now the Jewish festival of Booths was near. 3 So his brothers said to him, "Leave here and go to Judea so that your disciples also may see the works you are doing; 4 for no one who wants to be widely known acts in secret. If you do these things, show yourself to the world." 5 [For not even his brothers believed in him.] 6 Jesus said to them, "My time has not yet come, but your time is always here.

7 The world cannot hate you, but it hates me because I testify against it that its works are evil. 8 Go to the festival yourselves. I am not going to this festival, for my time has not yet fully come." 9 After saying this, he remained in Galilee. 10 ■ But after his brothers had gone to the festival, then he also went, not publicly but as it were in secret. 11 The Jews were looking for him at the festival and saying, "Where is he?" 12 And there was considerable complaining about him among the crowds. While some were saying, "He is a good man," others were saying, "No, he is deceiving the crowd." 13 Yet no one would speak openly about him for fear of the Jews. ■ About the 14 middle of the festival Jesus went up into the temple and began to teach. 15 The Jews were astonished at it, saying, "How does this man have such learning, when he has never been taught?" 16 Then Jesus answered them, "My teaching is not mine but his who sent me. 17 Anyone who resolves to do the will of God will know whether the teaching is from God or whether I am speaking on my own. 18 Those who speak on their own seek their own glory; but the one who seeks the glory of him who sent him is true, and there is nothing false in him. 19 ■ "Did not Moses give you the law? Yet none of you keeps the law. Why are you looking for an opportunity to kill me?" 20 The crowd answered, "You have a demon! Who is trying to kill you?" 21 Jesus answered them, "I performed one work, and all of you are astonished. 22 Moses gave you circumcision [it is, of course, not from Moses, but from the patriarchs], and you circumcise a man on the sabbath. 23 If a man receives circumcision on the sabbath in order that the law of Moses may not be broken, are you angry with me because I healed a man's whole body on the sabbath? 24 Do not judge by appearances, but judge with right judgment." 25 ■ Now some of the people of Jerusalem were saying, "Is not this the man whom they are trying to kill? 26 And here he is, speaking openly, but they say nothing to him! Can it be that the authorities really know that this is the Messiah? 27 Yet we know where this man is from; but when the Messiah comes, no one will know where he is from." 28 Then Jesus cried out as he was teaching in the temple, "You know me, and you know where I am from. I have not come on my own. But the one who sent me is true, and you do not know him. 29 I know him because I am from him, and he sent me." 30 Then they tried to arrest him, but no one laid hands on him, because his hour had not yet come. 31 Yet many in the crowd believed in him & were saying, "When the Messiah comes, will he do more signs than this man has done?" 32 ■ The Pharisees heard the crowd muttering such things about him, and the chief

u other ancient authorities read the Christ, the Son of the living God
w other ancient authorities read Judas Iscariot son of Simon; others, Judas son of Simon from Karyot [Kerioth]
x other ancient authorities read was not at liberty
y or Tabernacles
z other ancient authorities read wants it
a other ancient authorities add yet
b other ancient authorities lack as it were
c or this man knows his letters
d or the Christ
e or the Christ
f or the Christ
g other ancient authorities read is doing
h or come to me and drink
38 The one who believes in me, as
i Gk out of his belly
j other ancient authorities read for as yet the Spirit [others, Holy Spirit] had not been given
k or the Christ
l or the Christ
m or the Christ
n Gk him

priests and Pharisees sent temple police to arrest him. 33 Jesus then said, "I will be with you a little while longer, and then I am going to him who sent me. 34 You will search for me, but you will not find me; and where I am, you cannot come." 35 The Jews said to one another, "Where does this man intend to go that we will not find him? Does he intend to go to the Dispersion among the Greeks and teach the Greeks? 36 What does he mean by saying, 'You will search for me and you will not find me' and 'Where I am, you cannot come'?" 37 On the last day of the festival, the great day, while Jesus was standing there, he cried out, "Let anyone who is thirsty come to me, 38 and let the one who believes in me drink. As the scripture has said, 'Out of the believer's heart shall flow rivers of living water.'" 39 Now he said this about the Spirit, which believers in him were to receive; for as yet there was no Spirit, because Jesus was not yet glorified. 40 When they heard these words, some in the crowd said, "This is really the prophet." 41 Others said, "This is the Messiah." But some asked, "Surely the Messiah does not come from Galilee, does he? 42 Has not the scripture said that the Messiah is descended from David & comes from Bethlehem, the village where David lived?" 43 So there was a division in the crowd because of him. 44 Some of them wanted to arrest him, but no one laid hands on him. 45 Then the temple police went back to the chief priests and Pharisees, who asked them, "Why did you not arrest him?" 46 The police answered, "Never has anyone spoken like this!" 47 Then the Pharisees replied, "Surely you have not been deceived too, have you? 48 Has any one of the authorities or of the Pharisees believed in him? 49 But this crowd, which does not know the law — they are accursed." 50 Nicodemus, who had gone to Jesus before, and who was one of them, asked, 51 "Our law does not judge people without first giving them a hearing to find out what they are doing, does it?" 52 They replied, "Surely you are not also from Galilee, are you? Search and you will see that no prophet is to arise from Galilee."

8 [[53 Then each of them went home, 1 While Jesus went to the Mount of Olives. 2 Early in the morning he came again to the temple. All the people came to him and he sat down and began to teach them. 3 The scribes and the Pharisees brought a woman who had been caught in adultery; and making her stand before all of them, they said to him, "Teacher, this woman was caught in the very act of committing adultery. 5 Now in the law Moses commanded us to stone such women. Now what do you say?" 6 They said this to test him, so that they might have some

charge to bring against him. Jesus bent down and wrote with his finger on the ground. 7 When they kept on questioning him, he straightened up and said to them, "Let anyone among you who is without sin be the first to throw a stone at her." 8 And once again he bent down & wrote on the ground. 9 When they heard it, they went away, one by one, beginning with the elders; and Jesus was left alone with the woman standing before him. 10 Jesus straightened up & said to her, "Woman, where are they? Has no one condemned you?" 11 She said, "No one, sir." And Jesus said, "Neither do I condemn you. Go your way, and from now on do not sin again."]]

c other ancient authorities add *the sins of each of them*
f *Or Lord*
g The most ancient authorities lack 7.53 — 8.11; other authorities add the passage here or after 7.36 or after 21.25 or after Luke 21.38, with variations of text; some mark the passage as doubtful.

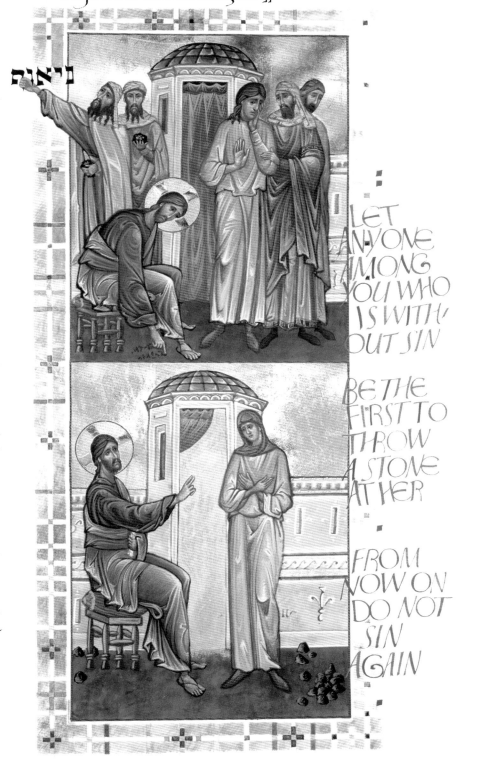

LET ANYONE AMONG YOU WHO IS WITHOUT SIN

BE THE FIRST TO THROW A STONE AT HER

FROM NOW ON DO NOT SIN AGAIN

12 ❧ Again Jesus spoke to them, saying, "I am the light of the world. Whoever follows me will never walk in darkness but will have the light of life." **13** Then the Pharisees said to him, "You are testifying on your own behalf; your testimony is not valid." **14** Jesus answered, "Even if I testify on my own behalf, my testimony is valid because I know where I have come from and where I am going, but you do not know where I come from or where I am going. **15** You judge by human standards; I judge no one. **16** Yet even if I do judge, my judgment is valid; for it is not I alone who judge, but I and the Father who sent me. **17** In your law it is written that the testimony of two witnesses is valid. **18** I testify on my own behalf and the Father who sent me testifies on my behalf." **19** Then they said to him, "Where is your Father?" Jesus answered, "You know neither me nor my Father. If you knew me, you would know my Father also."

20 He spoke these words while he was teaching in the treasury of the temple, but no one arrested him, because his hour had not yet come. ❧ **21** Again he said to them, "I am going away, and you will search for me, but you will die in your sin. Where I am going, you cannot come." **22** Then the Jews said, "Is he going to kill himself? Is that what he means by saying, 'Where I am going, you cannot come'?" **23** He said to them, "You are from below, I am from above; you are of this world, I am not of this world. **24** I told you that you would die in your sins, for you will die in your sins unless you believe that I am he." **25** They said to him, "Who are you?" Jesus said to them, "Why do I speak to you at all? **26** I have much to say about you and much to condemn; but the one who sent me is true, and I declare to the world what I have heard from him." **27** They did not understand that he was speaking to them about the Father. **28** So Jesus said, "When you have lifted up the Son of Man, then you will realize that I am he, and that I do nothing on my own, but I speak these things as the Father instructed me. **29** And the one who sent me is with me; he has not left me alone, for I always do what is pleasing to him." **30** As he was saying these things, many believed in him. ❧ **31** Then Jesus said to the Jews who had believed in him, "If you continue in my word, you are truly my disciples; **32** and you will know the truth, and the truth will make you free." **33** They answered him, "We are descendants of Abraham and have never been slaves to anyone. What do you mean by saying, 'You will be made free'?" ❧ **34** Jesus answered them, "Very truly, I tell you, everyone who commits sin is a slave to sin. **35** The slave does not have a permanent place in the household; the son has a place there forever. **36** So if the Son makes you free, you will be free indeed. **37** I

know that you are descendants of Abraham; yet you look for an opportunity to kill me, because there is no place in you for my word. **38** I declare what I have seen in the Father's presence; as for you, you should **39** do what you have heard from the father." ❧ They answered him, "Abraham is our father." Jesus said to them, "If you were Abraham's children, you would be doing what Abraham did, **40** but now you are trying to kill me, a man who has told you the truth that I heard from God. This is not what Abraham did. **41** You are indeed doing what your father does." They said to him, "We are not illegitimate children; we have one father, God himself." **42** Jesus said to them, "If God were your Father, you would love me, for I came from God and now I am here. I did not come on my own, but he sent me. **43** Why do you not understand what I say? It is because you cannot accept my word. **44** You are from your father the devil, and you choose to do your father's desires. He was a murderer from the beginning and does not stand in the truth, because there is no truth in him. When he lies, he speaks according to his own nature, for he is a liar and the father of lies. **45** But because I tell the truth, you do not believe me. **46** Which of you convicts me of sin? If I tell the truth, why do you not believe me? **47** Whoever is from God hears the words of God. The reason you do not hear them is that you are not from God." ❧ **48** The Jews answered him, "Are we not right in saying that you are a Samaritan & have a demon?" **49** Jesus answered, "I do not have a demon; but I honor my father, and you dishonor me. **50** Yet I do not seek my own glory; there is one who seeks it & he is the judge. **51** Very truly, I tell you, whoever keeps my word will never see death." **52** The Jews said to him, "Now we know that you have a demon. Abraham died, and so did the prophets; yet you say, 'Whoever keeps my word will never taste death.' **53** Are you greater than our father Abraham, who died? The prophets also died. Who do you claim to be?" **54** Jesus answered, "If I glorify myself, my glory is nothing. It is my Father who glorifies me, he of whom you say, 'He is our God,' **55** though you do not know him. But I know him; if I would say that I do not know him, I would be a liar like you. But I do know him and I keep his word. **56** Your ancestor Abraham rejoiced that he would see my day; he saw it and was glad." **57** Then the Jews said to him, "You are not yet fifty years old, and have you seen Abraham?" **58** Jesus said to them, "Very truly, I tell you, before Abraham was, I am." **59** So they picked up stones to throw at him, but Jesus hid himself and went out of the temple.

r Gk according to the flesh
s Other ancient authorities
 read he
t Gk I am
u Or What I have told you
 from the beginning
v Gk I am
w Other ancient authorities
 read you do what you have
 heard from your father
x Other ancient authorities
 read If you are Abraham's
 children, then do
y Other ancient authorities
 read has Abraham seen
 you?

9

As he walked along, he saw a man blind from birth. [2] His disciples asked him, "Rabbi, who sinned, this man or his parents, that he was born blind?" [3] Jesus answered, "Neither this man nor his parents sinned; he was born blind so that God's works might be revealed in him. [4] We must work the works of him who sent me while it is day; night is coming when no one can work. [5] As long as I am in the world, I am the light of the world." [6] When he had said this, he spat on the ground and made mud with the saliva and spread the mud on the man's eyes, [7] saying to him, "Go, wash in the pool of Siloam" (which means Sent). Then he went & washed & came back able to see. [8] The neighbors and those who had seen him before as a beggar began to ask, "Is this not the man who used to sit and beg?" [9] Some were saying, "It is he." Others were saying, "No, but it is someone like him." He kept saying, "I am the man." [10] But they kept asking him, "Then how were your eyes opened?" [11] He answered, "The man called Jesus made mud, spread it on my eyes, and said to me, 'Go to Siloam & wash.' Then I went and washed and received my sight." [12] They said to him, "Where is he?" He said, "I do not know." [13] They brought to the Pharisees the man who had formerly been blind. [14] Now it was a sabbath day when Jesus made the mud and opened his eyes. [15] Then the Pharisees also began to ask him how he had received his sight. He said to them, "He put mud on my eyes. Then I washed, and now I see." [16] Some of the Pharisees said, "This man is not from God, for he does not observe the sabbath." But others said, "How can a man who is a sinner perform such signs?" And they were divided. [17] So they said again to the blind man, "What do you say about him? It was your eyes he opened." He said, "He is a prophet." [18] The Jews did not believe that he had been blind and had received his sight until they called the parents of the man who had received his sight [19] and asked them, "Is this your son, who you say was born blind? How then does he now see?" [20] His parents answered, "We know that this is our son, and that he was born blind; [21] but we do not know how it is that now he sees, nor do we know who opened his eyes. Ask him; he is of age. He will speak for himself." [22] His parents said this because they were afraid of the Jews; for the Jews had already agreed that anyone who confessed Jesus to be the Messiah would be put out of the synagogue. [23] Therefore his parents said, "He is of age; ask him." [24] So for the second time they called the man who had been blind, and they said to him, "Give glory to God! We know that this man is a sinner." [25] He answered, "I do not know whether he is a sinner. One thing I do know, that though I was blind, now I see." [26] They said to him, "What did he do to you? How did he open your eyes?" [27] He answered them, "I have told you already, and you would not listen. Why do you want to hear it again? Do you also want to become his disciples?" [28] Then they reviled him, saying, "You are his disciple, but we are disciples of Moses. [29] We know that God has spoken to Moses, but as for this man, we do not know where he comes from." [30] The man answered, "Here is an astonishing thing! You do not know where he comes from, and yet he opened my eyes. [31] We know that God does not listen to sinners, but he does listen to one who worships him and obeys his will. [32] Never since the world began has it been heard that anyone opened the eyes of a person born blind. [33] If this man were not from God, he could do nothing." [34] They answered him, "You were born entirely in sins, and are you trying to teach us?" And they drove him out. [35] Jesus heard that they had driven him out, and when he found him, he said, "Do you believe in the Son of Man?" [36] He answered, "And who is he, sir? Tell me, so that I may believe in him." [37] Jesus said to him, "You have seen him, and the one speaking with you is he." [38] He said, "Lord, I believe." And he worshiped him. [39] Jesus said, "I came into this world for judgment so that those who do not see may see, and those who do see may become blind." [40] Some of the Pharisees near him heard this and said to him, "Surely we are not blind, are we?" [41] Jesus said to them, "If you were blind, you would not have sin. But now that you say, 'We see,' your sin remains.

10

"Very truly, I tell you, anyone who does not enter the sheepfold by the gate but climbs in by another way is a thief and a bandit. [2] The one who enters by the gate is the shepherd of the sheep. [3] The gatekeeper opens the gate for him, and the sheep hear his voice. He calls his own sheep by name and leads them out. [4] When he has brought out all his own, he goes ahead of them, and the sheep follow him because they know his voice. [5] They will not follow a stranger, but they will run from him because they do not know the voice of strangers." [6] Jesus used this figure of speech with them, but they did not understand what he was saying to them. [7] So again Jesus said to them, "Very truly, I tell you, I am the gate for the sheep. [8] All who came before me are thieves and bandits; but the sheep did not listen to them. [9] I am the gate. Whoever enters by me will be saved, and will come in and go out and find pasture. [10] The thief comes only to steal and

[2] Other ancient authorities read I
[3] Other ancient authorities read us
[b] Gk him
[c] Or the Christ
[d] Other ancient authorities read the Son of God
[e] Sir and Lord translate the same Greek word
[f] Sir and Lord translate the same Greek word

kill and destroy. I came that they may have life, and
11 have it abundantly. ■ "I am the good shepherd. The
good shepherd lays down his life for the sheep. [12] The
hired hand, who is not the shepherd and does not
own the sheep, sees the wolf coming and leaves the
sheep and runs away—and the wolf snatches them
and scatters them. [13] The hired hand runs away be-
cause a hired hand does not care for the sheep. [14] I
am the good shepherd. I know my own & my own
know me, [15] just as the Father knows me & I know
the Father. And I lay down my life for the sheep.
[16] I have other sheep that do not belong to this fold.
I must bring them also, and they will listen to my
voice. So there will be one flock, one shepherd. [17] For
this reason the Father loves me, because I lay down
my life in order to take it up again. [18] No one takes
it from me, but I lay it down of my own accord. I
have power to lay it down, and I have power to take
it up again. I have received this command from my
19 Father." ■ Again the Jews were divided because of
these words. [20] Many of them were saying, "He has
a demon & is out of his mind. Why listen to him?"
[21] Others were saying, "These are not the words of
one who has a demon. Can a demon open the eyes
22 of the blind?" ■ At that time the festival of the Ded-
ication took place in Jerusalem. It was winter, [23] and
Jesus was walking in the temple, in the portico of
Solomon. [24] So the Jews gathered around him and
said to him, "How long will you keep us in suspense?
If you are the Messiah, tell us plainly." [25] Jesus an-
swered, "I have told you, and you do not believe.
The works that I do in my Father's name testify to
me; [26] but you do not believe, because you do not
belong to my sheep. [27] My sheep hear my voice. I
know them, and they follow me. [28] I give them eter-
nal life, and they will never perish. No one will snatch
them out of my hand. [29] What my Father has given
me is greater than all else, and no one can snatch it
out of the Father's hand. [30] The Father and I are one."
31 ■ The Jews took up stones again to stone him. [32] Jesus
replied, "I have shown you many good works from
the Father. For which of these are you going to stone
me?" [33] The Jews answered, "It is not for a good work

that we are going to stone you, but for blasphemy
because you, though only a human being, are mak-
ing yourself God." [34] Jesus answered, "Is it not writ-
ten in your law, 'I said, you are gods'? [35] If those to
whom the word of God came were called 'gods'—
and the scripture cannot be annulled— [36] can you
say that the one whom the Father has sanctified &
sent into the world is blaspheming because I said,
'I am God's Son'? [37] If I am not doing the works of
my Father, then do not believe me. [38] But if I do them,
even though you do not believe me, believe the works,
so that you may know and understand that the
Father is in me & I am in the Father." [39] Then they
tried to arrest him again, but he escaped from their
40 hands. ■ He went away again across the Jordan to
the place where John had been baptizing earlier,
and he remained there. [41] Many came to him, and
they were saying, " John performed no sign, but
everything that John said about this man was true."
[42] And many believed in him there.

11

Now a certain man was ill, Lazarus of Beth-
any, the village of Mary and her sister
Martha. [2] Mary was the one who anoint-
ed the Lord with perfume and wiped his feet with
her hair; her brother Lazarus was ill. [3] So the sisters
sent a message to Jesus, "Lord, he whom you love
is ill." [4] But when Jesus heard it, he said, "This illness
does not lead to death; rather it is for God's glory,
so that the Son of God may be glorified through

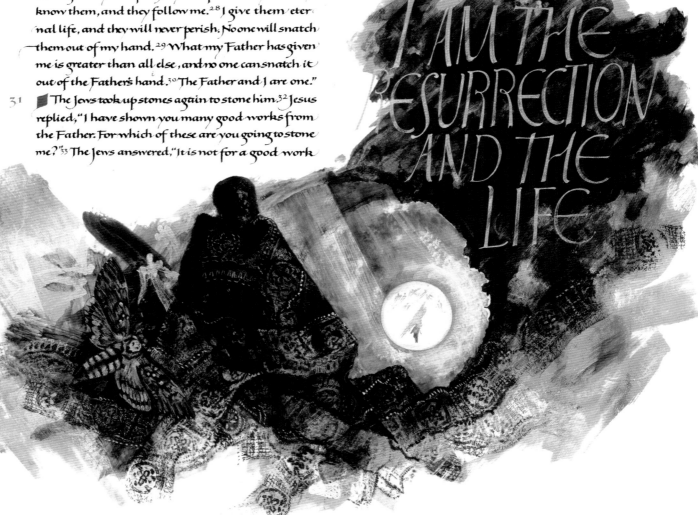

it." 5 Accordingly, though Jesus loved Martha and her sister and Lazarus, 6 after having heard that Lazarus was ill, he stayed two days longer in the place where he was. ❡ Then after this he said to the disciples, "Let us go to Judea again." 8 The disciples said to him, " Rabbi, the Jews were just now trying to stone you, and are you going there again?" 9 Jesus answered, "Are there not twelve hours of daylight? Those who walk during the day do not stumble, because they see the light of this world. 10 But those who walk at night stumble, because the light is not in them." 11 After saying this, he told them, "Our friend Lazarus has fallen asleep, but I am going there to awaken him." 12 The disciples said to him, "Lord, if he has fallen asleep, he will be all right." 13 Jesus, however, had been speaking about his death, but they thought that he was referring merely to sleep. 14 Then Jesus told them plainly, " Lazarus is dead. 15 For your sake I am glad I was not there, so that you may believe. But let us go to him." 16 Thomas, who was called the Twin, said to his fellow disciples, "Let us also go, that we may die with him." ❡ When Jesus arrived, he found that Lazarus had already been in the tomb four days. 18 Now Bethany was near Jerusalem, some two miles away, 19 and many of the Jews had come to Martha & Mary to console them about their brother. 20 When Martha heard that Jesus was coming, she went & met him, while Mary stayed at home. 21 Martha said to Jesus, "Lord, if you had been here, my brother would not have died. 22 But even now I know that God will give you whatever you ask of him." 23 Jesus said to her." Your brother will rise again." 24 Martha said to him," I know that he will rise again in the resurrection on the last day." 25 Jesus said to her. "I am the resurrection and the life. Those who believe in me, even though they die, will live, 26 and everyone who lives and believes in me will never die. Do you believe this?" 27 She said to him, "Yes, Lord, I believe that you are the Messiah, the Son of God, the one coming into the world." ❡ When she had said this, she went back and called her sister Mary, and told her privately, "The Teacher is here and is calling for you." 29 And when she heard it, she got up quickly and went to him. 30 Now Jesus had not yet come to the village, but was still at the place where Martha had met him. 31 The Jews who were with her in the house, consoling her, saw Mary get up quickly and go out. They followed her because they thought that she was going to the tomb to weep there. 32 When Mary came where Jesus was and saw him, she knelt at his feet & said to him, "Lord, if you had been here, my brother would not have died." 33 When Jesus saw her weeping, and the Jews who came with her

also weeping, he was greatly disturbed in spirit & deeply moved. 34 He said, "Where have you laid him?" They said to him, "Lord, come and see." 35 Jesus began to weep. 36 So the Jews said, "See how he loved him!" 37 But some of them said, "Could not he who opened the eyes of the blind man have kept this man from dying?" ❡ Then Jesus, again greatly disturbed, came to the tomb. It was a cave, and a stone was lying against it. 39 Jesus said, "Take away the stone." Martha, the sister of the dead man, said to him, "Lord, already there is a stench because he has been dead four days." 40 Jesus said to her, "Did I not tell you that if you believed, you would see the glory of God?" 41 So they took away the stone. And Jesus looked upward and said, " Father, I thank you for having heard me. 42 I knew that you always hear me, but I have said this for the sake of the crowd standing here, so that they may believe that you sent me." 43 When he had said this, he cried with a loud voice, "Lazarus, come out!" 44 The dead man came out, his hands and feet bound with strips of cloth, and his face wrapped in a cloth. Jesus said to them, "Unbind him, and let him go." ❡ Many of the Jews therefore, who had come with Mary and had seen what Jesus did, believed in him. 46 But some of them went to the Pharisees and told them what he had done. 47 So the chief priests & the Pharisees called a meeting of the council, and said, " What are we to do? This man is performing many signs. 48 If we let him go on like this, everyone will believe in him, and the Romans will come & destroy both our holy place and our nation." 49 But one of them, Caiaphas, who was high priest that year, said to them, "You know nothing at all! 50 You do not understand that it is better for you to have one man die for the people than to have the whole nation destroyed." 51 He did not say this on his own, but being high priest that year he prophesied that Jesus was about to die for the nation, 52 and not for the nation only, but to gather into one the dispersed children of God. 53 So from that day on they planned to put him to death. ❡ Jesus therefore no longer walked about openly among the Jews, but went from there to a town called Ephraim in the region near the wilderness; and he remained there with the disciples. 55 ❡ Now the Passover of the Jews was near, and many went up from the country to Jerusalem before the Passover to purify themselves. 56 They were looking for Jesus & were asking one another as they stood in the temple, "What do you think? Surely he will not come to the festival, will he?" 57 Now the chief priests and the Pharisees had given orders that any one who knew where Jesus was should let them know, so that they might arrest him.

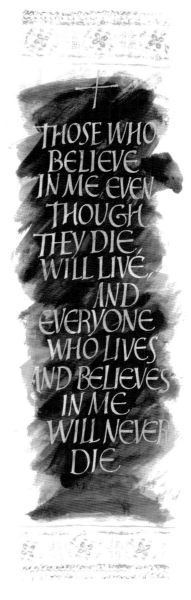

THOSE WHO BELIEVE IN ME, EVEN THOUGH THEY DIE, WILL LIVE, AND EVERYONE WHO LIVES AND BELIEVES IN ME WILL NEVER DIE

g Other ancient authorities read has taken
h Or the Christ
i Other ancient authorities read My Father who has given them to me is greater than all, and no one can snatch them out of the Father's hand
j Other ancient authorities read in the law
k Other ancient authorities lack and understand; others read and believe
l Gk him
m o t Gk he
n Gk Didymus
p Gk fifteen stadia
o Other ancient authorities lack and the life
o Or the Christ
o Or our temple; Greek our place

12

Six days before the Passover Jesus came to Bethany, the home of Lazarus, whom he had raised from the dead. ² There they gave a dinner for him. Martha served, and Lazarus was one of those at the table with him. ³ Mary took a pound of costly perfume made of pure nard, anointed Jesus' feet, and wiped them with her hair. The house was filled with the fragrance of the perfume. ⁴ But Judas Iscariot, one of his disciples [the one who was about to betray him], said, ⁵ "Why was this perfume not sold for three hundred denarii and the money given to the poor?" ⁶ [He said this not because he cared about the poor, but because he was a thief; he kept the common purse and used to steal what was put into it.] ⁷ Jesus said, "Leave her alone. She bought it so that she might keep it for the day of my burial. ⁸ You always have the poor with you, but you do not always have me." ⁹ When the great crowd of the Jews learned that he was there, they came not only because of Jesus but also to see Lazarus, whom he had raised from the dead. ¹⁰ So the chief priests planned to put Lazarus to death as well, ¹¹ since it was on account of him that many of the Jews were deserting and were believing in Jesus. ¹² The next day the great crowd that had come to the festival heard that Jesus was coming to Jerusalem. ¹³ So they took branches of palm trees and went out to meet him, shouting,

"Hosanna!
Blessed is the one who comes in the name of the Lord—
the King of Israel!"

¹⁴ Jesus found a young donkey and sat on it; as it is written:

¹⁵ "Do not be afraid, daughter of Zion.
Look, your king is coming,
sitting on a donkey's colt!"

¹⁶ His disciples did not understand these things at first; but when Jesus was glorified, then they remembered that these things had been written of him and had been done to him. ¹⁷ So the crowd that had been with him when he called Lazarus out of the tomb & raised him from the dead continued to testify. ¹⁸ It was also because they heard that he had performed this sign that the crowd went to meet him. ¹⁹ The Pharisees then said to one another, "You see, you can do nothing. Look, the world has gone after him!" ²⁰ Now among those who went up to worship at the festival were some Greeks. ²¹ They came to Philip, who was from Bethsaida in Galilee, and said to him, "Sir, we wish to see Jesus." ²² Philip went & told Andrew; then Andrew and Philip went and told Jesus. ²³ Jesus answered them, "The hour has come for the Son of Man to be glorified. ²⁴ Very truly, I tell you, unless a grain of wheat falls into the earth

& dies, it remains just a single grain; but if it dies, it bears much fruit. ²⁵ Those who love their life lose it, and those who hate their life in this world will keep it for eternal life. ²⁶ Whoever serves me must follow me, and where I am, there will my servant be also. Whoever serves me, the Father will honor. ²⁷ " Now my soul is troubled. And what should I say—'Father, save me from this hour'? No, it is for this reason that I have come to this hour. ²⁸ Father, glorify your name." Then a voice came from heaven, " I have glorified it, and I will glorify it again." ²⁹ The crowd standing there heard it and said that it was thunder. Others said, "An angel has spoken to him." ³⁰ Jesus answered, "This voice has come for your sake, not for mine. ³¹ Now is the judgment of this world; now the ruler of this world will be driven out. ³² And I, when I am lifted up from the earth, will draw all people to myself." ³³ He said this to indicate the kind of death he was to die. ³⁴ The crowd answered him, "We have heard from the law that the Messiah remains forever. How can you say that the Son of Man must be lifted up? Who is this Son of Man?" ³⁵ Jesus said to them, "The light is with you for a little longer. Walk while you have the light, so that the darkness may not overtake you. If you walk in the darkness, you do not know where you are going. ³⁶ While you have the light, believe in the light, so that you may become children of light." After Jesus had said this, he departed and hid from them. ³⁷ Although he had performed so many signs in their presence, they did not believe in him. ³⁸ This was to fulfill the word spoken by the prophet Isaiah:

"Lord, who has believed our message,
and to whom has the arm of the Lord been revealed?"

³⁹ And so they could not believe, because Isaiah also said,

⁴⁰ "He has blinded their eyes
and hardened their heart,
so that they might not look with their eyes,
and understand with their heart and turn—
and I would heal them.'"

⁴¹ Isaiah said this because he saw his glory and spoke about him. ⁴² Nevertheless many, even of the authorities, believed in him. But because of the Pharisees they did not confess it, for fear that they would be put out of the synagogue; ⁴³ for they loved human glory more than the glory that comes from God. ⁴⁴ Then Jesus cried aloud: "Whoever believes in me believes not in me but in him who sent me. ⁴⁵ And whoever sees me sees him who sent me. ⁴⁶ I have come as light into the world, so that everyone who believes in me should not remain in the darkness. ⁴⁷ I do not judge anyone who hears my words

†
RSB
John 12:35

ᵘ Gk: his feet
ᵛ Three hundred denarii
would be nearly a year's
wages for a laborer
ʷ Gk lacks She bought it
ˣ Other ancient authorities
read with him began to
testify that he had called ...
from the dead
ʸ Other ancient authorities
read all things
ᶻ Or the Christ
Other ancient witnesses
read when

and does not keep them, for I came not to judge the world, but to save the world. 48 The one who rejects me & does not receive my word has a judge; on the last day the word that I have spoken will serve as judge, 49 for I have not spoken on my own, but the Father who sent me has himself given me a commandment about what to say & what to speak. 50 And I know that his commandment is eternal life. What I speak, therefore, I speak just as the Father has told me."

13

Now before the festival of the Passover, Jesus knew that his hour had come to depart from this world & go to the Father. Having loved his own who were in the world, he loved them to the end. 2 The devil had already put it into the heart of Judas son of Simon Iscariot to betray him. And during supper 3 Jesus, knowing that the Father had given all things into his hands, and that he had come from God and was going to God, 4 got up from the table, took off his outer robe, and tied a towel around himself. 5 Then he poured water into a basin and began to wash the disciples' feet and to wipe them with the towel that was tied around him. 6 He came to Simon Peter, who said to him, "Lord, are you going to wash my feet?" 7 Jesus answered, "You do not know now what I am doing, but later you will understand." 8 Peter said to him, "You will never wash my feet." Jesus answered, "Unless I wash you, you have no share with me." 9 Simon Peter said to him, "Lord, not my feet only but also my hands and my head!" 10 Jesus said to him, "One who has bathed does not need to wash, except for the feet, but is entirely clean. And you are clean, though not all of you." 11 For he knew who was to betray him; for this reason he said, "Not all of you are clean." ¶ After he had washed their feet, had put on his robe, and had returned to the table, he said to them, "Do you know what I have done to you? 13 You call me Teacher & Lord — and you are right, for that is what I am. 14 So if I, your Lord and Teacher, have washed your feet, you also ought to wash one another's feet. 15 For I have set you an example, that you also should do as I have done to you. 16 Very truly, I tell you, servants are not greater than their master, nor are messengers greater than the one who sent them. 17 If you know these things, you are blessed if you do them. 18 I am not speaking of all of you; I know whom I have chosen. But it is to fulfill the scripture, 'The one who ate my bread has lifted his heel against me.' 19 I tell you this now, before it occurs, so that when it does occur, you may believe that I am he. 20 Very truly, I tell you, whoever receives one whom I send receives me; and whoever receives me receives him who sent me." ¶ After saying this Jesus was troubled in spirit, and declared, "Very truly, I tell you, one of you will betray me." 22 The disciples looked at one another, uncertain of whom he was speaking. 23 One of his disciples — the one whom Jesus loved — was reclining next to him; 24 Simon Peter therefore motioned to him to ask Jesus of whom he was speaking. 25 So while reclining next to Jesus, he asked him, "Lord, who is it?" 26 Jesus answered, "It is the one to whom I give this piece of bread when I have dipped it in the dish." So when he had dipped the piece of bread, he gave it to Judas son of Simon Iscariot. 27 After he received the piece of bread, Satan entered into him. Jesus said to him, "Do quickly what you are going to do." 28 Now no one at the table knew why he said this to him. 29 Some thought that, because Judas had the common purse, Jesus was telling him, "Buy what we need for the festival"; or, that he should give something to the poor. 30 So, after receiving the piece of bread, he immediately went out. And it was night. ¶ When he had gone out, Jesus said, "Now the Son of Man has been glorified, and God has been glorified in him. 32 If God has been glorified in him, God will also glorify him in himself & will glorify him at once. 33 Little children, I am with you only a little longer. You will look for me; and as I said to the Jews so now I say to you, 'Where I am going, you cannot come.' 34 I give you a new commandment, that you love one another. Just as I have loved you, you also should love one another. 35 By this everyone will know that you are my disciples, if you have love for one another." 36 ¶ Simon Peter said to him, "Lord, where are you going?" Jesus answered, "Where I am going, you cannot follow me now; but you will follow afterward." 37 Peter said to him, "Lord, why can I not follow you now? I will lay down my life for you." 38 Jesus answered, "Will you lay down your life for me? Very truly, I tell you, before the cock crows, you will have denied me three times.

14

Do not let your hearts be troubled. Believe in God, believe also in me. 2 In my Father's house there are many dwelling places. If it were not so, would I have told you that I go to prepare a place for you? 3 And if I go and prepare a place for you, I will come again and will take you to myself, so that where I am, there you may be also. 4 And you know the way to the place where I am going." 5 Thomas said to him, "Lord, we do not know

b Gk: from supper
c Other ancient authorities lack except for the feet
d The Greek word for you here is plural
e Gk: slaves
f Other ancient authorities read ate bread with me
g Gk: I am
h Gk: dipped it
i Other ancient authorities read Judas Iscariot son of Simon; others, Judas son of Simon from Karyot [Kerioth]
j Gk: After the piece of bread
k Other ancient authorities lack If God has been glorified in him
l Or: You believe
m Or: If it were not so, I would have told you; for I go to prepare a place for you
n Other ancient authorities read Where I am going you know, and the way you know

where you are going. How can we know the way?" 6 Jesus said to him, "I am the way, and the truth, and the life. No one comes to the Father except through me. 7 If you know me, you will know my Father also. From now on you do know him and have seen him." ❚ 8 Philip said to him, "Lord, show us the Father, and we will be satisfied." 9 Jesus said to him, "Have I been with you all this time, Philip, and you still do not know me? Whoever has seen me has seen the Father. How can you say, 'Show us the Father'? 10 Do you not believe that I am in the Father and the Father is in me? The words that I say to you I do not speak on my own; but the Father who dwells in me does his works. 11 Believe me that I am in the Father and the Father is in me; but if you do not, then believe me because of the works themselves. 12 Very truly, I tell you, the one who believes in me will also do the works that I do and, in fact, will do greater works than these, because I am going to the Father. 13 I will do whatever you ask in my name, so that the Father may be glorified in the Son. 14 If in my name you ask me for anything, I will do it. ❚ 15 "If you love me, you will keep my commandments. 16 And I will ask the Father, and he will give you another Advocate, to be with you forever. 17 This is the Spirit of truth, whom the world cannot receive, because it neither sees him nor knows him. You know him, because he abides with you, and he will be in you. ❚ 18 "I will not leave you orphaned; I am coming to you. 19 In a little while the world will no longer see me, but you will see me; because I live, you also will live. 20 On that day you will know that I am in my Father, and you in me, and I in you. 21 They who have my commandments and keep them are those who love me; and those who love me will be loved by my Father, and I will love them and reveal myself to them." 22 Judas (not Iscariot) said to him, "Lord, how is it that you will reveal yourself to us, and not to the world?" 23 Jesus answered him, "Those who love me will keep my word, and my Father will love them, and we will come to them and make our home with them. 24 Whoever does not love me does not keep my words; and the word that you hear is not mine, but is from the Father who sent me. ❚ 25 "I have said these things to you while I am still with you. 26 But the Advocate, the Holy Spirit, whom the Father will send in my name, will teach you everything, and remind you of all that I have said to you. 27 Peace I leave with you; my peace I give to you. I do not give to you as the world gives. Do not let your hearts be troubled, and do not let them be afraid. 28 You heard me say to you, 'I am going away, and I am coming to you.' If you loved me, you would rejoice

that I am going to the Father, because the Father is greater than I. 29 And now I have told you this before it occurs, so that when it does occur, you may believe. 30 I will no longer talk much with you, for the ruler of this world is coming. He has no power over me; 31 but I do as the Father has commanded me, so that the world may know that I love the Father. Rise, let us be on our way.

15

I am the true vine, and my Father is the vine-grower. He removes every branch in me that bears no fruit. Every branch that bears fruit he prunes to make it bear more fruit. 3 You have already been cleansed by the word that I have spoken to you. 4 Abide in me as I abide in you. Just as the branch cannot bear fruit by itself unless it abides in the vine, neither can you unless you abide in me. 5 I am the vine, you are the branches. Those who abide in me & I in them bear much fruit, because apart from me you can do nothing. 6 Whoever does not abide in me is thrown away like a branch and withers; such branches are gathered, thrown into the fire, and burned. 7 If you abide in me, and my words abide in you, ask for whatever you wish, and it will be done for you. 8 My Father is glorified by this, that you bear much fruit and become my disciples. 9 As the Father has loved me, so I have loved you; abide in my love. 10 If you keep my commandments, you will abide in my love, just as I have kept my Father's commandments and abide in his love. 11 I have said these things to you so that my joy may be in you, and that your joy may be complete. ❚ 12 "This is my commandment, that you love one another as I have loved you. 13 No one has greater love than this, to lay down one's life for one's friends. 14 You are my friends if you do what I command you. 15 I do not call you servants any longer, because the servant does not know what the master is doing; but I have called you friends, because I have made known to you everything that I have heard from my Father. 16 You did not choose me but I chose you. And I appointed you to go & bear fruit, fruit that will last, so that the Father will give you whatever you ask him in my name. 17 I am giving you these commands so that you may love one another. ❚ 18 "If the world hates you, be aware that it hated me before it hated you. 19 If you belonged to the world, the world would love you as its own. Because you do not belong to the world, but I have chosen you out of the world — therefore the world hates you. 20 Remember the word that I said to you, 'Servants are not greater than their master.' If they persecuted me, they will persecute you; if they kept my word,

o Other ancient authorities read If you had known me, you would have known
p Other ancient authorities lack me
q Other ancient authorities read me, keep
r Or Helper
s Or among
t Or Helper
u The same Greek root refers to pruning and cleansing
v The same Greek root refers to pruning and cleansing
w Or be
x Gk slaves
y Gk slave
z Gk were of the world
a Gk slaves

they will keep yours also. 21 But they will do all these things to you on account of my name, because they do not know him who sent me. 22 If I had not come and spoken to them, they would not have sin; but now they have no excuse for their sin. 23 Whoever hates me hates my Father also. 24 If I had not done among them the works that no one else did, they would not have sin. But now they have seen and hated both me and my Father. 25 It was to fulfill the word that is written in their law, 'They hated me without a cause.' ¶ 26 "When the Advocate comes, whom I will send to you from the Father, the Spirit of truth who comes from the Father, he will testify on my behalf. 27 You also are to testify because you have been with me from the beginning.

16

" I have said these things to you to keep you from stumbling. 2 They will put you out of the synagogues. Indeed, an hour is coming when those who kill you will think that by doing so they are offering worship to God. 3 And they will do this because they have not known the Father or me. 4 But I have said these things to you so that when their hour comes you may remember that I told you about them. ¶ "I did not say these things to you from the beginning, because I was with you. 5 But now I am going to him who sent me; yet none of you asks me, 'Where are you going?' 6 But because I have said these things to you, sorrow has filled your hearts. 7 Nevertheless I tell you the truth; it is to your advantage that I go away, for if I do not go away, the Advocate will not come to you; but if I go, I will send him to you. 8 And when he comes, he will prove the world wrong about sin and righteousness and judgment: 9 about sin, because they do not believe in me; 10 about righteousness, because I am going to the Father & you will see me no longer; 11 about judgment, because the ruler of this world has been condemned. ¶ 12 "I still have many things to say to you, but you cannot bear them now. 13 When the Spirit of truth comes, he will guide you into all the truth; for he will not speak on his own, but will speak whatever he hears, and he will declare to you the things that are to come. 14 He will glorify me, because he will take what is mine & declare it to you. 15 All that the Father has is mine. For this reason I said that he will take what is mine and declare it to you. ¶ 16 "A little while, and you will no longer see me, and again a little while, and you will see me." 17 Then some of his disciples said to one another, "What does he mean by saying to us, 'A little while, & you will no longer see me, and again a little while, and

you will see me'; and 'Because I am going to the Father'?" 18 They said, "What does he mean by this 'a little while'? We do not know what he is talking about." 19 Jesus knew that they wanted to ask him, so he said to them, "Are you discussing among yourselves what I meant when I said, 'A little while, & you will no longer see me, and again a little while, and you will see me'? 20 Very truly, I tell you, you will weep and mourn, but the world will rejoice; you will have pain, but your pain will turn into joy. 21 When a woman is in labor, she has pain, because her hour has come. But when her child is born, she no longer remembers the anguish because of the joy of having brought a human being into the world. 22 So you have pain now; but I will see you again, and your hearts will rejoice, and no one will take your joy from you. 23 On that day you will ask nothing of me. Very truly, I tell you, if you ask anything of the Father in my name, he will give it to you. 24 Until now you have not asked for anything in my name. Ask and you will receive, so that your joy may be complete. ¶ 25 "I have said these things to you in figures of speech. The hour is coming when I will no longer speak to you in figures, but will tell you plainly of the Father. 26 On that day you will ask in my name. I do not say to you that I will ask the Father on your behalf; 27 for the Father himself loves you, because you have loved me and have believed that I came from God. 28 I came from the Father and have come into the world; again, I am leaving the world and am going to the Father." ¶ 29 His disciples said, "Yes, now you are speaking plainly, not in any figure of speech! 30 Now we know that you know all things, and do not need to have anyone question you; by this we believe that you came from God." 31 Jesus answered them, "Do you now believe? 32 The hour is coming, indeed it has come, when you will be scattered, each one to his home, and you will leave me alone. Yet I am not alone because the Father is with me. 33 I have said this to you, so that in me you may have peace. In the world you face persecution. But take courage; I have conquered the world!"

17

A fter Jesus had spoken these words, he looked up to heaven and said, "Father, the hour has come; glorify your Son so that the Son may glorify you, 2 since you have given him authority over all people, to give eternal life to all whom you have given him. 3 And this is eternal life, that they may know you, the only true God, and Jesus Christ whom you have sent. 4 I glorified you on earth by finishing the work that you gave me to do. 5 So now,

b Or Helper
c Or Helper
d Or convict the world of
e Or will ask me no question
f Other ancient authorities read Father, he will give it to you in my name
g Other ancient authorities read the Father
h Gk-flesh

Father, glorify me in your own presence with the glory that I had in your presence before the world existed. ∎ "I have made your name known to those whom you gave me from the world. They were yours, and you gave them to me, and they have kept your word. 7 Now they know that everything you have given me is from you; 8 for the words that you gave to me I have given to them, and they have received them and know in truth that I came from you; and they have believed that you sent me. 9 I am asking on their behalf; I am not asking on behalf of the world, but on behalf of those whom you gave me, because they are yours. 10 All mine are yours, and yours are mine; and I have been glorified in them. 11 And now I am no longer in the world, but they are in the world, and I am coming to you. Holy Father, protect them in your name that you have given me, so that they may be one, as we are one. 12 While I was with them, I protected them in your name that you have given me. I guarded them, and not one of them was lost except the one destined to be lost, so that the scripture might be fulfilled. 13 But now I am coming to you, and I speak these things in the world so that they may have my joy made complete in themselves. 14 I have given them your word, and the world has hated them because they do not belong to the world, just as I do not belong to the world. 15 I am not asking you to take them out of the world, but I ask you to protect them from the evil one. 16 They do not belong to the world, just as I do not belong to the world. 17 Sanctify them in the truth; your word is truth. 18 As you have sent me into the world, so I have sent them into the world. 19 And for their sakes I sanctify myself so that they also may be sanctified in truth. ∎ 20 "I ask not only on behalf of these, but also on behalf of those who will believe in me through their word, 21 that they may all be one. As you, Father, are in me and I am in you, may they also be in us, so that the world may believe that you have sent me. 22 The glory that you have given me I have given them, so that they may be one, as we are one, 23 I in them and you in me, that they may become completely one, so that the world may know that you have sent me & have loved them even as you have loved me. 24 Father, I desire that those also, whom you have given me, may be with me where I am, to see my glory, which you have given me because you loved me before the foundation of the world. ∎ "Righteous Father, the world does not know you, but I know you; and these know that you have sent me. 26 I made your name known to them, and I will make it known, so that the love with which you have loved me may be in them, and I in them."

i Other Ancient Authorities read protected in your name those whom
j Gk· except the son of destruction
k Or· among themselves
l Or· from evil
m Other ancient authorities read be one in us
n Gk· the Nazorean
o Gk· I am
p Gk· he
q Gk· I am
r Gk· the Nazorean
s Gk· I am

18

After Jesus had spoken these words, he went out with his disciples across the Kidron valley to a place where there was a garden, which he and his disciples entered. 2 Now Judas, who betrayed him, also knew the place, because Jesus often met there with his disciples. 3 So Judas brought a detachment of soldiers together with police from the chief priests & the Pharisees, and they came there with lanterns & torches & weapons. 4 Then Jesus, knowing all that was to happen to him, came forward and asked them, "Whom are you looking for?" 5 They answered, "Jesus of Nazareth." Jesus replied, "I am he." Judas, who betrayed him, was standing with them. 6 When Jesus said to them, "I am he," they stepped back and fell to the ground. 7 Again he asked them, "Whom are you looking for?" And they said, "Jesus of Nazareth." 8 Jesus answered, "I told you that I am he. So if you are looking for me, let these men go." 9 This was to fulfill the word that he had spoken, "I did not lose a single one of those whom you gave me." 10 Then Simon Peter, who had a sword, drew it, struck the high priest's slave, and cut off his right ear. The slave's name was Malchus. 11 Jesus said to Peter, "Put your sword back into its sheath. Am I not to drink the cup that the Father has given me?" ∎ 12 So the soldiers, their officer, and the Jewish police arrested Jesus and bound him. 13 First they took him to Annas, who was the father-in-law of Caiaphas, the high priest that year. 14 Caiaphas was the one who had advised the Jews that it was better to have one person die for the people. ∎ 15 Simon Peter & another disciple followed Jesus. Since that disciple was known to the high priest, he went with Jesus into the courtyard of the high priest, 16 but Peter was standing outside at the gate. So the other disciple, who was known to the high priest, went out, spoke to the woman who guarded the gate, and brought Peter in. 17 The woman said to Peter, "You are not also one of this man's disciples, are you?" He said, "I am not." 18 Now the slaves & the police had made a charcoal fire because it was cold, and they were standing around it and warming themselves. Peter also was standing with them and warming himself. ∎ 19 Then the high priest questioned Jesus about his disciples and about his teaching. 20 Jesus answered, "I have spoken openly to the world; I have always taught in synagogues & in the temple, where all the Jews come together. I have said nothing in secret. 21 Why do you ask me? Ask those who heard what I said to them; they know what I said." 22 When he had said this, one of the police standing nearby struck Jesus on the face, saying, "Is that how you answer the high priest?" 23 Jesus answered, "If I have spoken wrongly, testify to the

wrong. But if I have spoken rightly, why do you strike me?" 24 Then Annas sent him bound to Caiaphas the high priest. ¶ 25 Now Simon Peter was standing & warming himself. They asked him, "You are not also one of his disciples, are you?" He denied it and said, "I am not." 26 One of the slaves of the high priest, a relative of the man whose ear Peter had cut off, asked, "Did I not see you in the garden with him?" 27 Again Peter denied it, and at that moment the cock crowed. ¶ 28 Then they took Jesus from Caiaphas to Pilate's headquarters. It was early in the morning. They themselves did not enter the headquarters, so as to avoid ritual defilement and to be able to eat the Passover. 29 So Pilate went out to them and said, "What accusation do you bring against this man?" 30 They answered, "If this man were not a criminal, we would not have handed him over to you." 31 Pilate said to them, "Take him yourselves & judge him according to your law." The Jews replied, "We are not permitted to put anyone to death." 32 [This was to fulfill what Jesus had said when he indicated the kind of death he was to die.] ¶ 33 Then Pilate entered the headquarters again, summoned Jesus, & asked him, "Are you the King of the Jews?" 34 Jesus answered, "Do you ask this on your own, or did others tell you about me?" 35 Pilate replied, "I am not a Jew, am I? Your own nation & the chief priests have handed you over to me. What have you done?" 36 Jesus answered, "My kingdom is not from this world. If my kingdom were from this world, my followers would be fighting to keep me from being handed over to the Jews. But as it is, my kingdom is not from here." 37 Pilate asked him, "So you are a king?" Jesus answered, "You say that I am a king. For this I was born, and for this I came into the world, to testify to the truth. Everyone who belongs to the truth listens to my voice." 38 Pilate asked him, "What is truth?" ¶ After he had said this, he went out to the Jews again & told them, "I find no case against him. 39 But you have a custom that I release someone for you at the Passover. Do you want me to release for you the King of the Jews?" 40 They shouted in reply, "Not this man, but Barabbas!" Now Barabbas was a bandit.

19

Then Pilate took Jesus & had him flogged. 2 And the soldiers wove a crown of thorns and put it on his head, and they dressed him in a purple robe. 3 They kept coming up to him, saying, "Hail, King of the Jews!" and striking him on the face. 4 Pilate went out again & said to them, "Look, I am bringing him out to you to let you know that I find no case against him." 5 So Jesus came out,

wearing the crown of thorns and the purple robe. Pilate said to them, "Here is the man!" 6 When the chief priests and the police saw him, they shouted, "Crucify him! Crucify him!" Pilate said to them, "Take him yourselves & crucify him; I find no case against him." 7 The Jews answered him, "We have a law, and according to that law he ought to die because he has claimed to be the Son of God." ¶ 8 Now when Pilate heard this, he was more afraid than ever. 9 He entered his headquarters again & asked Jesus, "Where are you from?" But Jesus gave him no answer. 10 Pilate therefore said to him, "Do you refuse to speak to me? Do you not know that I have power to release you, and power to crucify you?" 11 Jesus answered him, "You would have no power over me unless it had been given you from above; therefore the one who handed me over to you is guilty of a greater sin." 12 From then on Pilate tried to release him, but the Jews cried out, "If you release this man, you are no friend of the emperor. Everyone who claims to be a king sets himself against the emperor." ¶ 13 When Pilate heard these words, he brought Jesus outside and sat on the judge's bench at a place called The Stone Pavement, or in Hebrew Gabbatha. 14 Now it was the day of Preparation for the Passover; and it was about noon. He said to the Jews, "Here is your King!" 15 They cried out, "Away with him! Away with him! Crucify him!" Pilate asked them, "Shall I crucify your King?" The chief priests answered, "We have no king but the emperor." Then he handed him over to them to be crucified. ¶ So they took Jesus; 17 and carrying the cross by himself, he went out to what is called The Place of the Skull, which in Hebrew is called Golgotha. 18 There they crucified him, and with him two others, one on either side, with Jesus between them. 19 Pilate also had an inscription written & put on the cross. It read, "Jesus of Nazareth, the King of the Jews." 20 Many of the Jews read this inscription, because the place where Jesus was crucified was near the city; and it was written in Hebrew, in Latin, and in Greek. 21 Then the chief priests of the Jews said to Pilate, "Do not write, 'The King of the Jews,' but, 'This man said, I am King of the Jews.'" 22 Pilate answered, "What I have written I have written." 23 When the soldiers had crucified Jesus, they took his clothes & divided them into four parts, one for each soldier. They also took his tunic; now the tunic was seamless, woven in one piece from the top. 24 So they said to one another, "Let us not tear it, but cast lots for it to see who will get it." This was to fulfill what the scripture says,

"They divided my clothes among themselves,
and for my clothing they cast lots."

t Gk: the praetorium
u Gk: the praetorium
v Gk: the praetorium
w Gk: the praetorium
x Or seated him
y That is, Aramaic
z That is, Aramaic
a Gk: the Nazorean
b That is, Aramaic

²⁵ And that is what the soldiers did. ▮ Meanwhile, standing near the cross of Jesus were his mother, and his mother's sister, Mary the wife of Clopas, & Mary Magdalene. ²⁶ When Jesus saw his mother & the disciple whom he loved standing beside her, he said to his mother, "Woman, here is your son." ²⁷ Then he said to the disciple, "Here is your mother." And from that hour the disciple took her into his own

28 home. ▮ After this, when Jesus knew that all was now finished, he said [in order to fulfill the scripture], "I am thirsty." ²⁹ A jar full of sour wine was standing there. So they put a sponge full of the wine on a branch of hyssop and held it to his mouth. ³⁰ When Jesus had received the wine, he said, "It is finished."

31 Then he bowed his head & gave up his spirit. ▮ Since it was the day of Preparation, the Jews did not want the bodies left on the cross during the sabbath, especially because that sabbath was a day of great solemnity. So they asked Pilate to have the legs of the crucified men broken & the bodies removed. ³² Then the soldiers came and broke the legs of the first & of the other who had been crucified with him. ³³ But when they came to Jesus & saw that he was already dead, they did not break his legs. ³⁴ Instead, one of the soldiers pierced his side with a spear, and at once blood & water came out. ³⁵ [He who saw this has testified so that you also may believe. His testimony is true, and he knows that he tells the truth.] ³⁶ These things occurred so that the scripture might be fulfilled, "None of his bones shall be broken." ³⁷ And again another passage of scripture says, "They

38 will look on the one whom they have pierced." ▮ After these things, Joseph of Arimathea, who was a disciple of Jesus, though a secret one because of his fear of the Jews, asked Pilate to let him take away the body of Jesus. Pilate gave him permission; so he came & removed his body. ³⁹ Nicodemus, who had at first come to Jesus by night, also came, bringing a mixture of myrrh & aloes, weighing about a hundred pounds. ⁴⁰ They took the body of Jesus and wrapped it with the spices in linen cloths, according to the burial customs of the Jews. ⁴¹ Now there was a garden in the place where he was crucified, and in the garden there was a new tomb in which no one had ever been laid. ⁴² And so, because it was the Jewish day of Preparation, and the tomb was nearby, they laid Jesus there.

20

E arly on the first day of the week, while it was still dark, Mary Magdalene came to the tomb and saw that the stone had been removed from the tomb. ² So she ran & went to Simon Peter and the other disciple, the one whom Jesus loved,

and said to them, "They have taken the Lord out of the tomb, and we do not know where they have laid him." ³ Then Peter and the other disciple set out & went toward the tomb. ⁴ The two were running together, but the other disciple outran Peter & reached the tomb first. ⁵ He bent down to look in and saw the linen wrappings lying there, but he did not go in. ⁶ Then Simon Peter came, following him, and went into the tomb. He saw the linen wrappings lying there, ⁷ and the cloth that had been on Jesus' head, not lying with the linen wrappings but rolled up in a place by itself. ⁸ Then the other disciple, who reached the tomb first, also went in, and he saw & believed; ⁹ for as yet they did not understand the scripture, that he must rise from the dead. ¹⁰ Then

11 the disciples returned to their homes. ▮ But Mary stood weeping outside the tomb. As she wept, she bent over to look into the tomb; ¹² and she saw two angels in white, sitting where the body of Jesus had been lying, one at the head & the other at the feet. ¹³ They said to her, "Woman, why are you weeping?" She said to them, "They have taken away my Lord, and I do not know where they have laid him." ¹⁴ When she had said this, she turned around and saw Jesus standing there, but she did not know that it was Jesus. ¹⁵ Jesus said to her, "Woman, why are you weeping? Whom are you looking for?" Supposing him to be the gardener, she said to him, "Sir, if you have carried him away, tell me where you have laid him and I will take him away." ¹⁶ Jesus said to her, "Mary!" She turned and said to him in Hebrew, "Rabbouni!" [which means Teacher]. ¹⁷ Jesus said to her, "Do not hold on to me, because I have not yet ascended to the Father. But go to my brothers & say to them, 'I am ascending to my Father and your Father, to my God and your God.'" ¹⁸ Mary Magdalene went & announced to the disciples, "I have seen the Lord"; and she told them that he had said these things to

19 her. ▮ When it was evening on that day, the first day of the week, and the doors of the house where the disciples had met were locked for fear of the Jews, Jesus came and stood among them and said "Peace be with you." ²⁰ After he said this, he showed them his hands and his side. Then the disciples rejoiced when they saw the Lord. ²¹ Jesus said to them again, "Peace be with you. As the Father has sent me, so I send you." ²² When he had said this, he breathed on them and said to them, "Receive the Holy Spirit. ²³ If you forgive the sins of any, they are forgiven them; if you retain the sins of any, they are retained."

רבולי.

ᶜ Or there is one who knows
ᵈ Gk lacks to look
ᵉ That is, Aramaic

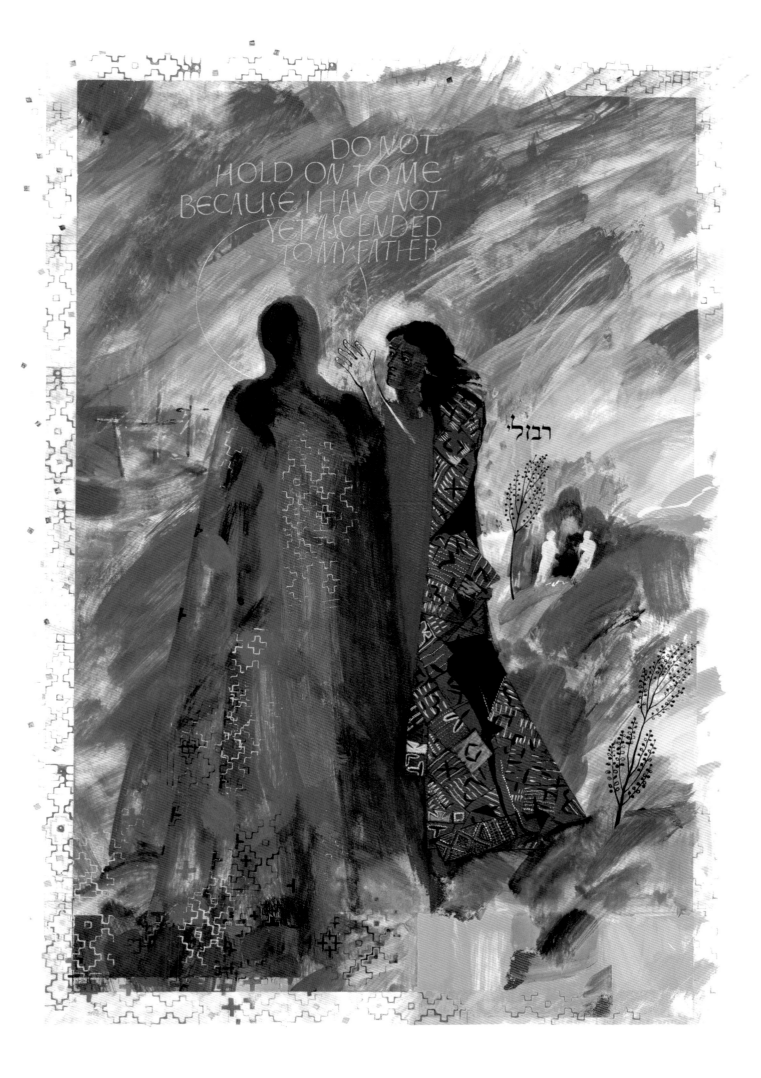

24 ■ But Thomas [who was called the Twin], one of the twelve, was not with them when Jesus came. 25 So the other disciples told him, "We have seen the Lord." But he said to them, "Unless I see the mark of the nails in his hands, and put my finger in the mark of the nails and my hand in his side, I will

26 not believe." ■ A week later his disciples were again in the house, and Thomas was with them. Although the doors were shut, Jesus came & stood among them and said, "Peace be with you." 27 Then he said to Thomas, "Put your finger here & see my hands. Reach out your hand and put it in my side. Do not doubt but believe." 28 Thomas answered him, "My Lord and my God!" 29 Jesus said to him, "Have you believed because you have seen me? Blessed are those who have not seen and yet have come to be

30 lieve." ■ Now Jesus did many other signs in the presence of his disciples, which are not written in this book. 31 But these are written so that you may come to believe that Jesus is the Messiah, the Son of God, and that through believing you may have life in his name.

21

After these things Jesus showed himself again to the disciples by the Sea of Tiberias; and he showed himself in this way. 2 Gathered there together were Simon Peter, Thomas called the Twin, Nathanael of Cana in Galilee, the sons of Zebedee, and two others of his disciples. 3 Simon Peter said to them, "I am going fishing." They said to him, "We will go with you." They went out & got into the boat, but that night they caught nothing.

4 ■ Just after daybreak, Jesus stood on the beach; but the disciples did not know that it was Jesus. 5 Jesus said to them, "Children, you have no fish, have you?" They answered him, "No." 6 He said to them, "Cast the net to the right side of the boat, and you will find some." So they cast it, and now they were not able to haul it in because there were so many fish. 7 That disciple whom Jesus loved said to Peter, "It is the Lord!" When Simon Peter heard that it was the Lord, he put on some clothes, for he was naked; and jumped into the sea. 8 But the other disciples came in the boat, dragging the net full of fish, for they were not far from the land, only about a hun-

9 dred yards off. ■ When they had gone ashore, they saw a charcoal fire there, with fish on it, and bread. 10 Jesus said to them, "Bring some of the fish that you have just caught." 11 So Simon Peter went aboard and hauled the net ashore, full of large fish, a hundred fifty-three of them; and though there were so many, the net was not torn. 12 Jesus said to them, "Come and have breakfast." Now none of the disci

ples dared to ask him, "Who are you?" because they knew it was the Lord. 13 Jesus came and took the bread and gave it to them, and did the same with the fish. 14 This was now the third time that Jesus appeared to the disciples after he was raised from

15 the dead. ■ When they had finished breakfast, Jesus said to Simon Peter, "Simon son of John, do you love me more than these?" He said to him, "Yes, Lord; you know that I love you." Jesus said to him, "Feed

16 my lambs." 16 A second time he said to him, "Simon son of John, do you love me?" He said to him, "Yes, Lord; you know that I love you." Jesus said to him, "Tend my sheep." 17 He said to him the third time, "Simon son of John, do you love me?" Peter felt hurt because he said to him the third time, "Do you love me?" And he said to him, "Lord, you know everything; you know that I love you." Jesus said to him, "Feed my sheep. 18 Very truly, I tell you, when you were younger, you used to fasten your own belt & to go wherever you wished. But when you grow old, you will stretch out your hands, and someone else will fasten a belt around you and take you where you do not wish to go." 19 [He said this to indicate the kind of death by which he would glorify God.]

20 After this he said to him, "Follow me." ■ Peter turned and saw the disciple whom Jesus loved following them; he was the one who had reclined next to Jesus at the supper and had said, "Lord, who is it that is going to betray you?" 21 When Peter saw him, he said to Jesus, "Lord, what about him?" 22 Jesus said to him, "If it is my will that he remain until I come, what is that to you? Follow me!" 23 So the rumor spread in the community that this disciple would not die. Yet Jesus did not say to him that he would not die, but, "If it is my will that he remain until I

24 come, what is that to you?" ■ This is the disciple who is testifying to these things & has written them, and we know that his testimony is true. 25 But there are also many other things that Jesus did; if every one of them were written down, I suppose that the world itself could not contain the books that would be written.

f Gk Didymus
g Other ancient authorities read may continue to believe
h or the Christ
i Gk Didymus
j Gk two hundred cubits
k Gk among the brothers
l Other ancient authorities lack what is that to you

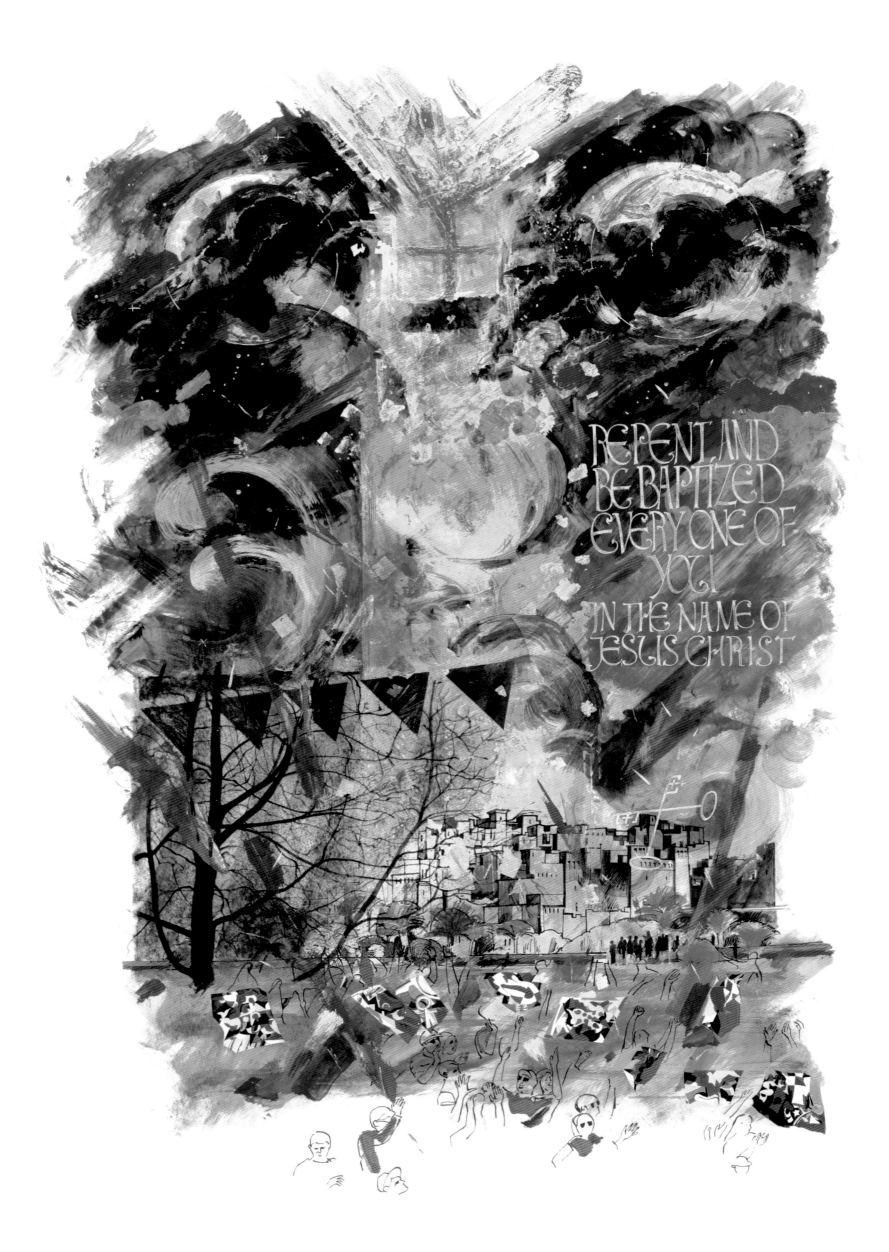

The ACTS OF THE APOSTLES

In the first book, Theophilus, I wrote about all that Jesus did & taught from the beginning ²until the day when he was taken up to heaven, after giving instructions through the Holy Spirit to the apostles whom he had chosen.³ After his suffering he presented himself alive to them by many convincing proofs, appearing to them during forty days and speaking about the kingdom of God. ⁴ While staying with them, he ordered them not to leave Jerusalem, but to wait there for the promise of the Father. "This," he said, "is what you have heard from me;⁵ for John baptized with water, but you will be baptized with the Holy Spirit not many days from now."⁶ So when they had come together, they asked him, "Lord, is this the time when you will restore the kingdom to Israel?"⁷ He replied, "It is not for you to know the times or periods that the Father has set by his own authority.⁸ But you will receive power when the Holy Spirit has come upon you; & you will be my witnesses in Jerusalem, in all Judea and Samaria, and to the ends of the earth."⁹ When he had said this, as they were watching, he was lifted up, and a cloud took him out of their sight.¹⁰ While he was going & they were gazing up toward heaven, suddenly two men in white robes stood by them. ¹¹ They said, "Men of Galilee, why do you stand looking up toward heaven? This Jesus, who has been taken up from you into heaven, will come in the same way as you saw him go into heaven."¹² Then they returned to Jerusalem from the mount called Olivet, which is near Jerusalem, a sabbath day's journey away.¹³ When they had entered the city, they went to the room upstairs where they were staying, Peter, and John, and James, and Andrew, Philip and Thomas, Bartholomew and Matthew, James son of Alphaeus, and Simon the Zealot, and Judas son of James.¹⁴ All these were constantly devoting themselves to prayer, together with certain women, including Mary the mother of Jesus, as well as his brothers.¹⁵ In those days Peter stood up among the believers [together the crowd numbered about one hundred twenty persons] and said, ¹⁶ Friends, the scripture had to be fulfilled, which the Holy Spirit through David foretold concerning Judas, who became a guide for those who arrested Jesus—¹⁷ for he was numbered among us and was allotted

his share in this ministry.¹⁸ [Now this man acquired a field with the reward of his wickedness; and falling headlong, he burst open in the middle and all his bowels gushed out.¹⁹ This became known to all the residents of Jerusalem, so that the field was called in their language Hakeldama, that is, Field of Blood.]²⁰ "For it is written in the book of Psalms,

'Let his homestead become desolate,'
and let there be no one to live in it';

And

'Let another take his position of overseer.'
²¹ So one of the men who have accompanied us during all the time that the Lord Jesus went in and out among us, ²² beginning from the baptism of John until the day when he was taken up from us—one of these must become a witness with us to his resurrection."²³ So they proposed two, Joseph called Barsabbas, who was also known as Justus, and Matthias.²⁴ Then they prayed & said, "Lord, you know everyone's heart. Show us which one of these two you have chosen²⁵ to take the place in this ministry and apostleship from which Judas turned aside to go to his own place."²⁶ And they cast lots for them, and the lot fell on Matthias; and he was added to the eleven apostles.

2

When the day of Pentecost had come, they were all together in one place. ²And suddenly from heaven there came a sound like the rush of a violent wind, and it filled the entire house where they were sitting.³ Divided tongues, as of fire, appeared among them, and a tongue rested on each of them. ⁴ All of them were filled with the Holy Spirit and began to speak in other languages, as the Spirit gave them ability.⁵ Now there were devout Jews from every nation under heaven living in Jerusalem.⁶ And at this sound the crowd gathered and was bewildered, because each one heard them speaking in the native language of each. ⁷ Amazed & astonished, they asked, "Are not all these who are speaking Galileans?⁸ And how is it that we hear, each of us, in our own native language?⁹ Parthians, Medes, Elamites, and residents of Mesopotamia, Judea and Cappadocia, Pontus and Asia,¹⁰ Phrygia and Pamphylia, Egypt and the parts of Libya belonging to Cyrene, and visitors from Rome, both Jews and proselytes, ¹¹ Cretans and Arabs—in our own languages we hear them speaking about God's deeds of power."¹² All were amazed and perplexed, saying to one another, "What does this mean?"¹³ But others sneered and said, ¹⁴ "They are filled with new wine."¹⁴ But Peter, standing with the eleven, raised his voice and addressed

REPENT, & BE BAPTIZED EVERY ONE OF YOU IN THE NAME OF JESUS CHRIST SO THAT YOUR SINS MAY BE FORGIVEN; AND YOU WILL RECEIVE THE GIFT OF THE HOLY SPIRIT.

ᵃ Or eating
ᵇ Or by
ᶜ Or the brother of
ᵈ Gk: brothers
ᵉ Gk: Men, brothers
ᶠ Or swelling up
ᵍ Other ancient authorities read the share

them, "Men of Judea and all who live in Jerusalem, let this be known to you, and listen to what I say. [15] Indeed, these are not drunk as you suppose, for it is only nine o'clock in the morning. [16] No, this is what was spoken through the prophet Joel:

[17] 'In the last days it will be, God declares,
 that I will pour out my Spirit upon all flesh,
 and your sons and your daughters shall prophesy,
 and your young men shall see visions,
 and your old men shall dream dreams.
[18] Even upon my slaves, both men and women,
 in those days I will pour out my Spirit,
 and they shall prophesy.
[19] And I will show portents in the heaven above
 and signs on the earth below,
 blood, and fire, and smoky mist.
[20] The sun shall be turned to darkness
 and the moon to blood,
 before the coming of the Lord's great & glorious day.
[21] Then everyone who calls on the name of the Lord
 shall be saved.'

[22] "You that are Israelites, listen to what I have to say: Jesus of Nazareth, a man attested to you by God with deeds of power, wonders, and signs that God did through him among you, as you yourselves know— [23] this man, handed over to you according to the definite plan and foreknowledge of God, you crucified and killed by the hands of those outside the law. [24] But God raised him up, having freed him from death, because it was impossible for him to be held in its power. [25] For David says concerning him,

 'I saw the Lord always before me,
 for he is at my right hand so that I will not be shaken;
[26] therefore my heart was glad, and my tongue rejoiced;
 moreover my flesh will live in hope.
[27] For you will not abandon my soul to Hades,
 or let your Holy One experience corruption.
[28] You have made known to me the ways of life;
 you will make me full of gladness with your presence.'

[29] "Fellow Israelites, I may say to you confidently of our ancestor David that he both died and was buried, and his tomb is with us to this day. [30] Since he was a prophet, he knew that God had sworn with an oath to him that he would put one of his descendants on his throne. [31] Foreseeing this, David spoke of the resurrection of the Messiah, saying,

 'He was not abandoned to Hades,
 nor did his flesh experience corruption.'

[32] This Jesus God raised up, and of that all of us are witnesses. [33] Being therefore exalted at the right hand of God, and having received from the Father the promise of the Holy Spirit, he has poured out this that you both see and hear. [34] For David did

not ascend into the heavens, but he himself says,
 'The Lord said to my Lord,
 "Sit at my right hand,
[35] until I make your enemies your footstool."'
[36] Therefore let the entire house of Israel know with certainty that God has made him both Lord and Messiah, this Jesus whom you crucified."

[37] Now when they heard this, they were cut to the heart & said to Peter and to the other apostles, "Brothers, what should we do?" [38] Peter said to them, "Repent, and be baptized every one of you in the name of Jesus Christ so that your sins may be forgiven; and you will receive the gift of the Holy Spirit. [39] For the promise is for you, for your children, and for all who are far away, everyone whom the Lord our God calls to him." [40] And he testified with many other arguments and exhorted them, saying, "Save yourselves from this corrupt generation." [41] So those who welcomed his message were baptized, and that day about three thousand persons were added. [42] They devoted themselves to the apostles' teaching and fellowship, to the breaking of bread and the prayers.

[43] Awe came upon everyone, because many wonders and signs were being done by the apostles. [44] All who believed were together & had all things in common; [45] they would sell their possessions and goods and distribute the proceeds to all, as any had need. [46] Day by day, as they spent much time together in the temple, they broke bread at home and ate their food with glad and generous hearts, [47] praising God and having the goodwill of all the people. And day by day the Lord added to their number those who were being saved.

3

One day Peter and John were going up to the temple at the hour of prayer, at three o'clock in the afternoon. [2] And a man lame from birth was being carried in. People would lay him daily at the gate of the temple called the Beautiful Gate so that he could ask for alms from those entering the temple. [3] When he saw Peter and John about to go into the temple, he asked them for alms. [4] Peter looked intently at him, as did John, and said, "Look at us." [5] And he fixed his attention on them, expecting to receive something from them. [6] But Peter said, "I have no silver or gold, but what I have I give you; in the name of Jesus Christ of Nazareth, stand up and walk." [7] And he took him by the right hand & raised him up; and immediately his feet and ankles were made strong. [8] Jumping up, he stood and began to walk, and he entered the temple with them, walking and leaping & praising

h Gk. Men, Israelites
i Gk. the Nazorean
j Gk. the pains of death
k Gk. Men, brothers
l Gk. he
m Or the Christ
n Or by
o Or Christ
p Gk. Men, brothers
q Gk. them
r Or from house to house
s Or sincere
t Gk. the Nazorean

God. 9 All the people saw him walking and praising God, 10 and they recognized him as the one who used to sit and ask for alms at the Beautiful Gate of the temple; and they were filled with wonder & amazement at what had happened to him. ¶ While 11 he clung to Peter & John, all the people ran together to them in the portico called Solomon's Portico, utterly astonished. 12 When Peter saw it, he addressed the people, "You Israelites, why do you wonder at this, or why do you stare at us, as though by our own power or piety we had made him walk? 13 The God of Abraham, the God of Isaac, and the God of Jacob, the God of our ancestors has glorified his servant Jesus, whom you handed over & rejected in the presence of Pilate, though he had decided to release him. 14 But you rejected the Holy and Righteous One and asked to have a murderer given to you, 15 and you killed the Author of life, whom God raised from the dead. To this we are witnesses. 16 And by faith in his name, his name itself has made this man strong, whom you see & know; and the faith that is through Jesus has given him this perfect health in the presence of all of you. ¶ "And now, 17 friends, I know that you acted in ignorance, as did also your rulers. 18 In this way God fulfilled what he had foretold through all the prophets, that his Messiah would suffer. 19 Repent therefore, and turn to God so that your sins may be wiped out, 20 so that times of refreshing may come from the presence of the Lord, and that he may send the Messiah appointed for you, that is, Jesus, 21 who must remain in heaven until the time of universal restoration that God announced long ago through his holy prophets. 22 Moses said, 'The Lord your God will raise up for you from your own people a prophet like me. You must listen to whatever he tells you. 23 And it will be that everyone who does not listen to that prophet will be utterly rooted out of the people.' 24 And all the prophets, as many as have spoken, from Samuel and those after him, also predicted these days. 25 You are the descendants of the prophets & of the covenant that God gave to your ancestors, saying to Abraham, 'And in your descendants all the families of the earth shall be blessed.' 26 When God raised up his servant, he sent him first to you, to bless you by turning each of you from your wicked ways."

4

While Peter and John were speaking to the people, the priests, the captain of the temple, and the Sadducees came to them, much annoyed because they were teaching the people and proclaiming that in Jesus there

is the resurrection of the dead. 3 So they arrested them and put them in custody until the next day, for it was already evening. 4 But many of those who heard the word believed; and they numbered about five thousand. ¶ The next day their rulers, elders, 5 and scribes assembled in Jerusalem, 6 with Annas the high priest, Caiaphas, John, and Alexander, and all who were of the high-priestly family. 7 When they had made the prisoners stand in their midst, they inquired, "By what power or by what name did you do this?" 8 Then Peter, filled with the Holy Spirit, said to them, "Rulers of the people & elders, 9 if we are questioned today because of a good deed done to someone who was sick and are asked how this man has been healed, 10 let it be known to all of you, and to all the people of Israel, that this man is standing before you in good health by the name of Jesus Christ of Nazareth, whom you crucified, whom God raised from the dead. 11 This Jesus is
'the stone that was rejected by you, the builders;
it has become the cornerstone.'
12 There is salvation in no one else, for there is no other name under heaven given among mortals by which we must be saved." ¶ Now when they saw 13 the boldness of Peter and John and realized that they were uneducated & ordinary men, they were amazed and recognized them as companions of Jesus. 14 When they saw the man who had been cured standing beside them, they had nothing to say in opposition. 15 So they ordered them to leave the council while they discussed the matter with one another. 16 They said, "What will we do with them? For it is obvious to all who live in Jerusalem that a notable sign has been done through them; we cannot deny it. 17 But to keep it from spreading further among the people, let us warn them to speak no more to anyone in this name." 18 So they called them & ordered them not to speak or teach at all in the name of Jesus. 19 But Peter & John answered them, "Whether it is right in God's sight to listen to you rather than to God, you must judge; 20 for we cannot keep from speaking about what we have seen and heard." 21 After threatening them again, they let them go, finding no way to punish them because of the people, for all of them praised God for what had happened. 22 For the man on whom this sign of healing had been performed was more than forty years old. ¶ After they were released, they went to 23 their friends and reported what the chief priests & the elders had said to them. 24 When they heard it, they raised their voices together to God & said, "Sovereign Lord, who made the heaven and the earth, the sea, and everything in them, 25 it is you who said by the Holy Spirit through our ancestor

a Gk Men; Israelites
b Or child
w Gk him
x Gk brothers
y Or his Christ
z Or the Christ
a Gk brothers
b Or child
c Gk While they
d Other ancient authorities
 read Jonathan
e Gk them
f Gk the Nazorean
g Gk This
h Or keystone
i Gk their own

David, your servant:

'Why did the Gentiles rage.

and the peoples imagine vain things?

²⁶ The kings of the earth took their stand,

and the rulers have gathered together

against the Lord and against his Messiah.'

²⁷ For in this city, in fact, both Herod and Pontius Pilate, with the Gentiles and the peoples of Israel, gathered together against your holy servant Jesus, whom you anointed, ²⁸ to do whatever your hand & your plan had predestined to take place. ²⁹ And now, Lord, look at their threats, and grant to your servants to speak your word with all boldness, ³⁰ while you stretch out your hand to heal, and signs and wonders are performed through the name of your holy servant Jesus." ³¹ When they had prayed, the place in which they were gathered together was shaken; and they were all filled with the Holy Spirit and spoke the word of God with boldness. ❚ ³² Now the whole group of those who believed were of one heart and soul, and no one claimed private ownership of any possessions, but everything they owned was held in common. ³³ With great power the apostles gave their testimony to the resurrection of the Lord Jesus, and great grace was upon them all. ³⁴ There was not a needy person among them, for as many as owned lands or houses sold them and brought the proceeds of what was sold. ³⁵ They laid it at the apostles' feet, and it was distributed to each as any had need. ³⁶ There was a Levite, a native of Cyprus, Joseph, to whom the apostles gave the name Barnabas [which means "son of encouragement"]. ³⁷ He sold a field that belonged to him, then brought the money, and laid it at the apostles' feet.

5

But a man named Ananias, with the consent of his wife Sapphira, sold a piece of property; ² with his wife's knowledge, he kept back some of the proceeds, and brought only a part and laid it at the apostles' feet. ³ "Ananias," Peter asked, "why has Satan filled your heart to lie to the Holy Spirit and to keep back part of the proceeds of the land? ⁴ While it remained unsold, did it not remain your own? And after it was sold, were not the proceeds at your disposal? How is it that you have contrived this deed in your heart? You did not lie to us but to God!" ⁵ Now when Ananias heard these words, he fell down & died. And great fear seized all who heard of it: ⁶ The young men came and wrapped up his body, then carried him out & buried him. ❚ ⁷ After an interval of about three hours his wife came in, not knowing what had happened. ⁸ Peter

said to her, "Tell me whether you & your husband sold the land for such and such a price." And she said, "Yes, that was the price." ⁹ Then Peter said to her, "How is it that you have agreed together to put the Spirit of the Lord to the test? Look, the feet of those who have buried your husband are at the door, and they will carry you out." ¹⁰ Immediately she fell down at his feet and died. When the young men came in, they found her dead, so they carried her out and buried her beside her husband. ¹¹ And great fear seized the whole church & all who heard of these things. ❚ ¹² Now many signs and wonders were done among the people through the apostles. And they were all together in Solomon's Portico. ¹³ None of the rest dared to join them, but the people held them in high esteem. ¹⁴ Yet more than ever believers were added to the Lord, great numbers of both men and women, ¹⁵ so that they even carried out the sick into the streets, and laid them on cots and mats, in order that Peter's shadow might fall on some of them as he came by. ¹⁶ A great number of people would also gather from the towns around Jerusalem, bringing the sick and those tormented by unclean spirits, and they were all cured. ❚ ¹⁷ Then the high priest took action; he and all who were with him [that is, the sect of the Sadducees], being filled with jealousy, ¹⁸ arrested the apostles & put them in the public prison. ¹⁹ But during the night an angel of the Lord opened the prison doors, brought them out, and said, ²⁰ "Go, stand in the temple and tell the people the whole message about this life." ²¹ When they heard this, they entered the temple at daybreak & went on with their teaching. When the high priest and those with him arrived, they called together the council and the whole body of the elders of Israel, and sent to the prison to have them brought. ²² But when the temple police went there, they did not find them in the prison; so they returned and reported, ²³ "We found the prison securely locked & the guards standing at the doors, but when we opened them, we found no one inside." ²⁴ Now when the captain of the temple & the chief priests heard these words, they were perplexed about them, wondering what might be going on. ²⁵ Then someone arrived & announced, "Look, the men whom you put in prison are standing in the temple and teaching the people!" ²⁶ Then the captain went with the temple police & brought them, but without violence, for they were afraid of being stoned by the people. ❚ ²⁷ When they had brought them, they had them stand before the council. The high priest questioned them, ²⁸ saying, "We gave you strict orders not to teach in this name, yet here you have filled Jerusalem with your teaching

RSB
Acts 4:32
Acts 4:35
Acts 5:1-11

j or child
k or his Christ
l or child
m Gk slaves
n or child
o Gk to men
p Meaning of Gk uncertain
q other ancient authorities
 read Did we not give you
 strict orders not to teach
 in this name?

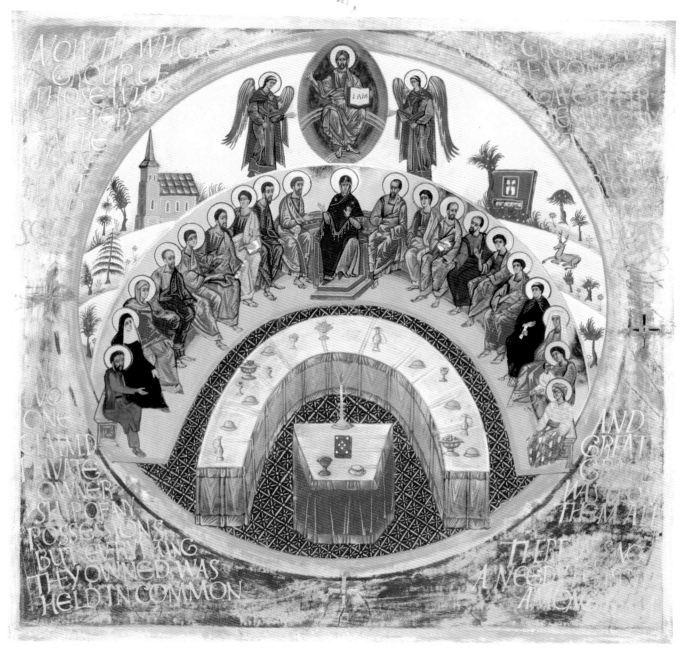

and you are determined to bring this man's blood on us." ²⁹ But Peter and the apostles answered, "We must obey God rather than any human authority. ³⁰ The God of our ancestors raised up Jesus, whom you had killed by hanging him on a tree. ³¹ God exhalted him at his right hand as Leader & Savior that he might give repentance to Israel and forgiveness of sins. ³² And we are witnesses to these things and so is the Holy Spirit whom God has given to those who obey him." When they heard this, they were enraged & wanted to kill them. ³⁴ But a Pharisee in the council named Gamaliel, a teacher of the law, respected by all the people, stood up and ordered the men to be put outside for a short time. ³⁵ Then he said to them, "Fellow Israelites, consider carefully what you propose to do to these men. ³⁶ For some time ago Theudas rose up, claiming to be somebody, and a number of men, about four hundred, joined him; but he was killed, and all who followed him were dispersed and disappeared. ³⁷ After him Judas the Galilean rose up at the time of the census and got people to follow him; he also perished, and

all who followed him were scattered. ³⁸ So in the present case, I tell you, keep away from these men and let them alone; because if this plan or this undertaking is of human origin, it will fail; ³⁹ but if it is of God, you will not be able to overthrow them—in that case you may even be found fighting against God!" They were convinced by him, ⁴⁰ and when they had called in the apostles, they had them flogged. Then they ordered them not to speak in the name of Jesus, and let them go. ⁴¹ As they left the council, they rejoiced that they were considered worthy to suffer dishonor for the sake of the name. ⁴² And every day in the temple and at home they did not cease to teach and proclaim Jesus as the Messiah.

6

Now during those days, when the disciples were increasing in number, the Hellenists complained against the Hebrews because their widows were being neglected in the daily distribution of food. ² And the twelve called together

ʳ Gk than men
ˢ Gk Men, Israelites
ᵗ Or from house to house
ᵘ Or the Christ

the whole community of the disciples and said, "It is not right that we should neglect the word of God in order to wait on tables. 3 Therefore, friends, select from among yourselves seven men of good standing, full of the Spirit and of wisdom, whom we may appoint to this task, 4 while we, for our part, will devote ourselves to prayer and to serving the word." 5 What they said pleased the whole community, and they chose Stephen, a man full of faith & the Holy Spirit, together with Philip, Prochorus, Nicanor, Timon, Parmenas, and Nicolaus, a proselyte of Antioch. 6 They had these men stand before the apostles, who prayed & laid their hands on them.

7 ❡ The word of God continued to spread; the number of the disciples increased greatly in Jerusalem, and a great many of the priests became obedient

8 to the faith. ❡ Stephen, full of grace and power, did great wonders and signs among the people. 9 Then some of those who belonged to the synagogue of the Freedmen (as it was called), Cyrenians, Alexandrians, and others of those from Cilicia and Asia, stood up & argued with Stephen. 10 But they could not withstand the wisdom & the Spirit with which he spoke. 11 Then they secretly instigated some men to say, "We have heard him speak blasphemous words against Moses & God." 12 They stirred up the people as well as the elders and the scribes; then they suddenly confronted him, seized him, and brought him before the council. 13 They set up false witnesses who said, "This man never stops saying things against this holy place and the law; 14 for we have heard him say that this Jesus of Nazareth will destroy this place and will change the customs that Moses handed on to us." 15 And all who sat in the council looked intently at him, and they saw that his face was like the face of an angel.

7

Then the high priest asked him, "Are these things so?" 2 And Stephen replied: ❡ "Brothers and fathers, listen to me. The God of glory appeared to our ancestor Abraham when he was in Mesopotamia, before he lived in Haran, 3 and said to him, 'Leave your country and your relatives and go to the land that I will show you.' 4 Then he left the country of the Chaldeans & settled in Haran. After his father died, God had him move from there to this country in which you are now living. 5 He did not give him any of it as a heritage, not even a foot's length, but promised to give it to him as his possession and to his descendants after him, even though he had no child. 6 And God spoke in these terms, that his descendants would be resident aliens in a country belonging to others, who would enslave

them & mistreat them during four hundred years. 7 'But I will judge the nation that they serve,' said God, 'and after that they shall come out & worship me in this place.' 8 Then he gave him the covenant of circumcision. And so Abraham became the father of Isaac & circumcised him on the eighth day; and Isaac became the father of Jacob, and Jacob of

9 the twelve patriarchs. ❡ "The patriarchs, jealous of Joseph, sold him into Egypt; but God was with him, 10 and rescued him from all his afflictions, and enabled him to win favor and to show wisdom when he stood before Pharaoh, king of Egypt, who appointed him ruler over Egypt & over all his household. 11 Now there came a famine throughout Egypt & Canaan, and great suffering, and our ancestors could find no food. 12 But when Jacob heard that there was grain in Egypt, he sent our ancestors there on their first visit. 13 On the second visit Joseph made himself known to his brothers, and Joseph's family became known to Pharaoh. 14 Then Joseph sent & invited his father Jacob & all his relatives to come to him, seventy-five in all; 15 So Jacob went down to Egypt. He himself died there as well as our ancestors, 16 and their bodies were brought back to Shechem and laid in the tomb that Abraham had bought for a sum of silver from the sons of Hamor

17 in Shechem. ❡ "But as the time drew near for the fulfillment of the promise that God had made to Abraham, our people in Egypt increased and multiplied 18 until another king who had not known Joseph ruled over Egypt. 19 He dealt craftily with our race and forced our ancestors to abandon their infants so that they would die. 20 At this time Moses was born, and he was beautiful before God. For three months he was brought up in his father's house; 21 and when he was abandoned, Pharaoh's daughter adopted him and brought him up as her own son. 22 So Moses was instructed in all the wisdom of the Egyptians & was powerful in his words and deeds.

23 ❡ "When he was forty years old, it came into his heart to visit his relatives, the Israelites. 24 When he saw one of them being wronged, he defended the oppressed man and avenged him by striking down the Egyptian. 25 He supposed that his kinsfolk would understand that God through him was rescuing them, but they did not understand. 26 The next day he came to some of them as they were quarreling & tried to reconcile them, saying, 'Men, you are brothers; why do you wrong each other?' 27 But the man who was wronging his neighbor pushed Moses aside, saying, 'Who made you a ruler and a judge over us? 28 Do you want to kill me as you killed the Egyptian yesterday?' 29 When he heard this, Moses fled & became a resident alien in the land of Midian.

y Or keep accounts
w Gk brothers
x Or spirit
y Gk the Nazorean
z Gk Men, brothers
a Gk he
b Gk they
c Gk his brothers, the sons
 of Israel
d Gk him

30 There he became the father of two sons. ▌ "Now when forty years had passed, an angel appeared to him in the wilderness of Mount Sinai, in the flame of a burning bush. 31 When Moses saw it, he was amazed at the sight; and as he approached to look, there came the voice of the Lord: 32 'I am the God of your ancestors, the God of Abraham, Isaac, and Jacob.' Moses began to tremble and did not dare to look. 33 Then the Lord said to him, 'Take off the sandals from your feet, for the place where you are standing is holy ground. 34 I have surely seen the mistreatment of my people who are in Egypt and have heard their groaning, and I have come down to rescue them. Come now, I will send you to Egypt.'

35 ▌ "It was this Moses whom they rejected when they said, 'Who made you a ruler and a judge?' and whom God now sent as both ruler and liberator through the angel who appeared to him in the bush. 36 He led them out, having performed wonders & signs in Egypt, at the Red Sea, and in the wilderness for forty years. 37 This is the Moses who said to the Israelites, 'God will raise up a prophet for you from your own people as he raised me up.' 38 He is the one who was in the congregation in the wilderness with the angel who spoke to him at Mount Sinai, and with our ancestors; and he received living oracles to give to us. 39 Our ancestors were unwilling to obey him; instead, they pushed him aside, and in their hearts they turned back to Egypt, 40 saying to Aaron, 'Make gods for us who will lead the way for us; as for this Moses who led us out from the land of Egypt, we do not know what has happened to him.' 41 At that time they made a calf, offered a sacrifice to the idol, and reveled in the works of their hands. 42 But God turned away from them & handed them over to worship the host of heaven, as it is written in the book of the prophets:

'Did you offer to me slain victims and sacrifices
 forty years in the wilderness, O house of Israel?
43 No; you took along the tent of Moloch,
 and the star of your god Rephan,
 the images that you made to worship;
so I will remove you beyond Babylon.'

44 ▌ "Our ancestors had the tent of testimony in the wilderness, as God directed when he spoke to Moses, ordering him to make it according to the pattern he had seen. 45 Our ancestors in turn brought it in with Joshua when they dispossessed the nations that God drove out before our ancestors. And it was there until the time of David, 46 who found favor with God and asked that he might find a dwelling place for the house of Jacob. 47 But it was Solomon who built a house for him. 48 Yet the Most High does not dwell in houses made with human hands; as the prophet says,

49 'Heaven is my throne,
 and the earth is my footstool.
 What kind of house will you build for me, says the Lord,
 or what is the place of my rest?
50 Did not my hand make all these things?'

51 ▌ "You stiff-necked people, uncircumcised in heart and ears, you are forever opposing the Holy Spirit, just as your ancestors used to do. 52 Which of the prophets did your ancestors not persecute? They killed those who foretold the coming of the Righteous One, and now you have become his betrayers and murderers. 53 You are the ones that received the law as ordained by angels, and yet you have not kept it." ▌ When they heard these things, 54 they became enraged & ground their teeth at Stephen. 55 But filled with the Holy Spirit, he gazed into heaven & saw the glory of God & Jesus standing at the right hand of God. 56 "Look," he said, "I see the heavens opened & the Son of Man standing at the right hand of God!" 57 But they covered their ears, and with a loud shout all rushed together against him. 58 Then they dragged him out of the city and began to stone him; and the witnesses laid their coats at the feet of a young man named Saul. 59 While they were stoning Stephen, he prayed, "Lord Jesus, receive my spirit." 60 Then he knelt down and cried out in a loud voice, "Lord, do not hold this sin against them." When he had said this, he died.

8 And Saul approved of their killing him. ▌ That day a severe persecution began against the church in Jerusalem, and all except the apostles were scattered throughout the countryside of Judea & Samaria. 2 Devout men buried Stephen and made loud lamentation over him. 3 But Saul was ravaging the church by entering house after house; dragging off both men and women, he committed them to prison. 4 ▌ Now those who were scattered went from place to place proclaiming the word. 5 Philip went down to the city of Samaria and proclaimed the Messiah to them. 6 The crowds with one accord listened eagerly to what was said by Philip, hearing and seeing the signs that he did, 7 for unclean spirits, crying with loud shrieks, came out of many who were possessed; and many others who were paralyzed or lame were cured. 8 So there was great joy in that city. 9 ▌ Now a certain man named Simon had previously practiced magic in the city & amazed the people of Samaria, saying that he was someone great. 10 All of them, from the least to the greatest, listened to him eagerly, saying, "This man is the power of God that is called Great." 11 And they listened eagerly to him because for a long time he had amazed them with his magic. 12 But when they believed Philip, who was proclaim-

e Gk your brothers
f Gk he
g Other ancient authorities
 read for the God of Jacob
h Gk with hands
i Gk him
j Gk fell asleep
k Other ancient authorities
 read a city
l Or the Christ

ing the good news about the kingdom of God and the name of Jesus Christ, they were baptized, both men and women. [13] Even Simon himself believed. After being baptized, he stayed constantly with Philip and was amazed when he saw the signs and great miracles that took place. ▮ [14] Now when the apostles at Jerusalem heard that Samaria had accepted the word of God, they sent Peter and John to them. [15] The two went down and prayed for them that they might receive the Holy Spirit [16] (for as yet the Spirit had not come upon any of them; they had only been baptized in the name of the Lord Jesus). [17] Then Peter and John laid their hands on them, and they received the Holy Spirit. [18] Now when Simon saw that the Spirit was given through the laying on of the apostles' hands, he offered them money, [19] saying, "Give me also this power so that anyone on whom I lay my hands may receive the Holy Spirit." [20] But Peter said to him, "May your silver perish with you, because you thought you could obtain God's gift with money! [21] You have no part or share in this, for your heart is not right before God. [22] Repent therefore of this wickedness of yours, and pray to the Lord that, if possible, the intent of your heart may be forgiven you. [23] For I see that you are in the gall of bitterness and the chains of wickedness." [24] Simon answered, "Pray for me to the Lord, that nothing of what you have said may happen to me." ▮ [25] Now after Peter and John had testified and spoken the word of the Lord, they returned to Jerusalem, proclaiming the good news to many villages of the Samaritans. ▮ [26] Then an angel of the Lord said to Philip, "Get up and go toward the south to the road that goes down from Jerusalem to Gaza." (This is a wilderness road.) [27] So he got up and went. Now there was an Ethiopian eunuch, a court official of the Candace, queen of the Ethiopians, in charge of her entire treasury. He had come to Jerusalem to worship [28] and was returning home; seated in his chariot, he was reading the prophet Isaiah. [29] Then the Spirit said to Philip, "Go over to this chariot and join it." [30] So Philip ran up to it and heard him reading the prophet Isaiah. He asked, "Do you understand what you are reading?" [31] He replied, "How can I, unless someone guides me?" And he invited Philip to get in and sit beside him. [32] Now the passage of the scripture that he was reading was this:

"Like a sheep he was led to the slaughter,
 and like a lamb silent before its shearer,
 so he does not open his mouth.
[33] In his humiliation justice was denied him.
 Who can describe his generation?
 For his life is taken away from the earth."

[34] The eunuch asked Philip, "About whom, may I ask you, does the prophet say this, about himself or about someone else?" [35] Then Philip began to speak, and starting with this scripture, he proclaimed to him the good news about Jesus. [36] As they were going along the road, they came to some water; and the eunuch said, "Look, here is water! What is to prevent me from being baptized?" [38] He commanded the chariot to stop, and both of them, Philip and the eunuch, went down into the water, and Philip baptized him. [39] When they came up out of the water, the Spirit of the Lord snatched Philip away; the eunuch saw him no more, and went on his way rejoicing. [40] But Philip found himself at Azotus, and as he was passing through the region, he proclaimed the good news to all the towns until he came to Caesarea.

9

Meanwhile Saul, still breathing threats and murder against the disciples of the Lord, went to the high priest and asked him for letters to the synagogues at Damascus, so that if he found any who belonged to the Way, men or women, he might bring them bound to Jerusalem. [3] Now as he was going along & approaching Damascus, suddenly a light from heaven flashed around him. [4] He fell to the ground & heard a voice saying to him, "Saul, Saul, why do you persecute me?" [5] He asked, "Who are you, Lord?" The reply came, "I am Jesus, whom you are persecuting. [6] But get up and enter the city, and you will be told what you are to do." [7] The men who were traveling with him stood speechless because they heard the voice but saw no one. [8] Saul got up from the ground, and though his eyes were open, he could see nothing; so they led him by the hand and brought him into Damascus. [9] For three days he was without sight, and neither ate nor drank. ▮ [10] Now there was a disciple in Damascus named Ananias. The Lord said to him in a vision, "Ananias." He answered, "Here I am, Lord." [11] The Lord said to him, "Get up and go to the street called Straight, and at the house of Judas look for a man of Tarsus named Saul. At this moment he is praying, [12] and he has seen in a vision a man named Ananias come in and lay his hands on him so that he might regain his sight." [13] But Ananias answered, "Lord, I have heard from many about this man, how much evil he has done to your saints in Jerusalem; [14] and here he has authority from the chief priests to bind all who invoke your name." [15] But the Lord said to him, "Go, for he is an instrument whom I have chosen to bring my name before Gentiles and kings and before the people of

m Gk fallen
n Gk they
o The Greek word for you and the verb pray are plural
p Gk after they
q Or go at noon
r Other ancient authorities add all or most of verse 37, And Philip said, "If you believe with all your heart, you may." And he replied, "I believe that Jesus Christ is the Son of God."
s Gk he
t Other ancient authorities lack in a vision

Israel; [16] I myself will show him how much he must suffer for the sake of my name." [17] So Ananias went and entered the house. He laid his hands on Saul & said, "Brother Saul, the Lord Jesus, who appeared to you on your way here, has sent me so that you may regain your sight and be filled with the Holy Spirit." [18] And immediately something like scales fell from his eyes, and his sight was restored. Then he got up & was baptized, [19] and after taking some food, he regained his strength. ¶ For several days he was with the disciples in Damascus, [20] and immediately he began to proclaim Jesus in the synagogues, saying, "He is the Son of God." [21] All who heard him were amazed and said, "Is not this the man who made havoc in Jerusalem among those who invoked this name? And has he not come here for the purpose of bringing them bound before the chief priests?" [22] Saul became increasingly more powerful and confounded the Jews who lived in Damascus by proving that Jesus was the Messiah.

[23] ¶ After some time had passed, the Jews plotted to kill him; [24] but their plot became known to Saul. They were watching the gates day and night so that they might kill him; [25] but his disciples took him by night and let him down through an opening in the wall, lowering him in a basket. ¶ When he had come to Jerusalem, he attempted to join the disciples; and they were all afraid of him, for they did not believe that he was a disciple. [27] But Barnabas took him, brought him to the apostles, and described for them how on the road he had seen the Lord, who had spoken to him, and how in Damascus he had spoken boldly in the name of Jesus. [28] So he went in and out among them in Jerusalem, speaking boldly in the name of the Lord. [29] He spoke and argued with the Hellenists; but they were attempting to kill him. [30] When the believers learned of it, they brought him down to Caesarea and sent him off to Tarsus. ¶ Meanwhile the church throughout Judea, Galilee, and Samaria had peace and was built up. Living in the fear of the Lord and in the comfort of the Holy Spirit, it increased in numbers.

[32] ¶ Now as Peter went here and there among all the believers, he came down also to the saints living in Lydda. [33] There he found a man named Aeneas, who had been bedridden for eight years, for he was paralyzed. [34] Peter said to him, "Aeneas, Jesus Christ heals you; get up and make your bed!" And immediately he got up. [35] And all the residents of Lydda and Sharon saw him & turned to the Lord. ¶ Now in Joppa there was a disciple whose name was Tabitha, which in Greek is Dorcas. She was devoted to good works and acts of charity. [37] At that time she

became ill and died. When they had washed her, they laid her in a room upstairs. [38] Since Lydda was near Joppa, the disciples, who heard that Peter was there, sent two men to him with the request, "Please come to us without delay." [39] So Peter got up and went with them; and when he arrived, they took him to the room upstairs. All the widows stood beside him, weeping and showing tunics and other clothing that Dorcas had made while she was with them. [40] Peter put all of them outside, and then he knelt down and prayed. He turned to the body and said, "Tabitha, get up." Then she opened her eyes, and seeing Peter, she sat up. [41] He gave her his hand and helped her up. Then calling the saints and widows, he showed her to be alive. [42] This became known throughout Joppa, and many believed in the Lord. [43] Meanwhile he stayed in Joppa for some time with a certain Simon, a tanner.

10

In Caesarea there was a man named Cornelius, a centurion of the Italian Cohort, as it was called. [2] He was a devout man who feared God with all his household; he gave alms generously to the people & prayed constantly to God. [3] One afternoon at about three o'clock he had a vision in which he clearly saw an angel of God coming in and saying to him, "Cornelius." [4] He stared at him in terror & said, "What is it, Lord?" He answered, "Your prayers and your alms have ascended as a memorial before God. [5] Now send men to Joppa for a certain Simon who is called Peter; [6] he is lodging with Simon, a tanner, whose house is by the seaside." [7] When the angel who spoke to him had left, he called two of his slaves and a devout soldier from the ranks of those who served him, [8] and after telling them everything, he sent them to Joppa. ¶ About noon the next day, as they were on their journey & approaching the city, Peter went up on the roof to pray. [10] He became hungry and wanted something to eat; and while it was being prepared, he fell into a trance. [11] He saw the heaven opened and something like a large sheet coming down, being lowered to the ground by its four corners. [12] In it were all kinds of four-footed creatures and reptiles and birds of the air. [13] Then he heard a voice saying, "Get up Peter; kill and eat." [14] But Peter said, "By no means, Lord; for I have never eaten anything that is profane or unclean." [15] The voice said to him again, a second time, "What God has made clean, you must not call profane." [16] This happened three times, and the thing was suddenly taken up to heaven. ¶ Now while Peter was greatly puzzled about what to make of

u Gk: him
v Gk: that this
w Or the Christ
x Gk: through the wall
y Gk: brothers
z Gk: all of them
a The name Tabitha in Aramaic and the name Dorcas in Greek mean a gazelle

the vision that he had seen, suddenly the men sent by Cornelius appeared. They were asking for Simon's house and were standing by the gate. [18] They called out to ask whether Simon, who was called Peter, was staying there. [19] While Peter was still thinking about the vision, the Spirit said to him, "Look, three men are searching for you. [20] Now get up, go down, and go with them without hesitation; for I have sent them." [21] So Peter went down to the men and said, "I am the one you are looking for; what is the reason for your coming?" [22] They answered, "Cornelius, a centurion, an upright & God-fearing man, who is well spoken of by the whole Jewish nation, was directed by a holy angel to send for you to come to his house & to hear what you have to say." [23] So Peter invited them in & gave them lodging. ∎ The next day he got up and went with them, and some of the believers from Joppa accompanied him. [24] The following day they came to Caesarea. Cornelius was expecting them and had called together his relatives & close friends. [25] On Peter's arrival Cornelius met him, and falling at his feet, worshiped him. [26] But Peter made him get up, saying, "Stand up; I am only a mortal." [27] And as he talked with him, he went in & found that many had assembled; [28] and he said to them, "You yourselves know that it is unlawful for a Jew to associate with or to visit a Gentile; but God has shown me that I should not call anyone profane or unclean. [29] So when I was sent for, I came without objection. Now may I ask why you sent for me?" ∎ Cornelius replied, "Four days ago at this very hour, at three o'clock, I was praying in my house when suddenly a man in dazzling clothes stood before me. [31] He said, 'Cornelius, your prayer has been heard and your alms have been remembered before God. [32] Send therefore to Joppa and ask for Simon, who is called Peter; he is staying in the home of Simon, a tanner, by the sea.' [33] Therefore I sent for you immediately, and you have been kind enough to come. So now all of us are here in the presence of God to listen to all that the Lord has commanded you to say." ∎ Then Peter began to speak to them: "I truly understand that God shows no partiality, [35] but in every nation anyone who fears him & does what is right is acceptable to him. [36] You know the message he sent to the people of Israel, preaching peace by Jesus Christ — he is Lord of all. [37] That message spread throughout Judea, beginning in Galilee after the baptism that John announced; [38] how God anointed Jesus of Nazareth with the Holy Spirit and with power; how he went about doing good and healing all who were oppressed by the devil, for God was with him. [39] We are witnesses to all that he did both in Judea and

in Jerusalem. They put him to death by hanging him on a tree; [40] but God raised him on the third day and allowed him to appear, [41] not to all the people but to us who were chosen by God as witnesses, and who ate & drank with him after he rose from the dead. [42] He commanded us to preach to the people and to testify that he is the one ordained by God as judge of the living and the dead. [43] All the prophets testify about him that everyone who believes in him receives forgiveness of sins through his name." ∎ While Peter was still speaking, the Holy Spirit fell upon all who heard the word. [45] The circumcised believers who had come with Peter were astounded that the gift of the Holy Spirit had been poured out even on the Gentiles, [46] for they heard them speaking in tongues & extolling God. Then Peter said, [47] "Can anyone withhold the water for baptizing these people who have received the Holy Spirit just as we have?" [48] So he ordered them to be baptized in the name of Jesus Christ. Then they invited him to stay for several days.

11

Now the apostles and the believers who were in Judea heard that the Gentiles had also accepted the word of God. [2] So when Peter went up to Jerusalem, the circumcised believers criticized him, [3] saying, "Why did you go to uncircumcised men and eat with them?" [4] Then Peter began to explain it to them, step by step, saying, [5] "I was in the city of Joppa praying, and in a trance I saw a vision. There was something like a large sheet coming down from heaven, being lowered by its four corners; and it came close to me. [6] As I looked at it closely I saw four-footed animals, beasts of prey, reptiles, and birds of the air. [7] I also heard a voice saying to me, 'Get up, Peter; kill and eat.' [8] But I replied, 'By no means, Lord; for nothing profane or unclean has ever entered my mouth.' [9] But a second time the voice answered from heaven, 'What God has made clean, you must not call profane.' [10] This happened three times; then everything was pulled up again to heaven. [11] At that very moment three men, sent to me from Caesarea, arrived at the house where we were. [12] The Spirit told me to go with them and not to make a distinction between them and us. These six brothers also accompanied me, and we entered the man's house. [13] He told us how he had seen the angel standing in his house & saying, 'Send to Joppa & bring Simon, who is called Peter; [14] he will give you a message by which you & your entire household will be saved.' [15] And as I began to speak, the Holy Spirit fell upon them just as it

b One ancient authority reads two; others lack the word
c Gk: he
d Gk: brothers
e Gk: brothers
f Gk: lacks believers
g Or: not to hesitate

had upon us at the beginning. ¹⁶ And I remembered the word of the Lord, how he had said, 'John baptized with water, but you will be baptized with the Holy Spirit.' ¹⁷ If then God gave them the same gift that he gave us when we believed in the Lord Jesus Christ, who was I that I could hinder God?" ¹⁸ When they heard this, they were silenced. And they praised God, saying, "Then God has given even to the Gentiles the repentance that leads to life."

¹⁹ ❡ Now those who were scattered because of the persecution that took place over Stephen traveled as far as Phœnicia, Cyprus, and Antioch, and they spoke the word to no one except Jews. ²⁰ But among them were some men of Cyprus and Cyrene who, on coming to Antioch, spoke to the Hellenists also, proclaiming the Lord Jesus. ²¹ The hand of the Lord was with them, and a great number became believers and turned to the Lord. ²² News of this came to the ears of the church in Jerusalem, and they sent Barnabas to Antioch. ²³ When he came and saw the grace of God, he rejoiced, and he exhorted them all to remain faithful to the Lord with steadfast devotion; ²⁴ for he was a good man, full of the Holy Spirit and of faith. And a great many people were brought to the Lord. ²⁵ Then Barnabas went to Tarsus to look for Saul, ²⁶ and when he had found him, he brought him to Antioch. So it was that for an entire year they met with the church and taught a great many people, and it was in Antioch that the disciples were first called "Christians." ❡ ²⁷ At that time prophets came down from Jerusalem to Antioch. ²⁸ One of them named Agabus stood up and predicted by the Spirit that there would be a severe famine over all the world; and this took place during the reign of Claudius. ²⁹ The disciples determined that according to their ability, each would send relief to the believers living in Judea; ³⁰ this they did, sending it to the elders by Barnabas and Saul.

12

About that time King Herod laid violent hands upon some who belonged to the church. ² He had James, the brother of John, killed with the sword. ³ After he saw that it pleased the Jews, he proceeded to arrest Peter also. [This was during the festival of Unleavened Bread.] ⁴ When he had seized him, he put him in prison & handed him over to four squads of soldiers to guard him, intending to bring him out to the people after the Passover. ⁵ While Peter was kept in prison, the ⁶ church prayed fervently to God for him. ❡ The very night before Herod was going to bring him out, Peter,

bound with two chains, was sleeping between two soldiers, while guards in front of the door were keeping watch over the prison. ⁷ Suddenly an angel of the Lord appeared and a light shone in the cell. He tapped Peter on the side and woke him, saying, "Get up quickly." And the chains fell off his wrists. ⁸ The angel said to him, "Fasten your belt and put on your sandals." He did so. Then he said to him, "Wrap your cloak around you & follow me." ⁹ Peter went out and followed him; he did not realize that what was happening with the angel's help was real; he thought he was seeing a vision. ¹⁰ After they had passed the first and the second guard, they came before the iron gate leading into the city. It opened for them of its own accord, and they went outside and walked along a lane, when suddenly the angel left him. ¹¹ Then Peter came to himself and said, "Now I am sure that the Lord has sent his angel & rescued me from the hands of Herod and from all that the Jewish people were expecting." ❡ ¹² As soon as he realized this, he went to the house of Mary, the mother of John whose other name was Mark, where many had gathered & were praying. ¹³ When he knocked at the outer gate, a maid named Rhoda came to answer. ¹⁴ On recognizing Peter's voice, she was so overjoyed that, instead of opening the gate, she ran in and announced that Peter was standing at the gate. ¹⁵ They said to her, "You are out of your mind!" But she insisted that it was so. They said, "It is his angel." ¹⁶ Meanwhile Peter continued knocking; and when they opened the gate, they saw him and were amazed. ¹⁷ He motioned to them with his hand to be silent, and described for them how the Lord had brought him out of the prison. And he added, "Tell this to James & to the believers." Then he left ¹⁸ and went to another place. ❡ When morning came, there was no small commotion among the soldiers over what had become of Peter. ¹⁹ When Herod had searched for him & could not find him, he examined the guards & ordered them to be put to death. Then he went down from Judea to Caesarea and stayed ²⁰ there. ❡ Now Herod was angry with the people of Tyre and Sidon. So they came to him in a body; and after winning over Blastus, the king's chamberlain, they asked for a reconciliation, because their country depended on the king's country for food. ²¹ On an appointed day Herod put on his royal robes, took his seat on the platform, and delivered a public address to them. ²² The people kept shouting, "The voice of a god, and not of a mortal!" ²³ And immediately, because he had not given the glory to God, an angel of the Lord struck him down, and he was ²⁴ eaten by worms and died. ❡ But the word of God continued to advance and gain adherents. ²⁵ Then

ʰ Other Ancient Authorities
ⁱ read Greeks
ʲ Or were guests of
ᵏ Gk: brothers
ˡ Gk: He
ᵐ Gk: brothers
ⁿ Gk: he

after completing their mission Barnabas and Saul returned to Jerusalem and brought with them John, whose other name was Mark.

13

Now in the church at Antioch there were prophets & teachers: Barnabas, Simeon who was called Niger, Lucius of Cyrene, Manaen a member of the court of Herod the ruler, and Saul. 2 While they were worshiping the Lord & fasting, the Holy Spirit said, "Set apart for me Barnabas & Saul for the work to which I have called them." 3 Then after fasting & praying they laid their hands on them and sent them off. ■ So, being sent out by the Holy Spirit, they went down to Seleucia; and from there they sailed to Cyprus. 5 When they arrived at Salamis, they proclaimed the word of God in the synagogues of the Jews. And they had John also to assist them. 6 When they had gone through the whole island as far as Paphos, they met a certain magician, a Jewish false prophet, named Bar-Jesus. 7 He was with the proconsul, Sergius Paulus, an intelligent man, who summoned Barnabas and Saul & wanted to hear the word of God. 8 But the magician Elymas [for that is the translation of his name] opposed them & tried to turn the proconsul away from the faith. 9 But Saul, also known as Paul, filled with the Holy Spirit, looked intently at him 10 and said, "You son of the devil, you enemy of all righteousness, full of all deceit & villainy, will you not stop making crooked the straight paths of the Lord? 11 And now listen — the hand of the Lord is against you, and you will be blind for a while, unable to see the sun." Immediately mist & darkness came over him, and he went about groping for someone to lead him by the hand. 12 When the proconsul saw what had happened, he believed, for he was astonished at the teaching about the Lord. ■ Then Paul and his companions set sail from Paphos and came to Perga in Pamphylia. John, however, left them & returned to Jerusalem; 14 but they went on from Perga and came to Antioch in Pisidia. And on the sabbath day they went into the synagogue and sat down. 15 After the reading of the law & the prophets, the officials of the synagogue sent them a message, saying, "Brothers, if you have any word of exhortation for the people, give it." 16 So Paul stood up and with a gesture began to speak: ■ "You Israelites, and others who fear God, listen: 17 The God of this people Israel chose our ancestors & made the people great during their stay in the land of Egypt, and with uplifted arm he led them out of it. 18 For about forty years he put up with them in the wilderness. 19 After he

n Other Ancient Authorities read from
o Gk: tetrarch
p Gk: Men, Israelites
q Other Ancient Authorities read cared for
r Gk: untie the sandals
s Other Ancient Authorities read you
t Gk: fell asleep
u Gk: this
v Gk: all

had destroyed seven nations in the land of Canaan, he gave them their land as an inheritance 20 for about four hundred fifty years. After that he gave them judges until the time of the prophet Samuel. 21 Then they asked for a king; and God gave them Saul son of Kish, a man of the tribe of Benjamin, who reigned for forty years. 22 When he had removed him, he made David their king. In his testimony about him he said, 'I have found David, son of Jesse, to be a man after my heart, who will carry out all my wishes.' 23 Of this man's posterity God has brought to Israel a Savior, Jesus, as he promised; 24 before his coming John had already proclaimed a baptism of repentance to all the people of Israel. 25 And as John was finishing his work, he said, 'What do you suppose that I am? I am not he. No, but one is coming after me; I am not worthy to untie the thong of the sandals on his feet.' ■ "My brothers, you descendants of Abraham's family, and others who fear God, to us the message of this salvation has been sent. 27 Because the residents of Jerusalem and their leaders did not recognize him or understand the words of the prophets that are read every sabbath, they fulfilled those words by condemning him. 28 Even though they found no cause for a sentence of death, they asked Pilate to have him killed. 29 When they had carried out everything that was written about him, they took him down from the tree and laid him in a tomb. 30 But God raised him from the dead; 31 and for many days he appeared to those who came up with him from Galilee to Jerusalem, and they are now his witnesses to the people. 32 And we bring you the good news that what God promised to our ancestors 33 he has fulfilled for us, their children, by raising Jesus; as also it is written in the second psalm,

'You are my Son;

today I have begotten you.'

34 As to his raising him from the dead, no more to return to corruption, he has spoken in this way,

'I will give you the holy promises made to David.'

35 Therefore he has also said in another psalm,

'You will not let your Holy One experience corruption.'

36 For David, after he had served the purpose of God in his own generation, died, was laid beside his ancestors, and experienced corruption; 37 but he whom God raised up experienced no corruption. 38 Let it be known to you therefore, my brothers, that through this man forgiveness of sins is proclaimed to you; 39 by this Jesus everyone who believes is set free from all those sins from which you could not be freed by the law of Moses. 40 Beware, therefore, that what the prophets said does not happen to you:

⁴¹ 'Look, you scoffers!
Be amazed and perish,
for in your days I am doing a work,
a work that you will never believe,
even if someone tells you.'"

⁴² ❡ As Paul and Barnabas were going out, the people urged them to speak about these things again the next sabbath. ⁴³ When the meeting of the synagogue broke up, many Jews & devout converts to Judaism followed Paul and Barnabas, who spoke to them and urged them to continue in the grace of God.

⁴⁴ ❡ The next sabbath almost the whole city gathered to hear the word of the Lord. ⁴⁵ But when the Jews saw the crowds, they were filled with jealousy; and blaspheming, they contradicted what was spoken by Paul. ⁴⁶ Then both Paul and Barnabas spoke out boldly, saying, "It was necessary that the word of God should be spoken first to you. Since you reject it and judge yourselves to be unworthy of eternal life, we are now turning to the Gentiles. ⁴⁷ For so the Lord has commanded us, saying,

'I have set you to be a light for the Gentiles,
so that you may bring salvation to the
ends of the earth.'"

⁴⁸ ❡ When the Gentiles heard this, they were glad & praised the word of the Lord; and as many as had been destined for eternal life became believers. ⁴⁹ Thus the word of the Lord spread throughout the region. ⁵⁰ But the Jews incited the devout women of high standing & the leading men of the city, & stirred up persecution against Paul and Barnabas, and drove them out of their region. ⁵¹ So they shook the dust off their feet in protest against them, and went to Iconium. ⁵² And the disciples were filled with joy and with the Holy Spirit.

14

The same thing occurred in Iconium, where Paul and Barnabas went into the Jewish synagogue and spoke in such a way that a great number of both Jews and Greeks became believers. ² But the unbelieving Jews stirred up the Gentiles & poisoned their minds against the brothers. ³ So they remained for a long time, speaking boldly for the Lord, who testified to the word of his grace by granting signs and wonders to be done through them. ⁴ But the residents of the city were divided; some sided with the Jews, and some with the apostles. ⁵ And when an attempt was made by both Gentiles and Jews, with their rulers, to mistreat them and to stone them, ⁶ the apostles learned of it and fled to Lystra and Derbe, cities of Lycaonia, and to the surrounding country; ⁷ and there they contin-

⁸ ued proclaiming the good news. ❡ In Lystra there was a man sitting who could not use his feet and had never walked, for he had been crippled from birth. ⁹ He listened to Paul as he was speaking. And Paul, looking at him intently & seeing that he had faith to be healed, ¹⁰ said in a loud voice, "Stand upright on your feet." And the man sprang up and began to walk. ¹¹ When the crowds saw what Paul had done, they shouted in the Lycaonian language, "The gods have come down to us in human form!" ¹² Barnabas they called Zeus, and Paul they called Hermes, because he was the chief speaker. ¹³ The priest of Zeus, whose temple was just outside the city, brought oxen and garlands to the gates; he and the crowds wanted to offer sacrifice. ¹⁴ When the apostles Barnabas & Paul heard of it, they tore their clothes & rushed out into the crowd, shouting, ¹⁵ "Friends, why are you doing this? We are mortals just like you, and we bring you good news, that you should turn from these worthless things to the living God, who made the heaven and the earth and the sea and all that is in them. ¹⁶ In past generations he allowed all the nations to follow their own ways; ¹⁷ yet he has not left himself without a witness in doing good—giving you rains from heaven & fruitful seasons, and filling you with food & your hearts with joy." ¹⁸ Even with these words, they scarcely restrained the crowds from offering sacrifice to them.

¹⁹ ❡ But Jews came there from Antioch and Iconium and won over the crowds. Then they stoned Paul and dragged him out of the city, supposing that he was dead. ²⁰ But when the disciples surrounded him, he got up and went into the city. The next day he went on with Barnabas to Derbe. ❡ After they had proclaimed the good news to that city and had made many disciples, they returned to Lystra, then on to Iconium & Antioch. ²² There they strengthened the souls of the disciples and encouraged them to continue in the faith, saying, "It is through many persecutions that we must enter the kingdom of God." ²³ And after they had appointed elders for them in each church, with prayer and fasting they entrusted them to the Lord in whom they had come to believe. ❡ Then they passed through Pisidia and came to Pamphylia. ²⁵ When they had spoken the word in Perga, they went down to Attalia. ²⁶ From there they sailed back to Antioch, where they had been commended to the grace of God for the work that they had completed. ²⁷ When they arrived, they called the church together and related all that God had done with them, and how he had opened a door of faith for the Gentiles. ²⁸ And they stayed there with the disciples for some time.

w Gk: they
x Other ancient authorities read God
y Gk: they
z Gk: they
a Gk: he
b Or The priest of Zeus Outside the City
c Gk: Men
d Or committed in the grace of God to the work

15

Then certain individuals came down from Judea and were teaching the brothers, "Unless you are circumcised according to the custom of Moses, you cannot be saved." And after Paul and Barnabas had no small dissension and debate with them, Paul and Barnabas & some of the others were appointed to go up to Jerusalem to discuss this question with the apostles and the elders. So they were sent on their way by the church, and as they passed through both Phoenicia and Samaria, they reported the conversion of the Gentiles, and brought great joy to all the believers. When they came to Jerusalem, they were welcomed by the church and the apostles & the elders, and they reported all that God had done with them. But some believers who belonged to the sect of the Pharisees stood up and said, "It is necessary for them to be circumcised & ordered to keep the law of Moses."

6 ¶ The apostles and the elders met together to consider this matter. After there had been much debate, Peter stood up & said to them, "My brothers, you know that in the early days God made a choice among you, that I should be the one through whom the Gentiles would hear the message of the good news & become believers. And God, who knows the human heart, testified to them by giving them the Holy Spirit, just as he did to us; and in cleansing their hearts by faith he has made no distinction between them and us. Now therefore, why are you putting God to the test by placing on the neck of the disciples a yoke that neither our ancestors nor we have been able to bear? On the contrary, we believe that we will be saved through the grace of the Lord Jesus, just as they will." ¶ The whole 12 assembly kept silence, and listened to Barnabas & Paul as they told of all the signs and wonders that God had done through them among the Gentiles. After they finished speaking, James replied, "My brothers, listen to me. Simeon has related how God first looked favorably on the Gentiles, to take from among them a people for his name. This agrees with the words of the prophets, as it is written,

After this I will return,
and I will rebuild the dwelling of David, which has fallen;
from its ruins I will rebuild it,
and I will set it up,

17 so that all other peoples may seek the Lord—
even all the Gentiles over whom my name has been called.

Thus says the Lord, who has been making these things known from long ago.'

Therefore I have reached the decision that we should not trouble those Gentiles who are turning to God, but we should write to them to abstain only from things polluted by idols and from fornication and from whatever has been strangled and from blood. For in every city, for generations past, Moses has had those who proclaim him, for he has been read aloud every sabbath in the synagogues." ¶ Then the apostles and the elders, with 22 the consent of the whole church, decided to choose men from among their members & to send them to Antioch with Paul & Barnabas. They sent Judas called Barsabbas, & Silas, leaders among the brothers, with the following letter: "The brothers, both the apostles and the elders, to the believers of Gentile origin in Antioch & Syria & Cilicia, greetings. Since we have heard that certain persons who have gone out from us, though with no instructions from us, have said things to disturb you and have unsettled your minds, we have decided unanimously to choose representatives and send them to you, along with our beloved Barnabas and Paul, who have risked their lives for the sake of our Lord Jesus Christ. We have therefore sent Judas and Silas, who themselves will tell you the same thing by word of mouth. For it has seemed good to the Holy Spirit and to us to impose on you no further burden than these essentials: that you abstain from what has been sacrificed to idols and from blood and from what is strangled and from fornication. If you keep yourselves from these, you 30 will do well. Farewell." ¶ So they were sent off and went down to Antioch. When they gathered the congregation together, they delivered the letter. When its members read it, they rejoiced at the exhortation. Judas & Silas, who were themselves prophets, said much to encourage and strengthen the believers. After they had been there for some time, they were sent off in peace by the believers to those who had sent them. But Paul and Barnabas remained in Antioch, and there, with many others, they taught and proclaimed the word of the Lord.

36 ¶ After some days Paul said to Barnabas, "Come, let us return & visit the believers in every city where we proclaimed the word of the Lord and see how they are doing." Barnabas wanted to take with them John called Mark. But Paul decided not to take with them one who had deserted them in Pamphylia & had not accompanied them in the work. The disagreement became so sharp that they parted company; Barnabas took Mark with him & sailed away to Cyprus. But Paul chose Silas and set out, the believers commending him to the grace of the Lord. He went through Syria & Cilicia, strengthening the churches.

e Gk brothers
f Gk Men, brothers
g Gk Men, brothers
h Other ancient authorities read things. Known to God from old are all his works.
i Other ancient authorities lack and from whatever has been strangled
j Gk from among them
k Gk brothers
l Other ancient authorities add saying, 'you must be circumcised and keep the law,'
m Gk men
n Other ancient authorities lack and from what is strangled
o Gk When they
p Gk brothers
q Gk brothers
r Other ancient authorities add verse 34, But it seemed good to Silas to remain there
s Gk brothers
t Gk brothers

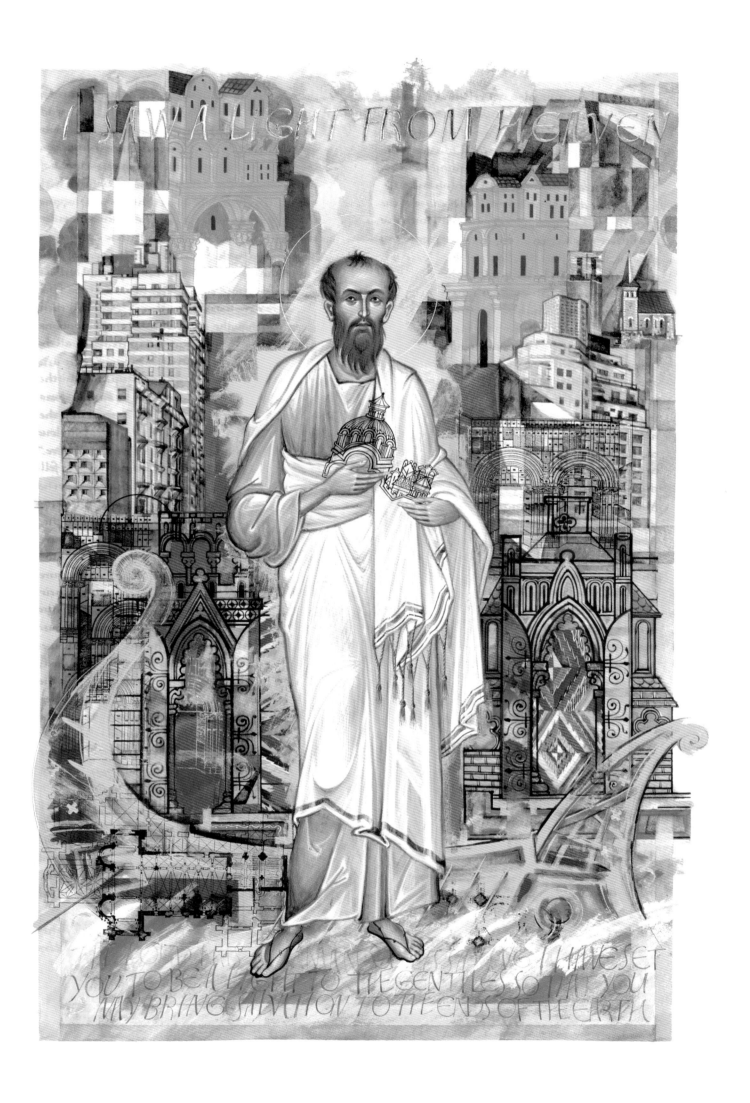

16

Paul went on also to Derbe and to Lystra, where there was a disciple named Timothy, the son of a Jewish woman who was a believer; but his father was a Greek. [2] He was well spoken of by the believers in Lystra and Iconium. [3] Paul wanted Timothy to accompany him; & he took him and had him circumcised because of the Jews who were in those places, for they all knew that his father was a Greek. [4] As they went from town to town, they delivered to them for observance the decisions that had been reached by the apostles & elders who were in Jerusalem. [5] So the churches were strengthened in the faith & increased in numbers daily. ¶ They went through the region of Phrygia & Galatia, having been forbidden by the Holy Spirit to speak the word in Asia. [7] When they had come opposite Mysia, they attempted to go into Bithynia, but the Spirit of Jesus did not allow them; [8] so, passing by Mysia, they went down to Troas. [9] During the night Paul had a vision: there stood a man of Macedonia pleading with him & saying, "Come over to Macedonia and help us." [10] When he had seen the vision, we immediately tried to cross over to Macedonia, being convinced that God had called us to proclaim the good news to them. ¶ We set sail from Troas & took a straight course to Samothrace, the following day to Neapolis, [12] and from there to Philippi, which is a leading city of the district of Macedonia and a Roman colony. We remained in this city for some days. [13] On the sabbath day we went outside the gate by the river, where we supposed there was a place of prayer; and we sat down and spoke to the women who had gathered there. [14] A certain woman named Lydia, a worshiper of God, was listening to us: she was from the city of Thyatira and a dealer in purple cloth. The Lord opened her heart to listen eagerly to what was said by Paul. [15] When she and her household were baptized, she urged us, saying, "If you have judged me to be faithful to the Lord, come and stay at my home." And she prevailed upon us. ¶ One day, as we were going to the place of prayer, we met a slave girl who had a spirit of divination & brought her owners a great deal of money by fortune-telling. [17] While she followed Paul and us, she would cry out, "These men are slaves of the Most High God, who proclaim to you a way of salvation." [18] She kept doing this for many days. But Paul, very much annoyed, turned and said to the spirit, "I order you in the name of Jesus Christ to come out of her." And it came out that very hour. ¶ But when her owners saw that their hope of making money was gone, they seized Paul and Silas and dragged them into the market place before the authorities. [20] When they had brought

u Gk: He
v Gk: brothers
w Other authorities read a city of the first district
x Other ancient authorities read to us
y Gk: He
z Other ancient authorities read word of God
A Gk: brothers

them before the magistrates, they said, "These men are disturbing our city; they are Jews [21] and are advocating customs that are not lawful for us as Romans to adopt or observe." [22] The crowd joined in attacking them, and the magistrates had them stripped of their clothing and ordered them to be beaten with rods. [23] After they had given them a severe flogging, they threw them into prison and ordered the jailer to keep them securely. [24] Following these instructions, he put them in the innermost cell & fastened their feet in the stocks. ¶ About midnight Paul and Silas were praying and singing hymns to God, and the prisoners were listening to them. [26] Suddenly there was an earthquake, so violent that the foundations of the prison were shaken; and immediately all the doors were opened and everyone's chains were unfastened. [27] When the jailer woke up and saw the prison doors wide open, he drew his sword & was about to kill himself, since he supposed that the prisoners had escaped. [28] But Paul shouted in a loud voice, "Do not harm yourself, for we are all here." [29] The jailer called for lights, and rushing in, he fell down trembling before Paul and Silas. [30] Then he brought them outside and said, "Sirs, what must I do to be saved?" [31] They answered, "Believe on the Lord Jesus, and you will be saved, you and your household." [32] They spoke the word of the Lord to him & to all who were in his house. [33] At the same hour of the night he took them and washed their wounds; then he & his entire family were baptized without delay. [34] He brought them up into the house & set food before them; and he and his entire household rejoiced that he had become a believer in God. ¶ When morning came, the magistrates sent the police, saying, "Let those men go." [36] And the jailer reported the message to Paul, saying, "The magistrates sent word to let you go; therefore come out now & go in peace." [37] But Paul replied, "They have beaten us in public, uncondemned, men who are Roman citizens, and have thrown us into prison; and now are they going to discharge us in secret? Certainly not! Let them come & take us out themselves." [38] The police reported these words to the magistrates, and they were afraid when they heard that they were Roman citizens; [39] so they came & apologized to them. And they took them out and asked them to leave the city. [40] After leaving the prison they went to Lydia's home; and when they had seen and encouraged the brothers and sisters there, they departed.

17

After Paul and Silas had passed through Amphipolis and Apollonia, they came to Thessalonica, where there was a synagogue of the Jews. 2 And Paul went in, as was his custom, and on three sabbath days argued with them from the scriptures, 3 explaining and proving that it was necessary for the Messiah to suffer and to rise from the dead, and saying, "This is the Messiah, Jesus whom I am proclaiming to you." 4 Some of them were persuaded and joined Paul and Silas, as did a great many of the devout Greeks and not a few of the leading women. 5 But the Jews became jealous, and with the help of some ruffians in the market places they formed a mob & set the city in an uproar. While they were searching for Paul and Silas to bring them out to the assembly, they attacked Jason's house. 6 When they could not find them, they dragged Jason and some believers before the city authorities, shouting, "These people who have been turning the world upside down have come here also, 7 and Jason has entertained them as guests. They are all acting contrary to the decrees of the emperor, saying that there is another king named Jesus." 8 The people and the city officials were disturbed when they heard this, 9 and after they had taken bail from Jason & the others, they let them 10 go. ¶ That very night the believers sent Paul and Silas off to Beroea; and when they arrived, they went to the Jewish synagogue. 11 These Jews were more receptive than those in Thessalonica, for they welcomed the message very eagerly and examined the scriptures every day to see whether these things were so. 12 Many of them therefore believed, including not a few Greek women & men of high standing. 13 But when the Jews of Thessalonica learned that the word of God had been proclaimed by Paul in Beroea as well, they came there too, to stir up and incite the crowds. 14 Then the believers immediately sent Paul away to the coast, but Silas & Timothy remained behind. 15 Those who conducted Paul brought him as far as Athens; and after receiving instructions to have Silas and Timothy join him as 16 soon as possible, they left him. ¶ While Paul was waiting for them in Athens, he was deeply distressed to see that the city was full of idols. 17 So he argued in the synagogue with the Jews & the devout persons, and also in the marketplace every day with those who happened to be there. 18 Also some Epicurean and Stoic philosophers debated with him. Some said, "What does this babbler want to say?" Others said, "He seems to be a proclaimer of foreign divinities." [This was because he was telling the good news about Jesus and the resurrection.] 19 So they took him and brought him to the Areopagus and

asked him, "May we know what this new teaching is that you are presenting? 20 It sounds rather strange to us, so we would like to know what it means." 21 Now all the Athenians and the foreigners living there would spend their time in nothing but telling 22 or hearing something new. ¶ Then Paul stood in front of the Areopagus and said, "Athenians, I see how extremely religious you are in every way. 23 For as I went through the city and looked carefully at the objects of your worship, I found among them an altar with the inscription, 'To an unknown god.' What therefore you worship as unknown, this I proclaim to you. 24 The God who made the world and everything in it, he who is Lord of heaven and earth, does not live in shrines made by human hands, 25 nor is he served by human hands, as though he needed anything, since he himself gives to all mortals life & breath & all things. 26 From one ancestor he made all nations to inhabit the whole earth, and he allotted the times of their existence & the boundaries of the places where they would live, 27 so that they would search for God and perhaps grope for him and find him—though indeed he is not far from each one of us. 28 For 'In him we live and move & have our being'; as even some of your own poets have said,

'For we too are his offspring.'

29 Since we are God's offspring, we ought not to think that the deity is like gold, or silver, or stone, an image formed by the art & imagination of mortals. 30 While God has overlooked the times of human ignorance, now he commands all people everywhere to repent, 31 because he has fixed a day on which he will have the world judged in righteousness by a man whom he has appointed, and of this he has given assur 32 ance to all by raising him from the dead." ¶ When they heard of the resurrection of the dead, some scoffed; but others said, "We will hear you again about this." 33 At that point Paul left them. 34 But some of them joined him and became believers, including Dionysius the Areopagite and a woman named Damaris, and others with them.

18

After this Paul left Athens & went to Corinth. 2 There he found a Jew named Aquila, a native of Pontus, who had recently come from Italy with his wife Priscilla, because Claudius had ordered all Jews to leave Rome. Paul went to see them, 3 and, because he was of the same trade, he stayed with them, and they worked together— by trade they were tentmakers. 4 Every sabbath he would argue in the synagogue and would try to

b Gk: they
c Or the Christ
d Or the Christ
e Gk: brothers
f Gk: politarchs
g Gk: brothers
h Gk: brothers
i Or civic center; Gk: agora
j Gk: From one; other ancient authorities read From one blood
k Other ancient authorities read the Lord
l Gk: he
m Gk: He

5 convince Jews and Greeks. ■ When Silas & Timothy arrived from Macedonia, Paul was occupied with proclaiming the word, testifying to the Jews that the Messiah was Jesus. 6 When they opposed and reviled him, in protest he shook the dust from his clothes and said to them, "Your blood be on your own heads! I am innocent. From now on I will go to the Gentiles." 7 Then he left the synagogue and went to the house of a man named Titius Justus, a worshiper of God; his house was next door to the synagogue. 8 Crispus, the official of the synagogue, became a believer in the Lord, together with all his household; and many of the Corinthians who heard Paul became believers and were baptized. 9 One night the Lord said to Paul in a vision, "Do not be afraid, but speak and do not be silent; 10 for I am with you, and no one will lay a hand on you to harm you, for there are many in this city who are my people."

11 He stayed there a year and six months, teaching
12 the word of God among them. ■ But when Gallio was proconsul of Achaia, the Jews made a united attack on Paul & brought him before the tribunal. 13 They said, "This man is persuading people to worship God in ways that are contrary to the law." 14 Just as Paul was about to speak, Gallio said to the Jews, "If it were a matter of crime or serious villainy, I would be justified in accepting the complaint of you Jews; 15 but since it is a matter of questions about words and names and your own law, see to it yourselves; I do not wish to be a judge of these matters." 16 And he dismissed them from the tribunal. 17 Then all of them seized Sosthenes, the official of the synagogue, and beat him in front of the tribunal. But Gallio paid no attention to any of these things.

18 ■ After staying there for a considerable time, Paul said farewell to the believers and sailed for Syria, accompanied by Priscilla and Aquila. At Cenchreae he had his hair cut, for he was under a vow. 19 When they reached Ephesus, he left them there, but first he himself went into the synagogue and had a discussion with the Jews. 20 When they asked him to stay longer, he declined; 21 but on taking leave of them, he said, "I will return to you, if God wills." Then he set sail from Ephesus. ■ 22 When he had landed at Caesarea, he went up to Jerusalem and greeted the church, and then went down to Antioch. 23 After spending some time there he departed & went from place to place through the region of Galatia and Phrygia, strengthening all the disciples.

24 ■ Now there came to Ephesus a Jew named Apollos, a native of Alexandria. He was an eloquent man, well-versed in the scriptures. 25 He had been instructed in the Way of the Lord; and he spoke with burning enthusiasm & taught accurately the things concerning Jesus, though he knew only the baptism of John. 26 He began to speak boldly in the synagogue; but when Priscilla & Aquila heard him, they took him aside and explained the Way of God to him more accurately. 27 And when he wished to cross over to Achaia, the believers encouraged him and wrote to the disciples to welcome him. On his arrival he greatly helped those who through grace had become believers, 28 for he powerfully refuted the Jews in public, showing by the scriptures that the Messiah is Jesus.

19

While Apollos was in Corinth, Paul passed through the interior regions & came to Ephesus, where he found some disciples. 2 He said to them, "Did you receive the Holy Spirit when you became believers?" They replied, "No, we have not even heard that there is a Holy Spirit." 3 Then he said, "Into what then were you baptized?" They answered, "Into John's baptism." 4 Paul said, "John baptized with the baptism of repentance, telling the people to believe in the one who was to come after him, that is, in Jesus." 5 On hearing this, they were baptized in the name of the Lord Jesus. 6 When Paul had laid his hands on them, the Holy Spirit came upon them, and they spoke in tongues and prophesied — 7 altogether there were about
8 twelve of them. ■ He entered the synagogue & for three months spoke out boldly, and argued persuasively about the kingdom of God. 9 When some stubbornly refused to believe and spoke evil of the Way before the congregation, he left them, taking the disciples with him, and argued daily in the lecture hall of Tyrannus. 10 This continued for two years, so that all the residents of Asia, both Jews &
11 Greeks, heard the word of the Lord. ■ God did extraordinary miracles through Paul, 12 so that when the handkerchiefs or aprons that had touched his skin were brought to the sick, their diseases left them, and the evil spirits came out of them. 13 Then some itinerant Jewish exorcists tried to use the name of the Lord Jesus over those who had evil spirits, saying, "I adjure you by the Jesus whom Paul proclaims." 14 Seven sons of a Jewish high priest named Sceva were doing this. 15 But the evil spirit said to them in reply, "Jesus I know, and Paul I know; but who are you?" 16 Then the man with the evil spirit leaped on them, mastered them all, and so overpowered them that they fled out of the house naked and wounded. 17 When this became known to all residents of Ephesus, both Jews and Greeks, everyone was awestruck; and the name of the Lord Jesus was praised. 18 Also many of those who became

u Gk with the word
o Or the Christ
p Gk reviled him, he shook out his clothes
q Gk left there
r Other ancient authorities read Titus
s Other ancient authorities read all the Greeks
t Gk brothers
u Other ancient authorities read I must at all costs keep the approaching festival in Jerusalem, but I
v Gk went up
w Gk the Galatian region
x Gk brothers
y Or the Christ
z Other ancient authorities read of a certain Tyrannus, from eleven o'clock in the morning to four in the afternoon

believers confessed and disclosed their practices. [19] A number of those who practiced magic collected their books and burned them publicly; when the value of these books was calculated, it was found to come to fifty thousand silver coins. [20] So the word of the Lord grew mighty and prevailed.

[21] ❡ Now after these things had been accomplished, Paul resolved in the Spirit to go through Macedonia & Achaia, and then to go on to Jerusalem. He said, "After I have gone there, I must also see Rome." [22] So he sent two of his helpers, Timothy & Erastus, to Macedonia, while he himself stayed for some time longer in Asia. ❡ [23] About that time no little disturbance broke out concerning the Way. [24] A man named Demetrius, a silversmith who made silver shrines of Artemis, brought no little business to the artisans. [25] These he gathered together, with the workers of the same trade, and said, "Men, you know that we get our wealth from this business. [26] You also see and hear that not only in Ephesus but in almost the whole of Asia this Paul has persuaded and drawn away a considerable number of people by saying that gods made with hands are not gods. [27] And there is danger not only that this trade of ours may come into disrepute but also that the temple of the great goddess Artemis will be scorned, and she will be deprived of her majesty that brought all Asia & the world to worship her." ❡ [28] When they heard this, they were enraged and shouted, "Great is Artemis of the Ephesians!" [29] The city was filled with the confusion; and people rushed together to the theater, dragging with them Gaius and Aristarchus, Macedonians who were Paul's travel companions. [30] Paul wished to go into the crowd, but the disciples would not let him; [31] even some officials of the province of Asia, who were friendly to him, sent him a message urging him not to venture into the theater. [32] Meanwhile, some were shouting one thing, some another; for the assembly was in confusion, and most of them did not know why they had come together. [33] Some of the crowd gave instructions to Alexander, whom the Jews had pushed forward. And Alexander motioned for silence & tried to make a defense before the people. [34] But when they recognized that he was a Jew, for about two hours all of them shouted in unison, "Great is Artemis of the Ephesians!" [35] But when the town clerk had quieted the crowd, he said, "Citizens of Ephesus, who is there that does not know that the city of the Ephesians is the temple keeper of the great Artemis & of the statue that fell from heaven? [36] Since these things cannot be denied, you ought to be quiet & do nothing rash. [37] You have brought these men here who are neither temple robbers nor blasphemers of our goddess. [38] If therefore Demetrius and the artisans with him have complaint against anyone, the courts are open, and there are proconsuls; let them bring charges there against one another. [39] If there is anything further you want to know, it must be settled in the regular assembly. [40] For we are in danger of being charged with rioting today, since there is no cause that we can give to justify this commotion." [41] When he had said this, he dismissed the assembly.

20

After the uproar had ceased, Paul sent for the disciples; and after encouraging them & saying farewell, he left for Macedonia. [2] When he had gone through those regions & had given the believers much encouragement, he came to Greece, where he stayed for three months. He was about to set sail for Syria when a plot was made against him by the Jews, and so he decided to return through Macedonia. [4] He was accompanied by Sopater son of Pyrrhus from Beroea, by Aristarchus & Secundus from Thessalonica, by Gaius from Derbe, and by Timothy, as well as by Tychicus & Trophimus from Asia. [5] They went ahead and were waiting for us in Troas; [6] but we sailed from Philippi after the days of Unleavened Bread, and in five days we joined them in Troas, where we stayed for seven days. ❡ [7] On the first day of the week, when we met to break bread, Paul was holding a discussion with them; since he intended to leave the next day, he continued speaking until midnight. [8] There were many lamps in the room upstairs where we were meeting. [9] A young man named Eutychus, who was sitting in the window, began to sink off into a deep sleep while Paul talked still longer. Overcome by sleep, he fell to the ground three floors below and was picked up dead. [10] But Paul went down, and bending over him took him in his arms, and said, "Do not be alarmed, for his life is in him." [11] Then Paul went upstairs, and after he had broken bread and eaten, he continued to converse with them until dawn; then he left. [12] Meanwhile they had taken the boy away alive and were not a little comforted. ❡ [13] We went ahead to the ship & set sail for Assos, intending to take Paul on board there; for he had made this arrangement, intending to go by land himself. [14] When he met us in Assos, we took him on board and went to Mitylene. [15] We sailed from there, and on the following day we arrived opposite Chios. The next day we touched at Samos, and the day after that we came to Miletus. [16] For Paul had decided to sail past Ephesus, so that he might not have to

a Gk them
b Gk they
c Gk some of the Asiarchs
d Meaning of Gk uncertain
e Other ancient authorities read your
f Other ancient authorities read about other matters
g Gk given them
h Other ancient authorities add after remaining at Trogyllium

spend time in Asia; he was eager to be in Jerusalem, if possible, on the day of Pentecost. From Miletus he sent a message to Ephesus, asking the elders of the church to meet him. [18] When they came to him, he said to them: "You yourselves know how I lived among you the entire time from the first day that I set foot in Asia, [19] serving the Lord with all humility and with tears, enduring the trials that came to me through the plots of the Jews. [20] I did not shrink from doing anything helpful, proclaiming the message to you & teaching you publicly and from house to house, [21] as I testified[i] to both Jews and Greeks about repentance toward God and faith toward our Lord Jesus. [22] And now, as a captive to the Spirit, I am on my way to Jerusalem, not knowing what will happen to me there, [23] except that the Holy Spirit testifies to me in every city that imprisonment and persecutions are waiting for me. [24] But I do not count my life of any value to myself, if only I may finish my course and the ministry that I received from the Lord Jesus, to testify to the good news of God's grace. "And now I know that none of you, among whom I have gone about proclaiming the kingdom, will ever see my face again. [26] Therefore I declare to you this day that I am not responsible for the blood of any of you, [27] for I did not shrink from declaring to you the whole purpose of God. [28] Keep watch over yourselves & over all the flock of which the Holy Spirit has made you overseers, to shepherd the church of God[j] that he obtained with the blood of his own Son.[k] [29] I know that after I have gone, savage wolves will come in among you, not sparing the flock. [30] Some even from your own group will come distorting the truth in order to entice the disciples to follow them. [31] Therefore be alert, remembering that for three years I did not cease night or day to warn everyone with tears. [32] And now I commend you to God and to the message of his grace, a message that is able to build you up & to give you the inheritance among all who are sanctified. [33] I coveted no one's silver or gold or clothing. [34] You know for yourselves that I worked with my own hands to support myself and my companions. [35] In all this I have given you an example that by such work we must support the weak, remembering the words of the Lord Jesus, for he himself said, 'It is more blessed to give than to receive.'" When he had finished speaking, he knelt down with them all and prayed. [37] There was much weeping among them all; they embraced Paul & kissed him, [38] grieving especially because of what he had said, that they would not see him again. Then they brought him to the ship.

When we had parted from them & set sail, we came by a straight course to Cos, and the next day to Rhodes, and from there to Patra. [2] When we found a ship bound for Phoenicia, we went on board and set sail. [3] We came in sight of Cyprus; and leaving it on our left, we sailed to Syria and landed at Tyre, because the ship was to unload its cargo there. [4] We looked up the disciples & stayed there for seven days. Through the Spirit they told Paul not to go on to Jerusalem. [5] When our days there were ended, we left & proceeded on our journey; and all of them, with wives and children, escorted us outside the city. There we knelt down on the beach and prayed[6] and said farewell to one another. Then we went on board the ship, and they returned home. [7] When we had finished the voyage from Tyre, we arrived at Ptolemais; and we greeted the believers[n] & stayed with them for one day. [8] The next day we left and came to Caesarea; and we went into the house of Philip the evangelist, one of the seven, and stayed with him. [9] He had four unmarried daughters who had the gift of prophecy.[o] [10] While we were staying there for several days, a prophet named Agabus came down from Judea. [11] He came to us and took Paul's belt, bound his own feet and hands with it and said, "Thus says the Holy Spirit, 'This is the way the Jews in Jerusalem will bind the man who owns this belt & will hand him over to the Gentiles.'" [12] When we heard this, we and the people there urged him not to go up to Jerusalem. [13] Then Paul answered, "What are you doing, weeping and breaking my heart? For I am ready not only to be bound but even to die in Jerusalem for the name of the Lord Jesus." [14] Since he would not be persuaded, we remained silent except to say, "The Lord's will be done." After these days we got ready and started to go up to Jerusalem. [16] Some of the disciples from Caesarea also came along & brought us to the house of Mnason of Cyprus, an early disciple, with whom we were to stay. When we arrived in Jerusalem, the brothers welcomed us warmly. [18] The next day Paul went with us to visit James; and all the elders were present. [19] After greeting them, he related one by one the things that God had done among the Gentiles through his ministry. [20] When they heard it, they praised God. Then they said to him, "You see, brother, how many thousands of believers there are among the Jews, and they are all zealous for the law. [21] They have been told about you that you teach all the Jews living among the Gentiles to forsake Moses and that you tell them not to circumcise their children or observe the customs. [22] What then is to be done? They will certainly hear that you have come. [23] So

[i] Or And now, bound in the spirit
[j] Other ancient authorities read of the Lord
[k] Or with his own blood; Gk with the blood of his own
[l] Other ancient authorities add and Myra
[m] Or continued
[n] Gk brothers
[o] Gk four daughters, virgins,

do what we tell you. We have four men who are under a vow. 24 Join these men, go through the rite of purification with them, and pay for the shaving of their heads. Thus all will know that there is nothing in what they have been told about you, but that you yourself observe and guard the law. 25 But as for the Gentiles who have become believers, we have sent a letter with our judgment that they should abstain from what has been sacrificed to idols and from blood and from what is strangled and from fornication." 26 Then Paul took the men, and the next day, having purified himself, he entered the temple with them, making public the completion of the days of purification when the sacrifice would be made for each of them. ▮ When the seven days were almost completed, the Jews from Asia, who had seen him in the temple, stirred up the whole crowd. They seized him, 28 shouting, "Fellow Israelites, help! This is the man who is teaching everyone everywhere against our people, our law, and this place; more than that, he has actually brought Greeks into the temple and has defiled this holy place." 29 For they had previously seen Trophimus the Ephesian with him in the city, and they supposed that Paul had brought him into the temple. 30 Then all the city was aroused, and the people rushed together. They seized Paul and dragged him out of the temple, and immediately the doors were shut. 31 While they were trying to kill him, word came to the tribune of the cohort that all Jerusalem was in an uproar. 32 Immediately he took soldiers and centurions and ran down to them. When they saw the tribune & the soldiers, they stopped beating Paul. 33 Then the tribune came, arrested him, and ordered him to be bound with two chains; he inquired who he was & what he had done. 34 Some in the crowd shouted one thing, some another; and as he could not learn the facts because of the uproar, he ordered him to be brought into the barracks. 35 When Paul came to the steps, the violence of the mob was so great that he had to be carried by the soldiers. 36 The crowd that followed kept shouting, "Away with him!" ▮ Just as Paul was about to be brought into the barracks, he said to the tribune, "May I say something to you?" The tribune replied, "Do you know Greek? 38 Then you are not the Egyptian who recently stirred up a revolt & led the four thousand assassins out into the wilderness?" 39 Paul replied, "I am a Jew, from Tarsus in Cilicia, a citizen of an important city; I beg you, let me speak to the people." 40 When he had given him permission, Paul stood on the steps & motioned to the people for silence; and when there was a great hush, he addressed them in the Hebrew language, saying:

22

"Brothers and fathers, listen to the defense that I now make before you." ▮ When they heard him addressing them in Hebrew, they became even more quiet. Then he said: ▮ "I am a Jew, born in Tarsus in Cilicia, but brought up in this city at the feet of Gamaliel, educated strictly according to our ancestral law, being zealous for God, just as all of you are today. 4 I persecuted this Way up to the point of death by binding both men and women and putting them in prison, 5 as the high priest & the whole council of elders can testify about me. From them I also received letters to the brothers in Damascus, and I went there in order to bind those who were there and to bring them back to Jerusalem for punishment. ▮ "While I was on my way & approaching Damascus, about noon a great light from heaven suddenly shone about me. 7 I fell to the ground and heard a voice saying to me, 'Saul, Saul, why are you persecuting me?' 8 I answered, 'Who are you, Lord?' Then he said to me, 'I am Jesus of Nazareth whom you are persecuting.' 9 Now those who were with me saw the light but did not hear the voice of the one who was speaking to me. 10 I asked, 'What am I to do, Lord?' The Lord said to me, 'Get up and go to Damascus; there you will be told everything that has been assigned to you to do.' 11 Since I could not see because of the brightness of that light, those who were with me took my hand & led me to Damascus. ▮ "A certain Ananias, who was a devout man according to the law and well spoken of by all the Jews living there, 13 came to me; and standing beside me, he said, 'Brother Saul, regain your sight!' In that very hour I regained my sight and saw him. 14 Then he said, 'The God of our ancestors has chosen you to know his will, to see the Righteous One and to hear his own voice; 15 for you will be his witness to all the world of what you have seen & heard. 16 And now why do you delay? Get up, be baptized, and have your sins washed away, calling on his name.' ▮ "After I had returned to Jerusalem & while I was praying in the temple, I fell into a trance 18 and saw Jesus saying to me, 'Hurry and get out of Jerusalem quickly, because they will not accept your testimony about me.' 19 And I said, 'Lord, they themselves know that in every synagogue I imprisoned and beat those who believed in you. 20 And while the blood of your witness Stephen was shed, I myself was standing by, approving & keeping the coats of those who killed him.' 21 Then he said to me, 'Go, for I will send you far away to the Gentiles.'" ▮ Up to this point they listened to him but then they shouted, "Away with such a fellow from the earth! For he should not be allowed to live." 23 And while they were shouting, throwing off their

f Other ancient authorities lack and from what is strangled
g Gk he
r Gk He
s That is Aramaic
t That is Aramaic
u Gk the Nazorean
v Gk him

cloaks, and tossing dust into the air, 24 the tribune directed that he was to be brought into the barracks, and ordered him to be examined by flogging, to find out the reason for this outcry against him. 25 But when they had tied him up with thongs, Paul said to the centurion who was standing by, "Is it legal for you to flog a Roman citizen who is uncondemned?" 26 When the centurion heard that, he went to the tribune & said to him, "What are you about to do? This man is a Roman citizen." 27 The tribune came and asked Paul, "Tell me, are you a Roman citizen?" And he said, "Yes." 28 The tribune answered, "It cost me a large sum of money to get my citizenship." Paul said, "But I was born a citizen." 29 Immediately those who were about to examine him drew back from him; and the tribune also was afraid, for he realized that Paul was a Roman citizen and 30 that he had bound him. ¶ Since he wanted to find out what Paul was being accused of by the Jews, the next day he released him and ordered the chief priests and the entire council to meet. He brought Paul down and had him stand before them.

23

While Paul was looking intently at the council he said, "Brothers, up to this day I have lived my life with a clear conscience before God." 2 Then the high priest Ananias ordered those standing near him to strike him on the mouth. 3 At this Paul said to him, "God will strike you, you whitewashed wall! Are you sitting there to judge me according to the law, and yet in violation of the law you order me to be struck?" 4 Those standing nearby said, "Do you dare to insult God's high priest?" 5 And Paul said, "I did not realize, brothers, that he was high priest; for it is written, 'You shall not speak evil of a leader of your people.'" 6 ¶ When Paul noticed that some were Sadducees & others were Pharisees, he called out in the council, "Brothers, I am a Pharisee, a son of Pharisees. I am on trial concerning the hope of the resurrection of the dead." 7 When he said this, a dissension began between the Pharisees and the Sadducees, and the assembly was divided. 8 (The Sadducees say that there is no resurrection, or angel, or spirit; but the Pharisees acknowledge all three.) 9 Then a great clamor arose, and certain scribes of the Pharisees' group stood up and contended, "We find nothing wrong with this man. What if a spirit or an angel has spoken to him?" 10 When the dissension became violent, the tribune, fearing that they would tear Paul to pieces, ordered the soldiers to go down, take 11 him by force, and bring him into the barracks. ¶ That

night the Lord stood near him and said, "Keep up your courage! For just as you have testified for me in Jerusalem, so you must bear witness also in Rome." 12 ¶ In the morning the Jews joined in a conspiracy & bound themselves by an oath neither to eat nor drink until they had killed Paul. 13 There were more than forty who joined in this conspiracy. 14 They went to the chief priests and elders and said, "We have strictly bound ourselves by an oath to taste no food until we have killed Paul. 15 Now then, you and the council must notify the tribune to bring him down to you, on the pretext that you want to make a more thorough examination of his case. And we are ready to do away with him before he 16 arrives." ¶ Now the son of Paul's sister heard about the ambush; so he went and gained entrance to the barracks and told Paul. 17 Paul called one of the centurions & said, "Take this young man to the tribune, for he has something to report to him." 18 So he took him, brought him to the tribune, and said, "The prisoner Paul called me and asked me to bring this young man to you; he has something to tell you." 19 The tribune took him by the hand, drew him aside privately, and asked, "What is it that you have to report to me?" 20 He answered, "The Jews have agreed to ask you to bring Paul down to the council tomorrow, as though they were going to inquire more thoroughly into his case. 21 But do not be persuaded by them, for more than forty of their men are lying in ambush for him. They have bound themselves by an oath neither to eat nor drink until they kill him. They are ready now and are waiting for your consent." 22 So the tribune dismissed the young man, ordering him, "Tell no one that you have informed me of this." 23 ¶ Then he summoned two of the centurions and said, "Get ready to leave by nine o'clock tonight for Caesarea with two hundred soldiers, seventy horsemen, and two hundred spearmen. 24 Also provide mounts for Paul to ride, and take him safely to Felix the governor." 25 He wrote a letter 26 to this effect: ¶ "Claudius Lysias to his Excellency the governor Felix, greetings. 27 This man was seized by the Jews & was about to be killed by them, but when I had learned that he was a Roman citizen, I came with the guard and rescued him. 28 Since I wanted to know the charge for which they accused him, I had him brought to their council. 29 I found that he was accused concerning questions of their law, but was charged with nothing deserving death or imprisonment. 30 When I was informed that there would be a plot against the man, I sent him to you at once, ordering his accusers also to state before 31 you what they have against him." ¶ So the soldiers, according to their instructions, took Paul & brought

w Or up for the lashes
x Gk him
y Gk he
z Gk Men, brothers
a Gk concerning hope and
 resurrection
b Other ancient authorities
 add Farewell

him during the night to Antipatris. The next day they let the horsemen go on with him, while they returned to the barracks. When they came to Caesarea and delivered the letter to the governor, they presented Paul also before him. On reading the letter, he asked what province he belonged to, and when he learned that he was from Cilicia, he said, "I will give you a hearing when your accusers arrive." Then he ordered that he be kept under guard in Herod's headquarters.

24

Five days later the high priest Ananias came down with some elders and an attorney, a certain Tertullus, and they reported their case against Paul to the governor. When Paul had been summoned, Tertullus began to accuse him, saying: "Your Excellency, because of you we have long enjoyed peace, and reforms have been made for this people because of your foresight. We welcome this in every way & everywhere with utmost gratitude. But, to detain you no further, I beg you to hear us briefly with your customary graciousness. We have, in fact, found this man a pestilent fellow, an agitator among all the Jews throughout the world, and a ringleader of the sect of the Nazarenes. He even tried to profane the temple, and so we seized him. By examining him yourself you will be able to learn from him concerning everything of which we accuse him." The Jews also joined in the charge by asserting that all this was true. When the governor motioned to him to speak, Paul replied: "I cheerfully make my defense, knowing that for many years you have been a judge over this nation. As you can find out, it is not more than twelve days since I went up to worship in Jerusalem. They did not find me disputing with anyone in the temple or stirring up a crowd either in the synagogues or throughout the city. Neither can they prove to you the charge that they now bring against me. But this I admit to you, that according to the Way, which they call a sect, I worship the God of our ancestors, believing everything laid down according to the law or written in the prophets. I have a hope in God—a hope that they themselves also accept—that there will be a resurrection of both the righteous & the unrighteous. Therefore I do my best always to have a clear conscience toward God & all people. Now after some years I came to bring alms to my nation and to offer sacrifices. While I was doing this, they found me in the temple, completing the rite of purification, without any crowd or disturbance. But there were some Jews from Asia—they

ought to be here before you to make an accusation, if they have anything against me. Or let these men here tell what crime they had found when I stood before the council, unless it was this one sentence that I called out while standing before them, 'It is about the resurrection of the dead that I am on trial before you today.'" But Felix, who was rather well informed about the Way, adjourned the hearing with the comment, "When Lysias the tribune comes down, I will decide your case." Then he ordered the centurion to keep him in custody, but to let him have some liberty and not to prevent any of his friends from taking care of his needs. Some days later when Felix came with his wife Drusilla, who was Jewish, he sent for Paul & heard him speak concerning faith in Christ Jesus. And as he discussed justice, self-control, and the coming judgment, Felix became frightened and said, "Go away for the present; when I have an opportunity, I will send for you." At the same time he hoped that money would be given him by Paul, and for that reason he used to send for him very often and converse with him. After two years had passed, Felix was succeeded by Porcius Festus; and since he wanted to grant the Jews a favor, Felix left Paul in prison.

25

Three days after Festus had arrived in the province, he went up from Caesarea to Jerusalem where the chief priests & the leaders of the Jews gave him a report against Paul. They appealed to him and requested, as a favor to them against Paul, to have him transferred to Jerusalem. They were, in fact, planning an ambush to kill him along the way. Festus replied that Paul was being kept at Caesarea, and that he himself intended to go there shortly. "So," he said, "let those of you who have the authority come down with me, and if there is anything wrong about the man, let them accuse him." After he had stayed among them not more than eight or ten days, he went down to Caesarea; the next day he took his seat on the tribunal and ordered Paul to be brought. When he arrived, the Jews who had gone down from Jerusalem surrounded him, bringing many serious charges against him, which they could not prove. Paul said in his defense, "I have in no way committed an offense against the law of the Jews, or against the temple, or against the emperor." But Festus, wishing to do the Jews a favor, asked Paul, "Do you wish to go up to Jerusalem & be tried there before me on these charges?" Paul said, "I am appealing

c Gk praetorium
d Gk he
e Gk lacks Your Excellency
f Gk Nazoreans
g Other ancient authorities add and we would have judged him according to our law. But the chief captain Lysias came and with great violence took him out of our hands, commanding his accusers to come before you.
h Other ancient authorities read of the dead, both of
i Gk him

to the emperor's tribunal; this is where I should be tried. I have done no wrong to the Jews, as you very well know. ¹¹ Now if I am in the wrong and have committed something for which I deserve to die, I am not trying to escape death; but if there is nothing to their charges against me, no one can turn me over to them. I appeal to the emperor." ¹² Then Festus, after he had conferred with his council, replied, "You have appealed to the emperor; to the emperor you will go." ▌ ¹³ After several days had passed, King Agrippa & Bernice arrived at Caesarea to welcome Festus. ¹⁴ Since they were staying there several days Festus laid Paul's case before the king, saying,"There is a man here who was left in prison by Felix. ¹⁵ When I was in Jerusalem, the chief priests and the elders of the Jews informed me about him and asked for a sentence against him. ¹⁶ I told them that it was not the custom of the Romans to hand over anyone before the accused had met the accusers face to face and had been given an opportunity to make a defense against the charge. ¹⁷ So when they met here, I lost no time, but on the next day took my seat on the tribunal and ordered the man to be brought. ¹⁸ When the accusers stood up, they did not charge him with any of the crimes that I was expecting. ¹⁹ Instead they had certain points of disagreement with him about their own religion and about a certain Jesus, who had died, but whom Paul asserted to be alive. ²⁰ Since I was at a loss how to investigate these questions, I asked whether he wished to go to Jerusalem and be tried there on these charges.ᵏ ²¹ But when Paul had appealed to be kept in custody for the decision of his Imperial Majesty, I ordered him to be held until I could send him to the emperor." ²² Agrippa said to Festus," I would like to hear the man myself.""Tomorrow,"he said," you will hear him." ▌ ²³ So on the next day Agrippa and Bernice came with great pomp, and they entered the audience hall with the military tribunes & the prominent men of the city.Then Festus gave the order & Paul was brought in. ²⁴ And Festus said," King Agrippa & all here present with us, you see this man about whom the whole Jewish community petitioned me, both in Jerusalem and here, shouting that he ought not to live any longer. ²⁵ But I found that he had done nothing deserving death; and when he appealed to his Imperial Majesty, I decided to send him. ²⁶ But I have nothing definite to write to our sovereign about him. Therefore I have brought him before all of you, and especially before you, King Agrippa, so that after we have examined him, I may have something to write— ²⁷ for it seems to me unreasonable to send a prisoner without indicating the charges against him."

j Other ancient authorities
read with anything
k Gk on them
l Gk O king
m Gk the Nazorean
n Gk O king
o That is, Aramaic
p Other ancient authorities
read the things that you
have seen

26

Agrippa said to Paul,"You have permission to speak for yourself."Then Paul stretched out his hand & began to defend himself: ² "I consider myself fortunate that it is before you, King Agrippa, I am to make my defense today against all the accusations of the Jews, ³ because you are especially familiar with all the customs & controversies of the Jews; therefore I beg of you to listen to me patiently. ▌ ⁴ "All the Jews know my way of life from my youth, a life spent from the beginning among my own people & in Jerusalem. ⁵ They have known for a long time, if they are willing to testify, that I have belonged to the strictest sect of our religion & lived as a Pharisee. ⁶ And now I stand here on trial on account of my hope in the promise made by God to our ancestors, ⁷ a promise that our twelve tribes hope to attain, as they earnestly worship day and night. It is for this hope, your Excellency, that I am accused by Jews! ⁸ Why is it thought incredible by any of you that God raises the dead? ▌ ⁹ Indeed, I myself was convinced that I ought to do many things against the name of Jesus of Nazarëth.ᵐ ¹⁰ And that is what I did in Jerusalem; with authority received from the chief priests, I not only locked up many of the saints in prison, but I also cast my vote against them when they were being condemned to death. ¹¹ By punishing them often in all the synagogues I tried to force them to blaspheme; and since I was so furiously enraged at them, I pursued them even to foreign cities. ▌ ¹² "With this in mind, I was traveling to Damascus with the authority and commission of the chief priests, ¹³ when at midday along the road, your Excellency, I saw a light from heaven, brighter than the sun, shining around me and my companions. ¹⁴ When we had all fallen to the ground, I heard a voice saying to me in the Hebrew language, 'Saul, Saul, why are you persecuting me? It hurts you to kick against the goads.' ¹⁵ I asked,'Who are you, Lord?' The Lord answered,' I am Jesus whom you are persecuting. ¹⁶ But get up & stand on your feet; for I have appeared to you for this purpose, to appoint you to serve & testify to the things in which you have seen me and to those in which I will appear to you. ¹⁷ I will rescue you from your people and from the Gentiles—to whom I am sending you ¹⁸ to open their eyes so that they may turn from darkness to light and from the power of Satan to God, so that they may receive forgiveness of sins & a place among those who are sanctified by faith in me.' ▌ ¹⁹ "After that, King Agrippa, I was not disobedient to the heavenly vision, ²⁰ but declared first to those in Damascus, then in Jerusalem & throughout the countryside of Judea, & also to the Gentiles, that they should repent and turn to God and do

deeds consistent with repentance. 21 For this reason the Jews seized me in the temple and tried to kill me. 22 To this day I have had help from God, and so I stand here, testifying to both small & great, saying nothing but what the prophets and Moses said would take place: 23 that the Messiah must suffer, and that, by being the first to rise from the dead, he would proclaim light both to our people and to the Gentiles." ▮ While he was making this defense, 24 Festus exclaimed, "You are out of your mind, Paul! Too much learning is driving you insane!" 25 But Paul said, "I am not out of my mind, most excellent Festus, but I am speaking the sober truth. 26 Indeed the king knows about these things, and to him I speak freely; for I am certain that none of these things has escaped his notice, for this was not done in a corner. 27 King Agrippa, do you believe the prophets? I know that you believe." 28 Agrippa said to Paul, "Are you so quickly persuading me to become a Christian?" 29 Paul replied, "Whether quickly or not, I pray to God that not only you but also all who are listening to me today might become such as I am – except for these chains." ▮ Then the king got 30 up, and with him the governor & Bernice & those who had been seated with them; 31 and as they were leaving, they said to one another, "This man is doing nothing to deserve death or imprisonment." 32 Agrippa said to Festus, "This man could have been set free if he had not appealed to the emperor."

27

When it was decided that we were to sail for Italy, they transferred Paul & some other prisoners to a centurion of the Augustan Cohort, named Julius. 2 Embarking on a ship of Adramyttium that was about to set sail to the ports along the coast of Asia, we put to sea, accompanied by Aristarchus, a Macedonian from Thessalonica. 3 The next day we put in at Sidon; and Julius treated Paul kindly, and allowed him to go to his friends to be cared for. 4 Putting out to sea from there, we sailed under the lee of Cyprus, because the winds were against us. 5 After we had sailed across the sea that is off Cilicia & Pamphylia, we came to Myra in Lycia. 6 There the centurion found an Alexandrian ship bound for Italy & put us on board. 7 We sailed slowly for a number of days and arrived with difficulty off Cnidus, and as the wind was against us, we sailed under the lee of Crete off Salmone. 8 Sailing past it with difficulty, we came to a place called Fair Havens, near the City of Lasea. 9 ▮ Since much time had been lost and sailing was now dangerous, because even the Fast had already

gone by, Paul advised them, 10 saying, "Sirs, I can see that the voyage will be with danger and much heavy loss, not only of the cargo and the ship, but also of our lives." 11 But the centurion paid more attention to the pilot and to the owner of the ship than to what Paul said. 12 Since the harbor was not suitable for spending the winter, the majority was in favor of putting to sea from there, on the chance that somehow they could reach Phoenix, where they could spend the winter. It was a harbor of Crete, facing southwest & northwest. ▮ When a moderate 13 south wind began to blow, they thought they could achieve their purpose; so they weighed anchor and began to sail past Crete, close to the shore. 14 But soon a violent wind, called the northeaster, rushed down from Crete. 15 Since the ship was caught and could not be turned head-on into the wind, we gave way to it and were driven. 16 By running under the lee of a small island called Cauda we were scarcely able to get the ship's boat under control. 17 After hoisting it up they took measures to undergird the ship; then, fearing that they would run on the Syrtis, they lowered the sea anchor and so were driven. 18 We were being pounded by the storm so violently that on the next day they began to throw the cargo overboard, 19 and on the third day with their own hands they threw the ship's tackle overboard. 20 When neither sun nor stars appeared for many days, and no small tempest raged, all hope of our being saved was at last abandoned. ▮ Since they 21 had been without food for a long time, Paul then stood up among them and said, "Men, you should have listened to me & not have set sail from Crete and thereby avoided this damage and loss. 22 I urge you now to keep up your courage, for there will be no loss of life among you, but only of the ship. 23 For last night there stood by me an angel of the God to whom I belong & whom I worship, 24 and he said, 'Do not be afraid, Paul; you must stand before the emperor; and indeed, God has granted safety to all those who are sailing with you.' 25 So keep up your courage, men, for I have faith in God that it will be exactly as I have been told. 26 But we will have to run aground on some island." ▮ When the four- 27 teenth night had come, as we were drifting across the sea of Adria, about midnight the sailors suspected that they were nearing land. 28 So they took soundings & found twenty fathoms; a little farther on they took soundings again and found fifteen fathoms. 29 Fearing that we might run on the rocks, they let down four anchors from the stern & prayed for day to come. 30 But when the sailors tried to escape from the ship and had lowered the boat into the sea, on the pretext of putting out anchors

q Or the Christ
r Or Quickly you will persuade me to play the Christian
s Gk it
t other ancient authorities read Clauda
u Gk helps

from the bow, [31] Paul said to the centurion and the soldiers, "Unless these men stay in the ship, you can not be saved." [32] Then the soldiers cut away the ropes

33 of the boat & set it adrift. ¶ Just before daybreak, Paul urged all of them to take some food, saying, "Today is the fourteenth day that you have been in suspense & remaining without food, having eaten nothing. [34] Therefore I urge you to take some food, for it will help you to survive; for none of you will lose a hair from your heads." [35] After he had said this, he took bread; and giving thanks to God in the presence of all, he broke it and began to eat. [36] Then all of them were encouraged and took food for themselves. [37] [We were in all two hundred seventy-six persons in the ship.] [38] After they had satisfied their hunger, they lightened the ship by throwing the

39 wheat into the sea. ¶ In the morning they did not recognize the land, but they noticed a bay with a beach, on which they planned to run the ship ashore, if they could. [40] So they cast off the anchors & left them in the sea. At the same time they loosened the ropes that tied the steering-oars; then hoisting the foresail to the wind, they made for the beach. [41] But striking a reef, they ran the ship aground; the bow stuck and remained immovable, but the stern was being broken up by the force of the waves. [42] The soldiers' plan was to kill the prisoners, so that none might swim away and escape; [43] but the centurion, wishing to save Paul, kept them from carrying out their plan. He ordered those who could swim to jump overboard first & make for the land, [44] and the rest to follow, some on planks & others on pieces of the ship. And so it was that all were brought safely to land.

s other ancient authorities read *seventy-six*; others *about seventy-six*
w Gk *place of two seas*
x Gk *brothers*
y Gk *brothers*
z Gk *they*
a Or *I have asked you to see me and speak with me*
b Other ancient authorities add verse 29, *And when he had said these words, the Jews departed, arguing vigorously among themselves*
c Or *in his own hired dwelling*

TO THE
ENDS
OF THE
EARTH

28

fter we had reached safety, we then learned that the island was called Malta. [2] The natives showed us unusual kindness. Since it had begun to rain and was cold, they kindled a fire and welcomed all of us around it. [3] Paul had gathered a bundle of brushwood and was putting it on the fire, when a viper, driven out by the heat, fastened itself on his hand. [4] When the natives saw the creature hanging from his hand, they said to one another, "This man must be a murderer; though he has escaped from the sea, justice has not allowed him to live." [5] He, however, shook off the creature into the fire and suffered no harm. [6] They were expecting him to swell up or drop dead, but after they had waited a long time & saw that nothing unusual had happened to him, they changed their minds &

7 began to say that he was a god. ¶ Now in the neighborhood of that place were lands belonging to the leading man of the island, named Publius, who received us and entertained us hospitably for three days. [8] It so happened that the father of Publius lay sick in bed with fever and dysentery. Paul visited him & cured him by praying and putting his hands on him. [9] After this happened, the rest of the people on the island who had diseases also came and were cured. [10] They bestowed many honors on us, and when we were about to sail, they put on board all

11 the provisions we needed. ¶ Three months later we set sail on a ship that had wintered at the island, an Alexandrian ship with the Twin Brothers as its figurehead. [12] We put in at Syracuse & stayed there for three days; [13] then we weighed anchor & came to Rhegium. After one day there a south wind sprang up, and on the second day we came to Puteoli. [14] There we found believers and were invited to stay with them for seven days. And so we came to Rome. [15] The believers from there, when they heard of us, came as far as the Forum of Appius and Three Taverns to meet us. On seeing them, Paul thanked God and

16 took courage. ¶ When we came into Rome, Paul was allowed to live by himself, with the soldier who

17 was guarding him. ¶ Three days later he called together the local leaders of the Jews. When they had assembled, he said to them, "Brothers, though I had done nothing against our people or the customs of our ancestors, yet I was arrested in Jerusalem and handed over to the Romans. [18] When they had examined me, the Romans wanted to release me, because there was no reason for the death penalty in my case. [19] But when the Jews objected, I was compelled to appeal to the emperor—even though I had no charge to bring against my nation. [20] For this reason therefore I have asked to see you and speak with you, since it is for the sake of the hope

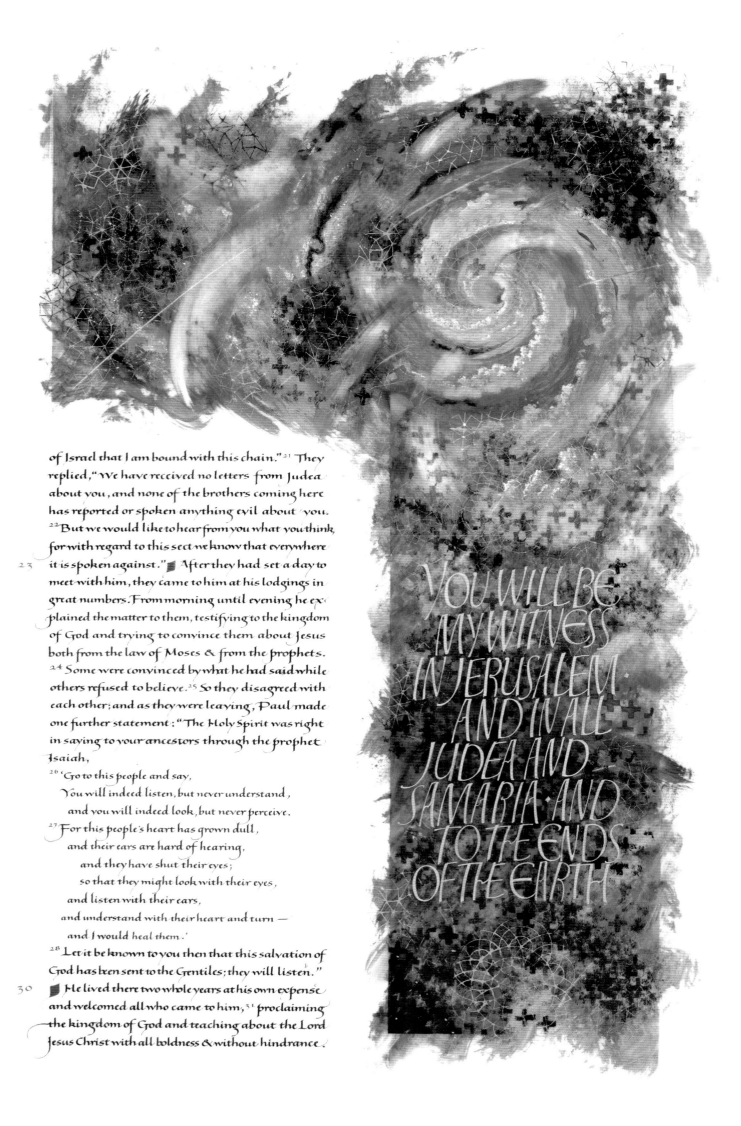

of Israel that I am bound with this chain." 21 They replied, "We have received no letters from Judea about you, and none of the brothers coming here has reported or spoken anything evil about you. 22 But we would like to hear from you what you think, for with regard to this sect we know that everywhere it is spoken against." 23 After they had set a day to meet with him, they came to him at his lodgings in great numbers. From morning until evening he explained the matter to them, testifying to the kingdom of God and trying to convince them about Jesus both from the law of Moses & from the prophets. 24 Some were convinced by what he had said while others refused to believe. 25 So they disagreed with each other; and as they were leaving, Paul made one further statement: "The Holy Spirit was right in saying to your ancestors through the prophet Isaiah,

26 'Go to this people and say,
 You will indeed listen, but never understand,
 and you will indeed look, but never perceive.
27 For this people's heart has grown dull,
 and their ears are hard of hearing,
 and they have shut their eyes;
 so that they might look with their eyes,
 and listen with their ears,
 and understand with their heart and turn —
 and I would heal them.'

28 Let it be known to you then that this salvation of God has been sent to the Gentiles; they will listen."

30 He lived there two whole years at his own expense and welcomed all who came to him, 31 proclaiming the kingdom of God and teaching about the Lord Jesus Christ with all boldness & without hindrance.

YOU WILL BE MY WITNESS IN JERUSALEM AND IN ALL JUDEA AND SAMARIA AND TO THE ENDS OF THE EARTH